RENAISSANCE
SELF-PORTRAITURE

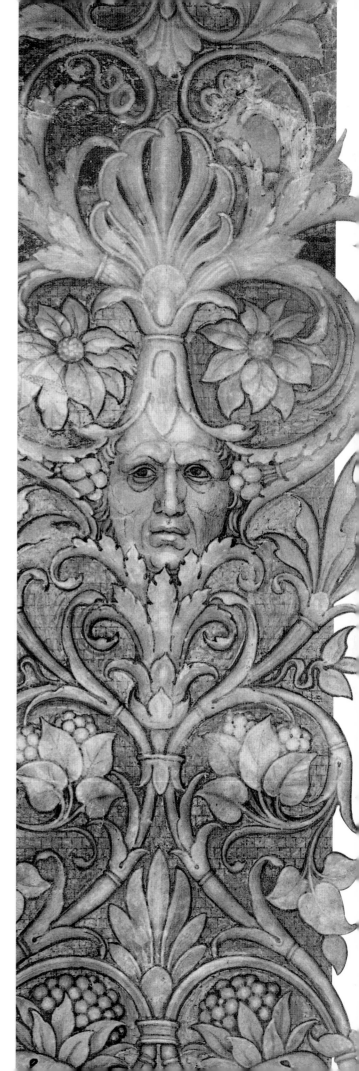

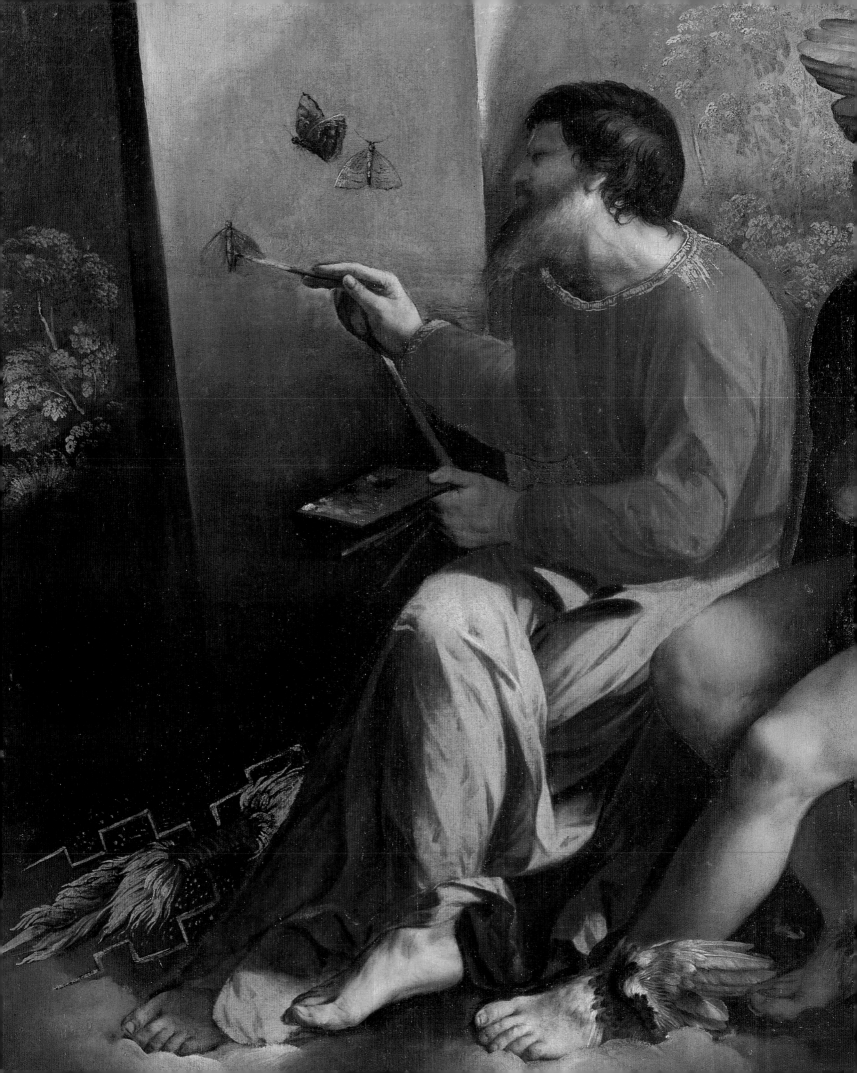

RENAISSANCE SELF-PORTRAITURE

The Visual Construction of Identity and the Social Status of the Artist

JOANNA WOODS-MARSDEN

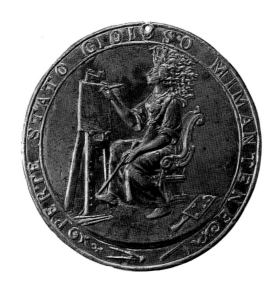

YALE UNIVERSITY PRESS
NEW HAVEN & LONDON

Designed by Gillian Malpass

Printed in Singapore

Library of Congress Cataloging-in-Publication Data

Woods-Marsden, Joanna, 1936–
 Renaissance self-portraiture: the visual construction of identity
and the social status of the artist / Joanna Woods-Marsden.
 p. cm.
 Includes bibliographical references and index.
 ISBN 0-300-07596-0 (cloth: alk. paper)
 1. Self-portraits, Italian. 2. Portraits, Renaissance – Italy.
3. Identity (Psychology) in art. 4. Artists – Italy – Social conditions.
I. Title.
N7619.5.I8W66 1998
704.9′42′094509031 – dc21 98-7688
 CIP

A catalogue record for this book is available from
The British Library

Page i: Andrea Mantegna, *Meeting Scene*, detail, with self-portrait,
Camera dipinta, 1465–74, Palazzo Ducale, Mantua.

Frontispiece: Dosso Dossi, *Jupiter painting in the Presence of Mercury* (detail),
1520s, Kunsthistorisches Museum, Vienna.

Contents

The Medici Court

Acknowledgments

I must start by acknowledging my debt to the earlier scholarship. Although there have been no sustained, scholarly explorations of Renaissance autonomous self-portraiture as a phenomenon, a number of articles on individual self-images or artists were of the utmost importance to this study. I have in mind Kathleen Weil-Garris Brandt's work on Bandinelli, Mary Garrard and Angela Ghirardi on Sofonisba Anguissola and other women artists, Roberto Zapperi on Annibale Carracci, Leo Steinberg and others on Velasquez, Laurie Schneider and Mark Jarzombek on Alberti, and, especially, Paul Barolsky on Michelangelo, Vasari, and Cellini's self-fashioning.

Scholarship cannot be accomplished without good research libraries; those in which I have been fortunate to work include the Kunsthistorisches Institut in Florence, the Hertziana and the American Academy in Rome, and the Warburg Institute in London. I have been especially privileged to work for some part of each summer in Villa I Tatti's Biblioteca Berenson, where I have benefited greatly from the intellectual contact with each year's group of new fellows, as well as from that with other returning scholars. I wish to thank the directors and librarians of all these institutions, as well as those in the Arts library and the Inter-Library loan service of my own institution, UCLA, and the Getty Research Institute, also in Los Angeles.

The UCLA Center for Medieval and Renaissance Studies provided a string of wonderful Research Assistants to help with the research; they included Allyson Burgess Williams, Silvia Orvietani Busch, Frederick Liers, and Vincent Barletta, who created the index. Welcome annual grants from the UCLA Academic Senate also allowed me to use the services of Andrea Park, Lola McKnight-Bier, Pauline Vaughn, J.B. Lundquist, who died the summer I began this study, and most recently, Maria DePrano, all in the Renaissance Program in the Art History Department of UCLA.

Two major fellowships made this study possible. A stint at CASVA at the National Gallery of Art as Paul Mellon Visiting Senior Fellow gave me three months in Washington in which to use the Library of Congress as well as the Gallery's own library. An unbelievable year as a National Endowment of the Humanities Fellow in the stimulating atmosphere of the National Humanities Center in Research Triangle Park, N.C., where scholars are treated like princes, allowed me to get ahead on the writing. Only I know how much the daily contact with the other fellows at this wonderful institution contributed to the study, not to mention discussions with the Renaissance historians and art historians in the area; I thank Melissa Bullard, Stanley Chojnacki, Michael Mezzatesta, Mary Pardo, Louise Rice, William Tronzo, and Ronald Witt for listening so patiently.

To express my gratitude here to everyone with whom I talked about this study over the past half a dozen years, and who shared bibliographic references and other self-portraits with me, would be impossible, but I must try to thank a few. Eric Frank was very generous with his store of references at the very beginning of the project, and Kenneth Gouwens gave me an extremely important reference at the very end. Many others suggested self-portraits that I didn't know: Thomas Tuohy brought Matteo di Giovanni's self-inclusion in his *Massacre of the Innocents* (Palazzo Communale, Siena) to

my attention, and Janet Smith suggested that the Judas in Sodoma's fresco of the *Last Supper* made a reference to the artist; unfortunately, neither work could be brought into the study.

Those with whom I also had valuable encounters include Susan Downey, Patricia Fortini Brown, Claudia Cieri-Via, Janet Cox-Rearick, Silvia Ferino-Pagden, Kristina Herrmann-Fiore, Marcia Hall, Tanis Hinchcliffe, Irving Lavin, Jonathon Nelson, Robert Williams, Susan Siegfried, Luke Syson, William Wallace, Mattias Winner, and Helmut Wohl. Several scholars, among whom Elizabeth Pilliod, Winifred McIver, and Paul Barolsky, shared research with me ahead of publication. Paul Barolsky and David Kunzle each read drafts of the study at different stages and offered sage advice. I can never thank them enough. I am also deeply grateful to Keith Christiansen, Janet Cox-Rearick, and Rona Goffen for their support at important junctures. Fiorella Superbi Gioffredi gave me invaluable council on the procurement of photos, and Sabine Eiche, Rona Goffen, and Elisabetta Papone, as well as Sheila Lee of Yale University Press, helped accomplish this painful task. Finally, there are no words with which to thank Margaret and Dyrk Riddell and Mary Magowan (not to mention Battista) for their quite exceptional hospitality, including our many visits to the theater.

Celia Jones copy-edited the manuscript, and my editor, Gillian Malpass, a model of patience, tact, talent, and vision must get sole credit for the beautiful form in which this study is presented, eminently appropriate to a discussion of the union of craft and intellect in the visual arts.

Research for the project ended in June 1997, and I am all too aware that it remains a study to which I must append the signature *faciebat* rather than that of *fecit*, as a work eternally in progress.

Research Triangle Park, N.C.,
and Los Angeles, CA,
January 1998

facing page Detail of pl. 135.

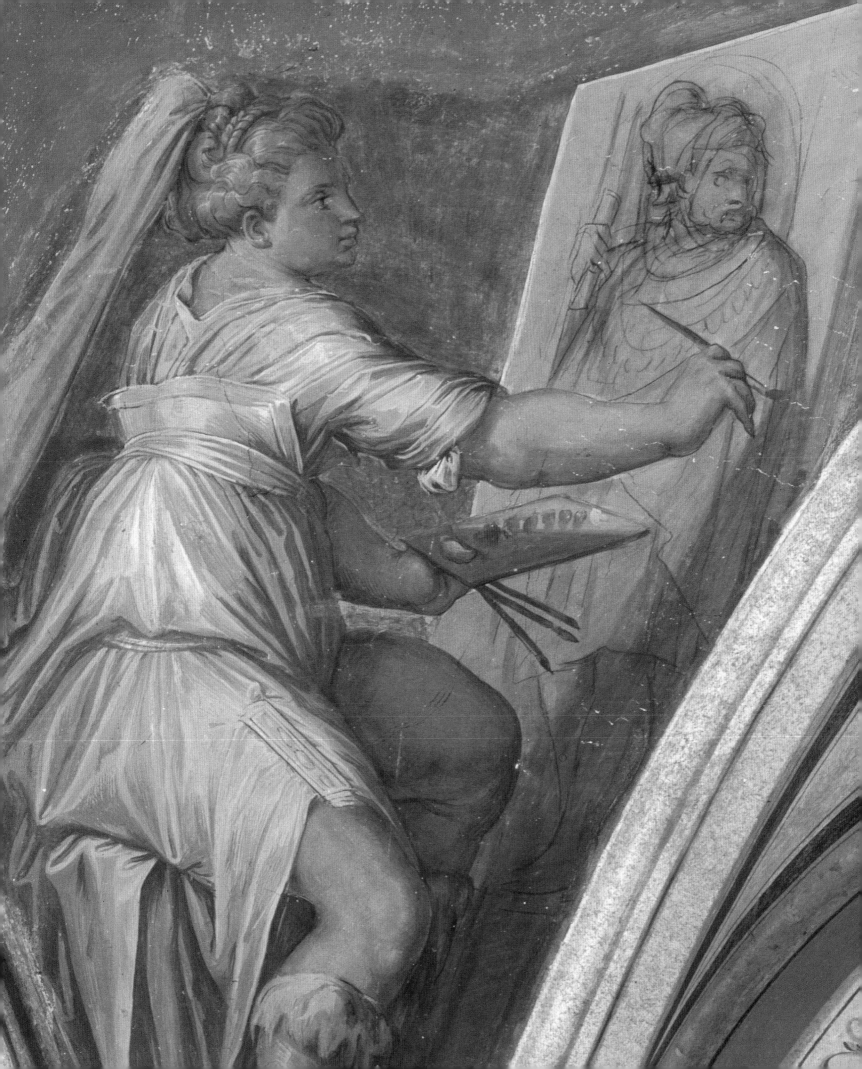

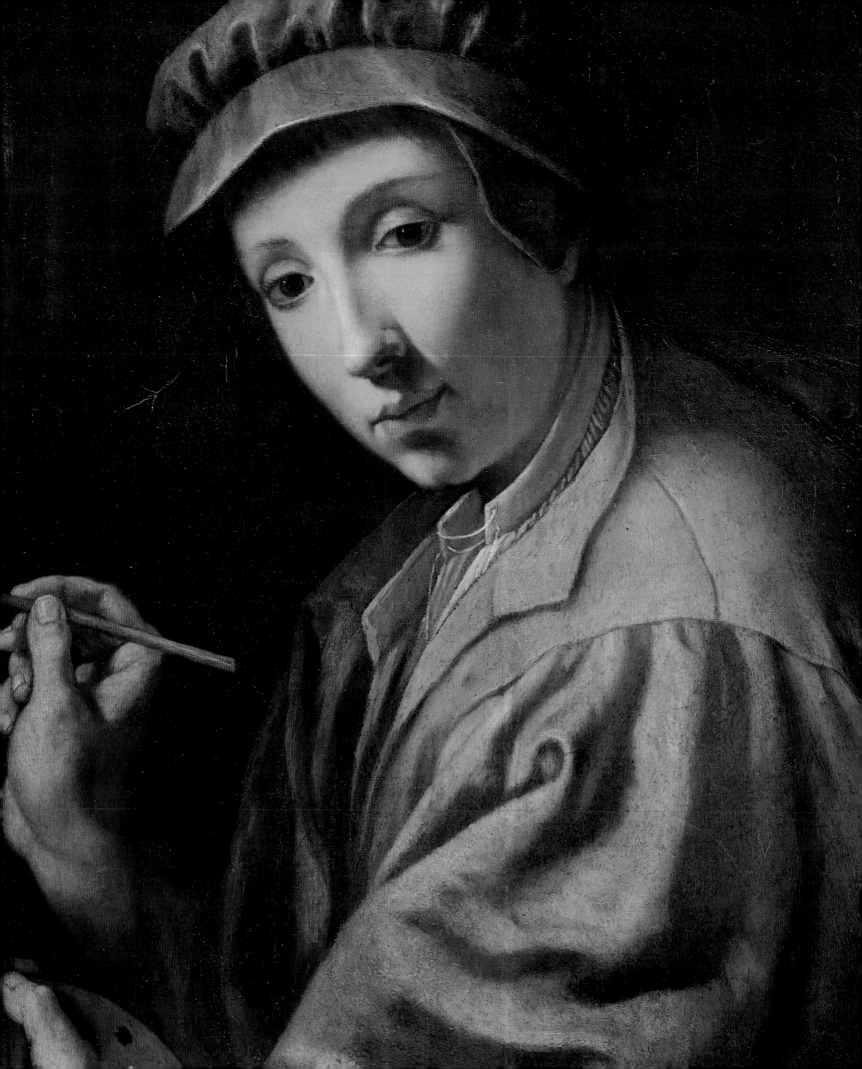

THE SOCIAL STATUS OF THE ARTIST IN THE RENAISSANCE

> Painting is work and labor more of the body than the mind, and is, more often than not, exercised by the ignorant.
> —Mario Equicola.[1]

The theme of this study is the genesis and early development of what would later become a central mode of expression in Western art: self-portraiture. The book explores a series of visual constructions in Renaissance Italy as these can be said to relate to a given social construction. The visual constructions comprise autonomous self-portraits, as the genre was invented in fifteenth- and developed in sixteenth-century Italy. The social construction in question was the prevailing Renaissance ideology concerning the social status of art and artists. The self-portraits are interpreted as specifically created to mediate between the artistic self, as it were, and its Renaissance audience. I argue that the images projected the aspirations of their creators for a change in the status of art and hence a change in their own personal social standing. In short, this is a study of the self-conscious visual self-fashioning of some Italian artists, as embodied in their self-imaging.

In this period when self-awareness slowly began to seek definition in art and literature, I have the additional objective of using the development of the self-image to explore the artist's experience of his own subjectivity – to the extent to which this is possible. Given our own culture's self-conscious preoccupation with the alleged self-knowledge that can be reached through psychoanalysis, an attempt to consider some of the same issues raised by early modern self-presentations and their contemporary resonance seems timely.

★ ★ ★

In the first paragraph, the word self-portrait was qualified with the adjective "autonomous." Autonomous or independent self-portraits are here defined as self-sufficient easel paintings within whose frame one (on rare occasions two or three) portrait head or a half- or full-length figure appears – in other words, the isolated self as both subject and object. The definition also extends to medals and portrait busts. One of the primary functions of these works was to record, or rather construct, the appearance of their makers. Such a definition of self-portraiture obviously does not extend to self-likenesses within religious narratives, whether altarpieces or frescoes, the locus for the earliest manifestation of self-imagery in Italy when artists occasionally included themselves among the crowds witnessing the depicted event. Such self-representations are sufficiently numerous to warrant a separate study of their own; thus, the many altarpieces including self-portraits by artists such as Pontormo and Bronzino do not – alas – find a place in this book.

"imagination," and *operazione di mano*, "handiwork," and by Vasari in 1568 as *il mio pensiero*, "my considered [judgment]," and *le mie mani*, "my hands." Renaissance society focused on the second component, *arte* or the Latin *ars*, which, along with other meanings, signified the skill of hand or mastery of illusionism required to execute the work, a skill that could be mastered by rule. The artists themselves, however, emphasized the *ingegno* or *ingenium* that could not be learnt, the inborn talent or creative power needed to conceive the work in the first place.[6]

One strategy in the artistic community's "public relations campaign" to re-classify art as "liberal" was to deny the role played by manual execution in its creation. "Painting is a mental occupation" (*pittura e' cosa mentale*), wrote Leonardo da Vinci, and Michelangelo stated equally firmly, "we paint with our brain, not with our hands" (*si dipinge col ciervello et non con le mani*) – implying almost that their works resembled Byzantine *Acheiropoieton*, images made not by human hands but by those of the Creator.[7] Leonardo laid down the correct sequence in the creative cycle: the painter must work "first in the mind [*mente*], then with the hands [*mani*]." "Astronomy and other sciences," he said, "proceed by means of manual activities, but [they] originate in the mind, as does painting, which is first in the mind of him who reflects on it, but," he was obliged to acknowledge, "painting cannot achieve perfection without manual participation."[8] The hand was to be understood as an *extension* of the mind, as in Alberti's claim that his objective in his treatise was to "instruct the painter how he can represent with his hand [*mano*] what he has understood with his talent [*ingegnio*]."[9]

Promoting this union of ideation and labor, Vasari sustained that only a "trained hand" could mediate the idea born in the intellect, or, as Michelangelo put it in a famous sonnet, "the hand that obeys the intellect" (*la man che ubbidisce all'intelletto*) – in other words, the "learned hand" (*docta manus*), that Nicola Pisano had claimed to possess three centuries earlier.[10] "The artist works first in the intellect," ventured Daniele Barbaro in his commentary on Vitruvius's *Treatise on Architecture*, "and conceives in the mind and symbolizes then the exterior matter after the interior image, particularly in Architecture."[11] The brilliant phrase with which Aretino conveyed Titian's greatness ran "from the hand [that conveys] the concept" (*di man' di quella idea*).[12] Only the last artist chronologically in this study was able to mention the manual labor involved in art without first having recourse to its intellectual principles. "Habbiamo da parlare con le mani," Annibale Carracci is reputed to have said in the 1590s, as he equated the artist's hands with the poet's voice: "*we* must speak with our *hands.*"

To be sure, the hand needed lengthy training to learn how to translate the invention of the intellect into a concrete image.[13] Both Alberti, at the beginning of our period, and Lomazzo, toward its end, stressed that only daily routine and disciplined study could cultivate the gifts of Nature, or inherent talents. For Alberti, industry, study, and practice (*esercitazione*) were essential, and Lomazzo identified rational learning, studious application, and manual discipline as necessary to bring the inherent artistic *ingegno* to its full fruition.[14]

So tenacious was the artistic community's long-term struggle for betterment that by the end of the sixteenth century it had succeeded dramatically in renegotiating the standing and the value of both artifact and maker. By 1600 it was possible for an artist to re-invent himself as a creator to be venerated for his godlike powers. Many of the artifacts, taking on a heightened aesthetic character and a mystique of greatness, were redefined as "art." The works of such an artist as Michelangelo were seen as entering a new realm of "genius" that transcended ordinary cultural production.[15] Accordingly, the period bracketed by the composition of Cennini's handbook of traditional workshop lore and recipes, *Il Libro dell'arte* (c.1400), and the developed expression of individual artistic talent in Lomazzo's *Idea del Tempio* in the 1590s, saw a profound shift in cultural values where the visual arts were concerned.[16]

I argue that the development of the self-portrait, an art form designed specifically for the affirmation of the *artist* rather than that of his patron, bears visual witness to this struggle for social acceptance, in that there was an inverse relationship between the extent of self-revelation as practicing artist, and the degree to which the case for the intellectual foundation of art had been won. Put very briefly, it was not until the late sixteenth century that artists felt sufficient confidence in their standing in society to acknowledge that they were indeed skilled manual workers for whom easel, palette, and brush represented attributes that could be embraced with pride. Previously, the very few artists who created autonomous self-portraits in the Quattrocento offered a vision of the artistic self as a Roman hero. Sixteenth-century self-portraitists, on the other hand, also suppressing visual evidence of professional identity, fashioned the self as *aeques Caesareus*, imperial knight, as the inscription on one of Titian's works reads, taking on such ennobling signs of elevated rank as swords, gloves, fine clothes, and architectural elements.

The study begins with an exploration of the intellectual, social, and psychic contexts for self-portraiture. It focuses initially on the intellectual historical background that encouraged the inventions of portraiture and self-portraiture in the Quattrocento. The humanists' construct of mankind's role in the universe is considered in an attempt to re-construct a shift in self-awareness in this period. The pervasive Renaissance phenomenon of conscious self-fashioning in life as well as art is then explored. Finally, the period terms and concepts with which Renaissance people both articulated their sense of self and related to visual representations, in particular their understanding of art as fictitious and deceptive, are considered.

The second chapter, on the social context, identifies the activities that comprised the liberal and mechanical arts, and considers early representations of exemplars of painting, sculpture, and architecture. The importance of geometry to the art community is touched upon, and the higher status of the art of poetry and its humanist practitioners explored. Finally, the status of art in Antiquity is focused on the career of Apelles, the most sought-after ancient exemplar for the Renaissance.

Chapter 3 explores visual representation of two self-referential themes: on the one hand, the act of painting and the artist's relation to his model – whether the self or the other – and to his artwork, and, on the other, works that suggest either the split or the harmony between the artist's two essential biological tools, each with its own status: the intellect and the hand. The development of the flat mirror in this period and its possible relation to the inventions of portraiture and self-portraiture are also explored.

The heart of the book, its study of specific self-portraits, begins with part II, which focuses on the fifteenth century, when *only* Boldù, Filarete, and Bramante, with medals, and Mantegna, with his high-relief bust for his tomb, can be said to have produced autonomous self-images. If the bronze plaquette in Washington is indeed *by* Leon Battista Alberti, and *of* him, and correctly dated to the 1430s, then the first self-conscious step toward the isolated self as both subject and object may have, very significantly, been taken by one who was *not* a craftsman at all but a patrician and a humanist.

By contrast to the Quattrocento exclusive use of bronze for the genre, part III considers the earliest autonomous *painted* self-portraits created around 1500 by Umbrians with ties to the courts of Urbino and Rome: Perugino and the young Raphael. Around the same time in Venice the equally youthful Giorgione produced an isolated experiment, figuring himself as a biblical warrior. The narrative then moves to the papal court of Leo X, where Raphael painted a double portrait – rare for the genre – his self-likeness with an unidentified friend; and the papal court of Clement VII, to whom Parmigianino presented his brilliant conceit of an autonomous self-likeness as a barber's convex mirror.

At the mid-century Florentine court of Cosimo I de' Medici, the biographer Vasari's self-images usually positioned him in the company of other artists – just as all the biographies in the second edition of his *Lives* give a context for his own long auto-biography as the climax of the book. The sculptor Baccio Bandinelli's many self-portraits were distributed among various media: paint, marble sculpture, and prints. As it happens, the third artist at the Medici court discussed, Cellini, produced no visual self-likeness to accompany his literary self-presentation.

The subjectivity of three Italian artists who worked for the Habsburg dynasty is then explored: Titian, who produced as many as 150 paintings for Charles V and other Habsburgs; the imperial sculptor Leoni, who travelled to Brussels and Madrid in the service of Charles V and Philip II; and the theorist-painter Federico Zuccari, who was called to Madrid by Philip, as well as working for many other courts. Each of them produced some half a dozen self-images, Zuccari's being marked by the frequent inclusion of family members.

The gender-specific "he" used hitherto is deliberate, and part IV addresses the late Cinquecento discourse of gender as embodied in the self-portraits of two sixteenth-century female artists. Paradoxically, one of the earliest surviving Italian self-images to reveal its creator seated unpretentiously at the easel was painted by a woman, Sofonisba Anguissola. Any Renaissance female who achieved competency in a cultural endeavor was considered a prodigy or freak of Nature. Anguissola's self-images in the act of painting were thus understood as embodying *two* "marvels," as a humanist put it – the curiosity of a work created *by* a female, *and* a portrait *of* its freakish creator. Thus, bizarrely, the manual craft that society condemned as base when undertaken by its usual male practitioners, was nonetheless perceived as valuable on those rare occasions when it was engaged in, against enormous odds, by *una donnesca mano*, "a lady-like hand."

Part V then explores the self-likenesses of the only male artists who, in the mid- and late Cinquecento, were prepared to offer visual proof that they were indeed skilled technicians prepared to embrace the attributes of easel, palette, and brush with pride: Titian, Allori, Cambiaso, and Palma Giovane. In 1550 Titian presented himself engaged in *disegno*, in the 1570s Luca Cambiaso produced perhaps his only portrait, depicting himself painting his father, and in the 1590s Jacopo Palma il Giovane, juxtaposing his likeness with a composition of the Resurrection, seems to have been the only Italian artist to project himself as pious believer in the post-Tridentine world.

The two self-images attributed to Annibale Carracci construct him in the workshop: the first, in the 1580s, by depicting him with other members of his artistic family, and, in the next century, by equating the self with a small canvas abandoned on an easel in a vacant site. Thus, the study of male self-imaging ends with an artist who presents himself as a craftsman, and as one who worked in the site in which the messy, manual labor of art production usually took place; his works set the stage for the many Seicento paintings on the theme of the artist working in the space that came to be known as the studio. This particular story accordingly ends with two paintings that can be interpreted as privileging the craft aspect of artistic creation. The issue of the visual representation of artistic identity in the Renaissance could be said to have been resolved, if only temporarily. Certainly, many of the issues addressed by Caravaggio's self-images are of a different nature from those that concerned artists in the previous 150 years.[17]

The study ends with a coda that considers the life and example of Michelangelo, the individual who – despite his lack of autonomous self-portraits – did more than anyone to raise the artist's status. Thus the much sought-after inclusion of the visual arts among the liberal arts in these centuries (and the concomitant phenomenon of the invention and development of autonomous self-portraiture) is presented as framed

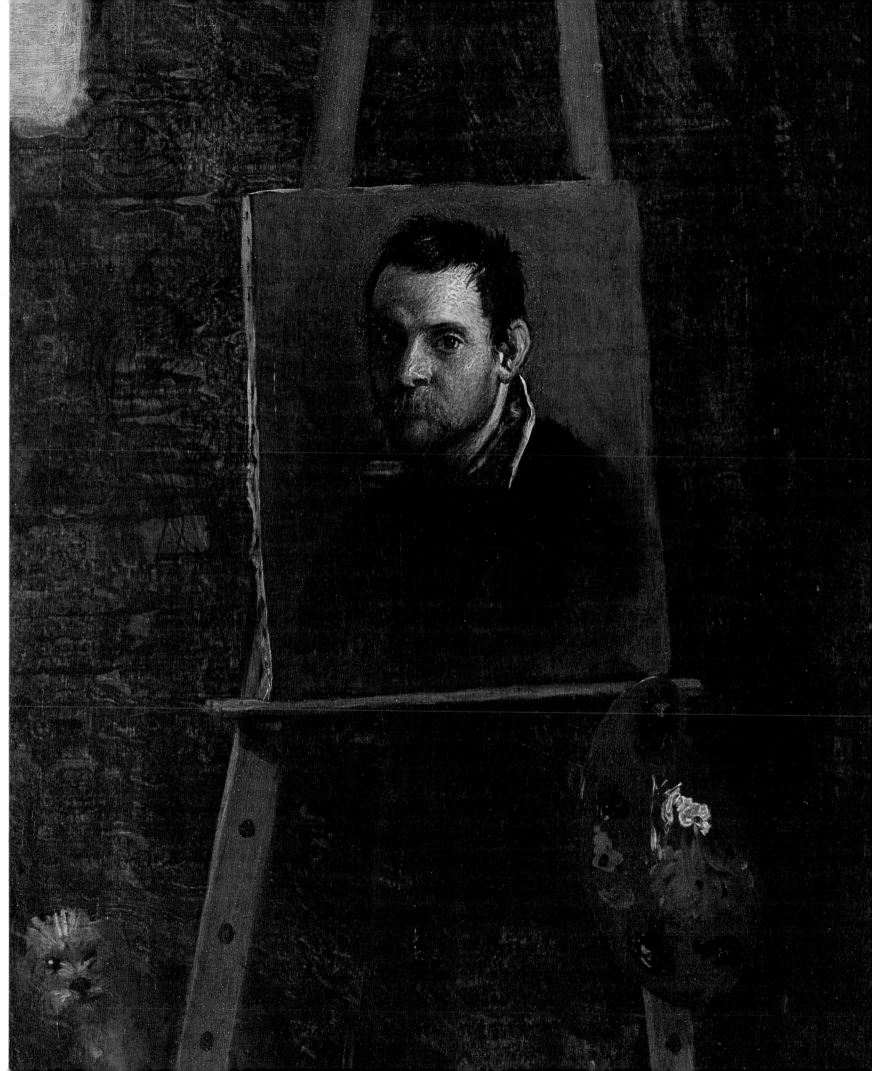

THE INTELLECTUAL, SOCIAL, AND PSYCHIC CONTEXTS FOR SELF-PORTRAITURE

3 Detail of pl. 65.

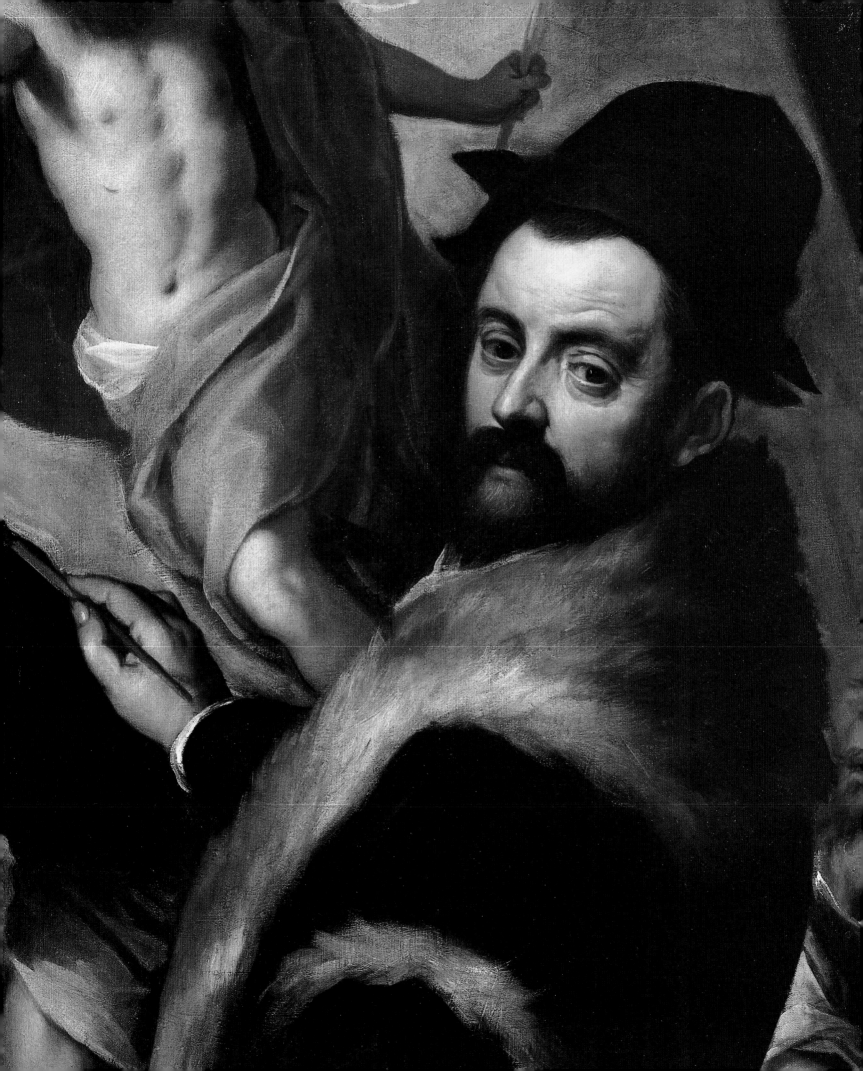

SELF-FASHIONING IN LIFE AND ART

Men are not born, but fashioned [*Homines non nascunter, sed finguntur*].
—Desiderius Erasmus[1]

How a person constructs the relations between an "I" and its world is *the* crucial factor in self-presentation, whether in life or art.[2] Here we address the question of the concept of the self in the early modern period. How did people of a very different age conceive of the self and its relation to the surrounding world? Specifically, what was the relationship between the practitioner of the visual arts and the ambient culture? How did Renaissance artists reconcile artistic or professional identity as imposed by the culture and that same identity as formed from within by the conscious self? What were the period terms in which they articulated this sense of identity or self?[3]

Our (seemingly natural) conception of the self is in actuality a construct with a long and varied social history. According to the anthropologist Mauss, the category of the "person", the idea of the "self," developed slowly over many centuries and always in relation to contemporary social history. Different cultures held different notions of the self at different times, the construction of each being connected to the culture's particular form of social organization.[4]

The notion of a *persona*, the Latin translation of the Greek *prosopon*, meaning the mask used in drama, is the character type or role that the mask represented. A key moment in this development for the Western world may have occurred in ancient Rome, when a person's given role – the mask or persona – was made the locus for a theory of general rights and duties as a legal "person" and a citizen of the state. Thus, the Romans established the notion of the "person" as a basic fact of law. All freemen of Rome were Roman citizens, and all had a civil persona. Only the slave was excluded from the right to a persona: *servus non habet personam*, "he has no personhood, he does not own his body, nor has he ancestors, name, cognomen, or personal belongings."[5]

To this notion of a "person" with citizenship and other rights, Christianity later added the concept of an inner conscience and inner life. Even the slave, albeit not in possession of his own body, was given a soul. The foundation then of the modern individual is this notion of a "person," bearing on the one hand a civic identity derived from Roman law and on the other a conscience and soul bestowed on it by Christianity.

★ ★ ★

There was, it has recently been argued, a general tendency beginning in the fifteenth, but accelerating in the sixteenth century, to view the internal self as an agent or subject.[6] One of the primary cultural factors in this development is seen as the emergence of humanism. Questions concerning humankind had not been ignored in the Middle Ages, but Renaissance humanists are thought to have paid more attention to the problems and experiences of the human person than their predecessors.[7] Indeed, the questions encountered by man and his life in this world were more pervasive in early Renaissance Italy, according to Kristeller, than in classical Antiquity.[8] Petrarch, for

instance, insisted that there was only one valid subject for human thought, man himself, and Facio and Manetti wrote their treatises on the dignity and excellence of man in conscious opposition to Innocent III's medieval treatise on contempt for this world and all it contained.[9] Indeed, merely by adopting the name *studia humanitatis* from Cicero and others as the definition of their occupation, the humanists can be said to have implicitly placed a new emphasis on man and his place in the universe.[10] Thus, by moving man's existence to the center of their concerns, the humanists are thought to have encouraged self-assertion by fostering human agency and sanctioning individual subjectivity.[11]

"Protagorus . . . declared that man is the mean and measure of all things," wrote Alberti in 1436.[12] Exploring the currents that came together to create "modern identity," Taylor hypothesized that the monumental change in self-understanding that this statement implied had been fed from many sources, one of which was Pico della Mirandola's landmark affirmation of the privileged position for humans within the universe.[13] To explain man's circumstances and his peculiar nature, Pico's *Oration on the Dignity of Man* offered his late Quattrocento version of the creation of man.

> Pico stresses especially man's freedom to choose his way of life. Consequently man no longer occupied any fixed place in the universal hierarchy, not even the privileged central place, but is entirely detached from that hierarchy and constitutes a world in himself. Illustrating this conception with a story, Pico recounts that man was created last among all the things when God had already distributed all his gifts among the other creatures: "Finally, the best of Workmen . . . spoke as follows: We have given thee, Adam, no fixed seat, no form of thy very own, no gift particularly thine, that . . . thou mayest . . . possess as thine own the seat, the form, the gifts which thou thyself shalt desire . . . In conformity with thy free judgment in whose hands I have placed thee, thou art confined by no bonds, and thou wilt fix the limits of thy nature for thyself . . . Neither heavenly nor earthly, neither mortal nor immortal have We made thee. Thou art the maker and molder of the self."[14]

Whereas Ficino had assigned to man and his soul a fixed, albeit central, place in the hierarchy of beings, Pico gave his fellow man neither a determined nature nor a fixed place but rather located him *outside* the hierarchy, giving him even greater freedom of choice.[15] The chameleon and the mutability of which it was capable was, he said, to be man's exemplar.[16]

To give man permission to select his own destiny was a new vision of human potential. There had never been, according to Greene, a more extravagant assertion of human freedom than that made by Pico.[17] The humanist addressed a world in which the earlier, Roman perception that a sense of personhood was primarily based on an individual's occupation or corporate role still held sway. If, however, man were able to recreate himself by his own deeds, he might instead become "the outcome of his own behavior," as Manetti said, rather than merely that of his occupation.[18]

Although Pico's assertion undoubtedly went beyond his period in the degree of flexibility of the self that he posited, it was representative, Greene has argued, of the optimism of Renaissance humanist thought, by revealing their faith in man's ability to control his own destiny as well as his freedom to make such a choice.[19] It can be seen as reflecting, on the one hand, the humanists' confidence in their contemporaries' ability to achieve a metamorphosis of their personalities and circumstances by sheer force of will, and, on the other, their new interest in the meaning of human existence – the nature of man and his place in the universe, whence he had come, whither he was going, and why he was born.[20] The supreme examplar of self-fashioning was Petrarch, who improvised for himself a multiplicity of roles with which he moved through life as if on a world stage.

Such a construction of the impact of humanism on the early Renaissance would seem to offer justification for the emergence, in this period, of the phenomena of biography and portraiture – not to mention those of autobiography and self-portraiture – as corresponding to the new sense of inwardness. A slight shift within the Italian art producer's sense of self – and, hence, his presentation of that self in life and art – led to the marked sense of identity exhibited in so many of their self-portraits.[21]

★ ★ ★

Greenblatt has explored the extent to which the upper classes of Elizabethan England – that is, those who would have been sufficiently educated in Latin letters to read Pico – felt that they could accept the freedom that he offered their class. In England the verb *to fashion*, a term for the process of creating a distinct, personal style, had long been in use, but in the sixteenth century it took on special connotations as a way of designating the shaping of a given person's identity, as revealed by a distinctive personality or a consistent mode of behavior. Thus, Elizabethans would have agreed with Pico that they had the power to impose a shape on themselves and the ability to control the emerging identity. They were, moreover, increasingly self-conscious and verbal about this "fashioning of human identity as a manipulable, artful process."[22]

It has been argued that one of the primary social factors of the new understanding of the self as an agent was the expanding size of Renaissance courts.[23] Italian Renaissance literature confirms the prevalent interest throughout the culture, but especially at court, in the possibility of self-transformation. Machiavelli's *Prince* was based on the author's conviction in the ruler's capacity to shape what we would call his public image into whatever form he wished.[24] The metaphor of the world as a stage was endemic at court, where to cut a good figure in public, *fare bella figura*, was essential to successful participation in sixteenth-century public life.[25] The entire text of Castiglione's *Book of the Courtier* addresses itself to this issue: the self-confection of the courtier and the development of that controlling behavioral technique called *sprezzatura*, a technique of performance that created the "*illusion* of spontaneity, if necessary by careful rehearsal."[26] The chameleon's constant transformations were compared to a form of theatrical representation, and Castiglione likewise conceived of the ideal courtier as an actor who, putting on a mask, consciously shaped his image to blend in with his surroundings and to satisfy his audience.[27] Playing at being himself in public, the courtier would "remember . . . *where* he is, and in the presence of *whom*, [assuming] . . . *apt poses* and *witty inventions*."[28] The resulting performance of eloquent speech, elegant demeanor, ready wit, scholarly attainment, and political acumen would "draw on [him] the eyes of the onlooker," and recommend him to the prince as a close confidante.[29] Who is to say whether life imitated art – that is, whether Castiglione's vision of the courtier as a work of art found its principles and practices already embodied in High Renaissance portraiture – or art, life – that is, whether artifacts called portraits codified already existing courtly values and practices?[30]

Burckhardt offered the heroic self-determination of Alberti's autobiographical *Life* as an example of the "perfecting of the individual."[31] More to the point perhaps in the context of this study, is the case that can be made that the main premise of Alberti's treatise on painting, *De Pictura*, was based on a typically humanist confidence in the pliability of the average craftsman and his inclination for self-reinvention. The artisan, he claimed, could not aspire to individual artistic accomplishment without a highly educated self. The Florentine Quattrocento artisan needed to fashion a new professional self, Alberti insisted, well versed in both Latin letters and the principles of geometry, albeit that these humanist disciplines were taught in a language, Latin, and in a

setting, the university, both denied to the artisan. Another major artistic text, Vasari's *Lives*, can be said to represent the ultimate affirmation of the humanists' confidence in the powers of the *artefice* to shape both his artistic and social selves.

The approach of Castiglione in his *Book of the Courtier* differed somewhat from that of Montaigne in his *Essais* to the conception of this "self" that was to be fashioned. While the French writer can be said to have developed a new awareness of the individual self as something to be discovered and explored, the Italian author seems to have conceived of the self, in Albertian terms, as something to be fashioned and created rather than discovered. In defining the relation of fact and fiction in the formation/discovery of the self through writing, modern theorists on autobiography seem to agree that the process was one of both self-discovery and self-invention, the two processes being inseparable.[32] We invent what we think we want to discover. The birth or invention of the autonomous self-portrait can thus be perceived as both an awakening to the existence of an inner self already in place, and that self's reinvention according to a new self-conscious awareness.

What were the period terms in which Renaissance people articulated this sense of self?[33] The terms *singolare*, "singular," "original," and *unico*, "unique," much employed to suggest the uniqueness of a given artist's talents and creativity, allow us to adumbrate his subjectivity without having recourse to anachronistic terms such as individualism. To be dubbed *singolare* in this culture was a term of praise. Ghiberti used it to define the wonders of his Gates of Paradise. The Duke of Milan claimed that his court painter Zanetto Bugatti made portraits of "singular perfection" (*singulare perfectione*).[34] Perugino was called *homo singulare . . . per tutto l'universo mondo*, "unique throughout the whole world."[35] Vasari used *singolarità* to characterize that most singular of individualists, Benvenuto Cellini, and the term was also employed to describe that most particular of sixteenth-century phenomena, the self-invention of the woman artist.[36] Both *singolarità* and *particularità* are useful period terms with which to adumbrate the culture's growing perception of the subjectivity that underlay the Renaissance artist's creation of so many unique visual products.

Renaissance sources make it very clear that these visual products were to be interpreted as if they were poetry, even when, or perhaps especially when, the skill of hand that gave verisimilitude to the paintings imparted the notion that the painted illusions literally represented the "truth." Like the poet, the artist always played illusionistically with his forms and his figures, and the work, whether it consisted of Renaissance images or Renaissance words, always artfully re-fashioned what it ostensibly described.[37]

The term often used for the process and the resulting product was *inganno*, "deception, illusion, trick."[38] Castiglione spoke of paintings that "deceive the eyes" (*ingannano gli occhi*), and in his introduction, Vasari called painting *piacevolissimo inganno*, "most pleasurable deception."[39] The *inganno* was no doubt "pleasurable" because the sophisticated viewer could watch that deceiver toy with deception without ever being himself deceived. Michelangelo used the verb *fabbricare*, to fabricate, to indicate the (literary) creation of illusions about the self. Aware that his image is being "fabricated" by a hostile source, he hastens to "fashion an alternative persona or mask, to become, as it were," a *fabbricatore di inganni*, creator of deceptions.[40] As it happens, in Renaissance diplomatic terminology, the term *arte*, "craft" or "skill," *itself* implied deceit, in the sense of artifice or trickery. *Fare con arte* meant to undertake something with the purpose of deceiving, with the word *arte* taking on the negative connotations of the English "crafty" or "cunning."[41]

In the late Middle Ages *fingere*, "to pretend, feign" was used in relation to poets as creators of myths and inventors of fables. "It is [the poet's] task to feign [*fingere*]," wrote Petrarch, "that is to say, compose and adorn and to shadow forth in artful colors and conceal with *a veil of pleasing fictions* the truth of things [emphasis added]."[42] In

Antiquity *fingere* signified the act of the potter making forms from clay, but its meaning was extended to cover the artifacts made by artisans in other media.[43] In the Renaissance, the term was linked to painting by Alberti in the Italian edition of his treatise: "the painter is concerned only with feigning [representing] what can be seen" (*sola studia il pictore fingiere quello si vede*).[44] The term was continually employed by later art critics and theorists; Comanini, for instance, thought Arcimboldo could "represent, feign, or pretend things that do not exist" (*fingere cose non esistenti*).[45] Just as the verb *cantare*, to sing, described what poets did, so *fingere* characterized the artist's task, as in the verse by the late Quattrocento poet Niccolò da Correggio, "that which a poet sings or a painter feigns" (*quel che un poeta o un pictor canta e finge*).[46] Leonardo frequently used the term: a painting for him was a *finzione*, "fiction, deception, that which simulates the real," and the painter a *fintore*, "creator of fictions, illusions, deceiver." Leonardo even once so addressed the painter: "remember, creator of illusions, deceiver . . ." (*Ricordati, fintore . . .*). Carpaccio went so far as to substitute the verb *fingere* for *pingere*, to paint, in his signature.[47] As it happens, what Pico really made the Deity declare to Adam in the famous passage from his *Oration* considered earlier, was "thou art the *plastes* and the *fictor* of the self," *plastes* meaning "sculptor/modeler," and *fictor* meaning "creator of artistic illusions."[48] In other words, in this famous text Adam learnt that he was to be the "sculptor" (*of* the self-image) and the "modeler/creator of illusions" (*about* the molded self).

The associations of the fictive or the deceptive of Pico's chosen term suggest that he expected man to shape his new, Renaissance persona along the same artful lines as the contemporary sculptor who modeled in wax or carved in marble, or the painter who placed colors on canvas, thus guaranteeing that the emerging human persona would be as fictional an entity as the emerging work of art. A similar analogy of artful deception was the self-fashioning whereby Castiglione's courtier hoped to shape *himself* as a living work of art. Thus the terms that characterized, behavioral self-fashioning in Renaissance life belonged to the same category as those used to describe the production of illusory art. Successful illusion is the best characterization for both the human and the artistic product, whether the living person in actuality, or the persona who continued to live through the art. Certainly, the term's connotations of simulation or forgery make *finzione* an apt definition for the self-invention that took place through self-portraiture, and *fictor* or *fintore* an appropriate synonym for the artisan who sought to present this newly minted self as convincing – even as he "conceal[ed] with a veil of pleasing fictions the truth of things."[49] Chastel's invention of the tag, *Fingo, ergo sum*, "I pretend, therefore I am," could well be the title of this study of Renaissance self-portraiture.[50] The mask – the persona – that signified the role or character type of the actor in Greek drama was ever present in Renaissance self-imaging. Indeed, the metaphor derived from Castiglione of the artist as a self-conscious performer undertaking a carefully rehearsed performance seems particularly apt in any exploration of the significance of seemingly spontaneous self-portraits.

These then are the period concepts in which we will consider, on the one hand, the illusory self-creation that took place through self-portraiture, that was nothing if not a *finzione*, "illusion," or *inganno*, "deception," and on the other, the maker's carefully cultivated personal *singolarità*, without which he could not have developed his particular artistic style. Individuality or *singolarità* must of course of itself be seen as the ultimate deception. To the extent to which individual selves can be said to exist, they too are fictions. "The self," as Barolsky phrased it, "is the seat of fiction and illusion," yet another factor to recall as we consider the many deceptions of art that were about the self – that fictional self – of the artist.[51]

THE SOCIAL CONTEXT

those arts that are closest to the liberal arts, to wit, painting, sculpture, and architecture, were first so long and so greatly degenerated, and almost perished with letters themselves, and are now being reawakened and revived, and there is such a flowering of the fine arts and lettered men. Happy these our times . . .
—Lorenzo Valla, *Elegantiae Linguae Latinae*, foreword.[1]

[Painting] deserves to be enthroned next to Theory and to be crowned with Poetry.
—Cennino Cennini, *Il Libro dell'arte.*[2]

5 Attributed to Donato Bramante, self-portrait medal, bronze, 1505, reverse (larger than actual size), British Museum, London.

This section introduces some of the key social and theoretical issues addressed in our exploration of Renaissance self-portraiture: the liberal and mechanical arts, the guilds and the Academy in Florence, the importance of geometry and the influence of ideas from Antiquity.

The liberal arts represented the knowledge that a freeman – as distinct from a slave – was supposed to possess.[3] The more advanced Quadrivium of the medieval scholastic tradition consisted of the four mathematical disciplines necessary for the comprehension of the structure of the world: arithmetic, defined as the nature of numbers; geometry, the nature of spatial relations; astronomy, the science concerned with the motion of the bodies; and, finally, harmonics, the motions apprehended by the ear (today called music theory). The more elementary Trivium of the same tradition added grammar, the study of language; rhetoric, the art of persuasion (and the liberal art to which poetry was usually allied), and dialectics, the Socratic art of logical debate, as the disciplines necessary to those aspiring to the study of the mathematical sciences of the Quadrivium. While the Trivium was considered indispensable for those seeking knowledge, the Quadrivium was broached only by students seeking to dedicate themselves to philosophical speculation. Thus, when the canon of the liberal arts was stabilized by the fifth-century grammarian Martianus Capella, there was no logical reason to admit the visual arts to either the mathematical sciences or the study of speech.

There were seven mechanical arts, of which three were equated with the Trivium: *lanificium* (weaving), *armatura* (making armor), and *navigatio* (navigation). The others: *agricultura* (agriculture), *venatio* (hunting), *medecina* (medicine), and *theatrica* (the living arts or sports) – later substituted by *ars fabrilis* (the art of building and, by extension, architecture) – were seen as corresponding to the Quadrivium. All these activities stressed physical, rather than intellectual, labor, as practiced by the "rude mechanicals" of Shakespeare's *Midsummer Night's Dream*, where this term of class distinction was taken to connote mean, vulgar, and unlettered.[4]

The first visual representations of the mechanical arts took the form of female personifications on Chartres cathedral, but an iconography did not develop until the fourteenth century.[5] The most conspicuous late medieval scheme in Italy – perhaps in all Europe – was developed on Florence campanile by Giotto and Andrea da Pisano (pl.

6).[6] Inserting the mechanical arts among the other creative activities of *homo faber*, in a scheme that also included the seven planets, the seven virtues, and the seven sacraments as well as the seven liberal arts, they were the first to offer visual embodiments of the visual arts. *Painting, Sculpture,* and *Architecture* appeared as a separate group of reliefs in a kind of limbo between the mechanical and liberal arts. In each case the female personifications at Chartres and elsewhere were replaced by an elderly male exponent of the craft – painting, sculpture, and architecture were gendered male on the eve of the Renaissance in the major art-producing center. Sculptura's carved statue took the vanguard form for the period of a male nude, whereas Pictura's task involved the painting of a more utilitarian shield, although an unpainted triptych hangs on the studio wall behind awaiting its holy image.

The status of the third art, Architectura, was the highest of the three, in that it was self-evidently based on the liberal arts of arithmetic and geometry, as well as requiring the most supervision, which automatically made it the most socially acceptable. Hence, architecture in this Trecento scheme required two reliefs: one, the *Art of Building*, depicted the supervision of construction by a master mason; in the other, a toga-clad geometrician sat at his desk with compasses in hand. The images predate by over a hundred years the distinction that Alberti made between the carpenter and the architect: to raise an edifice that was complete in every part was the business of an *architectus*, not a common carpenter, whose hand was only the former's instrument.[7]

Alberti was the first to articulate the proposition that painting, sculpture and architecture could be raised above the level of the mechanical arts only by being given a firm theoretical foundation, by which he meant the disciplines of the Quadrivium. The painter had to be as learned as possible, he said, "but I wish him above all to have a good knowledge of geometry."[8] One of his aims in *De Pictura* was to demonstrate the scientific base of painting by giving priority to mathematics, geometry, and the theory of proportions, and so on, as well as by codifying a method of one-point perspective that could be mastered by the practicing painter for whom he translated his treatise into Italian. Leonardo da Vinci, the painter who became the most persistent advocate for the elevation of painting to a liberal art, also argued that the scientific nature of painting lay in its possession of the rules of linear perspective, based on the laws of geometry.[9]

In the world of the Florentine guilds, however, such ideas would have seemed irrelevant, given that the members of the guild for painters included those who whitewashed walls and painted furniture, chests, and shields, as well as those who produced altarpieces and frescoes.[10] In Florence, the best-documented artistic center, there were seven major guilds (*arti*), and fourteen minor ones. Because painters (*dipintori*) prepared and sold pigments, they were included in the prestigious guild that brought together such essential occupations as the dispensing of drugs (apothecaries) and medicine (doctors), with whom the painters shared the same patron saint, St. Luke the Evangelist, who had been a doctor as well as a painter.[11] The guild also included a motley collection of other craftsmen, among whom were drapers, barbers, sword-makers, sellers of meat and cheese, booksellers, candlemakers, stationers, coif-makers, purse-makers, glove-makers, hatters, rope-makers, and flask-makers, as well as varnishers and goldbeaters.[12] Membership was compulsory for anyone painting in the city of Florence.

The social status of painters improved considerably in the course of the fourteenth century. After the Ciompi revolt in 1378, they were allowed to form an independent branch within the guild, and the latter briefly became known as the *arte dei medici, speziali, dipintori, e merciai*, the guild of doctors, apothecaries, painters, and drapers. Already in the mid-Trecento, the painters had sought to improve their social standing by forming the lay confraternity of St. Luke, which included the sculptors, architect-

6 Andrea Pisano, *Pittura, Scultura, Architettura, Art of Building*, marble reliefs, 1330s, formerly Campanile, Florence (now Museo dell'Opera del Duomo, Florence).

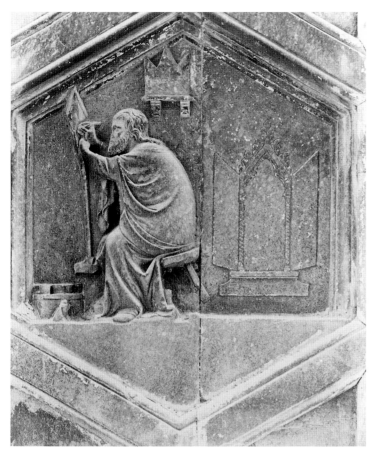

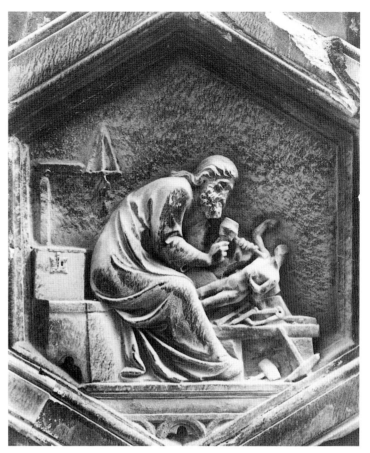

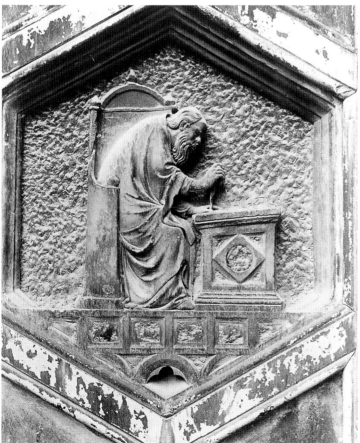

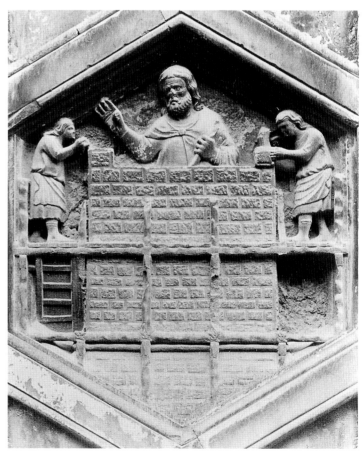

masons, and stone-cutters who had previously been segregated in the guild of the masters of stone and wood (*arte dei maestri di pietre e legnami*).

An event of great sociological significance, with far-reaching implications for the guilds, took place in Rome in 1540, when the consuls of the Roman guild for sculptors, the *scarpellini e marmorai*, objected that Michelangelo and other sculptors were allowed to exercize their occupation without being inscribed in the guild. Pope Paul III issued two edicts that exempted Michelangelo from membership in, or dues to, the guild because, among other reasons, he was said to possess exceptional gifts of *ingegno* and to be the greatest sculptor in the whole world (*totius terrarum*).[13] So Michelangelo officially became an "independent worker," freed from all guild ties, an unthinkable outcome in earlier centuries.

Like mathematics, letters were privileged above the visual arts. While not itself categorized as a liberal art, poetry was closely linked to rhetoric, which was.[14] By the fifteenth century, indeed, poetry, along with philosophy and theology, was being included in expanded liberal-arts cycles.[15] Aristotle's treatise on the theory of poetry had established that particular art's traditional prestige, on the grounds that it dealt with the very substance of human life and was therefore of universal significance.[16] Understandably then, poetry and music held correspondingly high places in early modern Italy, to the extent that both disciplines were included in the university curriculum. Instruction in the visual arts, on the other hand, was confined to artisans' workshops.[17]

Leonardo da Vinci lamented that the rise in the status of painting was hampered by its practitioners' inexperience in the use of words.[18] In Renaissance Italy, the creative elite formed two distinct cultural groups, a visual one recruited from the artisan class, and a literary one drawn mainly from the upper classes. These two cultures, defined as manual and intellectual, using, respectively, Italian and Latin, were the outcome of two systems of training: workshop-based and university-based. Hence most of those who dealt with the word had in actuality a higher social status and had therefore received a better education.[19]

The need for learning in general and theorizing in particular to ennoble the visual arts must have played a key role in the rapid growth industry in the number of treatises on art in the mid-Cinquecento, no doubt stimulated by publication of Alberti's treatise on painting in the 1540s: works by Pino in 1548, Doni in 1549, Vasari (in his introduction and prefaces) in 1550, Dolce in 1557, Cellini in the 1560s, Ligorio in the 1570s, and Lomazzo in the 1580s. The divide between the two cultures was also reduced by those Florentine artists who wrote autobiographies: Bandinelli, Michelangelo through Condivi, Cellini, and Vasari. The rise in status of Italian, the language used by the artisan class, was also a contributing factor. Whereas in the fourteenth and fifteenth centuries expertise in "poetry" was understood as the ability to interpret ancient poets and write Latin verse, in the Cinquecento vernacular poetry began to share in the prestige of Latin literature.[20]

The first known association of an artist with the term *accademia* occurs, at the beginning of the Cinquecento, in a series of engravings of interlaced knots, bearing the inscription ACHADEMIA LEONARDI VINCI, after a design by that artist.[21] The term was a synonym for *studium*, "university," a public seat of higher learning, and the engravings may have commemorated a gathering of Milanese court intellectuals for the purpose of learned debate on such liberal subjects as philosophy or music – and, Leonardo must have hoped, painting.[22] In Rome in the early 1530s, Bandinelli commissioned an engraving implying that he had organized a private *accademia* for young sculptors in his chambers in the Vatican Palace. The second such engraving that he commissioned twenty years later in Florence is illustrated in plate 97.

The academy, the Florentine Accademia del disegno, was founded in 1562. The sculptor Montorsoli to whom, as a servite monk, the Benizzi chapel in the cloister of

SS. Annunziata had been ceded, had the novel idea of making the tomb that he had built for himself a communal one for all artists without one.[23] At a meeting in this chapel in 1562, Vasari announced that Duke Cosimo I had accepted the role of protector of the new institution, thus putting into effect an unprecedented idea: state sponsorship of an art association.[24] Cosimo I and Michelangelo were made *capi*, honorary presidents, and the humanist Vincenzo Borghini the *luogotenente*, vice-president.[25] In 1571, the artists were finally liberated from the guild by the earlier creation of the "guild"-like academy, which nonetheless validated their new-found liberal status. The title of *accademico* itself immediately conferred a degree of nobility on its members, and the Academy's interest in developing a new curriculum and training appropriate to liberally educated artists also enhanced their social status.[26]

Nothing could have brought the Florentine academy's existence more effectively to the attention of the Italian intelligentsia than the spectacular funeral arranged for Michelangelo in 1564.[27] As the individual who had done more than any other artist to remove the stigma of manual labor from the Italian artist, Michelangelo's importance for the concept of the Academy was self-evident. Such a funeral was virtually unknown in Italy, the only precedent being the obsequies held the previous decade for Emperor Charles V in Bologna and Piacenza. In so honoring Michelangelo, their president, the Academy was able to express the notion that men of genius deserved to be ranked besides the highest dignitary in Europe, the Holy Roman Emperor. Michelangelo's immense talents had brought to fruition the theories expounded so earnestly fifty years earlier by Leonardo.

The social prestige of the visual arts in ancient Rome and Greece had been just as low as in Renaissance Italy, and for the same reasons: contempt for those who toiled manually for money.[28] A craftsman, according to Aristotle, was the equivalent of a slave to whom citizenship was denied; he worked – often labor that deformed the body and degraded the mind – for others.[29] As in the Renaissance, architecture was ranked first among the visual arts, because the master builder seldom undertook the manual toil himself; and painting, involving relatively light labor, was always placed ahead of sculpture.

The most dazzling exemplar for the Renaissance art community of a successful artist in Antiquity was of course Apelles, whose name was so often evoked in the Renaissance that it became a synonym for the art of painting, just as geometry was symbolized by Euclid, its most celebrated exponent. Petrarch was the first to compare an Italian artist, Simone Martini, to Apelles, followed by Boccaccio who similarly complimented Giotto. The list of those whose works were said to surpass the classical artist's work included Pisanello, Fra Angelico, Mantegna, and, eventually, too many to enumerate. In the mid-sixteenth century, the yardstick was applied with absurd hyperbole even to an aspiring young woman artist, who died while still an apprentice: in a funeral eulogy, Irene di Spilimbergo was said to have "obscured the names of the great Apelles and Phidias."[30]

Apelles' personal charisma was such that Alexander the Great supposedly frequented his studio. For Renaissance artists their relationship became the paradigm for that between the court artist and his patron. That any emperor could sufficiently value a mere artisan, even one as skilled as Apelles, to pick up his brush, much less hand over his favorite concubine, boggled the imagination. As a Daumier cartoon suggests, she who once belonged to an emperor cannot have been much pleased to become the property of a lowly painter (pl. 7). In this economy of gift exchange in which art and woman served as exchangeable commodities, the woman was in effect displaced in Alexander's affections by the art. Intoxicated by Pliny's anecdotes, Renaissance rulers became as avid as their court artists that the latter be characterized as a second Apelles; hopefully, it would transform many of them into second Alexanders.

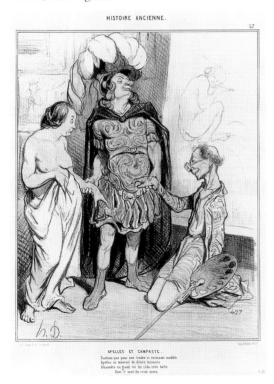

7 Honoré Daumier, "Apelles and Campaspe," *Histoire Ancienne*, lithograph, 1842, The Honoré Daumier and Contemporaries Collection, UCLA at the Armand Hammer Museum of Art and Cultural Center, Los Angeles.

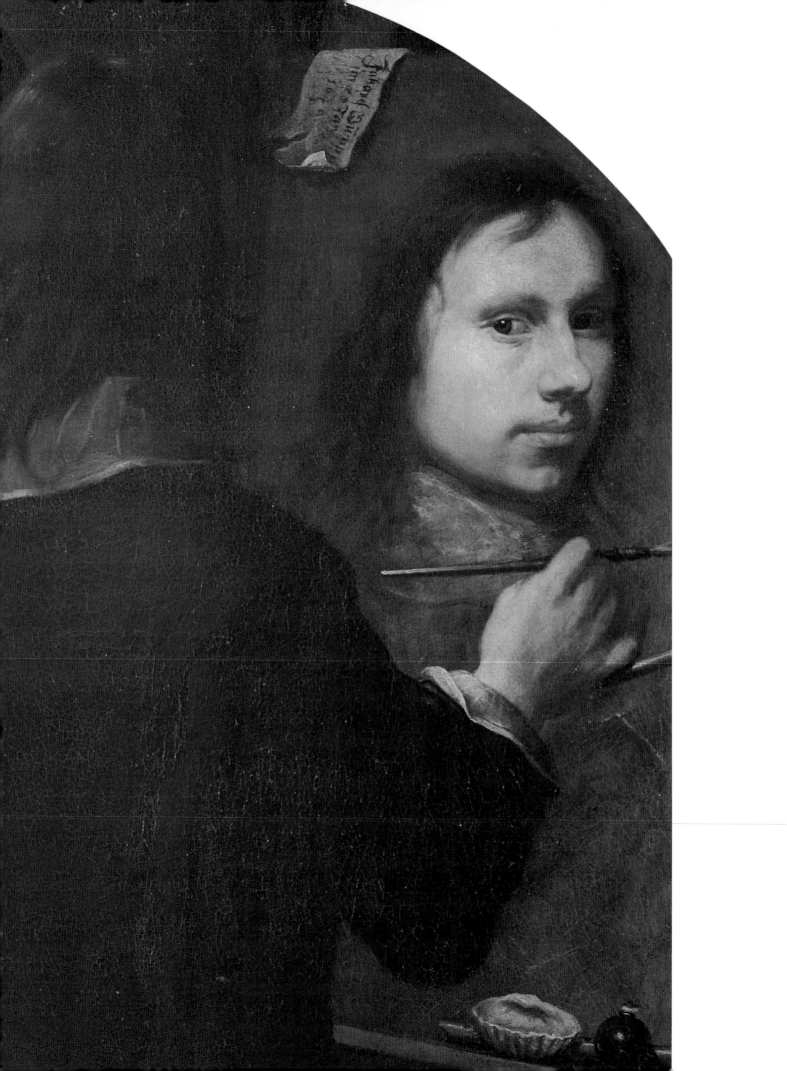

Chapter 3

VISUAL SELF-REPRESENTATIONS

No description is as difficult as the description of the self.
—Michel de Montaigne[1]

I promised to paint myself as I am.

—Jean-Jacques Rousseau[2]

REPRESENTATIONS OF THE ACT OF PAINTING

Since few Italian Renaissance paintings either visualize the act of painting or the artist's relation to his sitter, or represent the creative artistic impulse, it is necessary to explore some works post-dating the Renaissance in order to illuminate issues of portraiture and self-portraiture that are implicitly, if not explicitly, addressed in earlier paintings.[3]

Those few Renaissance works that include a creator *within* the image usually feature St. Luke, the legendary artist who was inspired by the Virgin to paint her "portrait," by appearing to him in person. Such a work is Vasari's fresco of *St. Luke painting the Virgin* (pl. 9) in the Cappella di San Luca in SS. Annunziata, the chapel given over to Vasari's Accademia del Disegno, where the work exemplified the art of painting. In it the painter-saint's physiognomy has a distinctly Vasarian cast, in a work in which the holy sitters, the inspired painter-saint – whose half-sitting, half-kneeling pose suggests genuflection – and the emerging work of great art, a canvas painted in fresco, are all three visible at once.

A painting from a very different period and culture from ours considers the same issue of the artist's relation to his sitter and his art, but allows the viewer to see the model from the same angle of vision as the creator: Matisse's *The Painter and his Model* (pl. 10).[4] Capturing the notion of the artist in the role of viewer, this painter shows more than he can see by featuring the self as a generic artist seen from the back, whose attention alternates between his sitter and his pictorial representation of her – when it is not claimed by the world framed by the window. Visualizing the subjectivity of his artistic consciousness, Matisse has "conflated into a single image his own special view of the world and his place in it."[5] As in Vasari's work, the style of the living sitter and the style of the sitter fixed for ever in paint are identical.

Rembrandt's early *Artist in his Studio* offers an image in which the model and maker appear to have reversed the sites they occupy in Matisse's work (pl. 11). Here painting and painter are positioned as if from the viewpoint of the sitter.[6] Rather than dominating his work by virtue of his scale and location, as in the previous examples, the painter has retreated as far from his easel as his studio will allow, so that he is dwarfed by the huge scale of his awesome creation in the extreme foreground. The work implies that the creative agency lies with the sitter – or indeed the viewer – rather than the artist (who of course in actuality *was* the viewer).

In a portrait, the relationship between painter and sitter is *the* crucial component informing the work of art, and all portraiture implies a silent dialogue between these two agents. Some works expose the social distance between sitter and artist that usually

8 Detail of pl. 13.

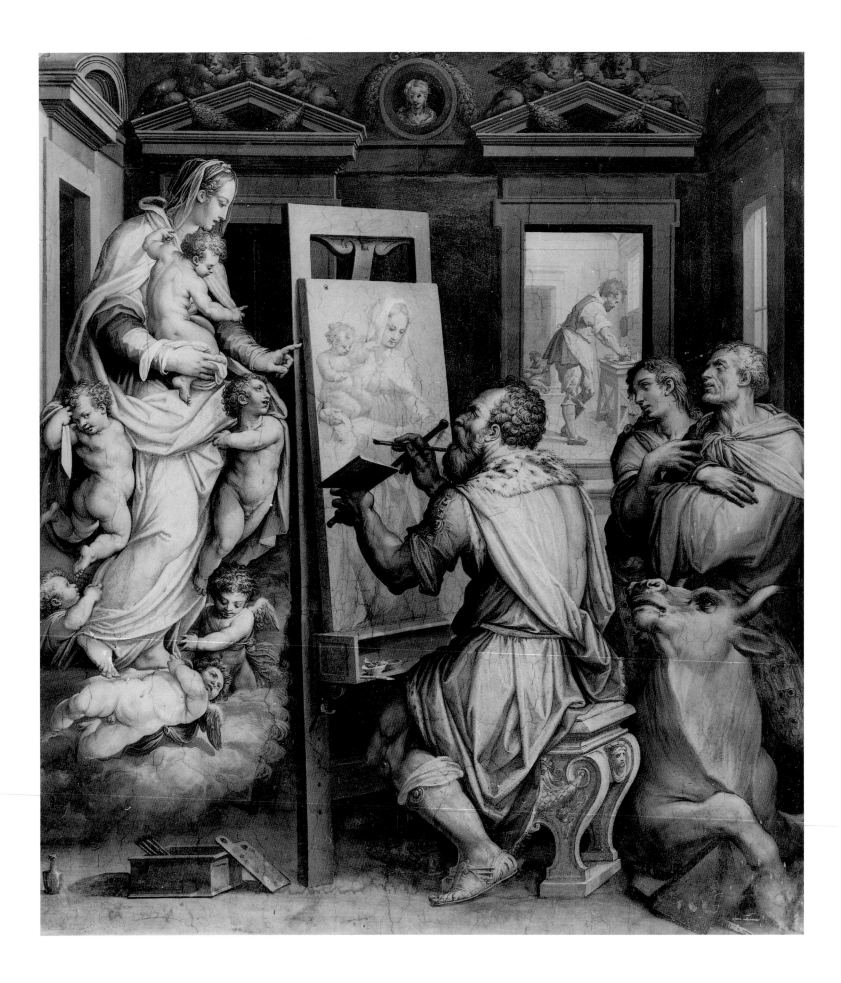

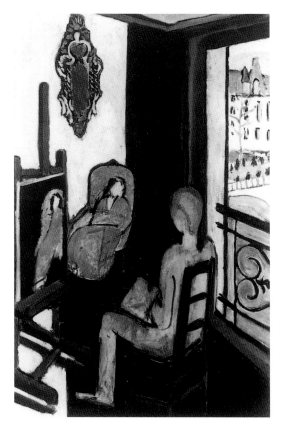

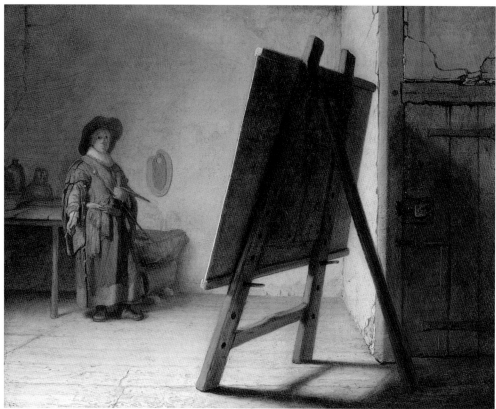

10 (*above left*) Henri Matisse, *The Painter and his Model*, canvas, 1917. Musée Nationale d'Art Moderne, Paris.

11 (*above right*) Rembrandt, *The Artist in his Studio*, canvas, 1629. Museum of Fine Arts, Boston. Zoë Oliver Sherman Collection. Given in memory of Lillie Oliver Poor.

9 Giorgio Vasari (finished by Allori), *St. Luke painting the Virgin*, fresco, *c.*1567–73, Cappella di S. Luca, SS. Annunziata, Florence.

prevailed in the Renaissance, and the ease with which the high-born sitter was able to impose his will, by his mere presence, to secure an image conforming to *his* vision of self over any that the artist may have had of him.[7] Other portraits suggest that this seldom-articulated struggle of will between model and maker remained unresolved to the end, to become embodied in the deceptive and illusory artwork itself.

In self-portraiture, where *fictor* and model are one and the same individual, this dialogue – uttered/unuttered, conscious/unconscious – takes place between self and self. The "sitter's" performance and dramatic style, as the "painter" constructs them, take center stage. The key relationship in the act of visualizing oneself is that between the self at the easel, and the image without substance that appears in the accomplice mirror; one self out there in the mirror and one here.[8] How the artist conceives and constructs the relations between the three compass points of the "I," the "me," and the work of art is one of the determining factors in all visual self-representations.

Plate 13 is a self-likeness in which the artist presents the self from the same viewpoint – the back – as in the painting by Matisse, equipoised between the mirror-image of his features on one side and the emerging *finzione* of the same face on the other. The sitter has become the mirror and its reflection. In this tondo image of the act of self-portrayal, created in Florence in 1646 by the Austrian Gumpp, the artist is framed by his mirrored self and his same-scale emerging construct on the canvas, a portrait of the self in the process of painting the self. The tensions underlying the twenty-year-old's act of self-affirmation, the strains that menace the harmony that ostensibly pertains among the three Gumpps within the tondo, are symbolized by the ferocious foreground antagonism between a cat and a dog, lurking respectively under mirror-image at left and easel picture at right. Their front stage "performance" must echo Gumpp's self-awareness of his own remarkable artistic performance for the

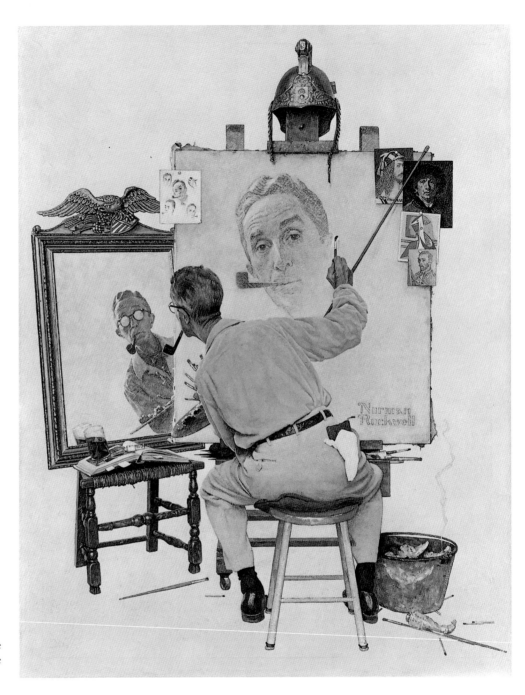

12 Norman Rockwell, *Self-Portrait*, cover of the *Saturday Evening Post* for February 13, 1960. The Norman Rockwell Family Trust.

13 Johannes Gumpp, *Self-Portrait*, 1646, Galleria degli Uffizi, Florence.

audiences of posterity: the "apt pose and witty invention," to use Castiglione's terms, in which he, the "real" Gumpp, turns his back on his public.

Norman Rockwell's *Triple Self-portrait* (pl. 12) constructs a similar performance, within a context that is both more spacious and more pretentious. The back of this creator's head is poised between the mirror-image surmounted by an American eagle, and the painting on the easel crowned by an imperial German helmet.[9] Created from the same angle of vision as the images by Gumpp and Matisse – as if painted by another, thus creating the illusion of being able to observe the artist observing himself – Rockwell reveals the extent to which his painted performance artfully refashions his image at the very moment of ostensible, literal "transcription" from mirror to canvas: his eyesight that requires no glasses, the phallic angle of his pipe, the colossal size of

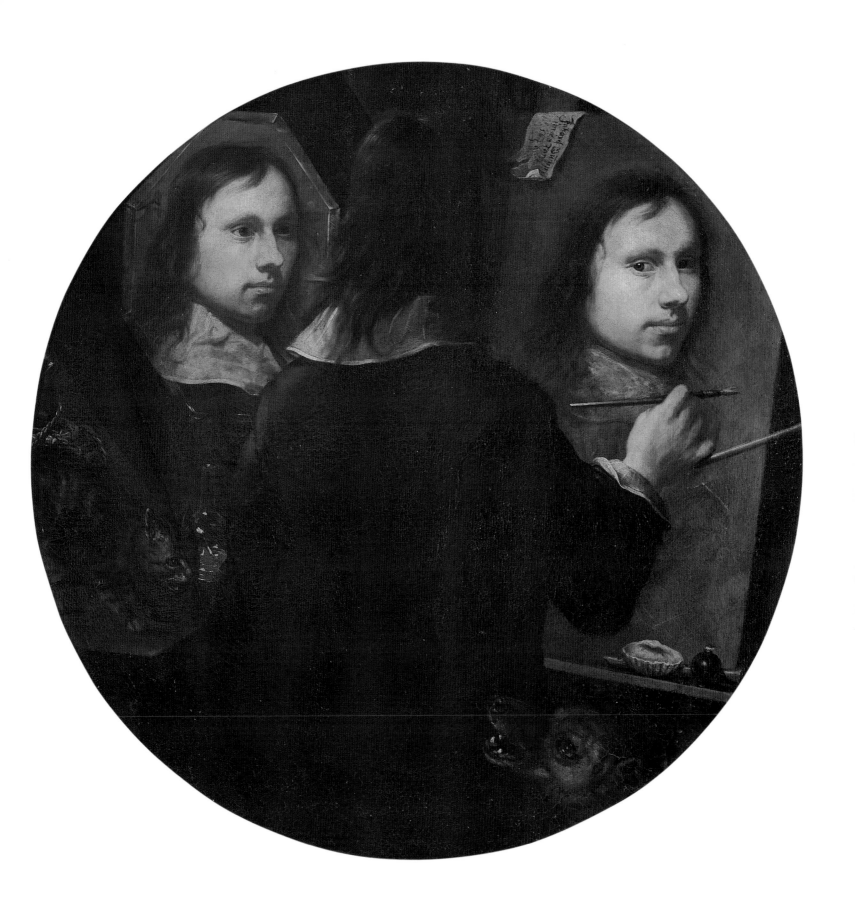

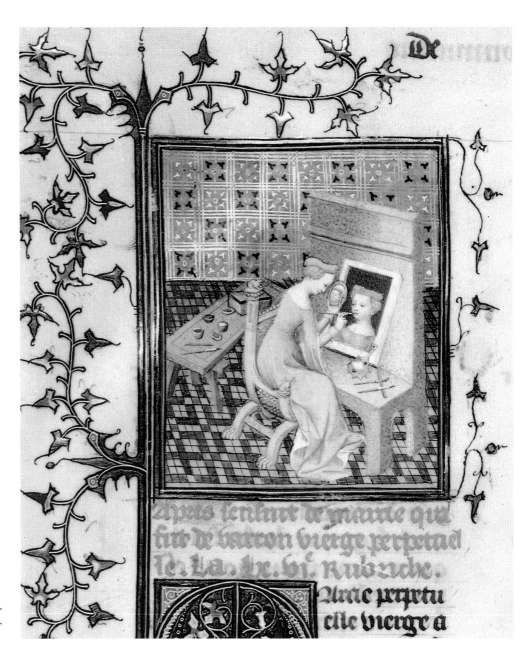

14 Boccaccio, *De claris mulieribus*, MS Fr. 12420,
f. 101v., *The Painter Marcia painting her Self-Portrait*,
French, 1402, Bibliothèque Nationale, Paris.

his head – and hence, of course, his intellect – placed, as it happens, directly below the
nineteenth-century helmet-crown.[10]

In a small early fifteenth-century French miniature, the female self, at full length, is
located to one side of the life-size emerging construct and the minute oval mirror-
image rather than, as was more usual, framed between them (pl. 14). The full-face bust
image of this remarkably early concept of the gendered self-portrait, corresponds to
the "demi-ymage" of portraits in contemporary French and Burgundian inventories.[11]
The order and relevance of the painting paraphernalia exhibited in the late Gothic
atelier – brushes, circular palette, pots and sea-shells filled with paint – points up the
anecdotal nature of the self-consciously confected disorder of Rockwell's mid-
twentieth-century studio.[12]

While the lady's autonomous self-image can be said to predate the history of self-
imaging in the early modern period, Rockwell's work, coming at the end of a long

sequence, inscribes him into a select history of Western self-portraiture; reproductions of famous self-projections by the Northern artists, Dürer, Rembrandt, Van Gogh, and Picasso, pinned to the canvas imply that the American artist is about to join this august group as the most recent great exponent of this celebrated Western genre.[13] Significantly, the canvas on which Rockwell has only started to delineate the self has already been inscribed in advance with a monumental signature.

The twentieth-century Rockwell no doubt took his mirror for granted, but such was not the case for the artist in the early modern period. "How the [flat] mirror is the master of painters," runs a heading in Leonardo's treatise on painting, where the mirror is described as an exemplary painter for its quality of duplicating everything: "the painter's mind should be like a mirror which transforms itself into the color of the thing it has as its object, and is filled with as many likenesses as there are things placed before it."[14] These unusual paintings by Gumpp, Rockwell, and the unknown French miniaturist highlight the role played by the mirror, Leonardo's "master," the secret accomplice without which no self-portraitist could produce, and which is, significantly, carried by Ripa's embodiment of Disegno (pl. 15). The mirror's immediate relevance to the self-image is also reflected in Vasari's incorporation of the phrases *alla sphera* or *allo specchio* into his definition of self-portraiture.[15] "Et stamani ho fatto di mio mano il mio viso, ritratto dallo specchio," he wrote, "this morning I made my face, portrayed in the mirror, with my hand."[16] In self-imaging, the mirror was an attribute as essential to the artist as the hand.

In the Middle Ages small metallic mirrors with highly polished surfaces were widely used. Those in glass were blown and were therefore not only convex but also circular in shape. Then a new method, the tin-amalgam process that dominated the manufacture of mirrors for the next four hundred years, was developed. This involved sticking a thin, even layer of tin-foil on the glass with mercury as the cementing process. For a long time the secret of making these larger mirrors was known only to the Gallo brothers of Murano, and throughout this period, the republic of Venice had a monopoly on the commercial manufacture of mirrors.[17] The development of undistorted mirror-images must have greatly encouraged self-awareness – a person's sense of his own *singolarità* – and can be said to have been essential to the cultural climate that gave rise to self-portraiture.[18] The difficulty of seeing oneself in the murky surfaces of some early Renaissance mirrors, at least in the form in which they have survived, should not, however, be minimized.

Even after the introduction of flat mirrors, circular frames continued to prevail, no doubt as a residue of the earlier technology: the woman in Giovanni Bellini's *Woman with Two Mirrors* uses two circular mirrors that are nonetheless flat (pl. 16).[19] Eventually, flat glass mirrors made the medieval convex ones obsolete. The period of transition between the old technology and the new is reflected in another Venetian work: both types of mirror occur in Titian's painting of another *Woman with Two Mirrors* (*c.*1512–17), a large convex mirror behind her, and a small rectangular one in front (pl. 17).[20]

Frequently used as a metaphor, the mirror gathered opposing symbolic connotations for the culture, being associated equally with the Cardinal Virtues and the Seven Deadly Sins. The positive or negative associations of the mirror depended on the length of time an individual spent studying his or her appearance in it, and on his or her motivation. Were they seeking the inner or spiritual self, invisible to the world? Or were they merely deriving gratification from a vision of the physical persona or mask as perceived by society?

Accordingly, the mirror was the attribute of such positive virtues as Veritas, truth, and Scienza, knowledge, symbolizing the truthfulness and verisimilitude that Renaissance painters claimed as their achievement.[21] The unblemished mirror, *speculum sine*

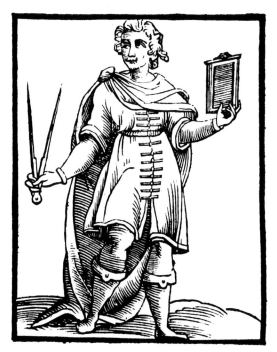

15 *Disegno*, from Cesare Ripa, *Iconologia*, woodcut, Padua, 1624.

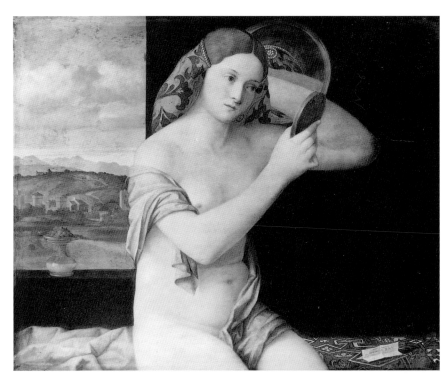

16 Giovanni Bellini, *Woman with Two Mirrors*, panel, 1515, Kunsthistorisches Museum, Vienna.

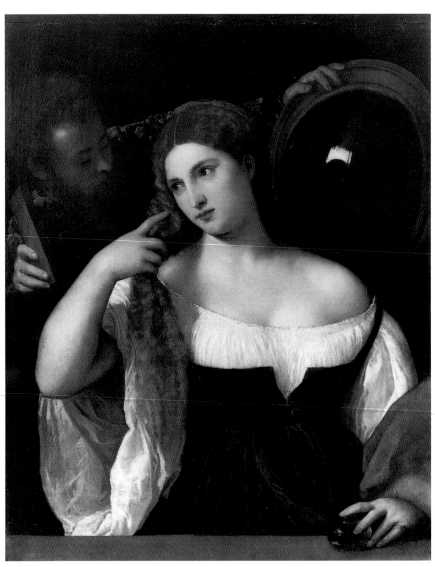

17 Titian, *Woman with Two Mirrors*, canvas, c.1512–17, Musée du Louvre, Paris.

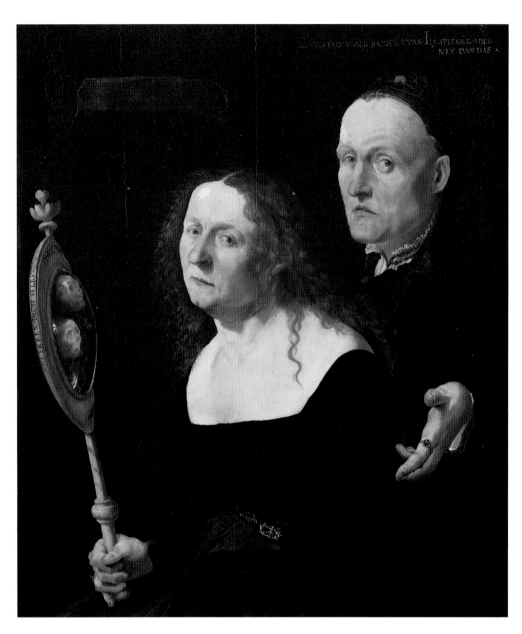

18 Laux Furtenagel, *Hans Burgkmair and his Wife*, canvas, 1529, Kunsthistorisches Museum, Vienna.

macula, also symbolized the purity of the Virgin, and there even existed an Order of the Mirror of the Blessed Virgin. Thus, the mirror was also an attribute given to the virtue Prudentia, whose act of self-contemplation was interpreted as the search for spiritual self-knowledge that was undertaken by the wise. Excessive mirror-gazing, however, indicated the opposite tendency and was interpreted as an obsession with his or her, but usually her, physical self, for which reason the mirror image also denoted the vice Vanitas, and was the symbol *par excellence* of the deadly sins of Voluptas, Superbia, and Luxuria.[22]

The ephemeral mirror-image was also linked to human transience. Functioning as a reminder of the inevitability of death, the mirror warned against indulgence in sin, acting as a stimulus to self-examination.[23] The overt moralistic meaning that could be conveyed by a mirror can be seen in the portrait of Hans Burgkmair and his wife (pl. 18) by Laux Furtenagel, where the mirror reflects the sitters as death-heads; while the portrait depicted the couple as they *appeared*, the mirror revealed them as they truly *were*.[24] Here the mirror signifies the self-knowledge that acknowledges the

inevitability of human transience, as indicated by the inscription ERKEN DICH SELBS, "know thyself."[25]

In the North, the mirror became an emblem of the artist, and circular convex glasses frequently hung in St. Luke's workshop in Flemish paintings of the saint depicting the Virgin. Although less attention was drawn to the mirror south of the Alps, it was nonetheless an attribute of Painting and Disegno (pl. 15), and hence of great professional significance to the artist. Already in 1435 Alberti recommended the practical use of the mirror as an artist's aid. Its reverse reflection would show up the imperfections in one's painting:

> I do not know how it is that paintings that are without fault look beautiful in a mirror; and it is remarkable how every defect in a picture appears more unsightly in a mirror. So the things that are taken from nature should be amended with the advice of the mirror.[26]

Leonardo also admonished the painter to use a mirror, which had to be flat, as his *maestro*, and often to check the accuracy of his rendition of Nature with the mirror's help.[27] Just as he envisaged the role of the artist as mediating between Nature and his art, so he hoped that the mirror would help the artist by further acting as mediator between Nature and himself. The painter, he thought, should keep his mind as clear as the surface of a mirror, so that ultimately he became his own mirror.

In a famous article, the twentieth-century psychiatrist Lacan uses an infant's encounter with a mirror to develop a psychoanalytic theory concerning the formation of subjectivity. The infant is split between identification with the mirror reflection and alienation from it as it realizes that it is an object for the gaze of others. Since the mirror-image made the child realize itself as a social being, the reflection played a crucial role in the child's gradual consciousness of self.[28] There was, Lacan claimed, no "self" before the "mirror stage;" the encounter between mirror and baby was at the origin of the constitution of the self, and hence a turning-point in the chronology of the self.[29] Thus vision, according to this theory, played a central role in the formation of subjectivity.

"C'est moy che je peins," wrote Montaigne: "it's myself that I paint." The paintings by Gumpp, Rockwell, and the French miniaturist, revealing the process of self-portraiture — the use of the first person — offer glimpses of the "process of negotiation" between the artist's consciousness, his subjectivity, and the Renaissance viewer to whom the image was addressed. In this dialogue, the hovering mirage in the looking-glass and the self that glimpses it join together to fashion a third "I," the convincing but always illusory *finzione* proposed by the art. This image eventually becomes the identity that displaces both the other "I"s, to live on through history as the "true likeness." On the one hand, it can be argued that the self-portraitist's *own* experience of the self-imaging looking-glass was a process whereby the Self became the Other; what is here is also out there, framed by the mirror. On the other hand, if we cannot become aware of our own subjectivity *until* we see it reflected back in the mirror, then the mirrored Other out there becomes the image of the self-portraitist's subjectivity.[30] The artist establishes a new relationship with the self as this self is interpreted in his art.

★ ★ ★

REPRESENTATIONS OF THE INTELLECTUAL AND THE MANUAL SELVES

> What clever servants for a great variety of arts are the hands, which nature has bestowed upon man . . . By the manipulation of the fingers, the hand is enabled to paint, to model, to carve, and to draw forth the notes of the lyre and of the flute . . . By means of our hands we try to effect, as it were, another nature.
>
> —Cicero, *De Natura Deorum*, ii, lx

The quintessential Italian pictorial formulation of the unity of the artist's two instruments, head and hand – the trained hand that mediates the idea born in the intellect – may well be Parmigianino's *Self-portrait in a Convex Mirror* (pl. 92), where the element in the foremost picture plane, the much magnified hand that he flaunts in the face of the viewer, should have forced its recipient, Pope Clement VII, to take cognizance of the remarkable intellect that conceived such an effective visual celebration of the painter's essential, but often despised, attribute: his hand.

The intellectual concept and technical skill, head and hand, are the two traditional centers of attention in portraiture; they are literally juxtaposed in two Northern works created at either end of the half millennium. *Portrait of an Artist* (pl. 19), the last of a series of self-images created by Paul Klee in 1919, shows the artist drawing with a brush in his right hand while his left props up his domed pate, a posture traditionally

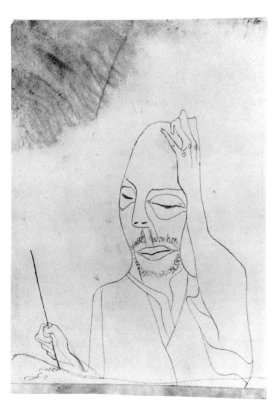

19 Paul Klee, *Portrait of the Artist*, pen, 1919. [Destroyed]

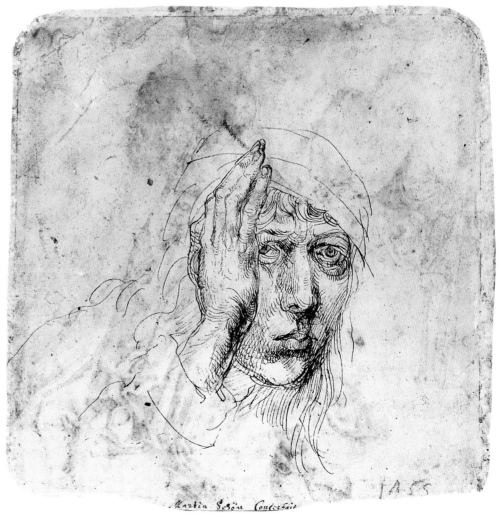

20 Albrecht Dürer, *Self-Portrait*, pen, *c*.1491. Universitäts-bibliothek, Erlangen.

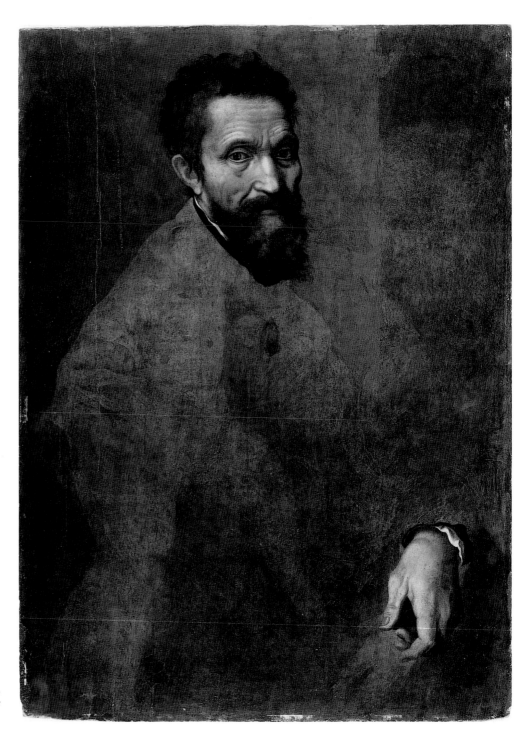

21 Jacopino del Conte, *Portrait of Michelangelo*, panel, *c.*1535, Metropolitan Museum of Art, New York.

associated with thought, self-absorption, or subjectivity, but one that can also be seen as symbolizing the union of intellect and skill necessary for all visual creation. Klee's comment in a 1918 diary entry, "my hand has become the obedient instrument of a remote will," echoes the Renaissance leitmotif of the control of the one over the other. As the last of a series of works embodying Klee's absorption in representations of the making of art, this final self-affirmation as a producing artist parallels the end of his self-analysis in the diaries.[31] Klee's drawing has been connected to Dürer's great early self-portrait of hand steadying face in Erlangen (pl. 20), with which the Swiss artist is believed to have been familiar, and which has been so cogently interpreted by Koerner

as an anatomy of the tensions that attend the double activity of looking and representing. Here the hand and eye, biological tools of the artist's trade – the hand that executes and the eye that judges – are physically conjoined at the center of the visual field in a drawing in which Dürer unites his roles of maker and model in his struggle to capture the self.[32]

In Jacopino del Conte's unfinished portrait of the "ingeniosissimo m[esser] Michele Angelo" (c.1535; pl. 21) his right hand is as highly finished as his head.[33] The hand and the intellect contained within the large cranium, however, are only sketchily linked to the shadowy pyramidal shape that was to have become his body. Pliny had observed that paintings left unfinished were valued more than finished work because they revealed traces of the artist's original conception.[34] Pliny was presumably referring to works left *non-finito* for external causes, such as the death of the artist, which was not the case here. By virtue of its incomplete state, Jacopino's portrait gives an impression of the unity of purpose of Michelanglo's intellect and hand. Whether deliberate or not, this clever use of *non-finito* offers powerful tribute to the unsurpassed greatness of both conceiving intellect and executing hand that the culture so fervently recognized in Michelangelo, while, at the same time, evoking the sculptor's own habit of leaving so many of his sculptures unfinished, a state that, according to Wittkower, required a new form of introspection.[35] As Vasari put it, Michelangelo had so perfect an imagination that the awesome concepts proposed in his thoughts were of a kind that the hand could not express.

Other paintings, offering intriguing visualizations of the two artistic selves suggest both the split and the unity between the two components of the artist's professional identity. *Self-Portrait with the Colosseum* is a small work by the Netherlandish artist, Maarten van Heemskerck, painted in 1553 (pl. 22). The artist returned to the memory of his protracted sojourn in Rome two decades earlier; when composing this work

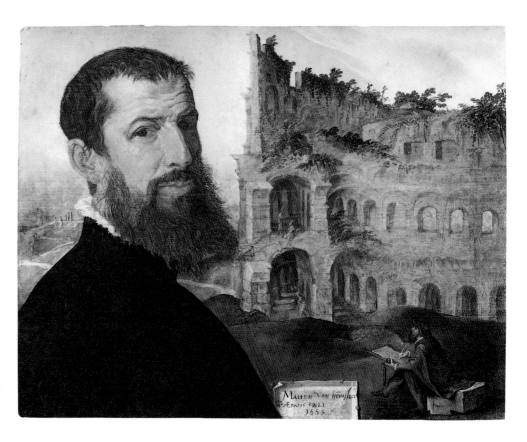

22 Maarten van Heemskerck, *Self-Portrait with the Colosseum*, panel, 1553, Fitzwilliam Museum, Cambridge.

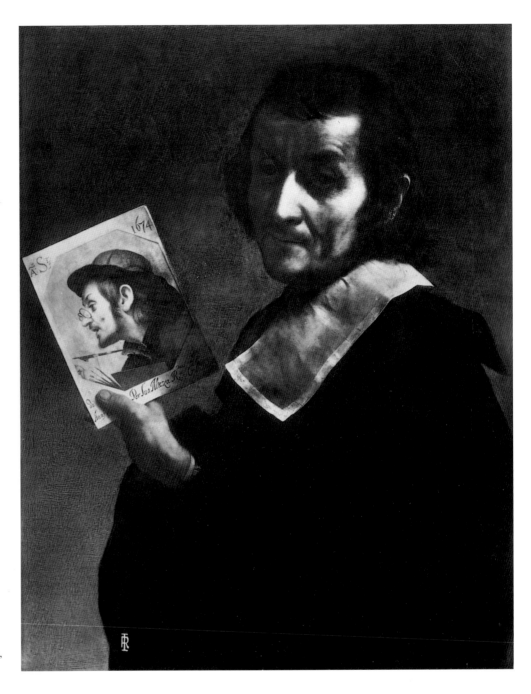

23 Carlo Dolci, *Self-Portrait with Drawing*, canvas, 1674, Galleria degli Uffizi, Florence.

that refers to his two personae. Heemskerck's huge intellect dominates the sky in a work in which the Colosseum, symbol of ancient Rome, is given special meaning as the artist's self-claimed attribute. In the distance, a tiny craftsman makes a preparatory drawing of this monument that will later be used for the image of the ruin that balances the artist's head in the painting, an image that Heemskerck's intellect had already conceived but his hand had not yet produced. The artist-craftsman is, as it happens, working on a *disegno* with all the intellectual connotations that that medium carried with it. It has recently been observed that the two halves of the painting lack unity. The *cartellino*, instead of lying in the foremost picture plane, is overlapped by the painter-sitter's clothes, creating the illusion that the artist poses in front of another painting, one featuring the Roman ruin being sketched by his 1530s self. This conceit may have been intended as a visual device to reflect the time that had elapsed between

Bart.ⁱⁱˢ Murillo seipsum depin
gens pro filiorum votis ac preci
bus explendis

24 Bartolomé Esteban Murillo, *Self-Portrait*, canvas, 1670s, National Gallery, London.

the foreground head (as embodying the social status acquired by the artist by 1553), and the background figure (as Heemskerck confected his appearance and actions in Rome twenty years earlier).[36]

In the next century, Carlo Dolci's self-likeness also promoted his talent in *disegno* in a *double* portrait in which the conceptual self displays the executive self, in another solution to the problem of how to represent the two facets of the artist's identity (pl. 23). Dolci acknowledges a split personality: his finely dressed intellectual self, with fashionable mien of melancholic introspection, holds up a drawing, a work of art within a work of art. The latter, a work of art that is a mere two-dimensional image at some remove from the reality of the three-dimensional painted intellectual self, constructs the artisanal self as imbued with the energy and intensity of one totally absorbed in the act of creation, energy that might not have been suspected of the conceptual persona as presented here.

Also in the 1670s, Murillo invented an equally complex self-image (pl. 24). A sculpted oval frame, containing the artist's image in oil on canvas, is located between two

Chapter 4

THE FLORENTINE ARTIST AS WITNESS IN RELIGIOUS NARRATIVE

DORMITION, ASSUMPTION, AND CORONATION OF THE VIRGIN

Before embarking on our study of Italian autonomous self-portraiture over a two-hundred-year period, let us briefly consider some representative examples of the early phenomenon of Italian self-likenesses that were *not* autonomous, that is, works in which an artist presented the self among the peripheral witnesses in the religious drama to which his altarpiece or fresco was devoted. The genre seems to have been a predominantly Florentine phenomenon, at times exported to other centers.

Discussion of self-portraiture within narrative immediately raises the issue of historical evidence, since identification of most of these early self-portraits is based solely on Vasari's accounts in his *Lives*, and is uncorroborated by other sources. It has been claimed that Vasari's "recognition" of portraits and self-portraits in Renaissance works – a total of ninety-two in the second edition of the *Lives* – was similar to his use of fables; his perception of a given likeness was poetically conceived for rhetorical reasons.[1] In the author/artist's synthesis of historical fact and historical fiction, the supposed portrait became a literary device with which to convey a larger truth.[2] "Vasari used portraiture as a means of emphasis," one scholar has written, "as an underscoring of circumstances he wished to stress" – as a means, for instance, of elevating the artist's status by placing him in the company of popes and kings.[3] To take Vasari's words as documentation is thus to misuse his book.

Nonetheless, despite the legitimacy of these concerns, Vasari's identifications of Orcagna, Taddeo di Bartolo, Botticelli, Andrea del Sarto, Filippo Lippi, and Ghirlandaio will be taken on faith here, so that this phenomenon – the artist as participant in religious narrative – can be considered. None of these identifications is obviously fanciful or outlandish, and strong visual evidence would tend to confirm those, in particular, of Orcagna, Benozzo Gozzoli, Botticelli, and Andrea del Sarto, each of whom is presented visually as if existing on a separate plane from that of the *dramatis personae* who enact the central drama.

In the case of what appears to be the earliest surviving Italian instance of such self-portraiture in religious narrative – Orcagna's presence at the *Dormition and Assumption of the Virgin* (pl. 28) on his tabernacle for Orsanmichele in 1359 – the formal evidence cannot but confirm Vasari's identification of the artist as the figure at extreme right. "The flat, round face" and downcast eyes of the figure standing self-consciously on the periphery are pointedly larger in scale than those of the apostles (pl. 29).[4] His face relatively unidealized, his clothing contemporary, Orcagna sought recognition from his peers. His signature was equally self-aware. Trained as a painter, Orcagna had to join a second guild, the masters of stone and wood, to be allowed to build the marble tabernacle. He nonetheless signed the tabernacle ANDREAS CIONIS PICTOR, "Andrea, son of Cione, painter," deliberately drawing attention to his virtuosity and range by claiming his sculpture as a painter.[5]

27 Detail of pl. 45, with self-portrait, and portraits of his brother, Davide, his brother-in-law, Sebastiano Mainardi, and probably his master, Baldovinetti.

43

28 Andrea Orcagna, *Dormition and Assumption of the Virgin*, marble, 1359, Tabernacle, Orsanmichele, Florence.

Donor portraits in religious paintings sprang from a wish for salvation in the here-after, and the same motivation underlay the self-inclusion of the artist in the altarpiece.[6] That a number of these early self-images in religious narrative were associated with the Virgin's Assumption and Coronation is in accord with her importance as an inter-cessor and the growth of her cult at the end of the Middle Ages. The artist as par-ticipant turns up in another *Assumption of the Virgin* at the turn of the century, and, as we will see, Filippo Lippi also associated the self with the Virgin's Coronation (pls. II-14, 15).[7] Identifying with his name saint, the Sienese Taddeo di Bartolo depicted the self as St. Thaddeus, one of the apostles exploring the Virgin's empty tomb, in the altar-piece for the high altar for Montepulciano cathedral (1403/4) commissioned by the

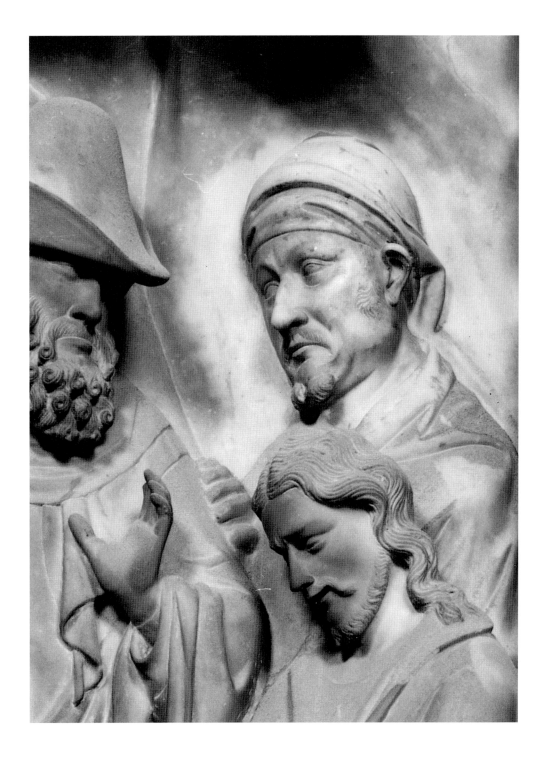

29 Orcagna, detail of pl. 28, with self-portrait.

30 and 31 (*following pages*) Taddeo di Bartolo, *Assumption of the Virgin*, high altar, 1401, Duomo, Montepulciano, and detail with self-portrait as St. Thaddeus.

powerful Aragazzi family, then the largest painting in Italy (pl. 30). Luxuriating in a site closer to the sacred center than Orcagna had granted himself, Taddeo, whose features are more individualized and painted in lighter tones than those of the other apostles, directs a strained glance at the viewer, which seems pregnant with meaning, while tugging conspicuously at the fourth finger of his left hand (pl. 31).[8]

This particular gesture was used in scenes of scholastic debate, linked to the custom of counting one's arguments in debates, and then ticking them off as each was articulated.[9] Both Masolino and Pinturicchio used this gesture of philosophic inquiry in scenes of St. Catherine disputing with the doctors of the Church in their respective fresco cycles in S. Clemente in Rome and the Borgia apartments in the Vatican Palace.

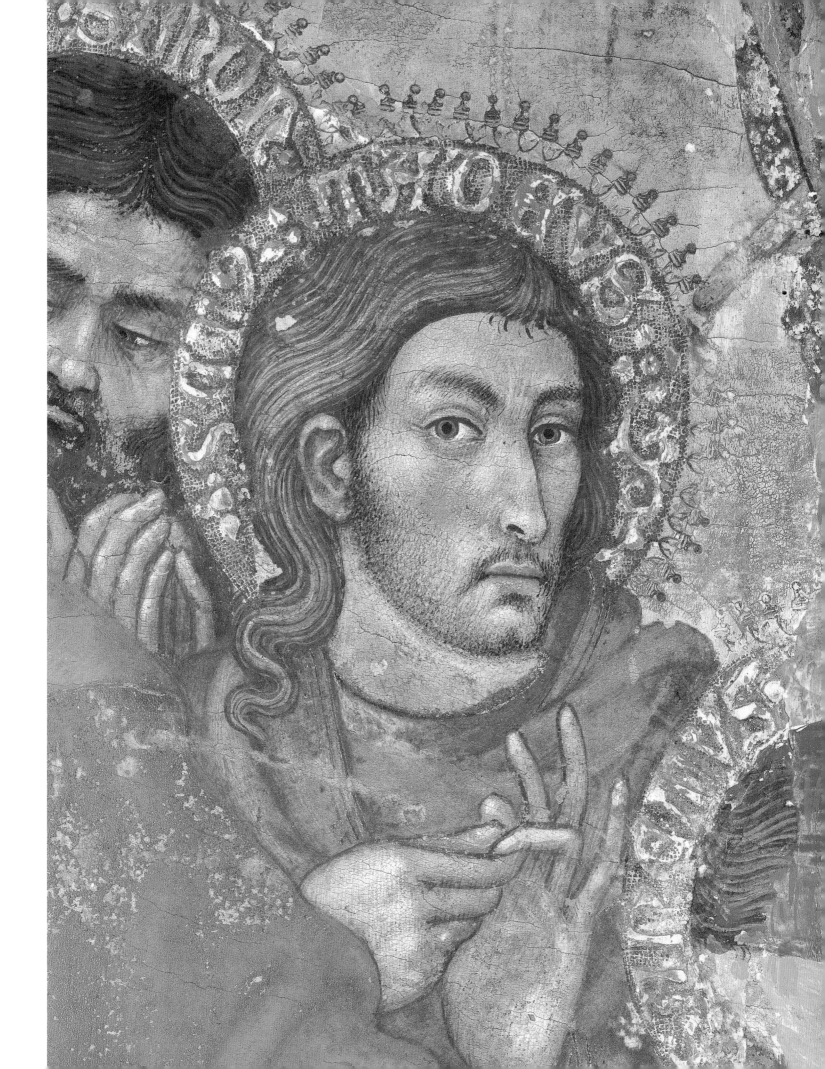

It also reappears in several of the portraits of famous men – above all, theologians – in Federico da Montefeltro's *studiolo* in Urbino. The precise issue being addressed here by Taddeo, who had a reputation as a *pictor doctus* and who mentions his *ingegno* in his inscription, presumably centers on his belief in life after death as a result of the Virgin's corporeal Assumption, his personal devotion to her as mediator for man on earth, and his hope for eternal life in heaven.

Visual self-presentation at this date indicated an unusual degree of self-consciousness on the part of the artist concerned. Not surprisingly, both Orcagna and Taddeo were major artistic figures in their respective communities whose self-esteem must have been raised by the prestigious commissions they received. Indeed, the inclusion of the artist, a specific individual well-known to the wider community, must have made the Virgin's bodily Assumption even more plausible to the worshipper, whether in Florence or Montepulciano.

EPIPHANY

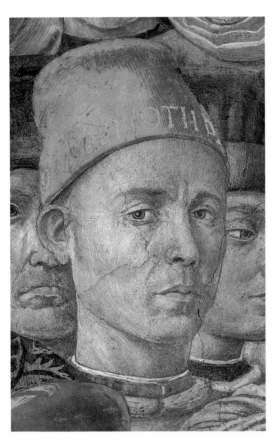

32 Detail of pl. 33, with self-portrait.

33 Benozzo Gozzoli, *Procession of the Magi*, fresco, 1459, Chapel, Medici Palace, Florence.

Epiphany was another popular religious festival in Florence with which artists wished to identify. As the first of the Gentiles to revere the Christ child, the Magi were the prototypes of Christian humility and devotion, and the spiritual founders of Christian worship. The figures of the three kings, exotic and noble monarchs associated with the splendor of the East, were also enormously popular in Florence for social reasons. On Epiphany, members of a confraternity, the Compagnia de' Magi, among whom the powerful Medici played a major role, would re-enact the Magi's journey by parading from "Jerusalem" at the Baptistery to "Bethlehem" at S. Marco. The procession reflected the values of a princely life style, with as great an appeal for the artisans of the city as its patricians.[10]

The thirty-eight-year-old Benozzo Gozzoli ensured that those who might not otherwise recognize him would not overlook his presence as proud author of the cycle in the Medici Palace chapel, by locating the words OPVS BENOTII D on his red *berretta* (pls. 32 and 33). Ahl has suggested that the inscription should be read as a punning allusion to the future renown, *ben noti*, that Benozzo sought for himself as author of the cycle.[11] But the artist's name served primarily as identification – the *only* person in this cast of hundreds to be so labeled – as well as punning signature. Painting in one of the most prominent secular sites of the city, the artist positioned himself among the retainers of the Medici family who participate in the Magi's pilgrimage around the walls of their chapel, just as they so often did in life around the city.

This cycle for the de facto leader of Florence was painted in 1459. Between 1470 and 1475, Sandro Botticelli is said to have located his own self-image prominently in the right foreground of another *Adoration of the Magi*, commissioned by Guasparre del Lama, in which members of the Medici family again appear (pl. 34). Rather than merely figuring among the Magi's retinue, however, here the leading members of the Florentine "first family" participate as the kings who acknowledge the divinity of the Christ child.[12]

These two self-presentations imply that in Florence, during the fifteen-year gap between their execution, the pictorial relationship between artist and patron underwent a significant shift in consciousness. Benozzo's relative self-marginalization as one of many in a distant crowd of onlookers, and his expression of strained anxiety, so often encountered in mirror portraits (perhaps because of the lack of clarity of the images glimpsed in the mirror, when these were seen under Renaissance lighting conditions), may be compared with Botticelli's prominent, full-length presence, wrapped in a brilliant mustard-yellow toga, demanding the worshipper's attention to the holy events as

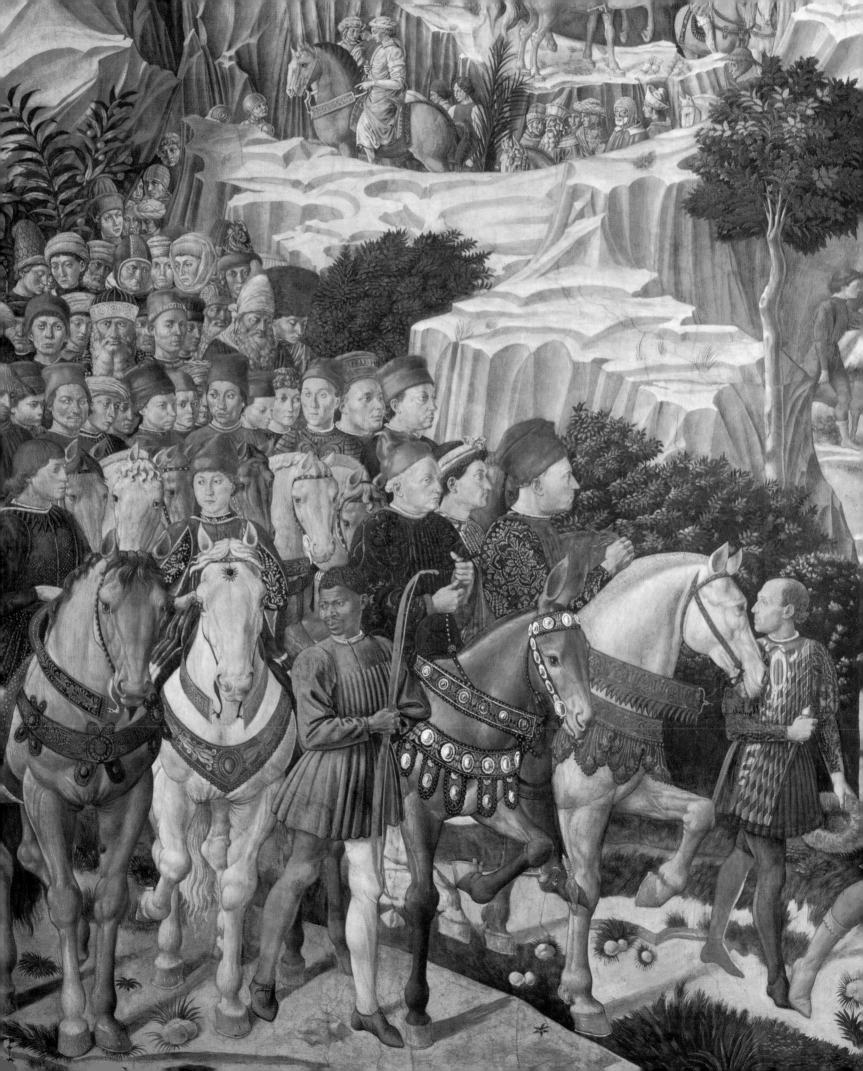

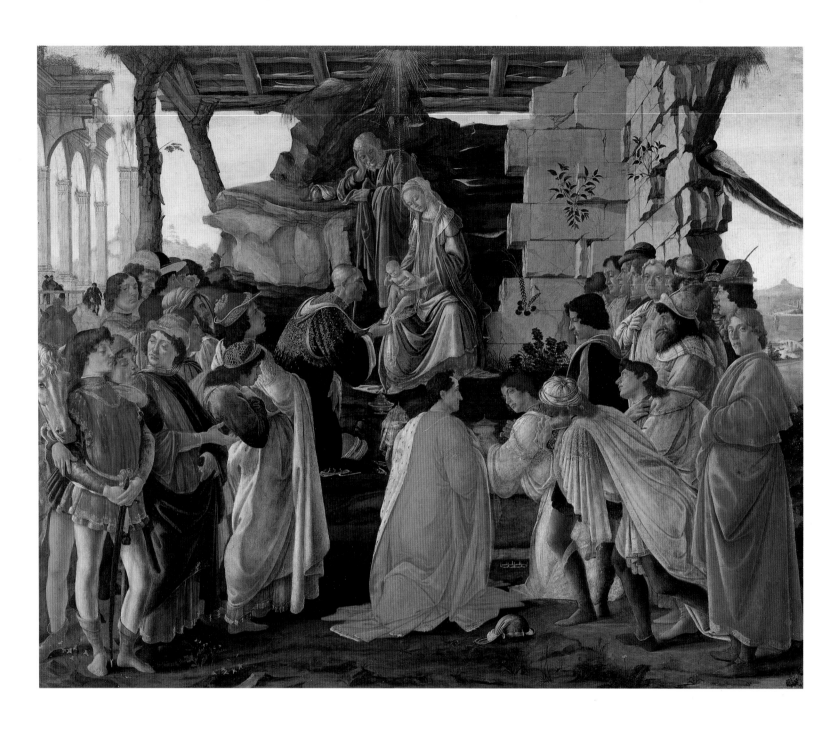

34 Sandro Botticelli, *Adoration of the Magi*, panel,
early 1470s, Galleria degli Uffizi, Florence.

35 Detail of pl. 34, with self-portrait.

re-enacted by the Medici. The artist, posing alone in front of the crowd, opposite the
individual often identified as the young Lorenzo de' Medici, further sports a hair style
that reflects and/or emulates that of the prominent dark-haired downward-gazing figure
usually identified as Lorenzo's brother Giuliano.[13]

At the beginning of the next century, Vasari "recognized" Andrea del Sarto as a
witness in another *Procession of the Magi*, in the atrium of SS. Annunziata, along with
his friends the architect Jacopo Sansovino and musician Francesco dell'Ajolle (pl. 36).[14]
Placed to the right of the church entrance, the scene depicts the arrival of the Magi
as they proceed toward the complementary scene of the *Nativity*, the fresco by Bal-
dovinetti to the left of the entrance to SS. Annunziata. Andrea made the three inter-
lopers very conspicuous by giving them an important compositional role: located in
the traditional right foreground, the friends balance the leftwards movement of the

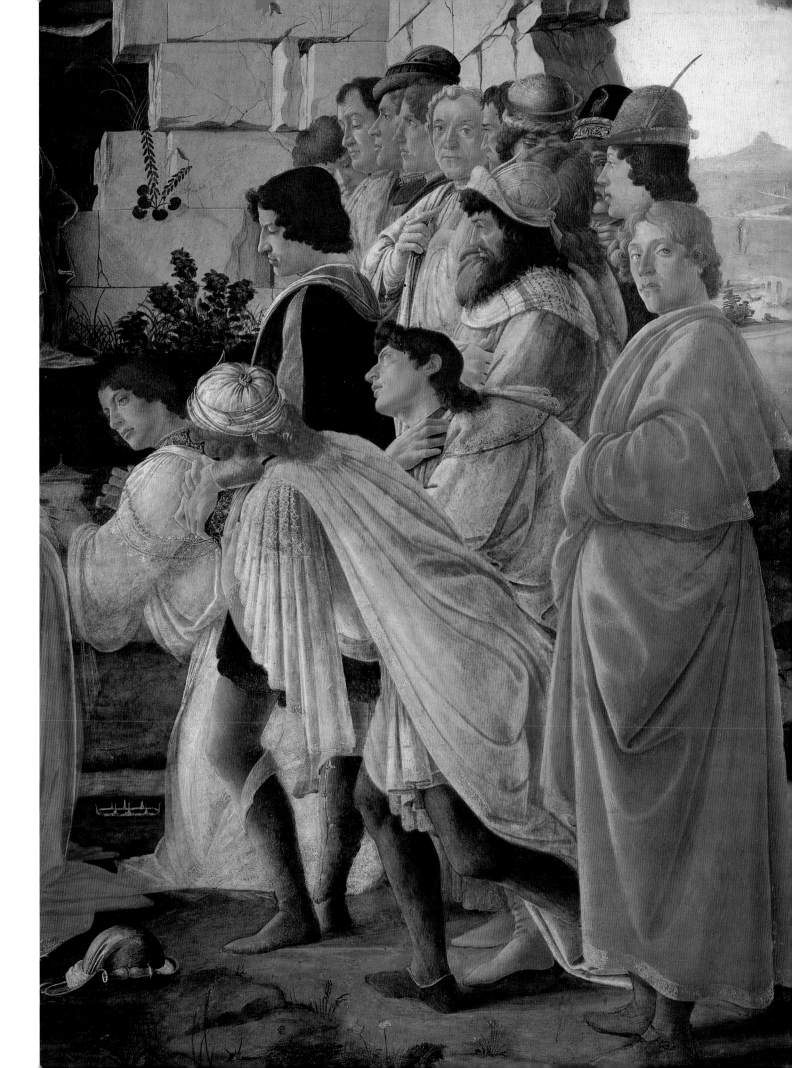

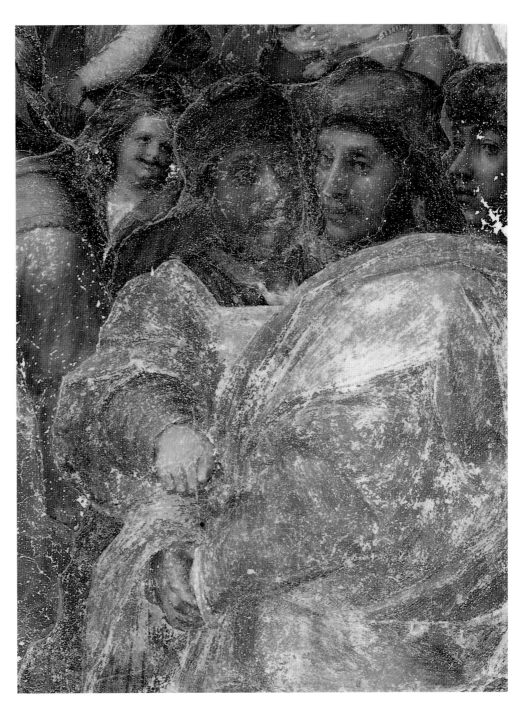

37 Andrea del Sarto, detail of pl. 36, with self-portrait and portraits of Jacopo Sansovino and Francesco dell'Ajolle.

36 Andrea del Sarto, *Procession of the Magi*, fresco, 1511, atrium of SS. Annunziata, Florence.

wise men and their retinue (pl. 37). Andrea however, breaks the fictional dramatic unity of the painting by aggressively drawing attention to events *outside* the pictorial space. He presents himself as though catching the attention of individual worshippers by means of his outstretched hand, as they cross the atrium toward the church door. Instead of indicating what was taking place *within* the pictorial site, the painter constructed the self as distracting the approaching devout by focusing attention back on them, as if they too were part of the Magi's suite on its way to worship the godhead in Baldovinetti's *Nativity* on the far side of the door. Unlike Benozzo and Botticelli, however, Andrea did not present the self as making eye contact with the viewer. This role he turned over to Sansovino, in the process implying that the architect authored the fresco.

Even when designed by a single creator, no altarpieces were produced without assistants, no frescoes without collaborators, and no large-scale bronze sculpture without a *bottega*. Having briefly explored the phenomenon of the Quattrocento self as witness in religious narrative, let us consider those instances when the artist was willing to acknowledge visually the role played by others, usually the members of his *bottega*, in the production of that art – a pictorialization of the workforce. We shall focus on three such examples in the context of religious drama, all of them by Florentine artists, dating from different moments in the century: Filarete in Rome in the 1440s, Filippo Lippi in Spoleto in the 1460s, and Ghirlandaio in Florence in the 1490s.

"On a whim Antonio made a little history [*storietta*] in bronze, in which he depicted himself and Simone and his pupils who, with an ass laden with enjoyable things [to eat and drink], make their way to a vineyard."[15] So wrote Vasari who, over a century later, created something similar, albeit less whimsical, in the Salone of the Palazzo Vecchio in Florence. It is this figurative signature on the *interior* of the doors for St. Peter's that reveals something of the idiosyncratic *singolarità* that flavors so much of the autobiographical treatise on architecture by Filarete (Antonio Averlino), and that Vasari so disliked. The sculptor may have been struck by the discrepancy between the complexity of the actual casting of such bronze doors, comprising so many parts, and the fiction offered by Ghiberti and himself that they were not only the doors' sole ideators but also their sole executants.

It was Filarete who first developed the concept of the Renaissance bronze plaquette as an autonomous work of art, and this figurative narrative plaquette, influenced by those on the doors' obverse depicting the Ecumenical Church Council in Ferrara

38 Filarete, *Self-Portrait with Workshop*, bronze plaquette, 1445, on reverse of doors to St. Peter's, Vatican City, Rome.

and Florence in 1438–9, was one of his earliest such endeavors (pl. 38).[16] Holding aloft a compass, ANTONIVS leads his *discipuli*, each carefully identified in Latin – VARRVS, IOVANNES, PASSQUINVS, IANNELLVS, IACOBVS, AGNIOLVS – in a joyous dance that breaks into a conga line, perhaps under the influence of the flask of wine held by the man mounted on an ass at left, and in tune to the pipes played by the individual mounted on what was probably intended to read as a dromedary at right.[17] Vasari's poetic interpretation of the narrative seems to the point: "with an ass laden with enjoyable things, they make their way to a vineyard" – for a celebratory *cena*, as he implies, at the official conclusion of the work on MCCCCXLV DIES ULTIMVS LULII, 31 July 1445. The procession has received other interpretations, not all of them plausible, but most convincingly as an early allegory on the theme of Virtue and Vice, anticipating Filarete's later choice of cognomen as "lover of virtue."[18] The ass often symbolized Sloth, while in medieval bestiaries the dromedary represented Temperance, and the dancers are clearly moving away from the "vice-laden" ass toward the "virtuous" dromedary.

Each member of the workshop is constructed as wearing a leather apron and as carrying a recognizable sculptor's tool – compass, sextant, sickle, trowel, file, claw hammer – which must indicate his function within the workshop. The pretensions suggested by the artist's profile on the front of the doors, his temporary appropriation there – in a work that we shall consider in the next chapter – of the status of a Caesar, are forgotten in this down-to-earth expression of his whole *bottega*'s delight and pride in its collective artistic achievement. Even the inscription can be read as reflecting a light-hearted spirit far from the *gravitas* of the doors themselves or the solemnity of the site: "for others the honor/fame and the money, for me joy [*hilaritas*]."[19] In words that may refer to a classical tag, Filarete affirms that, while others sought fame and fortune, *he* was rewarded by the joy of creation itself. His sentiments would be echoed

two hundred years later by the inscription surrounding a depiction of Pittura on Lavinia Fontana's medal: PER TE STATO GIOIOSO MI MANTENE, "through you, oh joyous state [of creativity] I am sustained" (pl. 136).

Nonetheless, even here "Antonius" has not abandoned certain pretensions embodied in his attribute and the profile presentation of his own features (pl. 39). The future *architectus* carries a very large up-ended compass with a screw-fitting, similar to that so often used by God in medieval miniatures of the Creation (pl. 69), and the earliest of the many compasses associated with self-portraiture. As symbol of geometry, the "liberal" compass enabled Filarete to project the perfect geometric shape of a circle on the wall behind him, one point on the circumference, the other on the centerpoint. For Filarete, the circle was perfect because "the eye . . . immediately encircles it at first glance . . . there is no hindrance or obstacle to the progress of the eye."[20]

The compass alluded also to Disegno and those who practiced the *arti del disegno*, as displayed in woodcuts illustrating *disegno* and *operazione perfetta* in Ripa's *Iconologia* (pl. 15).[21] In the 1618 edition of his handbook, Ripa privileged youthful Theory over aged Practice. The experienced Practica is a crippled old hag who uses her compass as if a walker, whereas the beautiful Theoria sprouts hers from her forehead, as if the horns of Moses (pls. 40, 41). Unlike Filarete, Practica draws her perfect circle on the ground; the compass and plumbline (and the rule not illustrated in this woodcut) prove that her objective was to measure the material world. Theoria, on the other hand, has her compass in her head, where it represents visual acumen or *ingegno*, inborn talent. Descending a staircase (not, as one might be forgiven for thinking, falling down),

39 Filarete, detail of pl. 38, with self-portrait.

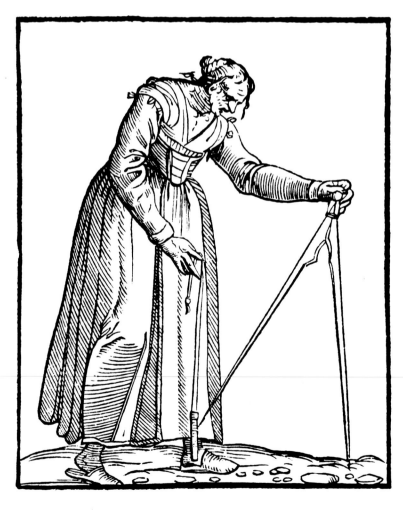

Theory holds her hands out from her body with her fingertips placed together in a gesture of reflection and judgment. Theory's reliance on her mental, rather than manual, compass reveals her *scientia*, learning or knowledge of art.[22]

The compasses could thus be used metaphorically, as in Geoffrey of Vinsauf's discussion of *inventio* when he spoke of the mind's interior compass which could encircle the material being considered.[23] Michelangelo also used them metaphorically in his powerful dictum concerning the executive hand versus the judging eye. Artistic good judgment was based on the artist having his "compasses in his eyes rather than in his hands."[24] This conclusion was echoed by Federico Zuccari when he declared that the artist must make himself so familiar with the practice of rules and measurement that "you have the compass and ruler in your eyes, and judgment and practice in your hands."[25]

Ripa's Theoria evokes a beautiful drawing attributed to Cherubino Alberti of God the Father as Architectus Mundi (pl. 42), who holds an up-ended pair of compasses above his head, in a gesture of triumph akin to those of Filarete on the plaquette and, as we shall see, of Bramante's Architettura (pl. 67); the other arm grasps a T-square. Filarete's huge instrument of Euclidean geometry accordingly signified the *scientia* he needed for his conception of the bronze doors. The dancing *garzoni*, who did the "manual" labor, are being led by the "intellectual" creator who, like Cherubino Alberti's God, proudly holds aloft the symbol of his ideation.

Whereas Ghiberti on the Gates of Paradise included a portrait of his son, as we shall see, here Filarete commemorates the contribution made by the whole workshop to the work of art. The relief is one of the very few celebrations in Italian art of the labor of a collectivity, and one of the few visual acknowledgments in the entire period of the importance of the *bottega* for any large sculptural undertaking. With the one exception of Filippo Lippi, the Quattrocento artist's interest in his own *singolarità* seems to have precluded him from acknowledging in his art the collaborative nature of so many of these enterprises.[26]

It is hard to estimate how accessible the plaquette was to the viewer in the Renaissance, when Vasari described it as at floor level, presumably on the interior of the doors where it is today. When the doors were replaced in the new St. Peter's in the early seventeenth century, they had to be heightened, and hence re-hung, and this in turn necessitated the removal and subsequent reinstallation of the plaquette. Its current placement inside the doors, at floor level where it is virtually invisible, certainly represents the ultimate marginalization of the creative artist in his role as director of an active *bottega*.

42 Cherubino Alberti, *Architectus Mundi*, drawing, late sixteenth century, private collection, Prato.

★ ★ ★

The entire apse of Spoleto cathedral, where the Assumption had been an important celebration since the twelfth century, was given over to a huge scene of the *Dormition, Assumption, and Coronation of the Virgin* by Filippo Lippi (pl. 43).[27] At the foot of her bier stand a small group of men and angels (pl. 44). The features given to the dominant male figure, wrapped in the white cloak of a Carmelite monk over a brown habit, are remarkably similar to those of the young monk said to be a self-portrait of Fra Filippo Lippi in an earlier depiction of the same Marian subject: the Maringhi *Coronation of the Virgin* in Florence.[28] The anonymous carved bust on Lippi's tomb in Spoleto, which closely resembles the portrait in the apse fresco and must have been based on it, indicates that only twenty years after his death Filippo was remembered as the frontally presented monk.

The plausible hypothesis that Lippi is here surrounded by his Spoleto workshop is also confirmed compositionally. Prominently located in the foreground of the lower

40 (*facing page bottom left*) *Practica*, from Cesare Ripa, *Iconologia*, woodcut, Padua, 1624.

41 (*facing page bottom right*) *Theoria*, from Cesare Ripa, *Iconologia*, woodcut, Padua, 1624.

register, they stand in profile or three-quarter view behind the presumed Fra Filippo, and must include Fra Diamante, Piermatteo d'Amelia (the *garzone* who helped with the scaffolding), both of whom are named in the accounts, and behind, Filippino, peering over his companion's shoulder. The use made by Lippi of this same location – the foot of the saint's bier – for contemporary portraits in his Prato fresco of the *Celebration of the Relics of St. Stephen*, reinforces the supposition that this small "group portrait" was comprised of living witnesses to the Virgin's Dormition.[29]

Because the figure identified as Lippi lacks the customary outward gaze of most self-portraits painted with the aid of a mirror, we may hypothesize that it is a portrait rather than a self-image, painted by Fra Diamante in the fall of 1469 between the master's death in October and the termination of the apse frescoes by Christmas. Such a hypothesis would justify the angels accompanying the four men, as well as Lippi's index finger pointing toward the dead Virgin, signifying the painter's faith that the Mother of God would intervene with her Son for his salvation.

Whether or not this is a posthumous portrait of Lippi, the small, somewhat forlorn group of men clustered closely together, isolated against an empty world, must have been read after October 1469 by those depicted as resonating with memories of the dead master with whom they had long been linked professionally and affectively, the years of warm companionship working on similar cycles. Outlined against the soft green of new grass, they contemplate the Virgin's Dormition, think back to Filippo's recent death, and, inevitably, forward to their own.[30] It is hard to imagine a more prominent presentation of the personnel of a workshop, given the site – a church apse – and the date – 1469.

★ ★ ★

Just as Ghiberti established his artistic "dynasty" on the Gates of Paradise at mid-century, so Ghirlandaio promoted his own family in fresco at century's end.[31] Vasari identified the four life-size figures standing at lower right in the *Expulsion of Joachim from the Temple* in the choir of S. Maria Novella as portraits of the Ghirlandaio family, who painted the frescoes (pl. 45).[32] The group was limited to the "partners" of the family painting firm, as it were, rather than the wider community of their *bottega*, the many hands of lesser importance who helped to produce this major mural cycle, the largest such Quattrocento endeavor.[33]

Ghirlandaio positioned his associates – his brother Davide, his brother-in-law Sebastiano Mainardi, and probably his master Baldovinetti, as well as himself – on the foremost picture plane, as near as possible to the center of the lowest register of the cycle of the Life of the Virgin, on the gospel side of the altar, and on an equal footing with the life-size figures opposite, who are traditionally identified as the Tornabuoni heir Lorenzo with members of his clan.[34] The eminently appropriate iconographic context, a tale about fertility and family, was a last minute insertion into the Virgin's cycle for which it provided a new opening.[35]

Virtually appropriating one "wing" of a tripartite composition, Ghirlandaio gave his own dynasty prominence equal to, but compositional interest greater than the portraits of his patrician patrons opposite, who were denied such energetic poses or flowing drapery. The narrative action, moreover, is directed not toward the patrons but the painters on the right, in the direction of the next scene, the Birth of the Virgin. Thus, it is as if into the arms of Davide, the member of the Ghirlandaio family who seems to pay most attention to the religious narrative, that the High Priest forcefully ejects Joachim. Unlike the contemporary dress of Lorenzo Tornabuoni and his friends, Davide is seen from the back wearing a voluminous violet toga.[36] Domenico himself stands in the swaggering pose of the lord of the piazza, his protruding elbow as aggressively

43 and 44 (*previous pages*) Filippo Lippi, *Dormition, Assumption, and Coronation of the Virgin*, fresco, 1469, Duomo, Spoleto, and detail, with self-portrait.

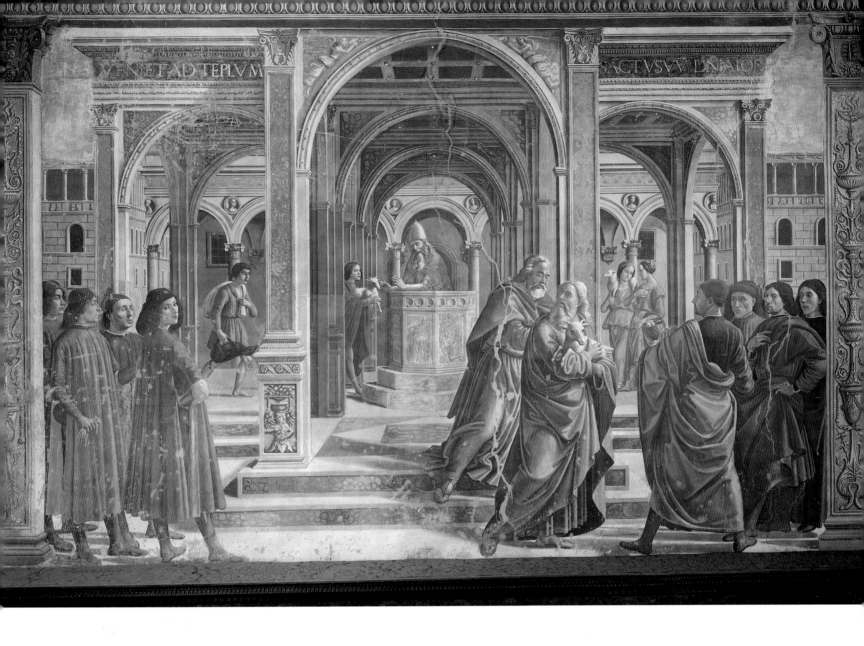

45 Domenico Ghirlandaio, *Expulsion of Joachim from the Temple*, fresco, 1485–90, Cappella Maggiore, S. Maria Novella, Florence.

akimbo as that of young Tornabuoni; one arms holds drapery on his hip, while the other indicates himself as the lead painter for the cycle.[37] The composition of the group, in which all the heads are aligned on the same level, with the tallest, Davide, positioned on a lower step, gives a strong impression of cohesion, equality, and harmony among the principals of the "firm."[38] Significantly, the GRILLANDAII signature in the next scene is in the plural.

This decisive Ghirlandaio invasion of Tornabuoni pictorial territory underscores Vasari's statement about the friendship and close links (*l'amicizia e la familiarità*), between these artists and patrons.[39] The Ghirlandaio firm worked on at least eight other occasions for Giovanni and his son, and the relationship must have been one of trust. The Ghirlandaio family's own links to the Dominican church may also have played a role in the prominence with which they positioned themselves in this opening scene of the cycle: S. Maria Novella was the site of many Ghirlandaio burials and commemorations; only four years later Domenico himself would be buried in this church of the Order founded by his name saint.[40] All of which may account for the boldness of the artist's painted proposition: that the Church's license at the end of the Quattrocento, permitting patricians to include so many portraits of themselves in religious cycles, also extended to walk-on parts for the craftsmen who created the works.

These three "*bottega* self-portraits" by Florentine artists, Filarete, Lippi, and Ghirlandaio, all in religious sites, could hardly be more different among themselves. The prominent placement of Fra Filippo with his entourage in the apse of Spoleto cathedral, and of Domenico Ghirlandaio with his in the choir of S. Maria Novella, together reveal such an immeasurably stronger sense of self-assurance than does Filarete's plaquette, that the latter seems to belong to a different era. Only predating Lippi's frescoes by twenty-five years, and Ghirlandaio's by some forty-five, the dominant tone of Filarete's low-relief plaquette – the communal joy at having finally finished a seemingly endless task – is so out of tenor with the solemn import of the iconography of the doors' obverse – Christ, the Virgin, Saints Peter and Paul, and the scenes celebrating the Ecumenical Council – that the marginalization of the *storietta* into the unlit interior is hardly surprising. The wonder is that a narrative in such a "vernacular" style was permitted even in an effectively invisible location on the doors' reverse. In Spoleto and Florence, on the other hand, the artistic protagonists display themselves in the same space and on the same scale as the holy protagonists and the patrons.

Even the twenty years that separate the works by Lippi and Ghirlandaio suggest a further shift in self-consciousness, not unlike that seen earlier between the self-portrayals of Benozzo and Botticelli. In Florence in the last decade of the fifteenth century, *neither* the artists *nor* the patrons were presented as though immersed in the narrative of Joachim's rejection. The self-absorption of the Ghirlandaios' self-conscious gazes suggests a presentation of the self at many leagues removed from the seemingly thoughtful and pious demeanor of the bereaved Lippi workshop in the presence of death. There they are all, including Filippo, fashioned as if totally absorbed by the mysteries of life and death – earth to earth, ashes to ashes, and dust to dust – and by their fervent prayer that the Virgin should reward Fra Filippo's devotion by mediating on his behalf in the hereafter.

Chapter 5

SCULPTURAL SELF-PORTRAITS WITHIN FRAMES

In the first half of the Quattrocento two Florentine sculptors offered a new form of self-portraiture that differed from the earlier type of self-presentation: small disembodied heads placed on large, important sculptural enterprises in key locations within an urban context. Ghiberti and Filarete's understanding of the historical and religious importance of the Baptistery in Florence and the Basilica of St. Peter's in Rome encouraged them to develop ways with which to proclaim their associations, through their authorship of the entrance doors – in Filarete's case, the door though which the pope himself entered the basilica – of these hallowed buildings. In each case they extended the artist's signature by the addition of a small, "semi-autonomous" self-portrait head.

Ghiberti's gesture in asserting himself forcefully in the prominent outdoor site was no doubt stimulated by the importance of the commission, which he won at such pains, and the centrality of the Baptistery within the urban fabric of Florence, whether for its dedication to the city's patron saint, its supposed origin as an antique temple of Mars, or its site at the heart of the city. Ghiberti's signature – OPVS LAVREN/TII FLORENTINI – straddles the opening of the North Doors and stretches above the quatrefoils of the *Nativity* and *Epiphany* that initiate the narrative cycle (pl. 46). The inscription is preceded by his portrait-head in the center of the left leaf just above the height of the passing citizen. On his second door, the Gates of Paradise, the inscription – LAVRENTII CIONIS DE GHIBERTIS / MIRA ARTE FABRICAM, ". . . made with admirable skill" – placed at the same height and literally on the frame, lies to either side of the centralized heads of Ghiberti on the left leaf and his son Vittorio on the right – a location that gave the self-portraits greater prominence (pl. 47).[1] The location of the heads also coincides with the perspectival system of the reliefs on this door.[2] Since the stories in the adjacent reliefs relate father and son to another paterfamilias, Isaac, and his son, Jacob, and his son, Joseph, the Ghiberti dynasty likenesses offered a Renaissance counterpart to the door's theme of the patriarchal succession in the Old Testament.[3]

On each door the self-portraits are integrated among the decorative heads of prophets and sibyls, many of whom wear a similar turban to that sported by the balding Ghiberti on his first door. While the turban integrates the artist among the biblical prophets, it may carry further symbolic connotations. The turban-like towel wrapped around Michelangelo's head in Bugiardini's portrait of the sculptor has been interpreted as an ostentatious reference to *Labor*, since its function was to keep the sculptor's head from being covered with marble dust.[4] Ghiberti's turban may also have referred to his profession as sculptor.

In this period so deeply influenced by the classical past, it was to be expected that a vanguard idea like autonomous self-portraiture would first be advanced in sculpture of which, unlike painting, so many Roman examples were then being unearthed. No self-portraits by Greek and Roman artists were identified in sources as surviving.

46 Lorenzo Ghiberti, North Doors, bronze, before 1425, Baptistery, Florence, detail showing self-portrait.

Indeed, only two are mentioned: Theodore of Samos, who created the first self-image in bronze, which was famed for its verisimilitude, and Phidias, who presented himself as a bald old man lifting a stone with both hands in the midst of a battle scene carved on the shield of Athena on the Acropolis.[5] Since Ghiberti had, then, for practical purposes, no visual precedents, how did he present himself in what he must have been aware had a good claim to be the first bronze self-portrait since classical Antiquity? Using the same medium as Theodore, one with strong classical connotations for the Renaissance, Ghiberti preferred to place his features among those of the Old Testament *uomini illustri* – the prophets and sibyls who foretold the coming of Christ – as if he himself were an "artistic prophet" – as indeed, in respect to self-portraiture, he was.[6] In the North Doors the frieze heads are contained within the Gothic quatrefoils used throughout, but on the Gates of Paradise, the sculptor appropriated a particular

47 Lorenzo Ghiberti, Gates of Paradise, bronze, c.1447–8, Baptistery, Florence, detail with self-portrait.

antique form, the *imago clipeata* (an ideal head or bust rising from a shield that was the perfect geometric shape of a circle), which in Antiquity had been used first for gods and later for emperors.[7] Who is to say whether Ghiberti was influenced in his choice of encircling *clipeus* "frame" for his own features by his knowledge of, and/or misinterpretation of, Phidias's self-presentation as a bald old man on a shield?[8] The sources – texts attributed to Aristotle, Pliny, Cicero, and Plutarch – were current in the early Quattrocento.

On both doors Ghiberti inhabits the frame only, a significant location in that it was often used for signatures; the location may have been dependent on earlier self-images, such as Cola di Petruccio's self-portrait in a quatrefoil on the frame of a fresco painting of around 1400, in S. Domenico, Perugia.[9] Nonetheless, despite their frames Ghiberti's images cross categories: they are on the frame and of the frame, but their

own frames separate them from other frame elements. Ghiberti's self-portraits can be seen as having the same relationship to the whole as the self-image in the Christian narrative previously considered; both self-images exhibit some degree of the self-marginalization that was appropriate to the craftsman's contemporary social standing. Rather than mingle with the curious crowd at the periphery of the scene like Orcagna in the fourteenth and Gozzoli in the fifteenth century, this new Florentine prophet chose a presentation that was in some ways more prominent but paradoxically at the same time less conspicuous.

The extraordinarily ambitious Ghiberti, one of the earliest Italian artists to figure the self, was also the first professional artisan of the modern era to write his autobiography, around 1450, in the manner adopted by Florentine merchants who wrote *ricordanze* or memoirs of personal and familial achievement. Chosing a title, *Commentarii*, favored by such humanists as Bruni and Pius II, Ghiberti fashioned an account of his own achievements squarely within a context of the history of the art of classical Antiquity and his immediate Trecento predecessors. To undertake either a self-image and/or an autobiography the Quattrocento mechanical worker had to possess a strong sense of his own self-worth, and Ghiberti's text frequently exhibits his apparently unshakable belief in his own central position within the history of Quattrocento art, and in the glory and fame that were his due. Today the language reads as hyperbolic: "to me was conceded the palm of victory by all the experts and by all those who had competed with me. To me the honor was conceded universally and with no exception," he wrote of the 1401 competition with Brunelleschi.[10] The passages sounded like hyperbole to Vasari also, who grumbled about Ghiberti's propensity for clauses that started "I made, I saw, I was making, I was saying" (*io feci, io dissi, io facevo, io dicevo*).[11] Ghiberti's confrontational use of the subjective first person was, however, remarkably innovative for the date; it was a move that was *not* emulated by Vasari, who instead used the distancing, seemingly objective, third person for his own *Life* in 1568. Like Vasari, however, the last artist mentioned by Ghiberti was himself; in each case, their achievements were intended to be seen as the crowning point toward which all the previous history of art led.[12]

Ghiberti was professionally and financially independent of other artists. "I want to be master of my shop," he wrote, foreswearing the collaborative practices so common among other artists in early Renaissance Florence, by never entering into the kind of financial partnership that would have protected him from the fluctuations of an unstable market.[13] This factor made Ghiberti one of the few masters who was the sole proprietor of his workshop, and he was able to acquire considerable financial and real estate holdings.[14] His professional autonomy and financial success must have encouraged both his independence as a historian and his willingness to move in new artistic directions.

These are two self-portraits from different moments in Ghiberti's life, one in full maturity around forty, the other as an old man of sixty or seventy. They give a sense of this artist's personal evolution: the earlier head has bland, generalized features, an unfocused gaze, and is as idealized as the surrounding prophets.[15] In the later head, the decorative turban gives way to a particularized self-image of a specific individual whose pride in his achievement is evident in the slight smile formed by his lips. Contemporary with the composition of his autobiography in the first person, this visual representation also fashions a shrewd and authoritative self-inscription at the center of the artistic revival taking place in Florence. To the words inscribed on the Gates of Paradise, "made with admirable skill [*arte*]," he added in the *Commentaries* that "of all my work it is the most singular [*singulare*] I have done and it was finished with skill of hand [*arte*], correct proportions [*misura*], and outstanding creative talent [*ingegno*]." The vocabulary central to the thesis of this study was already in place in this early

source, but, perhaps significantly, the only term "published" for all to see on the Gates of Paradise was *arte*, skill of hand.[16]

★ ★ ★

Just as Ghiberti had assimilated his presence among the Old Testament prophets in his doors by doing as they did – gazing frontally out of individual frames set within the overall frame – so Filarete, in his parallel Roman commission (1433–45), contemporary with, but larger than, the Gates of Paradise, adopted the profile presentation of the Roman emperors, on a scale similar to that of its possible source, a Roman *denarius*, for his self-image.[17] As one might expect, the sculptor isolated his own head from those of the emperors by placing it within yet a further frame, that of the *Martyrdom of St. Paul*, one of the two lowest and most visible scenes (pl. 48). While his profile is much smaller than those of the emperors in the friezes, Filarete gave it what

48 Filarete, doors of St. Peter's, bronze, 1445, Vatican City, Rome, detail of the *Martyrdom of St. Paul*.

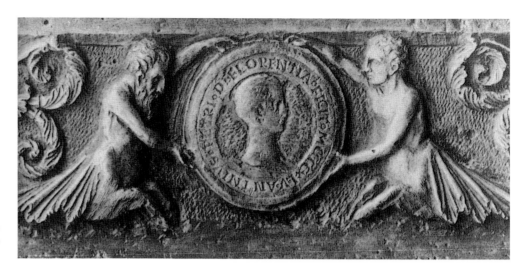

49 Filarete, doors of St. Peter's, bronze. 1445, Vatican City, Rome, detail showing self-portrait in framing.

prominence he could, by centralizing it, introducing color – gilding against a no longer visible cobalt blue enamel ground – and by surrounding it with an inscription: ANTNIVS [sic] PETRI DE FLORENTIA FECIT MCCCCXLV (pl. 49).[18]

Yet a further factor differentiated Filarete's sophisticated solution from that of Ghiberti, in whose workshop he may have learnt his trade: the conceit that the roundel containing *his* profile was the obverse of a double-sided medal, with the "medal reverse," crudely inscribed OPV/S ANTO/NII, centrally located in the border of *St. Peter's Martyrdom*, the scene on the twin leaf. Filarete's work signals his inventive power. Not only did actual medallic *self*-portraits hardly exist – the earliest being probably that by Boldù in 1458 – but the few contemporary medals in circulation in the early 1440s all depicted princes. Thus, Filarete's self-portrait "quasi-medal," as it were, was exactly contemporary with the earliest medals created by Pisanello for Marchese Leonello d'Este of Ferrara. The sculptor thus cunningly identifies the self with both ancient emperors *and* modern princes.

Filarete's "quasi-medal" was profoundly influenced by his admiration for classical antiquity,

> the ancients, who made medals . . . in bronze, silver and gold as one can still see, for some are found every day . . . By means of this skill we recognize Caesar, Octavian, Vespasian, Tiberius, Hadrian, Trajan, Domitian, Nero, Antoninus Pius, and all the others. What a noble thing is [this skill], for through [it] we know those who died a thousand or two thousand or more years ago,

to which he gives such lavish praise in his treatise on architecture, and which is manifest in the many scenes from Greek and Roman myths on the doors.[19] Indeed, not only do these references to classical mythology on the Roman doors suggest that its program may have been overseen by a humanist, but one scholar, on the basis of the doors' appearance after cleaning, further proposed that the totality of the doors, not merely their individual parts, was intended to evoke doors surviving from Antiquity. The cleaning revealed the many different tonalities of the various bronze alloys that Filarete used for the different sections, and doors in such an important site may originally have received an artificial patina to unify them, thus becoming in effect "instant antiques," with the patina and softness of age.[20]

Filarete finished the doors of St. Peter's in 1445. Precisely how Filarete's "pseudo-medal" stands in chronological relationship to Ghiberti's second, late, self-portrait is not known. The sequence of the parts of the Gates of Paradise is unknown, and hence its

dating arbitrary, but it seems probable that Filarete's self-image precedes that by Ghiberti, which both Krautheimer and Pope-Hennessy at any rate, dated late, to around 1447/8.[21]

In their self-images, isolated from other elements in the borders of their bronze doors by their ring frames, Ghiberti and Filarete can be said to have adumbrated the slow emergence of the autonomous self-portrait in bronze works by Alberti, Filarete, Mantegna, and Bramante, that were contemporary with the invention and development of the autonomous portrait.

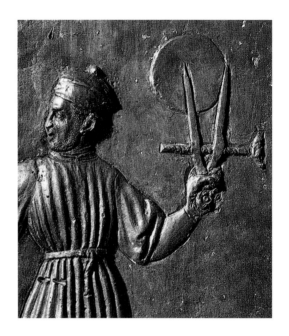

50 Detail of pl. 38, with self-portrait.

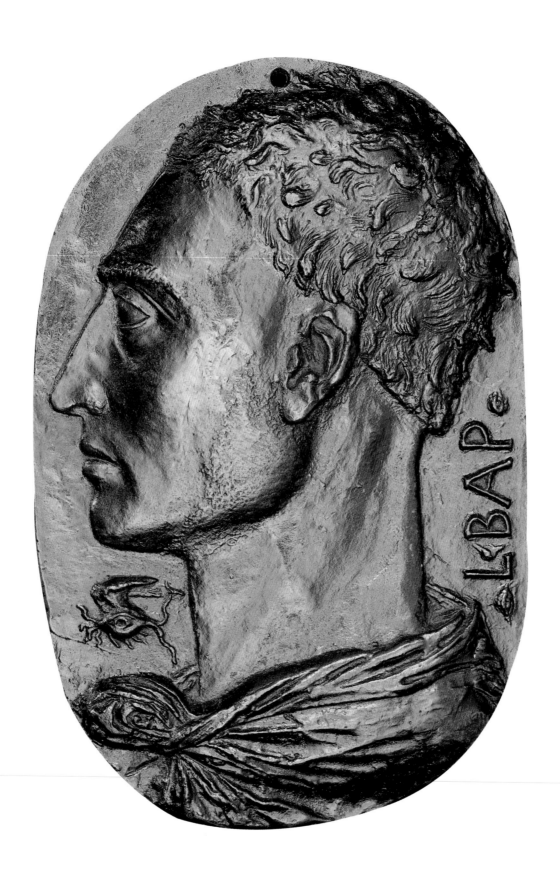

ALBERTI

> He [Alberti] copied his own expression and likeness . . . His talent
> was so versatile that you might judge all the fine arts to be his.[1]

If Alberti's bronze plaquette in Washington is of him and by him and correctly dated to the mid-1430s, the first self-conscious step toward the isolated self as both subject and object may have, significantly, been taken by a humanist rather than an artisan – and, even more to the point, by a patrician (pl. 51).

The plaquette shows the head and neck of a relatively young man in profile to the left, with strongly marked and somewhat angular features, consisting of compressed lips, strong brows, straight nose, a large left eye, and an odd left ear, not unlike those of some twentieth-century boxers. A piece of drapery is pulled into a knot at the front of his neck. Under his chin an isolated left eye with wings flies to the left; at the back of his neck the brief inscription: L BAP.

This work presents major problems of identification, attribution, and dating.[2] It is not clear whether the inscription identifies the sitter or the artist – or, as is usually presumed, both. A medallic portrait of Alberti by Matteo de' Pasti dates either to 1446–50, when both men were associated with the court of Ferrara, or to 1453–5, when they were collaborating on the Tempio Malatestiano (pl. 52).[3] Accepting that Matteo fashioned a relatively naturalistic representation of the humanist in either his forties – which seems more likely – or his fifties, then Matteo's "Alberti" does not greatly resemble the "Alberti" on the Washington plaquette, especially the curve of nose and the eye socket. Another Alberti portrait or self-portrait as a relatively young man, shown in three-quarter view, copied by Cristofano dell'Altissimo in the 1550s for the Medici collection of portraiture, is somewhat closer (pl. 53). Cristofano's sixteenth-century "Alberti" may thus bridge the gap between the sitter's appearance on the fifteenth-century plaquette and Matteo's medal.[4] In addition, the presence of the inscription and Alberti's personal emblem would seem to confirm that the features depicted were intended to be recognized as those of Leon Battista.

Authorship and dating of this relief are less certain. In favor of ascribing it to the humanist are the many statements that he made concerning his artistic accomplishments. In the very first paragraph of his treatise on painting, Alberti declared that he wrote not as a mathematician but as a painter.[5] Elsewhere, he recalled the "miracles of painting" at which his friends marveled, a statement confirmed in his anonymous *Vita*, that is generally agreed to be autobiographical – certainly as autobiographical as Condivi's life of Michelangelo, which was virtually dictated by the sculptor – and to date around 1437, immediately following *De Pictura*:[6]

he strove so hard to attain a name in modeling and painting that he wished to neglect nothing by which he might gain the approbation of good men . . . he would paint [his friends'] portraits or model them in wax . . . He copied his own expression and likeness . . .[7]

In addition, Landino, a close friend, confirmed only nine years after Alberti's death that he had been an artist as well as a writer: "He . . . made art with his own hands; I possess

51 L. B. Alberti, self-portrait bronze plaquette, *c*.1436, National Gallery of Art, Washington, D.C. Samuel H. Kress Collection.

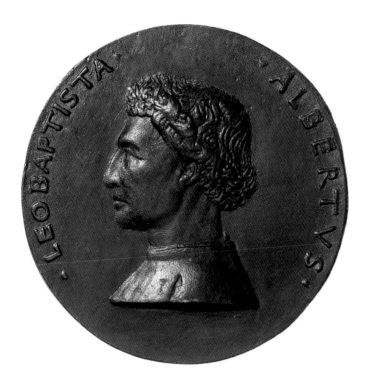
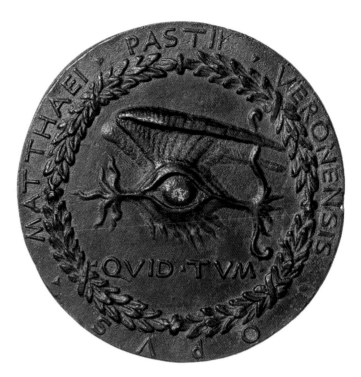

52 Matteo de' Pasti, medal of L. B. Alberti, bronze, c.1446–50, obverse and reverse, British Museum, London.

some admirable works executed by him with the brush, the chisel, the graver, and by casting,"[8] and Poliziano also called him "an excellent painter and sculptor."[9] Vasari, too, saw some works that he believed to be by Alberti, including *un ritratto di sé medesimo fatto alla spera*, "a portrait of himself made with [the aid of] a mirror," in the Rucellai Palace.[10]

The Washington bronze relief demonstrates a certain lack of technical skill. There is a prominent casting fault that runs through the cheek, and the modeling of neck and back of head is insensitive. Other passages open to criticism are the *horror vacui* of the whole, the very tight compositional framing of the head, and the awkward crowding of the emblem and inscription into left-over space below chin and at back of neck; the clumsily modeled ear and its location on the head; the toga knotted in a curious – and perhaps unique – way. In a masterful formal analysis Middeldorf discussed the implications of the piece's facture:

> The artist's attention has been concentrated on the surface to the detriment of the fundamental structure and three-dimensional organization; the physical skeleton seems to be lacking, the head looking altogether hollow, like inflated skin, and details such as eyes and ears are not integrated with the whole and obtrude awkwardly. In brief, the art of sculpture has been mastered only in its most elementary and super-ficial aspects . . .[11]

Vasari too was critical of the overall quality of Alberti's art: "The works he made were not large or very beautiful; those from his hand are not particularly perfect."[12] This work thus seems to be the product of an amateur, rather than professional, sculptor. Alberti's *manus*, hand, may have been *docta*, learned, but it lacked the subtle *ars* of a skilled professional hand such as Ghiberti's – for all the humanist's presentation of his own work as "miracles" of art.[13] It may be concluded that, while the attribution must remain conjectural, given the lack of a documented work by Alberti, the bronze pla-quette seems more likely to be by him than by any other amateur of the period.[14]

The humanist emerges as the first "dilettante" artist of the early modern period:

53 Cristofano dell'Altissimo, *L. B. Alberti*, mid-sixteenth century, Galleria degli Uffizi, Florence.

Let me speak of my own experience. Whenever I devote myself to painting for pleasure, which I very often do when I have leisure from other affairs, I persevere with such pleasure in finishing my work that I can hardly believe later on that three or even four hours have gone by.[15]

These words were written in a period in which the concept of "painting for pleasure" would have astonished a professional craftsman. "Leisure" was in itself an upper-class concept, not available to those whose livelihood depended on their productivity. For this humanist the creation of art was a pastime, to be taken up in the interstices of time devoted to "real" work, the study of texts. Alberti here pointedly separates himself from the general run of artisans.

This amateur seems to have had a nervous breakdown in the mid-1420s, and according to his *Vita* he used his writing as a form of self-therapy in periods of personal anguish. To immerse oneself in the production of art could also be a palliative for, and distraction from, psychic pain or anxiety, and Alberti is recorded as using architectural planning to this end: "I built in my mind some very elaborate buildings . . . until sleep overcame me."[16] The dilettante Alberti appears to have used art as a hobby with which to escape his angst.

Accordingly, the first step toward an autonomous construction of artistic identity in visual form – the creator as primary raison d'être for the work of art – was, significantly, very likely taken by one who was *not* an artist in the sense of a professional who had been trained in a *bottega*. The self-portrait was, furthermore, produced by an individual who indulged in a lifelong fascination with his own *singolare* identity and who created many autobiographical interlocutors. This "autobiographical imagination" led him not only to create a physical appearance in art for one of his personae, but also to compose the inner *Vita* of that same persona in literary form. Alberti was especially intrigued with issues of masking, whether it consisted of his literary self-imaging personae or the use of facade shells on his churches in Rimini and Florence.

The generally accepted date of 1434–6 does not appear to be contradicted by the sitter's age, usually read as approximately thirty. But the age of a sitter is a notoriously unreliable means of dating portraits, which here could range between, say, twenty-five years old, around 1430, to say, thirty-five, around 1440. In the present state of our knowledge, the dating of this work is arbitrary, and its chronological place among the earliest surviving self-images speculative. For the purposes of this study, the plaquette will be assigned the conventional date of the mid–late 1430s, which would place it after Ghiberti's first self-portrait, but before both that artist's second self-image and the one by Filarete on the doors for St. Peter's.

In terms of the geographic center in which the work was created, the strongest case can be made for the court of Ferrara, which was the center of medal re-invention and production during the art form's earliest years, where Leonello d'Este was an important patron of Alberti, and where the hubbub surrounding the Church Council in 1438–9 (which Alberti attended) must have been the catalyst for creative activities of all kinds. The friendship and evident admiration of both Leonello and Meliaduse d'Este, and Alberti's unofficial role as cultural czar of Ferrara, would also have greatly appealed to one who often imagined himself surrounded by detractors and rivals.

Historically, this is among the first in a series of miniature bronze portraits in which only a small amount of the body is shown and the head is presented in profile, traits suggested by the heads of Roman emperors on imperial coinage. By virtue of its dual association with Antiquity and with empire, the profile bust was a symbolic form that, for the early Renaissance, encoded majesty and might, suggesting the sitter's personal authority, and the continuity of his dynasty.[17] Small-scale medals were created for Italian *signori*, who had the authority to interpret their own roles as that of modern Caesars,

and whose craftsmen and humanists would manipulate image and word to equate them to their supposed counterparts in myth and history. Thus, the patrician Alberti appropriated an art form hitherto employed solely for the ruling classes, albeit in the format of medals rather than the unique format of this larger plaquette. By its mere formal presentation then, the patrician's self-portrait carried connotations of nobility and rulership.[18] Comparison with Matteo de Pasti's presumably more naturalistic profile portrait of ostensibly the same individual, showing him either ten years older, in his forties, or twenty years older, in his fifties, also brings out forcefully the drama of Alberti's self-construction in the plaquette, where he gave himself the classicizing features and toga of an Augustan prince.

The profile portrait in general, in which only one eye is visible, can be equated to a literary address to the world in the third person, the distancing that results from the use of the formal Italian *Lei*, in opposition to the more intimate *tu*, the second person singular, resonating from the three-quarter or frontal pose in which the sitter makes eye contact.[19] After his nervous breakdown in the mid-1420s, Alberti had developed considerable skills in detaching parts of the self, or removing self from self, so as to present himself in the third person.[20] The artist who models a self-image in profile practices a similar kind of self-distancing in life, akin to Alberti's illeism, his self-representation in the third person in his *Vita*.

Alberti was convinced that contemporary art should emulate Roman art. While models in Antiquity can be found for the details of the relief, no convincing classical model has so far been proposed for the work as a whole. Republican and Augustan gems offer a general frame of reference, and a large cameo portrait of Augustus in the British Museum has been proposed as a close antique model.[21] The comparison is useful in terms of the oval format and the left-facing profile, but unhelpful when it comes to the plaquette's scale (201 mm. high, compared to the cameo's 128 mm.), costume (Augustus is given the aegis with a central gorgoneion), and hair style.

While Alberti's head is in profile, the frontal eye under his chin confronts the viewer directly.[22] This emblem, which the humanist had adopted by 1436, consists of a flying left eye with wings and wavy rays at the corners. Two representations of the device in its most complete form – in which it is accompanied by the motto QVID TVM, best translated as "what next?" or "what then?" and surrounded by a laurel wreath – survive, one on the reverse of Matteo de' Pasti's medal (pl. 52), and the other in a drawing, possibly autograph, at the end of a manuscript of *Della Famiglia* (mid-1430s).[23] The eye symbolized in general the traditional supremacy of sight over the other senses that, going back to Antiquity, made it the privileged organ of perception, and which Leonardo celebrated "as the window of the human body through which the soul views and enjoys the beauties of the world."[24]

Alberti explained the significance for him of an eye adorned with eagle wings within a crown of laurel in the dialogue *Anuli* from his *Intercoenales* (Dinner Pieces), probably written in 1432: "There is nothing more powerful, swift, or worthy than the eye . . . it is the foremost of the body's members, a sort of king or god."[25] Since Antiquity, the eye, as container of the divine spark of life, had been seen as the sensory organ most closely linked to divinity; Horapollo, for instance, had glossed the word *deus* by juxtaposing it with an eye, and Alberti himself wrote that Egyptian deities were represented by an eye.[26] Thus, the eye was traditionally linked to kings and mythological gods. The eye was further connected to the sun, which was also traditionally related to gods and kings, Plato having proposed that the eye was the organ that most resembled that planet. All these associations produced an equation of eye/god/king/sun with royal and solar implications for Alberti's emblem.[27]

Wings usually symbolized *celeritas*, speed of flight, in this particular case that of an eagle, the swiftest of all birds, according to Ripa.[28] The eagle, said to have the keenest

eyesight among birds and the ability to gaze directly at the sun, was of course an attribute of the god Jupiter, which meant that the wavy rays at the corners of Alberti's eye emblem have further been read as the light of Jupiter's attribute, the thunderbolt.[29] Alberti's divine eye in flight accordingly included two motifs associated with Jupiter's eagle: its wings and the thunderbolt that it often holds in its claws.[30]

As well as representing the ancient gods, Alberti's watchful eye was also that of the all-seeing and omniscient Christian God: "Didn't the ancients regard God as similar to the eye, since he surveys all things . . . [and is an] ever-present witness to all our thoughts and deeds?"[31] Like God, the eye had the capacity to make judgments, in particular aesthetic judgments: "the eye is by its very nature desirous of beauty and harmony, and in this respect shows itself to be fastidious and hard to please."[32]

In *De Pictura* both the artist and the art of painting are seen as having godlike powers, and the artist is several times likened to a deity: "painting possesses this distinction, that any master painter will see his own works adored, and will hear himself judged, as it were, another god."[33] Thus Alberti's emblem can be read as the judging eye of the godlike artist who perceives his idea of beauty through his sense of sight. Just as the eye of God metes out moral judgment, so the eye of the artist makes aesthetic judgments. God and artist were conflated visually in the Middle Ages, when the artist as God molded physical matter into the universe with the help of a compass (pl. 69), and, in the Renaissance, when the artist as Jupiter gave visual representation to the inner psyche, "our thoughts and deeds," as butterflies (pl. 147).

Alberti gave a precise interpretation to the wreath that surrounds his emblem on Matteo's medal, as symbol of joy and gladness. Not only did he devote one of his *Dinner Pieces* to the subject of the bestowal of "Garlands," but in Florence in 1441 he also organized the *Certame Coronario*, a contest for poems in the vernacular for which the prize was to be a silver laurel wreath.[34] And yet, curiously, the humanist refrained from adorning his self-portrait with the laurel wreath that would appear on so many other humanists' medals in the ensuing years.[35]

The laconic motto, *Quid Tum?*, "what next?" (deriving from Cicero, Virgil, and Terence), placed beside the eye on Matteo's later medal, can be linked also to the emblem on the earlier plaquette. We may hypothesize that Alberti, one of outstanding orators of his day, would have used these words as an expression of oratorical suspense.[36] Hypothetically, the expression was deliberately open-ended, as if in recognition that no work of art ever reaches its permanent, stable, form – in short, that all art is essentially and inevitably on-going or, in Renaissance terms, *non-finito*, unfinished. Such was often the case with Alberti's written pieces, many of which he left open-ended: "one piece ends with the author feigning suspense as to the outcome; another has no resolution at all; yet another is a fragment without ending; and a fourth a fragment without apparent beginning."[37]

The Emperor Augustus sported a distinctive hair style and so does Alberti in this plaquette; Augustus's hair was foregrounded in all his portraits, but Alberti's experiment in translating his hair into an attribute – short tufts evenly spaced all over the head in what today might be characterized as a punk cut – was not repeated by Matteo de' Pasti, perhaps because it was a convention more often used for a lion's mane than human hair. From an early but unknown date, Alberti added the classicizing name of Leone to his given name of Battista.[38] Having been named for the patron saint of Florence, St. John the Baptist, he adopted yet another name associated with the city, its lion symbol, the Marzocco.[39] There were other excellent reasons for associating oneself with Leo, such as the connotations of majesty and power bestowed by its role as king of beasts, its courage and pride, and its identification with the virtues of magnanimity and clemency.[40] The lion plays an important astrological role within the zodiac, often alluding to the powerful sign of Leo. Astrological doctrines of which, according to

Landino, Alberti was a master, often come up in *De Re Aedificatoria*.[41] The most important element of a natal horoscope in the Renaissance was the Ascendant, the sign rising on the eastern horizon at the moment of birth. Because the Ascendant was thought to signify the individual's life as a whole, the planetary ruler of the sign on the Ascendant was considered the Lord of the horoscope.[42] Thus, Alberti's choice of the name Leone might signify that the Ascendant of his horoscope was in fact Leo, whose planetary ruler was the Sun. This sign (Leo) and its rulership (Sun) carried a greater mystique of power than any other, and would have seemed a highly desirable portent for those aspiring to godlike powers. As Ficino put it, "the constellation which is the house of the sun, that is, Leo, is the heart of the constellations and controls the heart of all living things."[43]

In zodiacal iconography, the Sun shown entering Leo's mouth was often represented by a disk with human features from which rays emanate, much like the rays at the corners of Alberti's winged eye emblem.[44] If Alberti's hair style can be interpreted as referring to Leo, then the wavy rays at the corners of his eye emblem can also be, and have been, read as rays of the sun, and hence as a solar attribute of the divinity or king – not to mention the godlike artist – who is associated with, and represented by the eye, also rendered divine by its multiple solar connotations.[45]

Having dealt with the ʟ of the inscription, symbolizing the name Alberti adopted, let us consider the ʙᴀᴘ, the name given him at birth, and the dramatis personae, all with autobiographical overtones, who play important roles in the humanist's literary output. Such characters as Lepidus (who was cynical and witty), Philoponius (whose scholarly career paralleled Alberti's), and Baptista (who was artistically skilled) represented the voices in this "Albertian polyphonic song of self."[46] No one interlocutor speaks for Alberti in *propria persona*, because he does not claim to have an integrated self. In his literary work the author, wearing many masks, was intent in shaping not one identity, but several, and it is his performance as Baptista, the name he had borne all his life, that concerns us here.

Landino conferred humanist approbation on Alberti by likening him to a chameleon, that is, one who often changed the persona or mask he was wearing; more recently, it has been claimed that Alberti's oeuvre was marked "by a fondness for the pseudonym and anonymity."[47] He preferred to speak from behind a mask. Making his appearance in the 1430s, Alberti-as-Baptista has been characterized by Jarzombek "as a kind of king-saint, who combines physical and spiritual strength in one being."[48] This Baptista is prudent, virtuous, brave, blessed with significant talent and moral wisdom.[49] He has steady, self-effacing patience, never permits himself to show irritability, and despises the pursuit of material gain. It is a formidable idealization of the self; even the recreational pursuits of this terribly earnest young man were full of merit: he interspersed his bouts of hard work with long, healthy walks.[50] In short, Baptista, as presented in Alberti's *Vita*, was physically a hero, intellectually a genius, and morally a saint.[51]

In *Della Tranquillità dell'anima* (1442) Baptista is also identified as the artist in the Albertian family of personae, because of his skill with paintbrush and modeling wax: "perhaps Battista here can [paint and model], since he enjoys it and writes about it."[52] Baptista is Alberti in his guise of aspiring artist, his aesthetic self whose eye, constantly searching for beauty and harmony, is fastidious and hard to please. It will hence come as no surprise to discover that the voice that is heard in *De Pictura* is said to be that of Baptista, artist and critic.[53] If it is the *voice* of Baptista, the earnestly aspiring artist, who speaks in the treatise, then it must have been the *hands* of this same Baptista who modeled the bronze plaquette. And whose mask is most likely to be portrayed therein than that of Baptista, the king-saint who combines physical and spiritual strength in one being? In this heroic *finzione*, illusion, of the patrician humanist as artist, Alberti

dons the mask of Baptista as author and future author of the treatises on painting, sculpture, and architecture, as dilettante creator, and as both object and subject of the work.

De Pictura lays forth the demeanor and status of this new Renaissance Apelles who bears Baptista's features, much of it contradicting the contemporary perception of the artist's low status, even in vanguard Florence. Far from being Shakespeare's "rude mechanical," condemned to exist at the bottom of the social hierarchy along with other manual workers, Baptista's brilliance and godlike attributes place him at the apex of the social hierarchy.[54] Baptista is the artisan transmuted into a high-born, liberally educated Apelles, whose goal is to acquire praise and fame rather than riches, with the powers of not just any godlike figure but the supreme thunderer, Jupiter himself.

The bronze plaquette constructs Alberti's ideal artist, who, in the 1430s, was instructed to seize the exalted position, artistically and socially, that in the next century would be ceded by society, as fully deserved, to the "divine" Michelangelo, who fashioned the self as the first "modern" artist.[55] The position of Alberti at the beginning of this process of change is balanced by that of Michelangelo who took himself to the artistic and social zenith toward its end.[56] As already seen, the Washington plaquette embodies Baptista, the re-fashioner of an entire class of workers who were instructed to fashion new identities, and become well versed in Latin letters and the principles of geometry. Although Alberti never explicitly characterized the Quattrocento painter as a liberal artist, the exalted claims that he made on behalf of the discipline in the 1430s were, as Krautheimer noted, only just short of subversive.[57] It was not until a good hundred and thirty years later that Michelangelo and Vasari together brought Alberti's unlikely vision to pass, and that their construction of the myth of Michelangelo became part of the "reality" of the period.[58]

Chapter 7

FILARETE

Having introduced, when at the papal court, the concept of the medallic self-likeness before such a medal existed in actuality (pl. 49), Antonio Averlino, known as Filarete, subsequently produced, when at the Milanese court, the only oval Italian medal of the century (pl. 54). Whatever the chronological relationship between Alberti's plaquette and Filarete's first self-portrait in the "quasi-medal" on the doors of St. Peter's, his next self-image was deeply dependent on the Washington bronze. On a smaller scale than Alberti's work and double-sided, it offered an alternative format for the Renaissance medal, one that was destined to have no success.[1]

As Alberti sought multivalent identities at a relatively early date in his career, so, toward the end of his, Antonio Averlino adopted a new persona as *philaretos*, "lover of virtue." Referring almost casually to himself as "tuo filarete architecto" in the dedication of his architectural treatise to Piero de' Medici, the subsequent success of this new appellation would surely have astonished him. By the next century this was, for all practical purposes, his only identity.[2]

Alberti dedicated *De Re Aedificatoria* to Pope Nicholas V in 1452. Documented at the court of Milan from 1451, Filarete must have started planning his own foray into the "liberal" word soon thereafter. His *Treatise on Architecture*, mostly written in the early 1460s, is a remarkable achievement, given that his education was inadequate for the task and his Italian prose style neither succinct nor particularly clear. Vasari (not himself the most succinct of writers) was probably Filarete's harshest critic: "for the most part ridiculous, perhaps the most stupid book that was ever written . . . a man of little judgment, meddling in something he did not understand."[3] And yet the treatise, an invaluable compilation of architectural lore and much else, presented in a most *singolare*, or idiosyncratic fashion, has been characterized as the first modern theory of architecture.[4] The very concept itself of a treatise on architecture was vanguard at this date, and perhaps even more modernist was this artisan's ability to transcend his lack of Latin and write it in the Tuscan dialect of daily life.[5] He managed nonetheless to give it a humanist gloss by structuring it as a dialogue, a happy decision since it justified his use of the spoken vernacular.

54 Filarete, self-portrait medal, bronze, *c*.1460, reverse (larger than actual size), Collezione Numismatica, Castello Sforzesco, Milan.

The treatise recounts the planning and building of an ideal city, named Sforzinda for the Duke of Milan, and the reconstruction of a ruined Roman port, Plusiapolis (rich city). The book has a strong autobiographical cast, but the Lover of Virtue here adopted another mask: that of an architect called Onitoan Noliaver (an anagram for Antonio Averlino). The persona of Filarete was conceived only toward the end of the treatise, in which the concepts of Virtue and Vice were much featured, including their depiction on the facade of the architect's house. Otherwise the architect of Sforzinda would surely have borne the cognomen of Filarete rather than that of Noliaver. The voice of the loquacious Noliaver constitutes the bulk of the text, as he expounds on the details of siting, constructing, and decorating the many structures required for Sforzinda and Plusiapolis, for the benefit of the lord, Francesco Sforza, and his heir, Galeazzo Maria. The Sforza, however, get little more to say than *mi piace*, "I like that,"

55 Filarete, self-portrait medal, bronze c.1460, obverse and reverse, Collezione Numismatica, Castello Sforzesco, Milan.

at intervals. Rather than a dialogue between artist and patron, Filarete's work is for the most part a rambling monologue.

Filarete spent much of his productive life in the court milieux of Rome and Milan, and the ambitions revealed by the Greek name and literary tract are confirmed by his three surviving self-portraits, in which he explored the possibilities inherent in the genre (pls. 39, 49, 54). The date of his Milanese medal is not known, but there seems little reason to force a connection with the accession to power of Galeazzo Maria Sforza in 1466 or to take the Florence-centric position that the medal must have been connected to Filarete's hopes for Medicean patronage.[6] It is far more likely to have been produced at some point between the start of the artist's work on the Ospedale in Milan in 1456 and his departure from that city under a cloud in 1465. Since Averlino did not adopt the mask of "Philarete" on the medal, the work must predate his invention of that persona, and therefore probably dates around 1460, coinciding with the work on his treatise.

If Alberti presented himself visually as a young and strikingly handsome prince of the Augustan age, it is difficult, even in a Quattrocento context, to conceive of a rendition of the self that appears more naturalistic than that offered by Filarete in his medallic self-image. The relative lack of idealization of the features – pinched nostrils, focused gaze, pitted skin, compressed lips – of this particular artistic *finzione* may be characterized as overtly "anti-classicizing," if lacking in the expressivity and power of, say, Matteo de' Pasti's equally homely medallic portrait of Guarino da Verona.[7] Filarete's peculiar crewcut must surely be unique in the early Renaissance; had it appeared in the context of the English Civil War, it would read as a conception of the architectural self as a puritan roundhead, so to speak, as distinct from the patrician Alberti's self-inscription as an aristocratic cavalier.

Be this as it may, Filarete's head is beautifully proportioned to the scale of the medal and elegantly framed by its arched top, which is outlined by the handsome letters ANTONIVS AVERLINVS – a far cry from the crude lettering that disfigured the "reverse" of the quasi-medal on the Roman doors – ballooning like a rainbow over his head. Below, three bees, one of which is furnished with a blossom from which it extracts pollen, are interspersed among the letters ARCHITECTVS.

The reverse shows the seated *architectus* wielding mallet and chisel to open the trunk

of a laurel, the tree sacred to Apollo and the Muses, and the source of wreaths of fame. The honey from the beehive inside gushes out to form a pond in the foreground. Bees are swarming all around, and in the sky a sun with human face, from which rays emanate, shines down strongly. The inscription reads VT SOL AVGET APES SIC NOBIS COMODA PRINCEPS, "as the sun causes the bees to flourish, so the [patronage of] princes has the same beneficial [effects]."[8]

Classical references were to be expected after Filarete's twelve or fourteen years in Rome, and at a court where the resident humanist was his close associate, the Florentine Francesco Filelfo. Bees were prized in antiquity, and Filelfo would have been familiar with book IV of the *Georgics*, which was devoted to them. Virgil, writing against a background of the civil wars after the death of Julius Caesar, used the bees as a political allegory for the ideal Roman state.[9] He describes the development of a society in which the bee-citizens exhibit absolute patriotism, complete concord, and total subordination of the self to the common good. The unity, justice, and order of this ideal society are dependent on an absolute monarch, whom the bees revere. As long as the king survives, order will be maintained and the creative bee-artists and their works will flourish. Because of the ruler, this was a society that would survive any catastrophe – including war and revolution.[10]

The metaphor implies that the modern, Renaissance prince could also claim the capacity to regenerate his state, no matter what the circumstances, and that those citizens who, following the apian *exemplum*, obeyed the ruler, would be rewarded. This justification of absolutism would have been as valuable to Francesco Sforza, the *condottiere* who usurped the state of Milan in 1450, as to Octavian Augustus after the battle of Actium. Although Sforza's takeover of Milan was largely peaceful, his rule was overtly illegitimate; in the eyes of the law he was a usurper and the duchy was officially vacant. Only an imperial investiture from Emperor Frederick III, which Sforza was unable to obtain, could have settled his claim to the state beyond question.[11] Virgil's construction of a polis in which the bee-citizen, through love of his leader, surrendered his own individuality for the sake of the greater entity would accordingly have greatly appealed to this *signore*.

In his treatise, Filarete identifies the bee, which he occasionally incorporated into his signature, as symbolizing virtue as well as supporting a monarchical government:

> The bees are peace-loving, fruitful, and conscientious animals who harm no one who does not harm them but when they are touched and their goods are taken away, they attack ferociously. Thus will the men of this city [Sforzinda] be. They will be a great people like the bees, for they have a lord and have justice in them. When their lord can no longer fly, they carry him. This they do through clemency and the love they bear their lord. In the same way these people [of Sforzinda] will love their [Sforza] lord.[12]

The themes of the bees' industry and loyalty are again stressed when he discusses honey: "a very sweet liquid and useful for many things. The animals that produce it are industrious, severe, just. They desire and have a lord and ruler over themselves and they follow all his commands."[13] Elsewhere the bees are declared to possess that much desired quality *ingegno*, creative power. A badge to be worn by Sforza retainers would exhibit "a garland of laurel leaves, because it signifies wisdom . . . In the middle I will place a bee on a flower, which is gathering honey . . . which signifies *ingegno*."[14] This nexus of bees, honey, virtue, and sun returns as a sculpture decorating the facade of Noliaver's house in Sforzinda. The figure of Virtue, whose head is a sun with rays, stands on a diamond base from which a pool of sweet liquid, presumably honey, flows, over which two bees hover; fluttering winged eyes, ears, and mouths, symbolizing fame, surround the figure's head.[15]

What might the allegory on the medal reverse have signified? As bees were insects famous for their *ingegno* and their vocation for work, and were also symbols of virtue for the Lover of Virtue, the totality of elements would seem to imply that Filarete, that industrious bee-architect known for his own *ingegno*, not to mention his virtue – and whose loyalty to his princely patron could, of course, not be doubted – led a productive intellectual life, creating buildings and works of art whose beauty was inspired by the wisdom of the laurel and imbued with the sweet virtue of the honey.

Filelfo could also have shared his knowledge of Seneca's use of bees in a metaphor for the formation of a personal style.[16] The Roman argued that writers should model themselves on the bees that suck pollen from many different flowers which they then transform into a new substance called honey. Writers should take their material from the widest possible range of texts and then, through a process of transformation, "mix these various sips into one taste," creating something new and different. In all creations the disparate elements went to form a unity, just as the most varied voices in a choir blend into a single harmony. As Petrarch put it, "the bees would not be glorious if they did not convert what they found [pollen] into something different and better [honey]."[17] The metaphor may well have borne some of these connotations for this Tuscan transplanted first to Rome and then to Lombardy, who was one of the first to apply the term "style" to the visual arts, and who fused some aspects of the local Lombard or "gothic" *alla moderna* idiom into his version of the new "Renaissance" *all'antica* style practiced in Florence, in an effort to create a new style acceptable to the Milanese.[18]

A sun with human features shines on the medal reverse. As already seen, in zodiacal iconography, a sun with human face from which rays emanate often represented the combination of Ascendant (Leo) and planetary ruler (Sun) of a horoscope.[19] Inevitably the sun, said to be one of the natal zodiacal signs of Francesco Sforza, figured among the many Sforza emblems.[20] His heir, Galeazzo Maria, supposedly born when "the sun was in conjunction with Jupiter, Venus, and Mercury," and hence born "under the influence of the sun," had a medal reverse that showed a sun disk with human face and rays.[21] Thus, the parallels between sun and prince, sun and god, mirror those drawn previously between bee and artist.[22]

As the brilliant rays emanating from the sun-prince-god rewarded the hard-working bee-architect for his unswerving loyalty and his marvelously *ingegnoso* creations, so the laurel (wisdom) flourished and enabled the beehive to grow in its trunk, and eventually produce honey (art).[23] Alluding to the prince's munificence, without which no art could be created, the medal glorified Sforza generosity. The treatise, another work addressed to the ruler, also exalted ducal patronage. In these two autobiographical works, Filarete correctly located the patron at the heart of the court cultural and economic nexus.

"May every man be well paid!" runs a passage in Filarete's treatise, and his ingenious medal reverse offers a metaphor in court artist/patron relations.[24] It points up the differences between Filarete's position in Milan, where he was on the court payroll, and that of Alberti *vis-à-vis* the court of Ferrara. If not at the same social level as Leonello d'Este, the Florentine patrician-scholar was the marchese's friend and "cultural consultant," not his servant or his salaried artist. Alberti, for instance, wrote pointedly of painting "for pleasure," an unlikely concept for a Quattrocento artisan such as Filarete, whose livelihood depended on the steady production of artifacts.[25]

The reverse of Filarete's self-image thus focused on an issue of intense interest to all court artists: the search for a signorial patron who exhibited *liberalitas* and exhibited it often. The Sforza sun's golden rays symbolized the golden ducats or florins that were supposed to flow, in a Renaissance version of trickle-down supply-side economics, from the rich and powerful on high to the artist far below. The financial reality

of service at court, however, was too often otherwise. All the North Italian *signori* had cash-flow problems, and whatever stipends the artists may have been promised on paper, financial remuneration in practice seldom exchanged hands without much effort on the artist's part to collect it, and not even always then. Many of the surviving letters by Quattrocento artists – such as the exchanges between Mantegna and the Marchese of Mantua – were efforts to collect arrears of salary, as in this letter written by Filarete to the duke in 1465:[26]

> I pray your lordship that you will deign to hear me and not take what I have to say to you in this letter badly . . . I pray your lordship . . . to realize that they have delayed paying me my monies, as if it were done at your instruction. Therefore, I pray, speak to them in such a way that they will pay me . . . There remains up to now 1,240 lire, 4 soldi and 1 denaro [owed me].[27]

Filarete's deferential language conveys his sense of marginalization from the center of power. As was often the case, the artist's appeals for justice were not productive, and Filarete left Milan forever without the monies owed him in back-pay.

Filarete defined himself on the medal obverse as ARCHITECTVS. Of the three *arti del disegno*, architecture had the highest standing, in part because it involved less "hands-on" labor, being primarily supervisory. Alberti, in his foreword to *De Re Aedificatoria*, defined who was and who was not an *architettore*: "He who works by hand [only] serves as the architect's instrument. I consider the architect him who, by sure and wonderful reason [*ragione*] and method [*regola*], knows how to devise through his mind and spirit . . ."[28]

Architecture had required two reliefs on the Florence campanile, one showing a male Architectura pondering proportion with the compasses, the other a mason who focuses on the physical construction of a wall (pl. 6). As the two reliefs suggest, the term architect had two primary meanings, the Latin and the vernacular, as it were: it could be used in Alberti's Vitruvian-inspired sense, meaning one with the intellectual and scientific skills derived from a broad cultural, humanist, and mathematical education. Filarete's own definition of this type stressed the necessity for *disegno*, geometry, arithmetic, astrology, music, medicine, historiography, and civil law. In the other definition, the term signified the overseer – often a master mason – of the building site who watched as the builders (*muratori*) sullied their hands with bricks and mortar. Many of the "intellectual" theoretical architects, such as Alberti and Bramante, had virtually no experience of such actual construction. In practice, the experience of Antonio Averlino *Architectus* was primarily of this latter, "master-mason," type, as chief supervisor on the two major building sites in Milan, the Duomo and the Castello Sforzesco, and his appointment in 1456 as *inzignerius et architector* of the Ospedale Maggiore.[29] In theory and in fantasy, however, Filarete's elaborate plans for the Ospedale, and all the magnificent new buildings envisioned for Sforzinda in the treatise, convey his determination to be recognized as a master of the first type, an intellectual and scientific manipulator of the compasses, as he had portrayed himself in 1445 (pl. 39). Albeit the author of a treatise in Italian, he nevertheless sought recognition as a "Latinate" *architectus* who possessed the Vitruvian quality of *ratiocinatio*, theoretical knowledge.

Proof positive of the higher social status claimed by Filarete for his trade is the square footage that he proposed in the treatise for the architect's house in the Utopian Sforzinda, when its area is compared with that of other houses. The ground-floor dimensions of the largest structure in Sforzinda, the huge Ducal Palace, amounted to 52,800 square braccia, and that of the smallest, the house of the *povero uomo*, to 100 square braccia. At 3,468 square braccia, the ground floor of the architect's house is not only much larger than the "poor man's" hut, but also twice as large as the house in

56 Filarete, *The Architect's House in Sforzinda*, pen, first half of 1460s, from Filarete's *Trattato di Architettura*, MS Magliabecchianus II, IV, 140, f. 151r. (Book XVIII), Biblioteca Nazionale, Florence.

which the painters and sculptors lived, which amounted to 1,500 square braccia.[30] In the treatise the latter were defined as humble artisans, from whom Noliaver *Architectus* took care to distance himself.

And no wonder, for Filarete's visions for himself and his architectural colleagues caused him to give Noliaver a social rank in the treatise that would not be attained in reality until Raphael acquired the Palazzo Caprini in the teens of the next century, or better, until Leoni renovated the facade of the Casa Omenoni in Milan for himself at the end of that century.[31] Noliaver's own house in Sforzinda was not only much larger than that for the painters and sculptors but also very centrally located within the city, placed beside the House of Virtue, Sforzinda's educational center. Free-standing on a podium, it had a magnificent, ornate facade that rose up three storeys, all with multiple columns that echoed the pilasters on the facade of Alberti's recently constructed Palazzo Rucellai in Florence, and had, like the bishop's seat, two towers (pl. 56). On the facade (but not included in the drawing) stood a portrait bust of Noliaver with a list of his achievements, and, with special ducal dispensation, the sculptures of Virtue and Vice that he had invented.[32]

"The architect must be loved and honored as much as necessary . . ." wrote Filarete, and throughout the Treatise, the ruling family treats Averlino/Noliaver/Filarete with enormous respect for his encyclopedic knowledge and artistic talent.[33] When Noliaver points out the site where he plans to place statues of the Prince, his son, and his court humanist, the prince is made to reply, "very well, do as you wish, but put your own there as well." "My lord, mine would be too much," Filarete makes Noliaver reply humbly, but the unlikely fantasy response from the duke, as written by the would-be *architectus*, reads: "since you want the others, see to it that yours is there too."[34] The inscription on the facade of the Ospedale linked the names of the building's founder (Sforza) and author (Noliaver), and Noliaver's portrait was also connected to that of his patron on a boundary marker.[35] As it happens, Filarete's fantasy inscription and images were conceived several years before the Camera Dipinta in Mantua, where Mantegna placed his name beside that of the ruler, was begun.[36]

A phrase in the letter that Filarete wrote to Sforza in 1465 points up the different reality of the artist–patron relationship at the court of Milan as against that fantasized for the Utopia of Sforzinda: "since you have not given me an audience for some time . . ." Thus, the lord, who listened so admiringly as Noliaver spent hour after hour expounding his *ingegnoso* plans for his fantasy dream city, in Milanese reality did not grant Averlino audience. The *signore*, who said *mi piace* so often to Noliaver, exiled Averlino from his presence.[37]

Onians has pointed out the originality of Filarete's imaginative analogy between the social organization of society and the structure of buildings – social class and architecture – by comparing the aristocracy to large, finely carved exterior blocks and the peasants to rough rubble filling.[38] Just as powerfully inventive was Averlino's detailed formulation of his fantasies for his architectural *alter ego*'s place within the hierarchy of power, whether represented by his portrait and name paired with those of the duke; the location of his statue beside those of ruler and heir; or his unbelievably sumptous planned residence. Averlino's *singolare* social dreams for his architectural self and peers would only come to fruition in the next century in the persona and myth of Raphael.

Chapter 8

MANTEGNA

> You [Mantegna] have surpassed the ancients in both intellectual talents [*ingenium*] and manual skill [*ars*].
>
> —Janus Pannonius[1]

From a sculptor's career at the court of Milan we move to consider that of a painter at the nearby court of Mantua. Like Ghiberti and Filarete on their doors, Mantegna also included his far from autonomous self-portrait in the decorative framing of Lodovico Gonzaga's frescoed chamber – the Camera Dipinta (pl. 57). Peering out between the fictive marble foliage and flowers that decorate the fictive gold mosaic pilasters that support the fictive vault of the fictive loggia, Mantegna's painted features observe the observers observing his frescoes (pl. 58). His was the only such head included, and significantly he chose to locate it on the pilaster between the door into the room and the so-called Meeting Scene, that is, between the gilded *tabula* with formal inscription above the door and the (now) illegible signature, ANDREA ME PINXIT, on the folded note held by Cardinal Francesco in the narrative scene – the little *boletta*, as Pino characterized it, that was often slipped into a composition.[2]

While the simple signature on the folded paper, "Andrea painted me," composed as if the painting itself were speaking, can be called the craftsman's standard sign, the elaborate formulation of the monumental epigraphic inscription on the tablet may be read as representing the erudite *antiquarius* who yearned for recognition as a "liberal" artist.[3] Mantegna had already experimented with an archaeological signature when he simulated his name carved in Greek in a painting of St. Sebastian.[4] In the formal Latin and the elegant Roman lettering of the Camera Dipinta tablet, the cycle, OPVS HOC TENVE, "this humble [or slight, or trifling] work," was dedicated to the honor of the patron, Lodovico Gonzaga, PRINCIPI OPTIMO AC FIDE INVICTISSIMO, "most excellent of princes, of indomitable faith," and to the marchesa, Barbara of Brandenburg, MVLIERVM GLOR. INCOMPARABILI, "incomparable glory of women," by SVVS ANDREAS MANTINIA PATAVVS "their Andrea Mantegna of Padua."[5]

Battisti expounded on Mantegna's unexpected choice of adjective in characterizing his frescoes:

> the humble style, that is, according to Cicero, *genus humile o submissum*, [has] the exclusive aim of teaching, that is, to present honestly and clearly the facts . . . The *genus tenue* would be . . . a style without style (completely subordinate to the subject matter) . . . simplified in dictionary and diction, that does not attempt to create celebratory history and even less to approach the epic.[6]

The characterization of the Camera Dipinta as humble or slight, painted in a plain style – a style without style, as it were, or without rhetoric – can be read as suggesting that the art, by comparison with the glorious reality of the court of the worthy ruler and his incomparable consort, will inevitably disappoint. The clause would seem

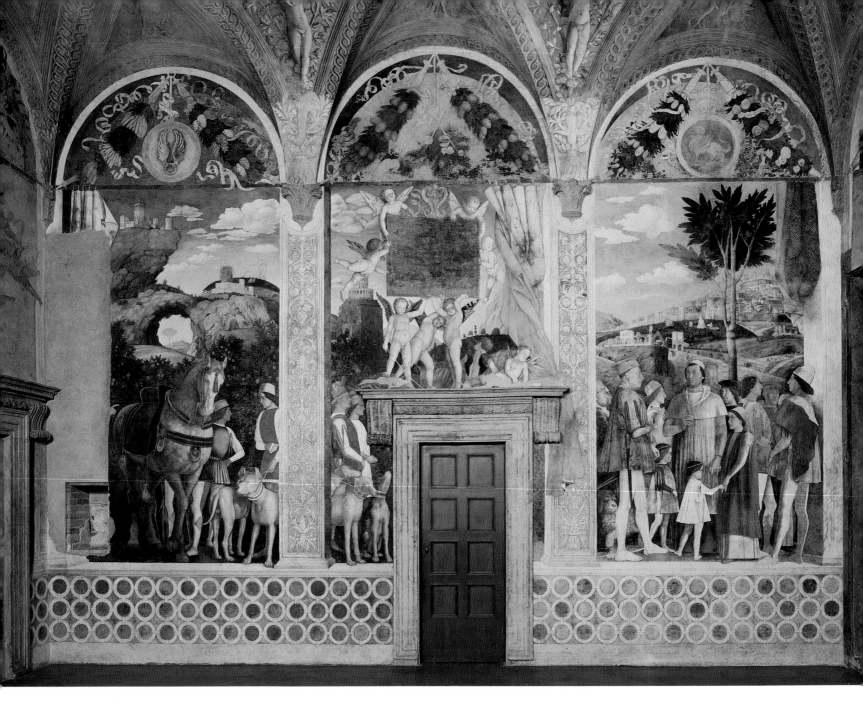

57 Andrea Mantegna, *Meeting Scene*, Camera dipinta, fresco, 1465–74, Palazzo Ducale, Mantua.

to claim that since Mantegna's only objective was to teach, in Battisti's words, "to present honestly and clearly the facts," his cycle offers a "faithful" likeness, without embellishment, of the Gonzaga court. The conceit denies equally the interpretive function of art, and the mediating role of the artist vis-à-vis Nature, by implying that this carefully staged visual construction of the ruling family is *not* a construction, not a work in which the courtier-artist has faithfully catered to his master's illusions, but "facts," reality, however these were perceived.[7]

Mantegna's means of *visual* self-inclusion, the tiny scale of his head in relation to those of either the painted protagonists or the living Gonzaga jostling around the room itself, its location some four meters from the floor, that is, above eye level, and the subordination of his features to the decorative foliage can be read as a witty comment on the artist's "correct" social place as established by the culture. Mantegna is known to have possessed great wit, and the image suggests a *facetia*, or jest, played by the artist for his patrons' benefit: his "concealed" self-image on the pilaster is so surreptitious that

58 Detail of pl. 57, with self-portrait.

he is present but not there, both seen and unseen, a mirage in paint-strokes that some-times resolve into the artist's features, sometimes into foliage. If such were the case, Mantegna's *jeu d'esprit* lasted five hundred years. From the approximate date of paint-ing in 1470 to Signorini's publication in the early 1970s, Mantegna's self-portrait in this site went unmentioned in the literature, that is, it was, for all practical purposes, "lost."[8] Paradoxically, Mantegna's gaze is so angled that those reading the inscription tablet during the intervening five hundred years were, all unknowingly, doing so under the painter's sharp scrutiny.[9] Those who thought they were judging him were them-selves being judged, in perpetuity.

The minute scale of Mantegna's *visual* self-image in the vernacular, as it were, is at odds with the boldness of his *literary* self-promotion in the noble "liberal" Latin of the dedicatory tablet. Here was a new breed of assertive and upwardly mobile court artist, one of sufficient learning and *ingegno* for his name to be placed alongside those of the rulers – just as Filarete had envisioned the linked names of Sforza and Noliaver on the facade of the Ospedale in Sforzinda. Mantegna arrived at the court of Mantua just as Filarete put pen to treatise at the court of Milan, but it was still chronologically too early for the Gonzaga's treatment of their court artist to come up to the standards posited by Averlino-Noliaver. Despite Filarete's vision of the statues of Sforza and Noliaver standing side by side in a public site in Sforzinda, and despite Mantegna's own claims embodied in the Camera Dipinta's Latinate epigraphic signature, the painter did not feel at liberty to figure the self at the same *visual* scale, much less in the same pictorial space, as the princes, emperor, and king who grace the walls of the Camera Dipinta. Or could it perhaps be argued that Mantegna preferred to hold himself aloof, gazing down from a viewpoint on the periphery that was almost subversive in its lack of ostentation, as a game of one-up-manship?

This brief apparition, done when the artist was around forty, was not Mantegna's first self-portrait but potentially his fourth, if credence is to be given to other art-historical "sightings" of his image. He is said to have included two self-portraits in the fresco cycle in the Ovetari Chapel, dating from the first half of the 1450s – and hence remarkably early in his career, not unlike the German Dürer's frequent, albeit autonomous, self-imaging in his relative youth in the 1490s.[10] Most compelling is the self-image in the right background of the *Presentation in the Temple*, probably around 1454–5 (pl. 60), in which he probably also depicted his wife, Nicolosia Bellini, as pendant on the extreme left (pls. 59a and b). The work most likely represented a votive picture, hypothetically to commemorate Nicolosia's survival of a difficult delivery.[11] The painting may have been hung on the right wall of a chapel, given that both Mantegna *sposi* look anxiously to the viewer's left, presumably toward the altar. Curiously, Mantegna's gaze in both putative self-portraits in the Ovetari Chapel was also focused toward the left; the orientation could reflect the way he had set up the mirror in which to observe his features.[12] If correctly identified, the self-images in narrative reveal Mantegna's precocious awareness of his own artistic *singolarità* and his concomitant pro-fessional and social ambitions; they match the profile of the young artist who demanded a coat of arms even before he arrived at the Mantuan court. This series of putative self-portraits, if such they are, form a remarkable autobiographical gesture both for the period and for such a youthful artist, one that was not to be duplicated until Raphael's possible early experiments in self-imaging in Umbria at the beginning of the next century.

59a and b Details of pl. 60, with portrait of the artist's wife and self-portrait.

★ ★ ★

It is a quantum leap from this tiny "concealed" self-image or the small-scale bronze low-reliefs by Alberti and Filarete to the next self-portrait: the autonomous life-size

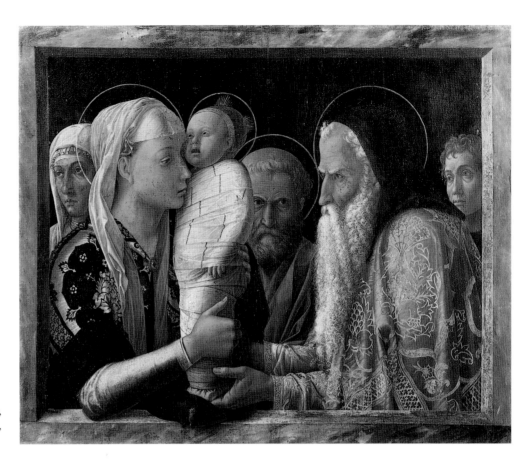

60 Andrea Mantegna, *Presentation in the Temple*, panel, *c.*1454–5, Staatliche Museen zu Berlin, Gemäldegalerie.

bronze bust that Mantegna created for his funerary chapel in S. Andrea, Mantua, a self-image worthy of his own Latinate signature in the Camera Dipinta's dedicatory tablet.[13]

Like so many Italian lords, Mantegna planned his own tomb before his death. For himself, his wife, and his sons, and their salvation in the hereafter, the artist created his own chapel as a mixed-media environment, a frescoed religious space with two foci, the altar and the bronze bust of himself as the new Apelles in the form of an imperial *imago clipeata*. While this bust is not strictly "autonomous" in the sense that it is one of a number of elements in a work of art that comprises the funerary chapel as a whole, the work is nonetheless "autonomous" in the sense that its primary raison d'être was to offer a simulacrum of its maker's appearance during his short time on this earth (pl. 61).

Unlike Filarete, Mantegna limited the assumption of other identities to the Latinate form of his name. He neither wrote an autobiographical text, nor – curiously, in light of his interest in reproducible prints – did he create his own medal. The cultural climate of the Mantuan court was different from that of Milan, and other kinds of artistic gesture and masks carried greater resonance within the Gonzaga court. In Mantua, Marchese Lodovico Gonzaga, who was *intendentissimo*, "very knowledgeable," in architecture, built and rebuilt properties all across the Mantovano, and sponsored two new churches by Alberti, pre-eminent architect of the age. These factors led Mantegna to seek recognition of his artistic *ingegno* by designing and decorating large-scale environments: his own house and his own funerary chapel. Both Filarete's medal and treatise had been consciously addressed to his Sforza lord, and were carefully calibrated to "speak" to that (alas, unreliable) source of patronage and protection. With his house and chapel, on the other hand, Mantegna intended to *emulate* his lord, not to address

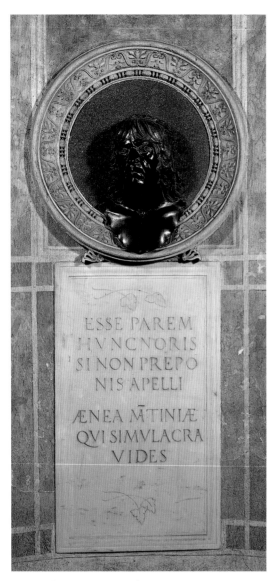

61 Andrea Mantegna, funerary monument, porphyry, marble and bronze, early sixteenth century, Cappella S. Giovanni Battista, S. Andrea, Mantua.

62 Detail of pl. 61, with self-portrait bust of funerary monument, bronze, *c*.1490.

him directly, by creating architectural complexes for which the artist was his *own* patron, and which competed in interest with those commissioned by the *signore*.

In 1504 Mantegna acquired the rights to the first chapel on the left of the entrance into S. Andrea, dedicated to St. John the Baptist, as his memorial funerary chapel.[14] Mantegna died in 1506, and the decoration and commemorative monument were completed in 1516. The chapel consisted of engaged arches supporting a little dome, and the decoration comprised two large narrative scenes on canvas opposite each other, *The Baptism of Christ*, in honor to the chapel's dedicatee, and an *Entombment of Christ* (a later substitute for another scene from the life of the Baptist), and, above the altar, the *Family of Christ with the Family of St. John the Baptist*. To frame the paintings, the walls of the chapel were decorated with an elaborate simulated architectural and sculptural setting against a background of fictive revetments of colored marbles.

The architectural concept of the chapel and the design of the frescoes may have been modeled on those Mantegna created for Innocent VIII's (lost) chapel in the Villa Belvedere in Rome, also dedicated to John the Baptist. The quality of the facture in Mantegna's own chapel, however, is not high, and it is generally accepted that, while the design of the paintings and the architectural setting were due to Mantegna, the execution was for the most part carried out by his son Francesco.[15]

An *imago clipeata*, consisting of a bronze bust of Mantegna, foregrounded against a disc of ancient imperial porphyry, and encircled by a frame of carved white Istrian stone, stands against the pier to the left of entry into the chapel (pl. 61).[16] The artist turns his head to the right, away from the altar and toward the entrance, creating a competing center with it. The eyes that greeted the visitor entering his chapel were probably originally inlaid with diamonds, silver, or glass. Below, a rectangular white marble tablet with the inscription ESSE PAREM / HVNC NORIS / SI NON PREPO / NIS APPELLI / AENEA MANTINIAE / QVI SIMVLCRA / VIDES, "you who see the bronze likeness of Aeneas [sic] Mantegna, know that he is equal, if not superior, to Apelles."[17]

Although little, if anything, of his work in three dimensions survives, Mantegna's activity in sculpture is confirmed by sources written before his death. In the 1490s Giovanni Santi wrote that Mantegna "has not omitted to work in relief . . ." and in a poem of 1497, Battista Spagnoli, a close friend, used the names of most of the Greek sculptors known to the Renaissance to convey a sense of the artist's superiority:

> Why gaze at statues of Myron and Lysippus? Why do the breathing marbles of Praxiteles and the statues of Euphranor delay your step? All the ivory of Phidias is overmatched. The genius of Polycletus is tarnished and loses all luster when compared to the genius of Andrea.[18]

Later, in 1560, Scardenone, perhaps on the authority of Campagnola, wrote that Mantegna "fused [this sculpture] for himself with his own hands." Vasari also believed Mantegna to have been a sculptor. There seems little reason to doubt the sources, given the consistent aesthetic of one who often painted sculptural figures in simulated stone or bronze high relief against a background of the same veined marbles decorating the chapel's walls. What then could have been more understandable than that the artist's well-known passion for Albertian *rilievo* – volumetric, three-dimensional figures created on a two-dimensional surface by means of light and shade – should have led him to experiment with work in actual three dimensions? Thus it is generally accepted that the bronze bust, probably intended from the beginning for his commemorative monument, was designed, if not cast, by Mantegna himself (pl. 62).[19]

Paradoxically, Middeldorf sustained the attribution of the sculpture's facture to Mantegna, on the grounds that, because designed by a painter, it lacks the necessary sculptural volume:

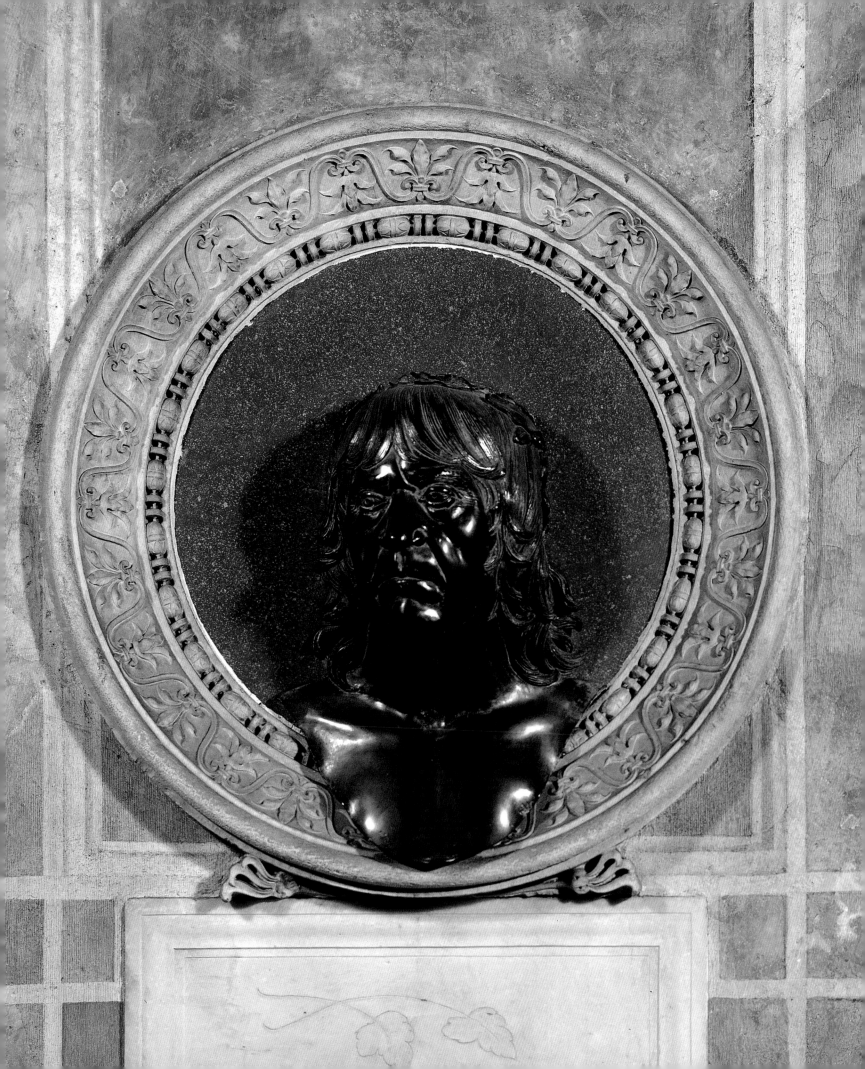

the head is superbly modeled and such a liveliness is found in few other contemporary portraits; it has the style of the master himself and must be principally his. And yet, in front of the original . . . the powerful drawing of the features is not matched by the basic construction. Planes are not organized to form an articulate volume; face, skull, and hair seem to be fitted together casually and the bust does not detach itself neatly from the ground.[20]

The bronze, however, is not a three-dimensional sculpture proper, but one in high relief, a "quasi-bust" rather than an actual one, and hence intended to read as a relief. It is possible that most of Mantegna's sculptural work was in relief, in keeping with the important model of Donatello's Santo altarpiece in Mantegna's home-town of Padua. *If* much of Mantegna's sculpted work was in relief, it is possible that his monochromatic relief paintings were produced in a kind of internal *paragone* with his actual relief sculpture.

Thus, the master whose antiquarian passions led to an lifelong interest in simulating the appearance of three-dimensional Roman sculpture in his paintings, here tackles actual relief. The artist who was contemporaneously creating monochromatic paintings here uses a medium that has only one color, with variations derived from the way actual, not fictive, light hits the surface. The painter who usually worked in the all too vulnerable medium of tempera, here chose obdurate metal and hard stones that were proverbially resistant to wear. The master who adopted the Latinate form of his name after 1470 masked the self as both Apelles, Hellenistic painter, and Aeneas, founder of Rome.

Mantegna chose the same antique sculptural type as Ghiberti: the *imago clipeata* mentioned by Pliny, in which a bust is set on a shield which in Antiquity was then hung up for display in the house or, as here, temple.[21] Mantegna had used the motif in paintings of buildings at an early date, as on the palace in the *Martyrdom of St. Christopher* in the Eremitani. Because so many ancient sarcophagi contained low-relief busts within circular medallions, the type had strong funerary connotations; it had equally strong imperial overtones due to its early and exclusive use by the Roman emperors. Even in Antiquity Roman citizens who used these tondo portrait frames were identifying with imperial iconography.[22] He who had created a fictive *imago clipeata* for each of the first eight emperors on the two-dimensional Camera Dipinta vault here created an actual three-dimensional *imago clipeata* for himself. Since Constantine the Great and many subsequent emperors were interred in valuable porphyry sarcophagi, this medium also carried specific imperial and funereal connotations, which it retained throughout the Middle Ages. The emulation of Antiquity was further reinforced by the painted revetment of colored marbles on the surrounding walls, an evocation of the ancient Roman custom of using actual colored marbles to sheath the inside of such buildings as the Pantheon; the custom was revived and emulated in such fifteenth-century interiors as the marble-veneered Cappella del Perdono in the Ducal Palace in Urbino, and S. Maria dei Miracoli in Venice.[23] Mantegna's *imago clipeata* was accordingly integrated into a venerable *all'antica* interior setting by means of the simulated marble cladding.

Unlike Alberti or Filarete, Mantegna crowned himself with a wreath of laurel leaves, assertive symbol of triumphant achievement and everlasting fame. Laurel was used in Antiquity primarily to honor great leaders and great poets. In the Quattrocento it was appropriated by *signori* such as Sigismondo Malatesta, who considered themselves great leaders, and by humanists such as Francesco Filelfo, who hoped to be accepted as great poets. Although it was used by the Venetian artist Boldù on his medallic self-portrait at the early date of 1458, it was unusual in portraits of artists, which were not, in any case, numerous. Mantegna may have been influenced by his brother-in-law, Giovanni Bellini; a painter from the Bellini circle encircled the head of the unknown sitter in

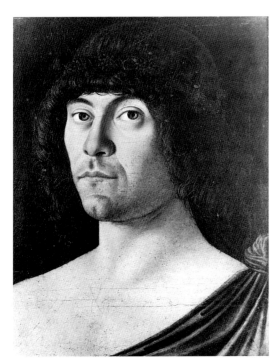

63 Shop of Giovanni Bellini, *Portrait of a Humanist*, panel, *c.*1475–80, Castello Sforzesco, Milan.

the *Portrait of a Humanist*, now in Milan, with a fillet of olive leaves (pl. 63).[24] The bronze laurel wreath around Mantegna's head reinforces the other concentric circles of deep red porphyry and white Istrian stone that enframe Mantegna's features like a halo, a classical nimbus, as it were.

Mantegna's quasi-bust (pl. 62) is finished in a curved U to indicate naked chest and shoulders, implying the heroic nudity of the whole, as well as evoking Roman bare-breasted relief busts. In the Belliniesque portrait, the unknown young man with wreath also wears the attribute of an antique toga-like garment draped to reveal a consider-able amount of naked chest and shoulder. Any attribute that evoked sculpted portrait busts from classical Antiquity also implied the sitter's classical learning, and indeed, this carpenter's son was genuinely erudite, a *doctus artifex* with unprecedented archaeological insight, despite his almost certain lack of formal education.[25]

Mantegna's heavily lined facial features are set in the same severe expression, with pronounced lines around the mouth, downturned lips, furrowed forehead, and heavy, frowning eyebrows, as that of the painter peering through the floral decoration into the Camera Dipinta. Mantegna's well-known inclination to irascibility suggests that his own humor, or temperament, was inclined to the bellicose, or what the Renaissance would have termed "choleric." It has been suggested that by stressing "a leonine glare or scowl that signifies *audacia*" the artist approximated his self-image to a specific type of heroic portraiture, that of a *condottiere* with leonine characteristics, redolent of bel-ligerence and, hence, virility.[26] The visual formula for this type of heroic portraiture, as outlined in antique and medieval texts on physiognomy, included muscular cheeks, mighty chin, strong eyebrows, and the formula of a "cloud" in the forehead, that is, strained eyebrows and a furrowed brow.[27] The artistic example usually cited is Colleone's ferocious snarl in Verrocchio's equestrian statue in Venice, intended to evoke the courage of Mars. In the case of Mantegna, however, the artist may be not so much emulating the warlike Mars or Hercules as his warlike Gonzaga patrons, as *they* emu-lated these gods and hoped to be perceived as embodiments of Herculean-leonine *audacia*.[28]

The traditional Gonzaga identity as an idealized *condottiere*, a professional com-mander who hired out his services in time of war, was particularly meaningful for Marchese Francesco, who came to power as a youth in 1484. Portrait busts and medals of Francesco, the self-styled "hero" of the battle of Fornovo against the French in 1495, play up the ferocity and courage of his martial persona.[29] In other words, the prevail-ing model for upper-class male portraiture at the Mantuan court included an expres-sion of aggressive *audacia* considered appropriate to leaders of men in warfare. Mantegna's "cloudy" leonine scowl may be interpreted as the boldness and strength of character of the leonine artist who has overcome the difficulties of art and produced a work that, by outdoing all others, became a unique, or *singolare*, tour de force.[30]

The relationship of Mantegna's features in actuality to Mantegna's representation of them in art is unknown – or, to put it differently, the likeness cannot be distinguished from the mask. Nevertheless, by hypothetically approximating his own portrait to the heroic, martial type espoused by his princely employer, the artist reveals his social aspi-rations and yearning for social standing – for a site on the social ladder that was so much higher in death than that into which he had been born. Mantegna, who started life as the son of a carpenter, ended by posturing as a Caesar, be he Roman or Renais-sance. As it happens, Mantegna was able to attain a professional and social status in Mantua that he might not have reached at a larger court.[31]

It is not known who composed the inscription on Mantegna's monument, but pre-sumably it represented sentiments that he would have endorsed. The monument calls not upon the Christian deity but the most famous painter of Antiquity, whose name stood for the art of painting. In the Renaissance, accounts of Apelles' life and work

were embroidered to give the title ever greater meaning. Apelles was re-created on a Renaissance model as the first learned painter in the Western world, credited with having written treatises on the principles of the art, and admired for his knowledge of geometry and arithmetic.[32] The bronze *finzione*, then, presents the learned Mantegna wearing the mask of Apelles, erudite theorist, eminent mathematician, and supreme artist of the classical past.

In a North Italian court tradition, Mantegna received more poetic tributes than any of his Central Italian contemporaries. In a 1492 decree issued by Marchese Francesco that specifically praised Mantegna for his achievements in the palace chapel, the Camera Dipinta, and the *Triumphs of Caesar*, the artist was called a second Apelles.[33] What more understandable than that the second Apelles should wish to transfer the "appellation" from a private document to a public site where all could reflect upon its implications? Self-identification with Apelles also served to establish the imperial grandeur of the new Apelles' Quattrocento patron. Through the canvases of the *Triumphs of Caesar*, Mantegna had already encouraged the warlike Gonzaga ruler to identify with the greatest general of Rome, Julius Caesar. If, shifting to an earlier culture, Mantegna were to be reborn as Apelles, why should his Gonzaga patron not be reborn as a new, perhaps greater Alexander the Great?

Created by an artist who rarely painted portraits, and who may have produced as many images of self as of others, this sculpture is usually dated between 1480 and 1490 on the grounds of the supposed age of the sitter.[34] Such an approach to the dating of portraits has been established as perilous, given the usual idealization of most Italian sitters in this period, which is surely also present in this bronze, even if created by an artist who was known rather for the verisimilitude of his portraits.[35] Although the date of the bronze does not affect its significance, an alternative dating to the first half of the 1490s is here suggested.[36] In this construction the work would postdate Mantegna's Roman experience and Marchese Francesco's 1492 decree. If a date in the 1490s is accepted, the sculpture can further be seen as having been created in a court climate filled with accounts of the bellicose exploits and the martial courage of the young marchese in what he saw as his great "victory" over the enemies of Italy at Fornovo.

One obvious way in which the ambitious artist could improve his social status was to acquire a noble title. Mantegna signed the chapel painted for Pope Innocent VIII "Comes Palatinus" (Count Palatine), and it is thought, but not documented, that this title was granted him by Emperor Frederick III in Ferrara in 1469.[37] His brother-in-law Gentile Bellini was knighted by the emperor at the same time, Mantegna and Gentile being among the first artists to seek titles of nobility.[38] The artist also signed the frescoes for the pope "Eques auratus" ("Knight of the Spur"), probably a knighthood given him by the Gonzaga.[39] Gonzaga heraldic devices, such as the eagle, bird of Jupiter, perched on a stone inscribed AB OLYMPO ("from Olympus") and the device of radiant sun (*sol*) with the motto *par un [seul] désir* were further inscribed in Mantegna's house as well as his funerary chapel, where his coat of arms also figures in the center of the vault, on the window wall, and on either side of the Gonzaga eagle on the altar frontal.

"Mantegna, true imitator of Antiquity, that second Apelles, the honor of our times, founded this house and gave it the form of a little amphitheater," wrote Bonavoglia in 1526. From almost the beginning of his stay in Mantua, Mantegna had wished to build his own house, but he was not able to proceed until 1476, and construction continued until 1494. In both its dimensions and its ground plan, Mantegna's house, on a site given to him by Marchese Lodovico, facing on to the Piazza S. Sebastiano, aspired to be a nobleman's palace rather than an artisan's *bottega*. Rosenthal found precedents for the plan, a circle inscribed within a square, among the designs for smaller palaces by Francesco di Giorgio, which were in turn inspired by the geometric perfection of the

Pantheon.[40] The heart and the main internal space of Mantegna's cubic structure is its central circular courtyard with four doorways, one on each axis. Measuring 25 by 25 meters, which amounted to a ground floor of 625 square meters, the dimensions of the house were also palatial; the total property, which included a large orchard, amounted to two and a half acres.

The suggestive hypothesis that Mantegna planned to place a dome with an oculus over the central rotunda in the house – on the basis of the central rotundas in Francesco di Giorgio's contemporary plans for small palaces, which were not open courtyards but domed halls and atria – has not won general acceptance. If it had, Mantegna's house could be read as anticipating Palladio's plan for the Villa Rotonda outside Vicenza.[41] In any case, Mantegna certainly believed his magnificent house to have been built on a Roman plan, fully worthy of the Gonzaga device that he used, Jupiter's eagle from Olympus.

It was clear to Vasari and Zuccari – not to mention the Mantuan Giulio Romano – that urban possession of property, a large, prominently located, prestigious residence, decorated with humanist themes, was a necessary condition in improving the artist's status to that of a intellectual. As with so much else, Mantegna seems to have been the first artist to design and build his own house, on a quite astonishingly original plan, a Pantheon of his own, as it were, whether or not the central court was intended to be vaulted. His courtyard can be read as an antique space similar to the domed hall created in paint in the Camera Dipinta, in which the Gonzaga could stand under their own oculus and dream of their glory. Mantegna could also stand in the heart of his centrally planned house, perhaps surrounded by his personal collection of antiquities, and dream of the glorious past in which his artistic *ingegno* would have been fully acknowledged by Apelles, Lysippus, and Vitruvius, not to mention Alexander the Great and Augustus. The very existence of Mantegna's house, with its elegant, classical plan, its scale, its location adjacent to Alberti's S. Sebastiano, can be said to epitomize Mantegna's lifelong effort to achieve noble status.[42]

Mantegna may have been the first artist to fashion his own tomb monument, but the earliest instance of an artist designing his own funerary chapel was Vecchietta.[43] Commanding, it is said, a social position unique among Sienese artists, in 1476 Vecchietta decorated the altar of his chapel, dedicated to the Savior, in S. Maria della Scala in Siena with traditional Christian images: a life-sized bronze statue of the Risen Christ on the altar (pl. 64) and, behind it, another work by the same artist, a painted altarpiece. It depicts the Virgin and Child with saints, with the name saints of Vecchietta and his wife, Lawrence and Francis, kneeling in the place normally reserved for the donors, betraying what has been termed "a kind of . . . alter non-ego of [Renaissance] pride and assertiveness."[44]

The two artists could hardly have made more divergent choices of iconography with which to express their sentiments at the approach of death. Rather than erect a commemorative monument for himself, Vecchietta chose to focus on the central mystery of Christianity with images created specifically to convey the essence of the Eucharist as a sacrament. Vecchietta's emotions in preparing for his death are summarized in the text of his inscription – OPVS LAVRENTII PETRI PICTORIS AL VECCIETTA DE SENIS MCCCCLXXVI PRO SVI DEVOTIONE FECIT HOC, "for his devotion he made this work . . ." – the next world and the Christian promise of salvation for believers being uppermost in his mind. The focus of Mantegna's chapel, and the bronze that *he* fashioned, on the other hand, showed not the Savior, but his own likeness. While paintings depicted the holy personages in Mantegna's chapel, no inscription made reference to Christianity.

There exists one surviving inscription on an artisan's tomb resembling that in Mantegna's chapel. The Roman marble sculptor Andrea Bregno died in 1506 after having formed his own collection of antiquities and, specializing in tomb monuments,

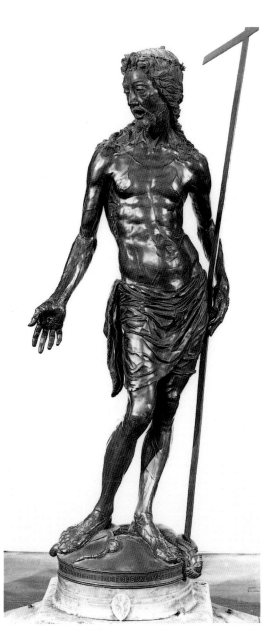

64 Lorenzo Vecchietta, *Standing Christ*, bronze, 1476–80, S. Maria della Scala, Siena.

65 Follower of Andrea Bregno, funerary monument of Andrea Bregno, marble, c.1505, S. Maria sopra Minerva, Rome.

worked extensively for the Curia and the cardinalate. His tomb in S. Maria sopra Minerva, consists of a long inscription, and a portrait bust of the Ghibertian *imago cli-peata* type, a bust encircled by a ring frame (pl. 65). Also omitting any reference to Christianity, his inscription invoked the name of Polycletus, whose skill in low relief Bregno is said to have revived, a statement borne out by the beauty of the carved motifs flanking the sculptor's bust: architect's tools, compasses, and other instruments for measuring.[45]

The fifteenth-century Gonzaga marchesi and their wives were traditionally buried in the chapel of St. Louis of Toulouse in S. Francesco, but no dynastic Gonzaga mau-

soleum resulted.[46] There were many good reasons for Mantegna's different choice of site for his own chapel, not least among them that church's dedication to his name saint. The harmony between his humanist-inspired monument and Alberti's architecture must also have been primary. Mantegna, one of the great modernists of the early Renaissance, immortalized himself in this monument by way of a naturalistic head in the classical and heroic medium of bronze, enclosed within a ruler's shield of precious porphyry, his brow wreathed with laurels, his breast nude, set against simulated Roman marble sheathing. The *finzione* and its Mantuan site were made for each other: a classically inspired monument, intended to ensure the artist's Christian salvation, erected in a Christian site which was as close to a recreation of a Roman structure as Alberti and Fancelli could achieve, in a setting as classical as the house Mantegna had designed for himself in life, in a work of art that allowed him, while living, to immortalize the self and orchestrate his posthumous reputation so effectively that it has seldom been questioned since.

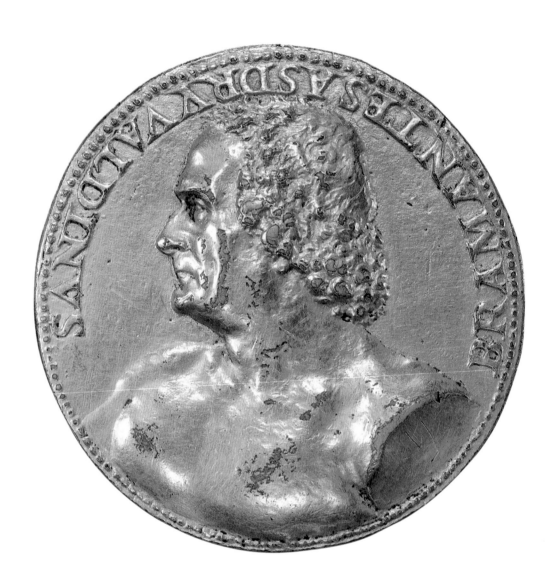

Chapter 9

BRAMANTE

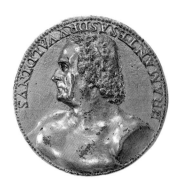

66 Attributed to Donato Bramante, self-portrait medal, bronze, 1505, obverse (larger than actual size), British Museum, London.

67 Attributed to Donato Bramante, self-portrait medal, bronze, 1505, obverse and reverse, British Museum, London.

In this exploration of the Quattrocento autonomous self-portrait, we return to the papal court of Rome and the genre of bronze medals. Bramante may be seen historically as *the* major architect of the High Renaissance, but his choice of genre and medium for his self-image allies him firmly to Quattrocento tradition and the Quattrocento court. The design and execution of Bramante's medal, traditionally attributed to Caradosso, have recently been given to the architect, much of whose career was spent as a painter (pl. 67).[1] The case made for the medal as a self-portrait is based on a reinterpretation of Vasari's sometimes confused prose in his *Life* of Bramante.[2] Whatever the truth about the work's facture, there is no need to doubt Bramante's close involvement in the design of both reverse and obverse.

The obverse presents a profile portrait of an elderly man – Bramante was then in his sixties – with almost frontal torso, much of which is displayed as heroically nude. The left arm, and by implication also the other, is truncated *all'antica* just below the shoulder, as if this were a fragmented sculptured bust from Antiquity, without arms – or hands. The reverse shows a seated female personification, also with profile head and frontal body, holding in her right hand a measuring rod or ruler, and in her left, a pair of compasses pointing up toward the heavens. Her foot rests on the weight of a plumbline. A distant view of Bramante's design for the facade of St. Peter's is compressed awkwardly into the available space to her left. The inscription reads FIDELITAS LABOR, "fidelity and toil," presumably meaning the architect's fidelity to, and toil for, God, his patron, Julius II, and the Church in general.[3] The medal design must be close in date to Caradosso's foundation medal of St. Peter's for Julius II, also showing Bramante's facade on the reverse, which was placed in the foundations of the new basilica on 18 April 1506, leading us to envision the architect's medal alongside that of the pope.

Despite its early sixteenth-century date, the medal belongs conceptually to the previous century. Beside the consciously antiquarian self-constructions of Alberti and Mantegna, Bramante's naked bust evokes the nudity of Mantegna's high-relief bust for his funerary chapel.[4] But the Quattrocento work that Bramante's medal most closely resembles is an image that has not yet been considered, one of two medallic self-portraits dated 1458 by the obscure Venetian painter Giovanni Boldù, by whom no paintings are extant. The medal obverse relevant to Bramante's work is the beautiful self-portrait *all'antica*, in which Boldù fashions himself wreathed in ivy with nude upper torso and inscription in (faulty) Greek (pl. 68). The obverse of Boldù's other medallic self-image, *alla moderna* as it were, represents him in contemporary dress, with signature in Hebrew, the first medallic inscription in that language, suggesting either the range of Boldù's antiquarian interests or his own ethnicity as Jewish.[5] The relation of image to circumference on Bramante and Boldù's medals are curiously alike, in that head and bust extend almost to the confines of the work.

Boldù also created a medal for a musician who held a position at the court of Ferrara, and his contacts with the literary and musical circles at the Este court may hold the clue to the otherwise isolated phenomenon of the painter's two self-

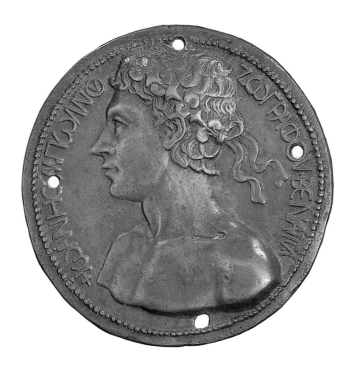

68 Giovanni Boldù, self-portrait medal, bronze, 1458, obverse, National Gallery of Art, Washington, D.C. Samuel H. Kress Collection.

69 "God as Architect," Bible Moralisée, Rheims, France, mid-thirteenth century. Illumination. Österreichische Nationalbibliothek, Vienna.

constructions in Venice at mid-century. At Ferrara Boldù may have been influenced by Pisanello's self-identification as a painter and repeated signatures in Greek and Latin on his own medals; many of them must still have been circulating at that court in the 1450s.[6]

In chapter 4, Filarete's compass was interpreted as symbolic of Geometry and Disegno. Here, Architettura's compass is shown to be emblematic also of God's creation of the universe. The notion of God as Architect, designer of the world, has a long history. Medieval miniatures of the Creation often show God imposing (concentric) order on the chaos from which the universe was created (pl. 69). Proverbs, 8:27, makes reference to the Lord "when He set a compass upon the face of the deep." When God holds scales as well as a compass, he is interpreted as illustrating a passage in the apocryphal Wisdom of Solomon. Since Bramante's female personification holds similar tools – compasses or dividers in one hand, a ruler or rod in the other, and the weight of a plumbline beneath her foot – she too implies the same passage: *omnia in mensura, et numero, et pondere disposuisti*, "Thou hast ordered all things in measure and number and weight."[7] The inscription FIDELITAS on the medal may accordingly also signify Architectura's fidelity to precision of measurement.

The compass makes its first appearance as symbol of God's creation in the eleventh-century English Eadwi Gospels, where, together with the balances, it implied that divine creation imposed mathematical order on the forces of Nature. When the geometric tool was illustrated as God's sole mechanical aid, it was interpreted as the perfect metaphor for the nature of creation (see also pl. 42).[8]

When included in the portrait of a painter, the compass asserts that this practitioner of the *arti del disegno* was as mathematically skilled and as learned in the sciences of perspective and proportion as any architect. One contemporary North Italian example is the *Portrait of a Man with a Pair of Dividers or Compasses*, identified as Giovanni Bellini, attributed to his brother Gentile Bellini, and datable to the first decade of the sixteenth century (pl. 70).[9] Half-length behind the usual parapet, Bellini, unlike so many of his own portraits in which the hands are suppressed, holds the dividers in one tightly clenched fist, while making a rhetorical gesture with the other. Bellini's claim to the practice of a liberal profession, not a mechanical trade, had already been established by

70 Attributed to Gentile Bellini, *Man with a Pair of Dividers or Compasses* (here identified as Giovanni Bellini), canvas, early sixteenth century, National Gallery, London.

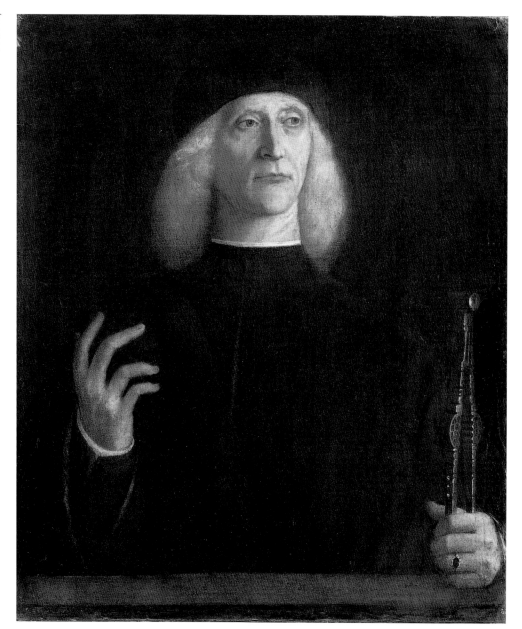

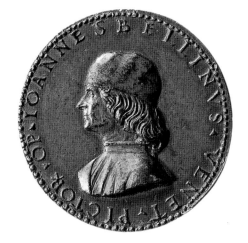

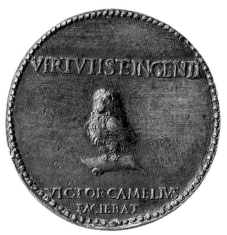

71 Vettor Gambello, medal of Giovanni Bellini, bronze, early sixteenth century, obverse and reverse, British Museum, London.

the medal created for him by Gambello, on which the reverse inscription reads unequivocally VIRTVTIS E[t] INGENII, "With Merit and Talent," located above a depiction of an owl, symbol of Minerva's wisdom (pl. 71).[10] The obverse inscription calls Bellini PICTOR[um] OP[timus], "greatest of painters," echoed in the words, *optimo pitor*, used by the diarist Sanudo the day the artist died. Bellini's social rank within Venetian high society is strongly suggested by the senator's stole placed over his right shoulder in Gambello's medallic image.

Vitruvius had defined the qualities required to create a building as *ratiocinatio*, theoretical knowledge, on one hand, and *fabrica*, technique, on the other. He who planned buildings with a concern for aesthetics was a different individual, with a different social status from he who was skilled in the practical techniques required for raising structures. As already discussed in chapter 7, throughout the Middle Ages, the responsible individual for a given building was usually a master mason, another craftsman.[11] In the Trecento, however, Florence turned to Giotto, the renowned painter, who lacked

any practical experience in actual construction, for help with the erection of the Campanile. Alberti defined the differences between *ingegno*, intellectual vision, and *arte*, craft skills; it was the architect, not the carpenter, who knew

> how to devise through his own mind and spirit . . . whatever can be most beautifully fitted out for the noble deeds of man, by the movement of weights and the joining and massing of the bodies.[12]

In Raphael's *School of Athens*, the figure of Euclid, exemplar of geometry, who is always shown in the act of measuring, bends over his tablet, just as God leans over the universe he is in the course of creating (pl. 84). Euclid, whom Vasari identified as bearing the features of Bramante, uses his compass to draw a proposition that has been interpreted as a hexagon formed from two equilateral triangles, or as a star formed by two triangles inserted into a circle.[13] As the inscription below the image of Euclid in Federico da Montefeltro's *studiolo* reads, this sage "grasped the spaces of the earth by means of lines and the compass," and indeed in that particular site he may have been located directly above the depiction of a many faceted *mazzocchio*.[14]

Bramante was an example of the new, Albertian type of architect, who knew as little as that humanist about building practice.[15] Although the double-sided medal lent itself to the illustration of the two facets of the architectural self, no master mason or carpenter is referred to on Bramante's medal. Unlike the two reliefs on Florence Campanile, the images on the obverse and reverse of Bramante's medal must *both* be read as embodying the erudite, intellectual, and *ingegnoso* architect. Without experiencing the need for *arte*, the armless classicizing bust and the compass-displaying personification will together beget the embryonic concept of a totally new St. Peter's at the heart of Christendom. Deliberately to depict the self as *lacking* hands was one strategy to avoid the taint of artisanal labor.

Part III

THE CINQUECENTO COURT ARTIST AS *AEQVES CAESAREVS*

THE UMBRIAN CONNECTION

We leave behind Bramante's world of the Quattrocento self presented as a classical bust, and move into the Cinquecento when the artist became adept at projecting the self as a courtier, AEQVES CAES., "Caesar's knight," as the inscription on a Titian painting for Emperor Charles V reads, or simply EQVES as on his medals (pls. 105a and b), the emperor's courtier, not the ruler himself.[1] From the exclusive use of the bronze medal to convey the artisan's intellect, *singolarità*, and *ingegno*, the visual producer chose the domain of painted panels with which to convey his social aspirations − or, in the eyes of society, his pretensions.

Earlier than any surviving autonomous painted self-image, Perugino and Pinturicchio introduced the *concept* of the constructed self within an autonomous painting, by depicting such an artifact contained within a frame on the walls of a painted chamber. Shortly thereafter the idea was taken up and developed as an actual free-standing easel painting by the young Raphael.[2]

Perugino first experimented with his own portrait as a witness embedded in religious narrative: in the altarpiece of the *Adoration of the Magi* painted for the Servite church in Perugia in the mid-1470s when he was approaching thirty; and in the *Circumcision of the Sons of Moses*, the first fresco in the Moses cycle in the Sistine Chapel in the early 1480s.[3] As already seen, Perugino was not the only artist to include himself as witness to the Magi's visit to the Christ child; Epiphany was a regal event with which it was desirable to identify. Since Perugino was the lead painter in the Sistine, the major fresco cycle of Quattrocento Rome, and the only artist to sign a fresco there, it is understandable that he should have wished to immortalize himself on its walls.[4]

In the Collegio del Cambio in 1500, however, Perugino adumbrated a new format for the genre, one in which the subject, insisting on his own significance, surged forward to occupy the entire picture space (pl. 74). Perugino positioned an image of his self-portrait against the decorative framing pilaster that separates a lunette showing Prudence and Justice hovering above six classical heroes from an adjacent lunette depicting Fortitude and Temperance above another half-dozen heroes from Antiquity (pl. 73).[5] The image is not only placed in front of the framing elements that separate these lunettes, so that it appears to share the viewer's space, but is also framed as if it were an independent painting − this at a date when the autonomous *painted* self-image hardly existed. Perhaps more important than, and certainly just as large as the painted self-portrait, is the laudatory epigraphic inscription on the tablet that hangs below, the first surviving one of its type connected to an artist's painted image.[6] In elegant *all'antico* letters the inscription tells the world that were the art of painting to be lost, Perugino would find it, and had it not been invented, Perugino could (of course) have created it − a text characterized by one historian as revealing a spectacular gift for publicity and self-glorification.[7] Like medals, frescoes permitted the addition of epigraphic inscriptions, an advantage that would be lost as soon as artists turned to autonomous painted panels as support for their self-images.[8]

The naturalism of the self that Perugino claims to have glimpsed in the mirror, so unlike the various masks adopted by earlier self-portraitists, seems at odds with the

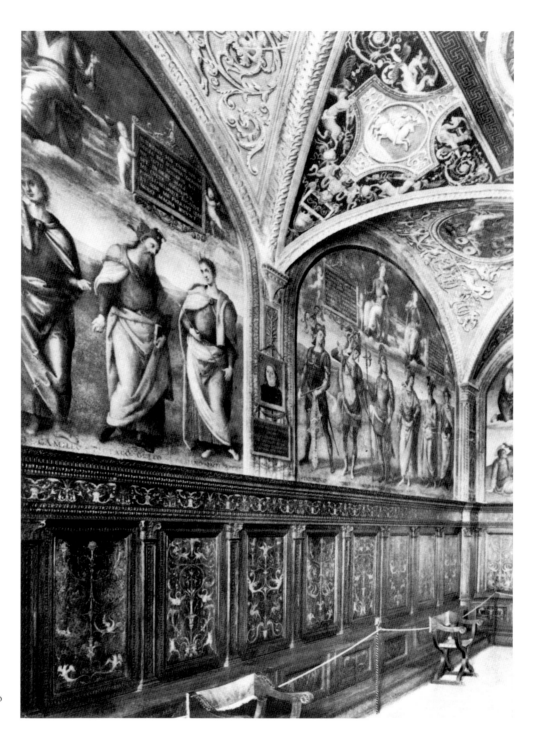

73 View of the Sala dell'Udienza in the Collegio del Cambio, Perugia, fresco, 1500.

74 Detail of pl. 73, with Perugino's self-portrait.

rhetoric of the written passage beneath, especially for a painter whose saintly – or, in this case, classical – protagonists were usually so idealized. Heavily influenced by Flemish works, the ruddy complexion and heavy jowls, the wispy hair and stern gaze of the portrait combine to give the impression of an uncompromising self-confection as a down-to-earth, no-nonsense, rapidly aging artist which, to a twentieth-century sensibility, seems remarkable in its lack of pretension. Delacroix perceived a "total lack of pretence" in the work of Titian; here the lack of pretence – or rather, pretence of a lack of pretence – seems moving in its forthrightness, suggesting an honesty and a depth not previously encountered in an Italian self-image.[9]

106

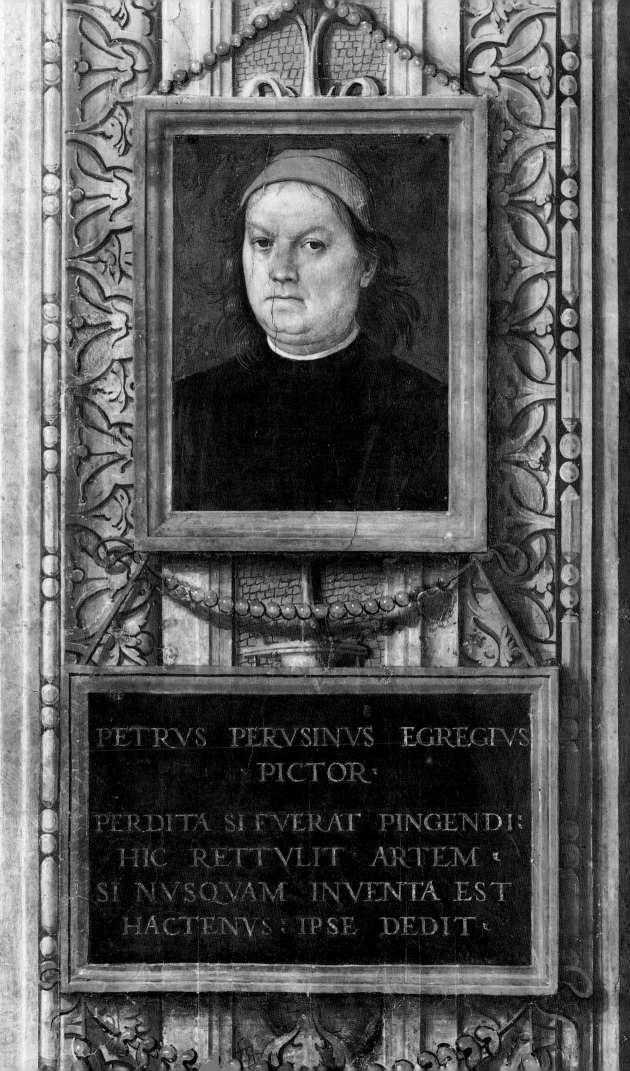

PETRVS PERVSINVS EGREGIVS
PICTOR·

PERDITA SI FVERAT PINGENDI·
HIC RETTVLIT ARTEM·
SI NVSQVAM INVENTA EST
HACTENVS· IPSE DEDIT

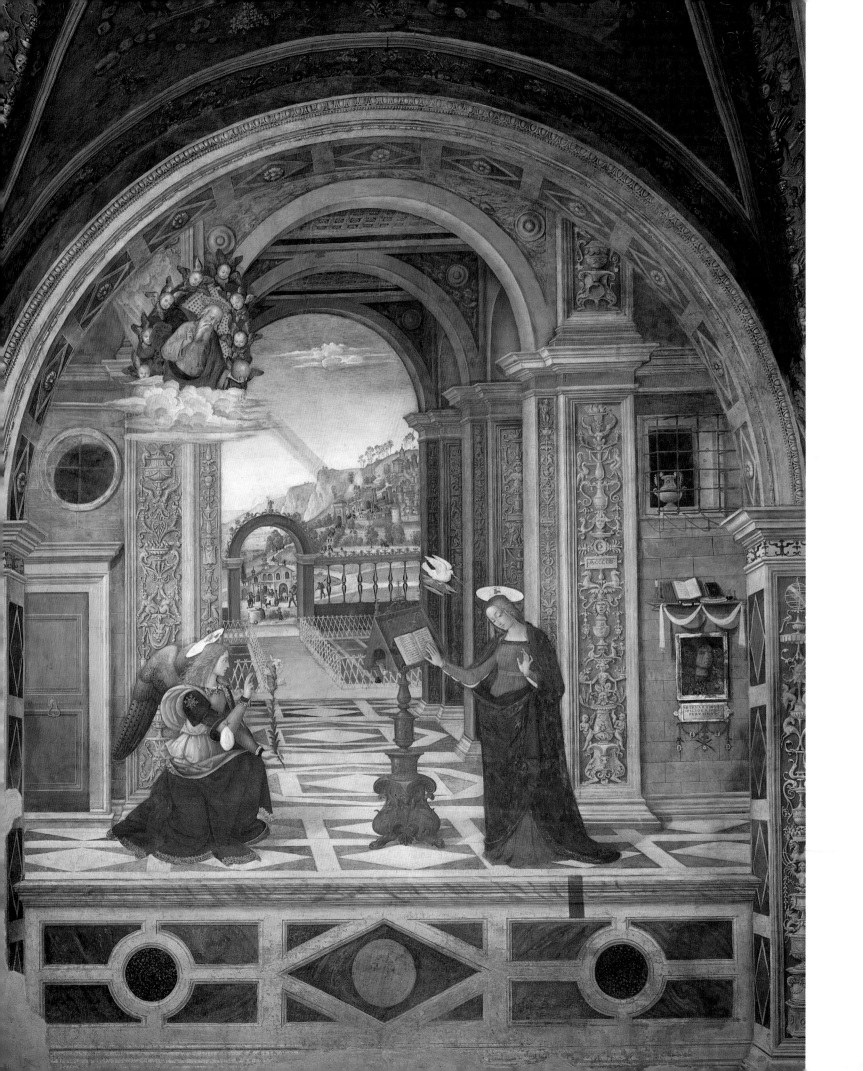

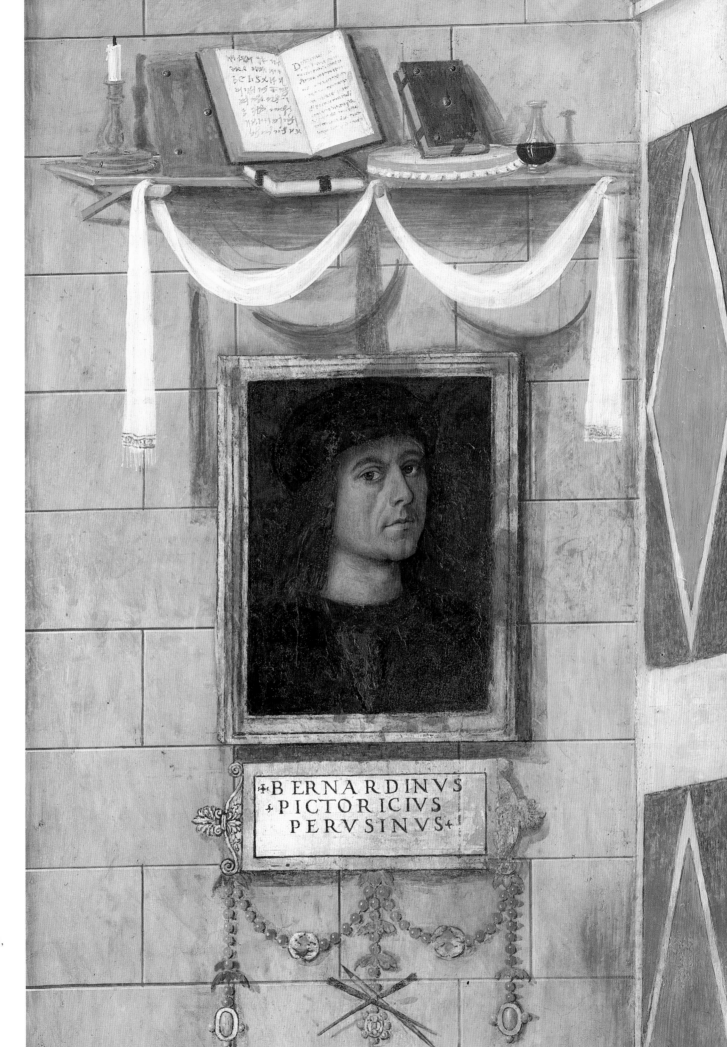

+BERNARDINVS
+PICTORICIVS
PERVSINVS+

75 (*facing page*)
Pinturicchio,
Annunciation, fresco,
1502, S. Maria
Maggiore, Spello.

76 Detail of pl. 75,
with self-portrait.

Pinturicchio's related self-portrait in Troilo Baglioni's chapel in the Collegiata of S. Maria Maggiore in Spello is both less prominently located within the cycle and makes fewer claims for his art (pl. 75). Within the luxurious house in which the Annunciation takes place, the framed portrait of the artist hangs below a shelf that holds some of the Virgin's personal effects (pl. 76). Above the artist's image and explanatory tablet, in which BERNARDINVS PICTORICVS PERVSINVS claims authorship of this beautiful cycle, an open book suggests further text "missing" from the tablet (or perhaps transposed from the tablet to the Virgin's book), in the form of a passage in Greek in which God is asked "to illuminate the intelligence and to sustain the hand of the artist who sets about illustrating the Christian mysteries."[10] Below, as if in a trophy, adorning the Virgin's wall, one of the earliest painted visions of pen and brush as tools of the painter's craft.

Scarpellini's observation that Perugino's self-portrait was added to the frescoed wall on a fresh piece of intonaco after the cycle was finished, led him to conclude that it, together with the verses composed in the artist's honor, was an afterthought on the part of the civic commissioners.[11] If such were the case, the work is brilliantly integrated into the cycle as a whole, in part by means of the inscribed tablet, whose form – not to mention content – imitates that of the inscribed tablets within the lunettes on either side. Pinturicchio's self-portrait, on the other hand, must always have been integrated into the Virgin's world, hanging in her house as if one of her dearest possessions, and the artist's gaze always intended to meet that of the approaching worshipper. Because of their status as pictures within a picture, both self-portraits are presented as images at second hand, as having less "reality" than the posturing classical heroes, in the one case, and the Incarnation, in the other.

In 1500 Perugino was at the height of his fame and, albeit not born in Perugia, was known throughout the length and breadth of Italy as one of the city's most illustrious men – as proclaimed in his signature in the Sistine Chapel. Our current understanding of the development of Italian Renaissance painting is heavily indebted to the Tuscan Vasari, whose criticism of the Umbrian Perugino has obscured the painter's high standing among his contemporaries. Today he is known above all as a skilled but conservative artisan, but at the end of the Quattrocento, Perugino was one of the most sought-after artists in the peninsula, and accorded the very highest rank.[12] Apart from Giovanni Santi's inclusion of his name beside that of Leonardo, as his equal in years and fame, in his Rhymed Chronicle, and the Milanese ambassador's famous report to the Duke of Milan – "his works seem angelic and very sweet" (*le sue cose hanno aria angelica et molto dolce*), only superlatives were used in the documents concerning him: "most excellent and most famous painter in all of Italy" (*excellentissimus Pictor et famossisimus in tota Italia*); "a man singular in that art in that period throughout the whole world" (*homo singulare di quell'arte in quel tempo, per tutto l'universo mondo*); or, as Agostino Chigi put it simply in 1500, "the best master in Italy" (*il meglio mastro [sic] d'Italia*).[13] Thus, for a number of years Perugino was an uncontested leader in painting, so famous that students traveled from France, Spain, and Germany to study with him.[14] Nor was he an exception to the links with a court, the factor that stimulated so many of these artists into visual self-declaration. Although not on the payroll of a specific court, he was nonetheless sought after by such Italian princes as Isabella d'Este, and he worked extensively for the papacy. Perugino's court experience, his patrons' recognition of the *singolarità* of his work, and the self-esteem suggested by both seemingly unidealized image and hyperbolic text in the Cambio self-likeness position him squarely within the profile being constructed here of the "self-portrait type."

★ ★ ★

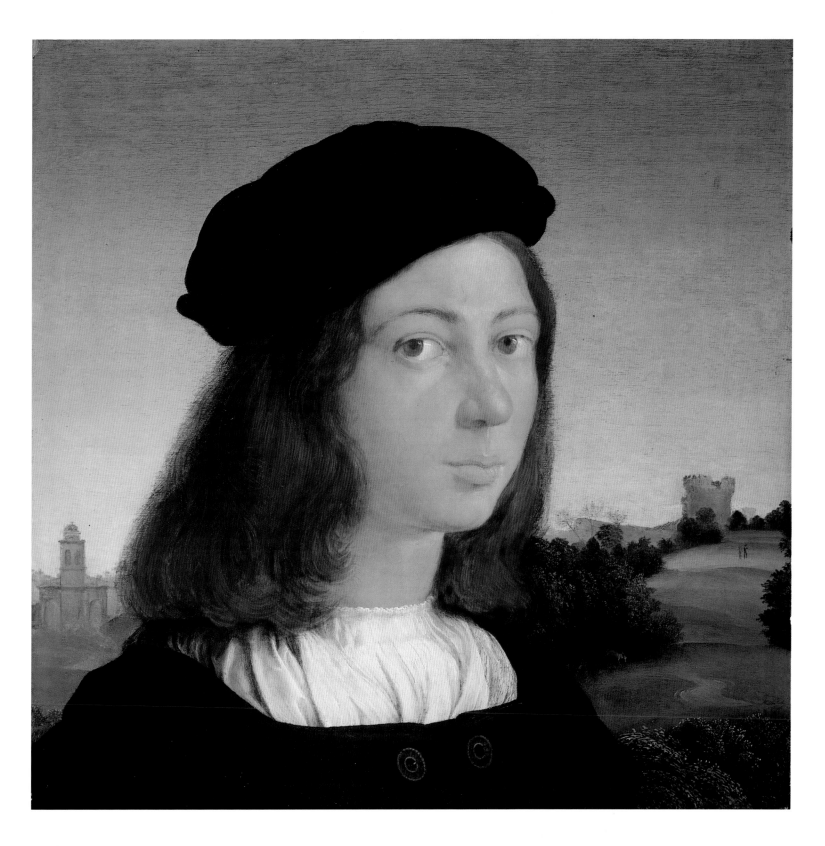

77 Attributed to Raphael, *Self-Portrait*, panel, *c.*1505–6, Royal Collection, Hampton Court.

The earliest autonomous painted self-portraits in Italy may all, with one isolated exception, be by the precocious young Raphael, who may have trained with Perugino.[15] Like most other self-portraitists, Perugino visualized himself in his maturity; he was at the height of his fame and success when he added his self-likeness to the Cambio frescoes, but when Raphael took his master's invention to its logical conclusion and created

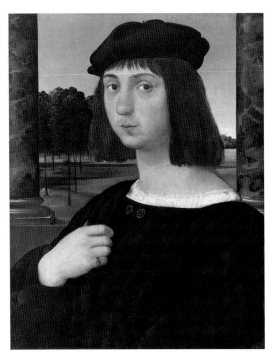

a genuinely independent painted image of the self in a work at Hampton Court attributed to him, he was only in his early twenties and at the beginning of his career (pl. 77).[16]

The ambitious painter figured himself in a three-quarter pose, his head silhouetted against the sky above a Flemish-inspired landscape of rolling hills and trees. The two rings or eyelets at the center of the youth's bodice, inscribed respectively RAFFAELLO and VRBINVS, may be read as both signature of maker and identification of sitter. The young man bears a strong likeness to the youth in a drawing in the British Museum, identified as an early self-portrait.[17] The painting, probably painted in Urbino in 1505–6, may have been cut down, and may originally have included both hands and a parapet.[18]

The expressive motif of the sitter's hands posed on the lower edge of the frame had been introduced into Flemish portraiture by Van Eyck at a very early date. The bottom edge of the frame was later developed into a separate window ledge or parapet, a motif that seems to have been introduced into Italian portraiture by Antonello da Messina in the 1470s. Hands *per se* were still relatively rare in Italian portraiture, especially a display of both hands, and those few surviving works preceding this painting were mostly by Central Italian artists. They include, among others, Botticelli's *Youth with a Medal of Cosimo Vecchio* (Uffizi), usually dated to the 1470s; Leonardo's portraits of Ginevra de' Benci (National Gallery of Art, Washington), 1470s, and Cecilia Gallerani, *c*.1490 (pl. 89); Perugino's portrait of Francesco delle Opere in 1494 (pl. 80), and of course the portrait of Mona Lisa (Louvre), which was more or less contemporary with Raphael's Hampton Court self-image, if this last is correctly dated.

The hypothesis that this self-portrait originally included more of the sitter's body is reinforced by two other portraits of similar dimensions of similarly Raphaelesque youths against Flemish-influenced landscapes that, overpainted and restored, survive in Budapest and Munich. They may be the ghosts of other early self-portraits, or workshop derivations after lost works, by the painter from Urbino. Albeit facing in the opposite direction, the youth in Munich displays an identical cap on the same shoulder-length straight hair, and a similar signature in similar eyelets on a similar bodice over a similar chemise (pl. 78).[19] The landscape is copied from a Flemish painting, and the portrait borrows the motif of the two marble columns that framed the *Mona Lisa* before it was cut down. In the painting in Budapest (pl. 79), which has in the past been identified as a highly idealized, early self-portrait by Raphael, the entire pose – head silhouetted against sky and landscape, with hands reposing at lower left of the parapet – is a close variant of that by Perugino in his 1494 portrait of Francesco delle Opere, which is the only work among those listed above to combine the sitter's hands with a ledge (pl. 80).[20] The image in Budapest could possibly reflect another, even earlier Raphael self-portrait deriving from this portrait by Perugino.[21]

The highly idealized presentation of Raphael's features that comprise the Uffizi "self-portrait" (pl. 81) cannot be inserted into this sequence, despite the sitter's appearance of youth, and the similar hat and hair.[22] The forms and spirit of this vision of the artist are markedly different from those in plates 78 and 79. Presenting head and bust only, against a neutral ground rather than a landscape setting, the artist of this work, whoever he was, tilted the sitter's head at a different angle from that in the other portraits, and gave the artist a veiled glance that does not meet the observer's gaze. Indeed, the "romanticized" tilt of the head and sly sideways glance is markedly dissimilar from the steady, forthright gaze of both the reflections of hypothesized earlier self-constructions (pls. 78 and 79) and the self-image in the *School of Athens*, on which this "self-portrait" is often said to have been based (pl. 85).[23] Support for such a hypothesis is provided only by the minute amount of body depicted in the fresco, which might

78 Umbrian/circle of Raphael, *Half-length Portrait of a Young Man* (? copy of possible Raphael self-portrait), Alte Pinakothek, Munich.

80 (*facing page*) Perugino, *Francesco delle Opere*, panel, 1494, Galleria degli Uffizi, Florence.

79 Umbrian/circle of Raphael, *Half-length Portrait of a Young Man* (? copy of possible Raphael self-portrait), Budapest, Szépművészeti Muzéum.

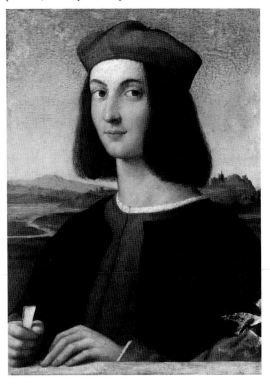

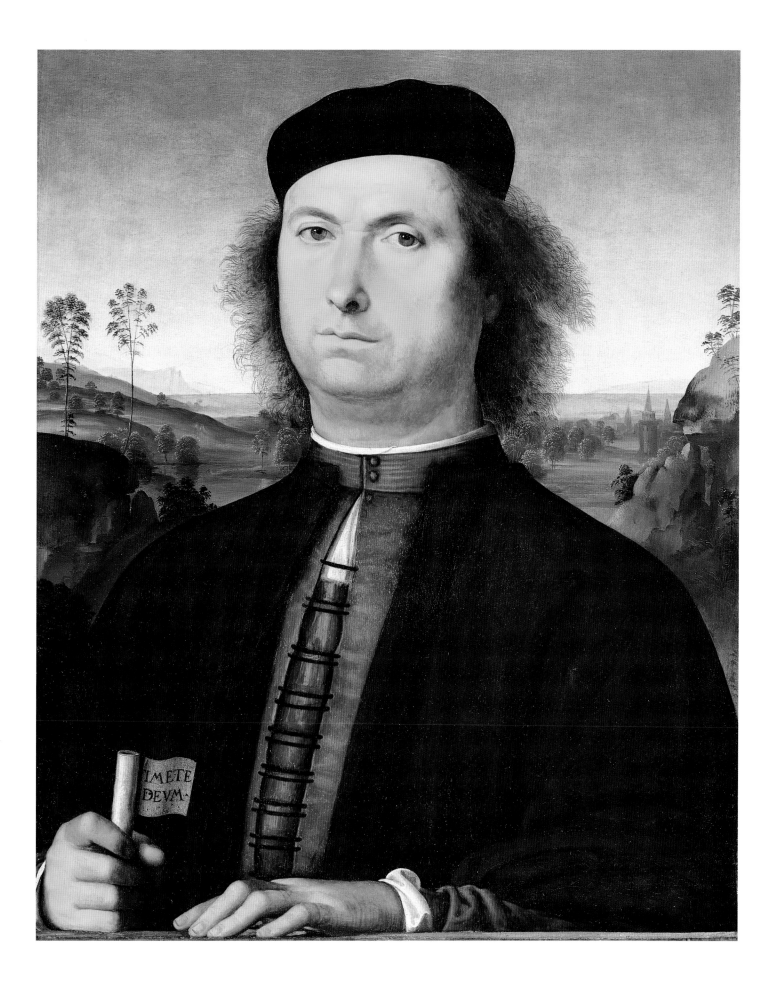

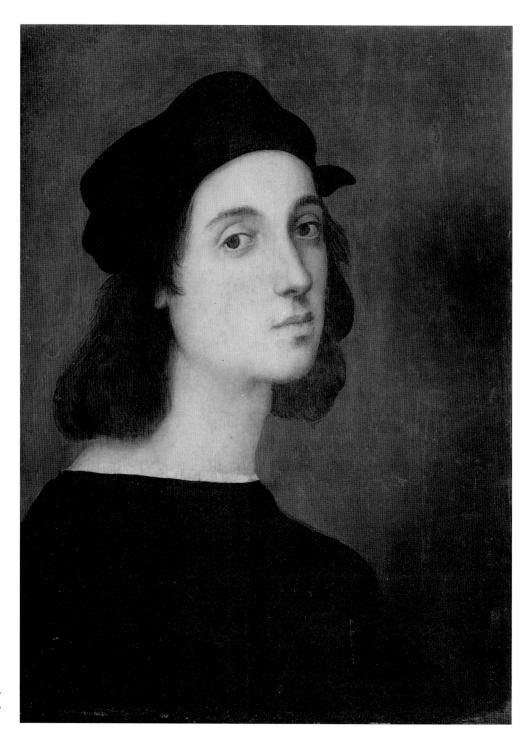

81 Attributed to Raphael or circle of Raphael, *Self-Portrait*, panel, *c.*1520, Galleria degli Uffizi, Florence.

account both for the awkward profile of body and neck, and the total lack of definition of shoulders and bust in the panel painting.

I propose that, regardless of their condition and attribution, the early sixteenth-century portraits in Munich and Budapest, depicting young men with Raphaelesque features, may reflect or echo self-portraits by the very young Raphael experimenting with the portrait solutions offered by Perugino in the 1490s and by Leonardo after the turn of the century. If the hypothesis can be tentatively entertained, we have here a statement of youthful ambition and precocious self-confidence in the artist's own talents that we have not hitherto encountered. Such early self-likenesses by Raphael, if they

Chapter 11

VENICE: AN ISOLATED EXPERIMENT

The exception mentioned above to Raphael's "monopoly" on the new genre of *painted* autonomous self-portraits at the beginning of the new century is the earliest recognizable painting of the Venetian artistic self: Giorgione's bold self-image, apparently as isolated an experiment as Boldù's low-relief medals half a century earlier. Listed in an inventory of the Grimani collection in 1528, it was seen there by Vasari later in the century.[1] More or less contemporary with Raphael's early self-imaging, the full composition is known from a seventeenth-century engraving, inscribed as the artist's self-portrait, made before the lower section of the painting was cut down (pl. 82).[2] Like the hypothetical reconstruction of the Umbrian's Hampton Court self-visualization (pl. 77), the Venetian also presented himself half-length, in a three-quarter pose – but without a background. He who painted so many poetic, arcadian landscapes here apparently wanted no landscape setting to distract the viewer from the central subject.

Unlike Raphael, who presents the self *as* himself, albeit a distinctly idealized self within an idealized world, Giorgione's self-likeness is a type in which the sitter is masked as a mythological, historical, or allegorical other, with his own identity subordinate to that of the role performed, in this case the Old Testament hero David.[3] Such a construction of the self is very unusual in the history of Italian Renaissance autonomous portraiture, as distinct from self-imaging in religious narrative.

To compare Giorgione's *finzione*, deceptive painting, with the Hampton Court self-likeness by the only slightly younger Raphael is to encounter another Renaissance. Giorgione's approach to issues of portraiture, and hence self-imaging, differed both from the standard types of contemporary Central Italy, and those of Quattrocento Venice, where Bellini had depicted the patriciate as emotionally neutral individuals concealed beneath the ritual dress of their public roles.[4] Goffen's thesis that Bellini's presentation in these works reflected the city's political system, in which the individual was "subjugated to the class and the class to the needs of the state," is supported by recent historical research into the dearth of contemporary *ricordanze* in that city.[5] At the turn of the century, however, the approach to portraiture in the lagoon city shifted, and new provinces of the psyche came to the fore in the work of the generation of young artists following Bellini. The new fashion in portraits by Giorgione, and, later, Palma Vecchio and Lotto, consisted in a shift from "an obligatory portrait type and an obligatory bearing" of the Quattrocento patrician class as constructed by Bellini, toward a focus on the moods of the inner psyche.[6] Giorgione in particular sought to incorporate an (often undefined) psychological state or emotional component into his images by way of fanciful costumes and the movement of body and/or face.[7]

The imposing presence of Dürer, in Venice again in 1506, must surely have played an important role in Giorgione's development of this self-image. The young Venetian must have been familiar with the underlying ideas, if not the specific images, of the northerner's great series of self-portraits of his early maturity, culminating in that created at the half millennium, in which the artist took on the persona, not of an Old Testament prophet, but of Christ, fusing the self-likeness with an image of the Holy

82 Wenceslaus Hollar, copy of Giorgione, *Self-Portrait*, c.1505–10, engraving, 1650. Made before the portrait was cut down.

Face.[8] It may not be irrelevant that in the same year Dürer is said to have also created a mythological self-image in the guise of Hercules.[9]

Giorgione-as-David introduces drama into the self-portrait by imposing a role on the viewer, as if the latter were another actor in the same play. From behind the parapet that, flush with the foremost picture plane, separates his biblical realm from that of sixteenth-century Venice, Giorgione-as-David dramatically places his vanquished foe's severed head, still dripping blood, on the parapet that seems specifically designed for its display. It has been argued that such a bust or half-length figure, who looks out over a stone parapet or ledge, often with only one hand showing, was inspired by Roman tombstones, and hence the ledge would convey the funerary symbolism of its visual source, symbolism that in this case was appropriate to the fate of the victim rather than that of the sitter.[10] Giorgione-as-David, in his moment of triumph, swivels his own head around to confront those before him who had doubted his ability to achieve his objective of killing the giant – we should surely envision ourselves in the role of the envious, spiteful, and persecuting Saul – with a glare that is both defiant and challenging.

Giorgione's defiance is conveyed by a furrowed brow that would, it is believed, have been read by contemporaries as the formula of the leonine "cloudy" brow that signi-fied *audacia* – as in the case of Mantegna's self-images.[11] Classical and Renaissance writers were interested in the analogy between human and animal physiognomy, and for them the lion, king of beasts, exemplified the manly qualities of courage and daring necessary in combat. Such a visual characterization of David was eminently appro-priate to the "lion of Judah." David's ferocious leonine scowl (and [?]mane-like hair), outward manifestations of his audacious spirit, here re-evoke his sentiments before the encounter with Goliath. In addition to the leonine audacity, proper to an undersized youth undertaking a mortal combat with an oversized opponent, was the armor with which the artist clad his own torso.[12] Significantly, nothing, according to Lomazzo, was more suitable than armor for adding dignity and the appearance of authority to the upper class sitter.[13] This particular biblical narrative accordingly enabled Giorgione, pre-sented by Vasari as of the most humble extraction (*nato di umilissima stirpe*), to appro-priate literally the accouterments of a *condottiere*, the only Renaissance artist to do so in a self-image.[14]

The scale of his antagonist's head, Giorgione-as-David's attribute, however, is not oversized but equal in dimensions to his own, implying that the artist-as-David had become a young giant as well as a giant-killer.[15] If David is on the same scale as Goliath, then his *doppelgänger* Giorgione was also a giant among contemporary creative men.[16] Wind suggested that Giorgione's conception of his David as a young giant may derive from the name *il gigante*, given to Michelangelo's *David* in Florence.[17] More recently, Lavin endorsed Seymour's thesis that Michelangelo used David's victory over Goliath as a metaphor for his ability to overcome the difficulties of his art.[18] If these hypo-theses can be tentatively entertained, the Venetian artist may also have interpreted David's victory over the giant Goliath as a prototype for his own artistic *ingegno*, creative power, in surmounting the difficulties of his art. As it happens, the inventory listing of this particular painting in 1528 was the first reference to the artist as Zorzon, "big George," as if in recognition of the artist's stature as a physical, as well as intel-lectual, giant.[19]

Accordingly, Giorgione may be read as comparing *his* artistic stature to that of the great Florentine sculptor, with perhaps more than a passing reference to the *paragone* between painting and sculpture that so absorbed the Venetian. There is no way of knowing where this self-portrait falls within the sequence of Giorgione's corpus of work; hypothetically it is a "mature work," which belongs to the second half of the first decade of the new century and hence postdates Michelangelo's famous sculpture.

Thus the artist's confrontational "cloudy" or leonine brow vis-à-vis his opponent (which also informs Michelangelo's *David*) may have signified both the physical daring of the biblical hero *and* the intellectual audacity of the Venetian painter in challenging the pre-eminence of the Florentine Goliath.[20] At the risk of over-interpretation, the spectator, to whom Giorgione-as-David issues his challenge, might be seen as a surrogate for Michelangelo as well as for Saul. Such a Venetian–Florentine competition could also be understood as a very early statement of the opposition between Venetian *colore* and Florentine *disegno*, in which the former would eventually be embodied in the person of Giorgione's follower Titian.

However – closer to home – there was another *gigante* in Giorgione's professional life: the dominant artistic figure of early sixteenth-century Venice, characterized in 1506 by Dürer as "still the best in painting," the artist whose powerful artistic influence the young painter must have long struggled to surmount. Giorgione's Venetian Goliath can only have been Giovanni Bellini, then in his seventies. Towering above all others in the field, Bellini's compelling talent and persuasive, if conservative, style must have exercised a vice-like grip over the imaginations of the younger generation, holding many of them as if hostage. Only the giant-killer Giorgione succeeded in challenging Bellini's influence by forging a new style and an iconography that was personal to him and his generation, one that established the direction that Venetian painting would take for the next half century.

If Vasari was correct in saying that Giorgione "liked to play the lute and sing, and played so divinely that the patriciate invited him [to perform] at musical soirées and parties," Giorgione could also have identified with David as the divinely inspired author of the psalms, which he sang to his own accompaniment.[21] The Florentine Bronzino, poet as well as painter, also identified with David as author of the psalms, and, as a musician, Giorgione could have masked the self as King David singing his poetry, just as he took on the role of Orpheus in a painting now lost.[22] This is how Garofalo, another North Italian, exploited music's superior status as a liberal art; he presented the self as David the Musician with viol in hand.[23]

Because Giorgione masked the self as a biblical character, the fictional component common to all portraiture and self-portraiture is more clearly revealed in this self-image than in most.[24] Like the poet, the artist always plays illusionistically with his forms and figures. The skill of hand that gave verisimilitude to the Renaissance painting imparts a notion that the painted illusion is literally accurate. But, of course, a work, whether it consisted of images or words, always artfully refashioned what it described.[25]

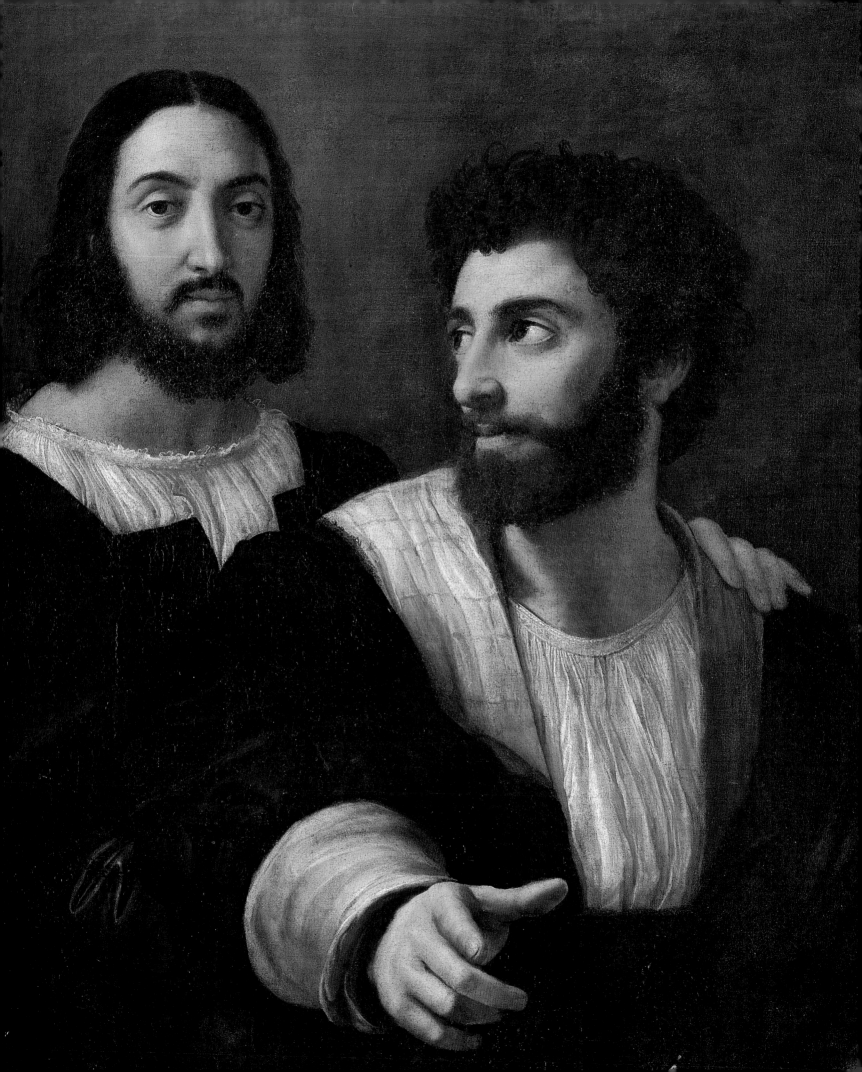

Chapter 12

RAPHAEL AND FRIEND

> What wonder if you, like Christ, perish by the light –
> He was the God of Nature, you the God of Art.
> —Tebaldeo on Raphael's death.[1]

This chapter follows Raphael to Rome, and discusses the self-images produced by the Urbinate at the papal court of Leo X, and by Parmigianino as a gift to Pope Clement VII. When Raphael next visualized his self-likeness, he was resident at the papal court where he spent the rest of his short life. Like so many other artists who depicted the self witnessing the holy events in frescoes, Raphael, now twenty-six, inserted his presence with a companion into a secular fresco, the so-called *School of Athens*, as witness to the discussions among the great philosophers of Antiquity (pl. 84).[2] Vasari's identification of Raphael's self-portrait (the only one he mentions in Raphael's work), as the studious youth standing retiringly, on the same right-hand side as Orcagna and Botticelli, is confirmed by the blank area in the cartoon where these two contemporary figures would later be positioned in the painting (pl. 85); in the drawing Zoroaster and Ptolemy turn to speak to a void.[3] Raphael improvised his own features directly on the wet intonaco by means of graffiti while studying his own appearance, in Vasari's words, *nello specchio*, in the mirror.[4]

Artists sometimes included a friend or colleague when introducing themselves into narrative frescoes – Andrea del Sarto's contemporary work in SS. Annunziata is a good example (pl. 36). Raphael's companion was traditionally identified as Perugino, whom the figure does not at all resemble, until Morelli proposed Sodoma. Such a pairing would have been an elegant acknowledgment of Sodoma's earlier frescoes on the vault of the Stanza della Segnatura, and would have formed a link with Signorelli's precedent in his depiction of Fra Angelico, who had started the cycle in Orvieto, standing beside his own self-representation in that site.[5] Raphael's companion, however, no more resembles Sodoma than he does Perugino. Or, to put it slightly differently, if Raphael intended this figure to be recognized as Sodoma, he has invented a "Sodoma" who would have been unrecognizable to the artist himself, because it differs so profoundly from that artist's own self-construction created five years earlier, as a witness to St. Benedict's first miracle, the repair of the cribble, in the cloister at Monte Olivetto Maggiore (pl. 86). Sodoma's self-image reveals a thinner and more youthful face, with large lustrous eyes, heavy eyelids, bulbous nose, thick shoulder-length black hair, and markedly "rosebud" lips. Raphael's companion has a broader face, thin lips, grey hair, and appears older than his mid-thirties, Sodoma's age in 1511.

Sodoma's audacious self-inclusion in religious narrative points up Raphael's own, more typical, discretion in the Vatican Stanza. Standing directly in the middle of the lunette, his head flanked on either side by the receding columns of a temple in the background, a full-length Sodoma, two tame badgers and a talking crow clustered at his heels, gazes coolly out at the monks taking their constitutionals in the cloister and, with his eyes and gloved hand, urges them to acknowledge the miraculously mended

83 Detail of pl. 87, with self-portrait.

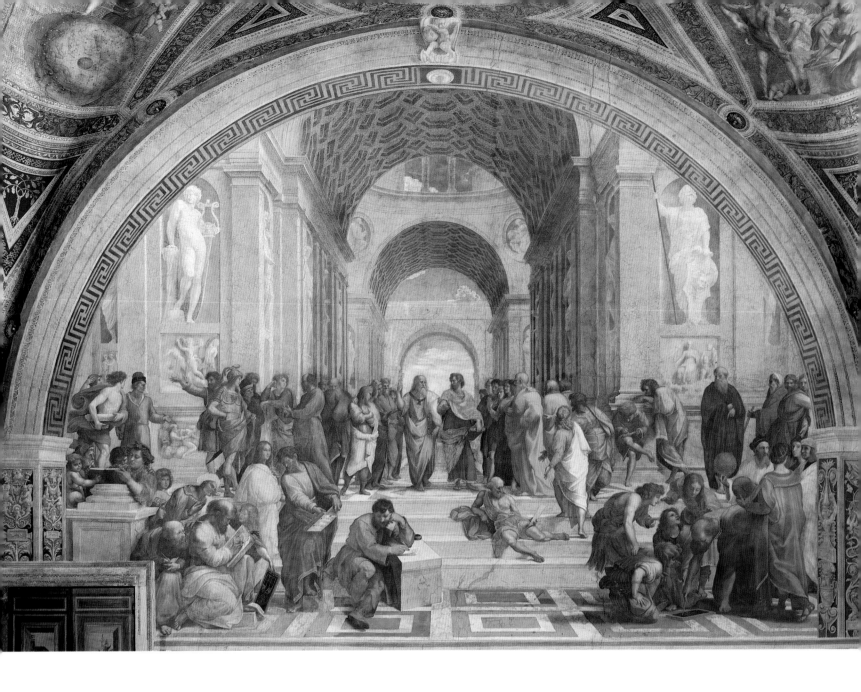

wooden tray that now hangs from the temple, the miracle accomplished by the praying saint to one side. In the process, the monks, who called the artist *mataccio*, the fool in the deck of *tarocchi* cards, were also meant to acknowledge his magnificent knightly toilette, the latest in Milanese fashions, including the sword to which he had no right, but which he nonetheless carries proudly along with the gloves, themselves symbols of the leisured life.[6]

Watson has recently identified Raphael's companion as Pinturicchio, who would then have been in his fifties.[7] There is more than a family resemblance between Pinturicchio's self-portrait ten years earlier in Spello, and the features of Raphael's companion (pl. 76). Pinturicchio was moreover an eminently suitable companion for Raphael. After much work in Rome on humanist and papal commissions, Pinturicchio settled in Umbria in 1495, where he was probably a second mentor to the young Raphael in the years shortly before and after 1500. In their collaboration on the cycle in the Piccolomini Library in Siena, for which Raphael designed many of the compositions, the influence became reciprocal, and Pinturicchio greatly profited from the work of the gifted young Urbinate.[8] Hence, Raphael may be accompanied by an

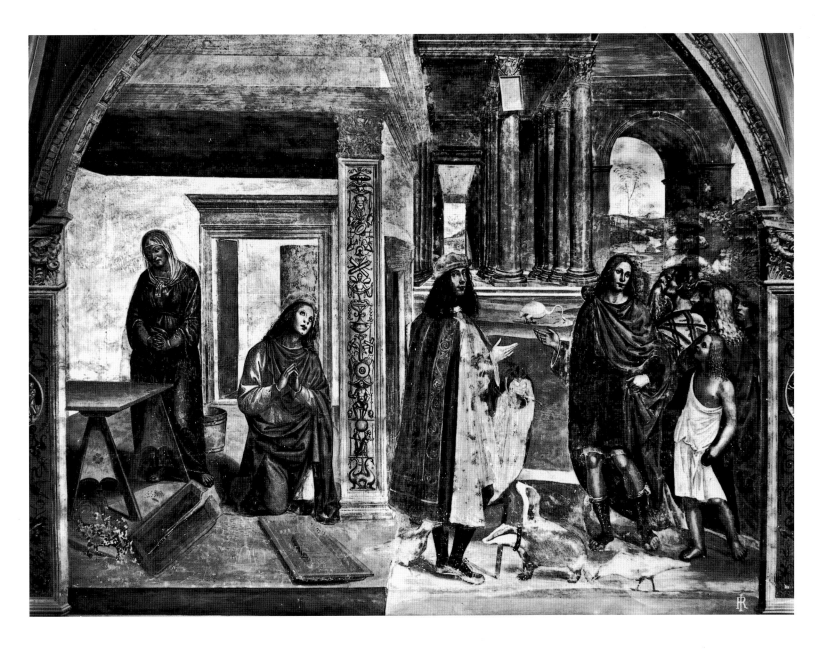

Umbrian colleague with whom he had long been intimate, who in an earlier papacy had decorated the Borgia apartments that ran immediately below the Stanze, and who had also been involved in another specifically Julian commission: the decoration of Bramante's choir in S. Maria del Popolo.[9]

Significantly, Raphael placed himself as a youthful sage on the heraldic sinister, among the followers of Aristotle who were dedicated to empirical thought. According to Leonardo, painting too was an empirical science because it derived from the observation of nature. Raphael and his companion converse with Zoroaster and Ptolemy, the exemplars of astrology and geography, who display their spheres of the terrestrial and celestial worlds for the artists' benefit.

Zoroaster, a powerful philosopher of the forces of Light and Darkness, and the founder of the sciences of astrology and magic, both so important to the Renaissance, was considered the ancient theologian from whom philosophy derived. The discovery of Ptolemy's *Geographia* or *Cosmographica* had a major impact on early fifteenth-century intellectual circles in Florence; it offered the most mathematically sound means then known for visually comprehending the globe and for giving it a sense of order and

proportion.[10] As the inscription under the representation of Ptolemy in Federico da Montefeltro's *studiolo* in the Urbino palace – with which the young Raphael must have been familiar – reads, "[he was included among the sages] for his precise measurement of the stars, and because he imposed lines on the earth" – in other words, his grid system for mapping the globe, which reduced the heterogeneity of that surface to geometric uniformity.[11] The relevance of a system that imposed geometric order and proportion on organic Nature to the development of the new science of linear perspective, as well as to cartography, is obvious. Indeed, Ptolemy himself indicated that the idea of proportion applied to painting as well as geography: "As in an entire painting, we [geographers] must first put in the larger features and afterward those detailed features which portraits and pictures may require, giving them proportion in relation to one another so that their correct measure . . . can be seen . . ."[12] In just such a way has Raphael constructed this three-dimensional world for the greatest classical philosophers, among whom he placed himself, on this two-dimensional lunette.[13] Nor is it any coincidence that Raphael placed himself close to Euclid, the exemplar of geometry who represented the art of measuring the height, width, and depth of all bodies, and who was said to be a portrait of Bramante.[14]

By virtue of his location in the part of the fresco inhabited by the followers of Aristotle and dedicated to empirical science, Raphael associated himself with the art of mathematics, the inventor of geometry, and the cartographers of the terrestrial and celestial spheres. Such a claim implied not only that the erudite modern artist also based his art on scientific knowledge and his ability to measure the human body, the microcosm that reflects the macrocosm of the universe, but also that he played a role as important as those of the ancients in this mapping of the stars, mapping of the earth, mapping of man's relation to the cosmos.[15]

★ ★ ★

Double portraits are relatively rare in Italian art, and Raphael's self-portrait with another, different, companion, of around 1519, is one of only three such self-portraits in this study (pl. 87).[16] Dressed in sober black and white, the two men exist within an undefined, gray world. The centrally placed, nearer figure, seated, fondles his sword hilt with his left hand, points theatrically out of the picture with his right, and turns his head toward the light to gaze up at the man behind him. This second figure who stands, at left, on the diagonal created by the seated man's pointing arm, is identifiable as Raphael in his mid-thirties. Raphael's self-construction in this late portrait differs radically from his youthful self-image: a much rounder face, different hair style, beard, and a more sober mien. Both men are elegantly dressed in richly gathered black silk over white chemises, the seated man's toilette including very full sleeves, very wide cream lapels and cuffs, and a greater display of chemise.

The simple but dramatic composition is based on the diagonal principle that the artist himself had first introduced into a portrait of a single seated figure, that of Julius II (National Gallery, London), whereby the foremost plane defined by a ledge or parapet, as in Giorgione's self-image as David (pl. 82), is eliminated.[17] Instead, the chair sustaining a three-quarter length Julius II was canted, that is, set at an oblique angle to the picture plane, so that the viewer's space fuses with that of the painted sitter.[18] A few years later Raphael developed this concept further in *Pope Leo X with Two Cardinals* (pl. 88), in which the diagonal created by the red velvet chair was continued by a table canted at an identical angle, and inserted in front of the pope, the diagonal being further accentuated by the cornice of the background architecture. The structure of the painting implies a viewer who, standing to the right, is observed by

87 Raphael, *Self-Portrait with a Friend*, c.1519, Musée du Louvre, Paris.

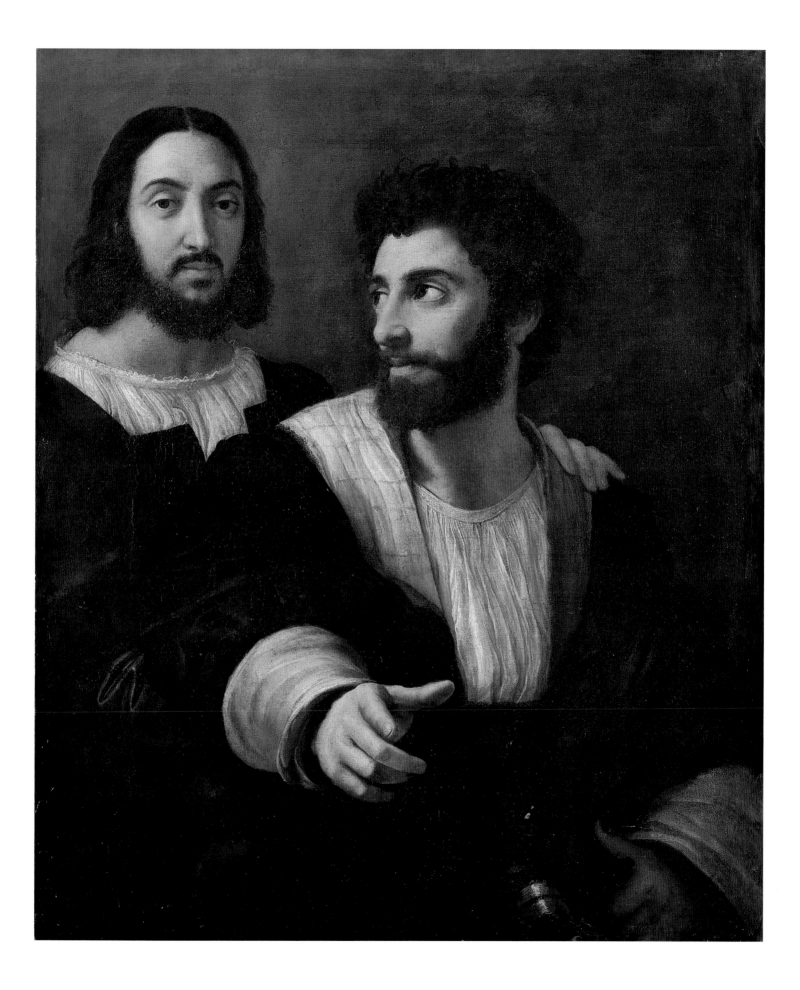

Cardinal Rossi. The pope's table can be read as continuing into this viewer's space, giving him the illusion that he can penetrate the picture plane without hindrance. With one step he can reach forward, past that liminal area between the two spaces, real and pictorial, and communicate with the sitters.[19] In Raphael's double portrait the demarcation between the two worlds that the parapet had earlier supplied was similarly blurred.

The *Self-Portrait with a Friend* reads as if Raphael had eliminated Cardinal Giulio de' Medici and the structural grid offered by the architecture and, especially, the furniture of the portrait of Leo X. Engraving Raphael's double portrait later, Larmessin felt obliged to anchor the two men in space by adding the structural elements of a column opposite Raphael and, ironically, a parapet in front, thus removing the ambiguity of the liminal area between Raphael's world as subject and his world as object. Fried has called attention in Courbet's self-portraits to the impermeability of the bottom framing edge, the liminal area between the world of the painting and that of the viewer, and that edge's capacity to contain the represented sitter and bring the image to a stop.[20] Leo X's legs in his portrait are placed diagonally under the table, but, given the apparent proximity of the Louvre painting to the beholder, the frontality of Raphael's friend's seated pose suggests that his legs continue to advance toward us, outside the limits of the canvas.

The two figures create a pyramidal composition diagonally in space in a work that focuses attention much more closely on hands and heads than in Raphael's portrait of Leo X. Such rhetorical gestures as that of the seated figure here were common in Raphael's grand frescoed narratives, but unprecedented at this date in portraiture. The energy, vitality, and sense of physical presence of these two men becomes palpable when they are compared to the still, almost frozen fixity, of the protagonists in the portrait of Leo X.[21]

The two poses adopted, seated and standing, carried connotations of differing status in early modern European portraiture.[22] In the Middle Ages the category of full-length seated figure was reserved for sovereigns, because "sitting is for princes," as Ripa said, "wherein they display their authority."[23] For Vasari, and for much of the century, the pose signified "taking possession over one's dominion."[24] The consistent use of the enthroned pose for popes into the next century is a clear indication of the symbolic importance given to any seat that could be equated with a throne. The act of standing offered no social competition to that of being metaphorically enthroned. He who stood was subservient to him who sat. Thus there can be no question as to which of the two individuals depicted by Raphael had a higher social status: it was not the artist.

Clothes were extraordinarily important to the Renaissance, partly because fine cloth was so expensive, as were certain colors. Appearances mattered so much that one's power was calculated by the magnificence of one's dress. The greater elaboration of the costume worn by the central figure merely reinforces the conclusions reached on the basis of his seated pose. The same can be said for the sword that he fondles so confidently. As well as being the attribute of Mars, Fame, and Victory, and an emblem of the profession of arms, the sword, a token of noble rank, was a common symbol of social status in portraiture, supposedly worn only by those who had the legal right to do so.[25] Thus, Raphael's friend is unlikely to be, as often supposed, an artist.

Just as the clothes and the sword denote the nobility of the central seated figure, so the lack of weapon and lesser sartorial splendor, combined with his pose, denote Raphael's lesser status within the culture for which this work was produced. Nonetheless, Raphael's appearance and demeanor are those of an intellectual rather than a manual worker, a thinker rather than a doer. Despite his lesser rank, our artist has positioned himself favorably in two respects: his head is the higher of the two, and one

88 Raphael, *Pope Leo X with two Cardinals*, panel, 1517, Galleria degli Uffizi, Florence.

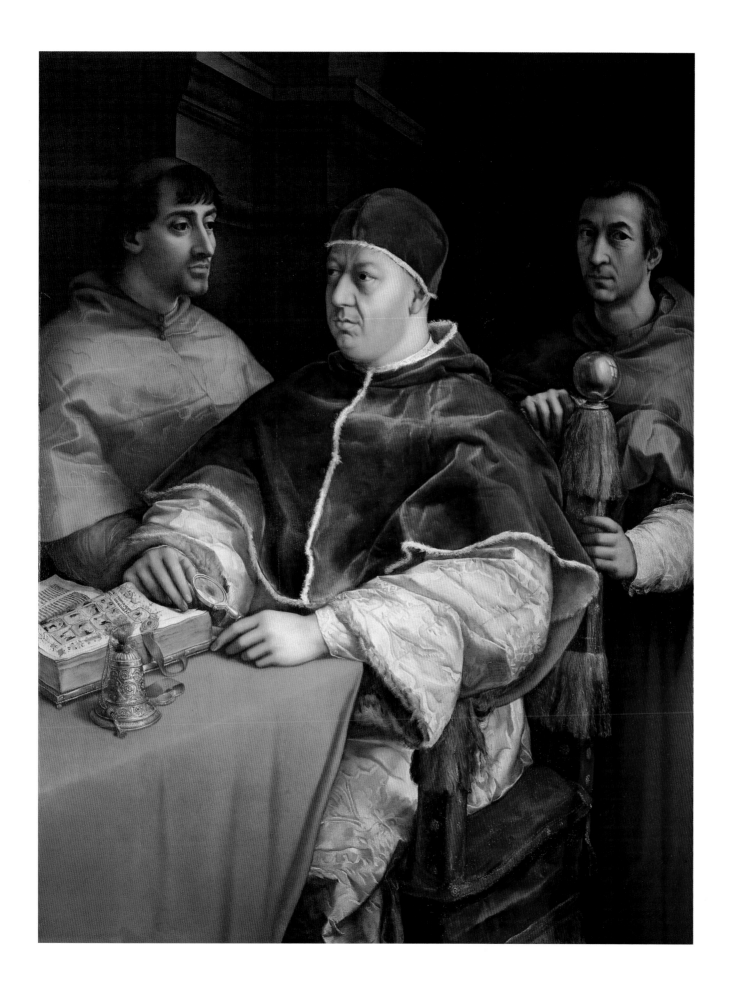

hand – clean, slim, and elegant, as that of no ordinary artisan – reposes on his companion's shoulder, with all the authoritative significance attached to that gesture, while the (almost invisible) other is placed around his companion's waist. Thus, these two men of different status are yet on such intimate terms that the superior accepts what could have been characterized as a patronizing gesture from the inferior.

While most read the standing individual as Raphael, no convincing case on the identity of his companion has yet been made. In past years he has been variously identified as the artists Giulio Romano, Polidoro da Caravaggio, or Giovanni Francesco Penni, which is extremely unlikely.[26] More recently, Pietro Aretino (1492–1556) in his late twenties, and Giuliano de' Medici, Duke of Nemours (1478–1516), who commissioned his own portrait from Raphael, have been proposed as candidates.[27] The hypothesis that Pietro Aretino is Raphael's friend scores high on the question of resemblance – the individual is very similar to Marcantonio Raimondi's engraved portrait (c.1524) of the satirist – but low on most other counts.[28] Aretino, born the son of a cobbler in 1492, ran away from home to Perugia in his early teens and arrived in Rome in 1517, where the first years were spent below stairs as a lackey in Agostino Chigi's household, until he was able to attract attention by means of his pungent and notoriously indiscreet tongue.[29] Despite the resemblance and the fact that the painted figure could be described as close to Aretino's age of twenty-seven, the satirist could not possibly have acquired the status of a sumptuously dressed – not to mention "enthroned" – nobleman, equipped with sword, by 1519. The clinching argument against this identification is Aretino's failure to mention the work in his published *Lettere*. To have been painted by the divine Raphael was an honor vouchsafed to few; to have been painted together *with* the divine Raphael was a guarantee of instant fame. Why would the satirist, perhaps the ultimate self-fashioner of the Cinquecento, who expended so much effort in buffing up his reputation for posterity, have refrained from boasting of this token of his intimacy with this cultural icon?[30]

It was Leonardo, whose twenty years in Milan proved so important for the development of sixteenth-century painting in northern Italy, who introduced the component of action into Italian portraiture with the image of Cecilia Gallerani (pl. 89) around 1490, in which the lady's head is on a different axis from her body as she turns in contrapposto to gaze into the light, her attention caught by something or someone outside the picture space.[31] Anderson has argued that Giorgione introduced something comparable into Venetian portraiture: a new conception of portraiture in which the artist represented his subject in a situation, often allegorical, as indeed he depicted himself (pl. 84).[32] Giorgione's most dramatic invention of this type is his ruined portrait of Gerolamo Marcello, now in Vienna, where the sitter turns his back, *mostra la schiena*, as Michiel wrote, to the viewer. Dressed as a Roman soldier, his noble profile confronts that of a grotesque servant in a work that probably lost one or more crucial motifs when cut down.[33]

In describing the portraits in which Giorgione and later Venetian artists introduced a component of narrative or action, Ridolfi used the formula *ritratto d'un homo in atto di . . .* as in *ritratto d'un homo in atto di girarsi* ("portrait of a man in the act of turning," or "as he turns"), a motif used in many sixteenth-century portraits, in which the component of action is at least as important as the likeness, if not more so.[34] Raphael's companion's body turning diagonally into space would seem to be a locus classicus of a portrait of a man *in atto di girarsi*.

Toward what or whom does this individual point? What *atto*, action, is he in the process of undertaking? Most suggestions cluster around a person: a mutual friend who commissioned the portrait, who is being included in the circle of friendship by way of the gesture that breaks through the picture plane into the recipient's space in his own home. An analogy is the double portrait Raphael painted of two friends, Andrea

89 Leonardo da Vinci, *Cecilia Gallerani*, *c*.1490, National Museum, Cracow.

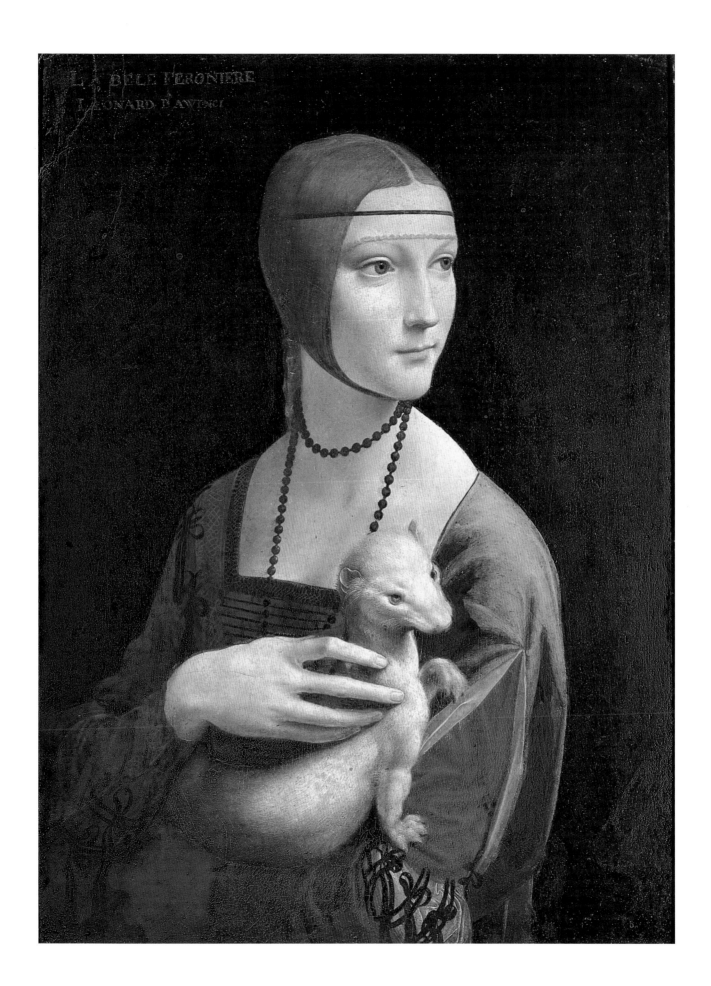

Navagero and Agostino Beazzano (Doria Gallery, Rome), to send to a third friend, Pietro Bembo, in which the depicted humanists focus their gaze on Bembo, as if he completed the circle of friendship by being seated as close to them as they are to each other.[35]

Those who identify the swordsman as Aretino suggest that Agostino Chigi is the friend toward whom Raphael's companion is pointing, and that it is Chigi's name that he utters as he turns toward Raphael. But, although Chigi was indeed the employer of both men while Raphael painted the vault of the Loggia di Psiche in the Villa Farnesina, Aretino's talents had not yet been recognized by this date, and he was not at the villa in his capacity of satirist but as servant. In any case, if the spectator is to be understood as such a crucial component of the painting, one would expect both sitters to look at him – or her – as Navagero and Beazzano, hanging on the walls of Bembo's house, look toward *their* friend. Raphael's double portrait gives the impression that Raphael is of greater importance to the seated figure than the painting's hypothetical recipient.

Chastel focused attention on "those masterful actors, our fingers, and in particular the most active and ambitious, the pointing index finger," when it was used, as it is in this painting, as a "gesture that denotes." The psychological charge of this gesture, as a "psycho-physiological perspective," was, he thought, akin in its potential impact on the composition and the viewer to that of one-point perspective.[36] It is necessary to think only of God's index finger summoning Adam to life on the Sistine ceiling to see his point. The issue of gesture, where to obtain models of them, how to build up a useful repertory, and when to incorporate them into one's work, was central to Leonardo, who could, in such a figure as St. John the Baptist (Louvre) transform the pointing index finger into the central motif of the composition.[37]

Another *Freundschaftbild* or friendship painting, *Self-Portrait with a Friend* (pl. 90), attributed to Giovanni Battista Paggi and dated *circa* 1580, uses a prominent index finger to explore the possibilities inherent in the depiction of a mirror within a painting, albeit this finger points into the picture space, rather than, as in the Raphael self-portrait, the reverse.[38] It points toward a small, rectangular looking glass which is slotted into the upper corner of the frame; in it we are given two views of the artist's companion who holds the compass that symbolizes architecture. As in Giorgione's portrait of Gerolamo Marcello, the friend has turned his back on the artist, and contemplates his own facial features in the reflecting surface. But it is to the second mirrored head, at the same level as his own, that his index finger insistently points: the self-portraitist leaning forward to regard his own reflection in the process of projecting this *finzione*, his face tense. The work was relevant to the *paragone* or debate, still current at the end of the Cinquecento, on the relative merits of painting and sculpture, in which sculptors claimed that their statues were superior because they showed all sides of a figure, in comparison to the one view only provided by painting. Only painting, Paggi implies, can represent his architect friend from back and front simultaneously. Paggi has focused on the phenomenon of one body with two reflected faces, or alternatively, one body with three heads, front and back views of his friend and his own specular lineaments. The viewer is equated with the artist, and we may fantasize that if we move to the right, our own features will appear in the mirror beside Paggi's, at the same level and on the same scale as his. By including the mirror, the artist's emblem, as a painting within his painting, Paggi uses a conspicuous gesture to acknowledge his indebtness to his mute accomplice.[39]

In Paggi's self-portrait the pointing index finger ensures that the mirror reflection becomes the center of attention. I propose that both autonomous self-portraits explored in this section on the papal court had the mirror as one of their central themes, that by Raphael as well as that by Parmigianino. Furthermore, the finger of Raphael's com-

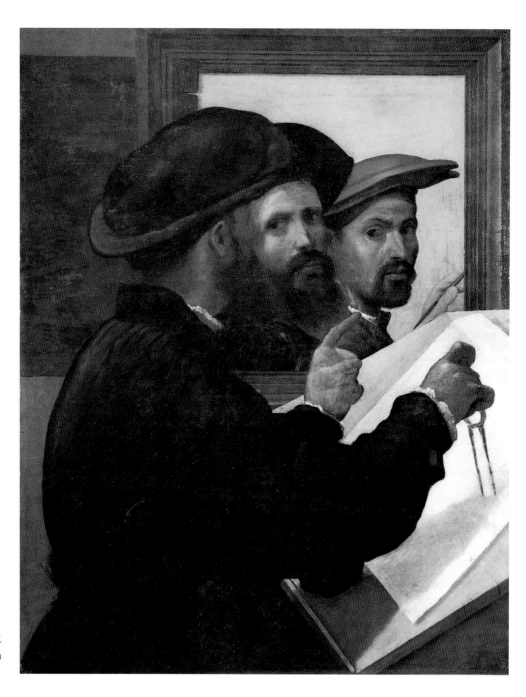

90 Attributed to Giovanni Battista Paggi, *Self-Portrait with an Architect Friend*, canvas, 1580s, Martin von Wagner Museum, Würzburg.

panion gesturing out of the picture space is here interpreted as pointing not at a person but at a thing – a mirror. Objects associated with sitters in portraits identify their profession; in Raphael's double portrait the self-portraitist's secret accomplice is invisible but, in this interpretation is included within the work as spectral subtext. Other sixteenth-century works, such as Lotto's *Portrait of a Man* (Kunsthistorisches Museum, Vienna) in which the sitter is seen from three sides, and which is also occasionally identified as a self-portrait, imply the presence of an one or more unseen mirrors, just as a self-portrait in profile implies a spectral subtext of at least two mirrors.[40]

As will soon be apparent, Parmigianino draws attention to his convex mirror with his hand, but it is not *Raphael's* hand that reaches toward the painter's aid in his painting; it is his *friend's* hand – one ennobled by its companion's association with the sword – which hypothetically acknowledges the presence of this mirror, sited parallel

to the picture plane, outside the painting's purview. Raphael can be constructed as having abandoned his easel and walked into the pictorial terrain, moving his body from the outer to the inner sphere, transferring the self from subject to object, to consider the effect of his composition when he himself is physically included in it. We can thus envision the artist as he turns around, takes up his self-allotted pose, and observes himself in the mirror.[41] Hypothetically, his companion gesticulates toward Raphael's specular image – and the viewer – while turning around to check the reflection against the "reality" behind him, as if to lend greater credibility to the painted "Raphael" than to the reflected one.[42] The painting is only the third element in an equation, of which the others are the mirror-image and the sitters as the mirror's source, from which the painting asserts its independence. Raphael may offer here a view of the artistic confrontation between the real and the unreal, his perception of the relationship between a being of flesh and blood and its bloodless asymmetrical reflection, his pictorial *doppelgänger*.[43]

Another obvious theme of the painting is Raphael's intimacy, which can be characterized as *familiarissimo*, with this friend of higher rank, on whose person the artist places both his hands. Whoever the mysterious swordsman may be, this central figure was of particular importance for Raphael, and must be read, like Ptolemy and Zoroaster in the *School of Athens,* as his attribute.[44]

With Raphael, called a mortal god (*dio mortale*), by Vasari, the social rank of the artist took a quantum leap. Dying early, *nel mezzo del cammin di nostra vita*, Raphael was already a great courtier, so esteemed that he seemed destined either to marry a cardinal's niece or become a cardinal himself.[45] In many ways he was the quintessential "self-portraitist type." He had his own palace, designed by Bramante, he wrote poetry, he was a wealthy man at his death, and his desire to be given an *all'antica* burial in one of the aedicules of the Pantheon, the sacrosanct site surviving from the Roman past, was honored. His last work, the aedicule itself without effigy, was for him the symbol of his immortality.[46]

Already in life, he was almost a myth in his own right.[47] Raphael had "charming manners, a noble demeanor, and a beautiful spirit" (*gentile di maniere, nobile di presenza e bello di spirito*), says one the characters in *La Talanta* by Pietro Aretino, who had known him and who was usually more given to blame than praise.[48] Giovio, too, in his *Life* written soon after the artist's death, stressed Raphael's "outstanding courtesy" which won him "great intimacy with the powerful."[49] Vasari, who never knew him, also fashioned Raphael as a man of charisma and remarkable personal talents: *tanta grazia, studio, bellezza, modestia ed ottimi costumi*.[50]

One of the themes of Vasari's *Life* of Raphael was the favor and riches that Raphael won by this "courteous" behavior. As constructed, his immense success was as much due to his personal charm and gracious demeanor as to his artistic talent. He who showed man in social interaction in the Vatican Stanze was himself skilled at it, as he sought to convey here. In this self-image that turned out to be his last portrait, he shows the self not in isolation but accompanied by a "friend." Growing up at one court, the offspring of an able and practiced courtier, Raphael had no difficulty negotiating his way around another. It was Raphael's social graces and affability that made Julius II and Leo X "treat him as a most intimate friend," *familiarissimo*, and bestow wealth on him.[51] Raphael proved himself, wrote Vasari, "sweet and pleasing with every kind of person" (*dolce e piacevole con ogni sorte di persone*). The skeptic might wish to phrase it otherwise: Raphael, appearing *dolce e piacevole*, was a clever and ambitious careerist, able to ingratiate himself with those in power and manipulate them without their realizing it.[52]

PARMIGIANINO'S MIRROR

Raphael's *Self-Portrait with a Friend* was created at the brilliant and sophisticated court of Leo X de' Medici. Five years later Parmigianino arrived in Rome bearing a gift – a work that is extraordinarily well documented as to its artist's intentions, its original recipient, and its subsequent audience – for yet another Medici pontiff knowledgeable in the arts, Clement VII (pl. 92).[1] In the case of each painting, of course, the patron – the motivating factor for the work's existence – was very likely the artist himself.

Parmigianino's *Self-Portrait in a Convex Mirror*, created as a tour-de-force to introduce his talents to the Roman art world, is one of the most singular performances of the entire Renaissance period. Vasari claimed to remember gazing at the painting *come cosa rara*, "as a rare work," in Aretino's house in his native Arezzo when he was very young. The portrait struck him so powerfully that he gave an extended account of how it had been created:

> in order to investigate the subtleties of illusion [*sottigliezze dell'arte*], he set himself one day to make his own portrait, looking at himself in a convex barber's mirror. And in doing this, perceiving the bizarre effects [*bizzarrie*] produced by the roundness of the mirror, which twists the beams of a ceiling into strange curves, and makes the doors and other parts of buildings recede in an extraordinary manner, the idea came to him to amuse himself by counterfeiting [*contrafare per suo capriccio*] everything. Thereupon he had a ball of wood made by a turner, and, dividing it in half so as to make it the same in size and shape as the mirror, set to work to counterfeit on it with supreme art all that he saw in the glass, and particularly his own self, which he did with such lifelike reality as could be imagined or believed. Now everything that is near the mirror is magnified, and all that is at a distance is diminished, and thus he made the hand engaged in drawing somewhat large, as the mirror showed it, and so marvelous that it seemed to be his very own. And since Francesco had an air of great beauty, with a face and aspect full of grace, in the likeness rather of an angel than of a man, his image on that ball had the appearance of a thing divine. So happily, indeed, did he succeed in the whole of this work, that the reality was no less real than the painting [*che il vero non istava altrimenti che il dipinto*], and in it were seen the luster of the glass, the reflection of every detail, and the lights and shadows, all so true and natural, that nothing more could have been hoped for from the human intellect [*che più non si sarebbe potuto sperare da umano ingegno*].[2]

At the center of the room and the work of art, the self-portraitist is dressed as a noble courtier in fur and cambric, and his hand, transformed into something attenuated, white, and aristocratic, is adorned with a gold ring.

The two main centers of interest in any portrait are the head and the hands, in a discourse in which the head, that is, the part of the body responsible for the conception of the work, usually dominates over the hand, the body part responsible for its execution. Freedberg proposed that it was Parmigianino who invented the hand as an item in the portrait painter's repertory of motifs; he was certainly the artist who proposed the most *singolare* presentation of that attribute.[3] Seated frontally, Parmigianino

placed his arm on a table, so close to the foreground that it seems to extend into our space, and pushed his hand forward until it met the actual convex surface of the barber's mirror. Much magnified, this hand rests on the foremost picture plane, following the curve of the fictive glass, which is also the curve of the actual picture surface. Parmigianino's head, so much further from the curved mirror surface, is correspondingly reduced in scale. Ignoring a classically inspired unified approach to the human body, Parmigianino painted a hand that far outweighs his head in scale, juxtaposing two different human proportions in the same image. While the illusion is of Parmigianino's right hand, the artist in actuality depicted his left hand, since in a mirror everything is reversed. As was usually the case, Parmigianino's actual painting hand is hidden, the artist's two roles of maker and model being, in this respect, irreconcilable.[4]

In the background, the illusion of a spherical room with window, door, and coffered ceiling, gives the impression that the architectural structure has dematerialized. In the painting Parmigianino banished all evidence of the paraphernalia involved in painting – easel, paint brushes – that must have been visible in the mirror. Vasari stressed the bizarre effects (*bizzarrie*), produced by the mirror reflection, remembering no doubt the eyes that appear to be on two slightly different planes and the mouth that diminishes toward the right. Apart from the hand, however, major distortions are limited to the background architecture and that in turn is restricted to the periphery of the tondo.

134

Comparison with a self-portrait in a convex mirror by M. C. Escher of 1935 (pl. 91) reveals the tact with which Parmigianino treated the space in which he ostensibly posed, eliminating any background features that might distract from his painted self. Escher's body and features, on the other hand, are dominated by the inert objects that also share his space. The human inhabitant seems lost amidst the curving walls and ceiling, chairs, books, pictures, that are all as real as, and in the case of the room's geometry, more compelling than he is. Vasari observed that Parmigianino focused on his own reflection. Holding the mirror up to himself, Escher, on the other hand, constructed the self as only one among many other elements in the cluttered world that he balances in the palm of his hand and offers, as an alternative reality, to the viewer.

Reflections held a profound attraction for Renaissance artists; Parmigianino's painting draws attention to his use of the reflecting mirror, that secret tool used by all self-portraitists, that was in its own way as essential, but usually as little acknowledged, as the hand. It is not by chance that the emergence of the independent self-portrait as a genre coincides with the development of much larger, flat, and more faithful mirrors. In respect to Dürer's three great autonomous self-portraits at the end of the Quattrocento, it cannot, for instance, be coincidence that the two places where the manufacture of mirrors flourished were Nuremberg, his home town, and Venice, his home away from home.[5]

Even after the introduction of flat mirrors, circular frames continued to prevail, one example being Giovanni Bellini's *Woman with Two Mirrors* in which the woman uses two circular – but flat – mirrors (pl. 16).[6] Eventually, flat glass mirrors made the medieval convex ones obsolete, although both types occur in Titian's painting of another *Woman with Two Mirrors* (c.1512–17; pl. 17).[7] Thus, given his choice of mirrors, Parmigianino, another North Italian, assimilated his self-portrait to one produced by a technology less and less used in the sixteenth century. A flat mirror could not have achieved what Parmigianino sought here, in that the properties of a plane mirror are different from those of a convex half-sphere. The flat mirror does not diminish or enlarge the size of the object it reflects, neither does it gather or concentrate a given set of motifs. The plane mirror could not, unlike the convex mirror, speak a language of its own, but merely recorded what lay within its field – although, by today's standards, the image in even a flat Renaissance mirror may still have been hard to decipher, if those now hanging in museums are anything to go by.[8]

Parmigianino claimed to paint what he glimpsed in the mirror in front of him, so that the mirrored self-portrait seemed to be consubstantial with the reflection in the actual mirror.[9] The artist did not, accordingly, use the mirror merely as a tool to create his self-image but rather to imitate his *reflection* in it; his work is not only a self-likeness, but a self-likeness as reflected in that particular mirror.[10] In this respect, the youth admiring his own beauty can be said to resemble Narcissus, whom Alberti and Filarete identified as the first painter, who fell in love with his own "reflection in the limpid mirror" of a pool of water, and who sought in vain to embrace that beautiful self that masqueraded as an unresponsive other.[11]

Because of the type of mirror being simulated, Parmigianino's painting is the earliest surviving Italian example of an autonomous painted portrait within a tondo. Although rarely used for secular subjects, the tondo nonetheless echoed the circularity of the earlier medallic self-portraits, and recalls that Italians used the same word (*spera*) for both sphere and mirror.[12] The panel's shape had important connotations. The sphere, symbol of the *orbis mundi*, was interpreted as the most perfect geometric solid body, since all points were at an equal distance from the central point, and the circle, symbolizing perfection and harmony, was yet another perfect geometric figure.[13] Because the surface of Parmigianino's image is curved, suggestive of a small section of a real sphere, the work was closely linked by its format to the terrestrial and

celestial spheres carried by Ptolomy and Zoroaster in the *School of Athens*. Indeed, Parmigianino's spherical head within the "spherical" work, in turn within its circular frame, evokes an analogy between macrocosm and microcosm: the structure of the cosmos and the structure of the human head, placed here as the central focus of both composition and artifact.[14]

Giulio de' Medici, Clement VII, was a discriminating patron with a lifetime of experience in looking at works of art. Upon seeing Parmigianino's works and noting his youth, the pontiff, like Vasari, was stunned: *restò stupefatto, e, con esso tutta la corte*. The papal courtiers must have been all the more fascinated, in that round, convex mirrors in themselves very rarely appear in Italian art.[15] The Medici pope was in a position to know that this agent through which the self-portrait was accomplished, had never before been so openly confessed and exploited as here.[16] Above all, the element closest to the picture surface forced the recipient to recognize the conceptual talent that had conceived such an *invenzione*: a *mano* that dominates the *ingegno* in a visual celebration of the painter's essential biological attribute: his hand.

All too little is known about the original location of, and audience for, most Renaissance self-portraits. Thus the peregrination of Parmigianino's work among major figures of the Cinquecento art world is suggestive. It was originally intended as a gift that would engender a commission, but by the time Vasari saw it, it had moved into the hands of Pietro Aretino, who exploited the idea for his own purposes, having a portrait of himself engraved as if he, too, were reflected in a convex mirror, which was, however, oval in shape.[17] For a time it belonged to Valerio Belli and then Andrea Palladio. In 1560 it was acquired by Alessandro Vittoria, who also owned portraits of Titian, Tintoretto, Veronese, and Palma Giovane. After the sculptor's death in 1608, it found its way into the suitable environment of Emperor Rudolph II's collection of *bizzarri* works.[18] Intended as a *capriccio*, amusing conceit, to demonstrate the artist's *ingegno*, it was evidently greatly admired by the *intendentissimi*, those very knowledgeable in the arts.

This extraordinary *finzione* by a talented twenty-year-old from the provinces, combines youth, a high degree of self-consciousness, and chutzpah. Indeed, the painting's mere existence suggests that this precocious young man had the same measure of belief in his own talents as that manifested by Raphael in *his* early self-portraits. As a badge of the self, the painting was a display of Parmigianino's art at its most *ingannoso*, deceptive.

Chapter 14

CAVALIERE BANDINELLI AND HIS DISCIPLES IN *DISEGNO*

The narrative shifts from the Medicean papal courts of Leo X and Clement VII to the Medicean Florentine court, and the self-images, houses, treatises, autobiographies, titles, and tombs of three of the artists who served Duke Cosimo I: Bandinelli, Vasari, and Cellini. Other painters, such as Pontormo, Bronzino, and Salviati, who also graced Cosimo's court, have been omitted because they restricted their self-projections to the time-honored Florentine tradition of self-inclusion in religious narrative.[1] Baccio Bandinelli can, however, be said to have more than compensated for his compatriots' reticence in the creation of autonomous self-images, by producing some half a dozen in various media.[2]

Bandinelli's painted self-projection, now in the Gardner Museum, is usually dated around 1540 (pl. 93). Dressed in black with the insignia of the Order of Santiago reposing on his breast, Bandinelli sits full length in extreme contrapposto on a canted stone cube between two classical columns on high bases. His legs crossed, balancing on the toes of one foot, the artist holds up a piece of chalk and a very large red chalk drawing in one hand, at which he points ostentatiously with the index finger of the other. The drawing shows Hercules triumphing over Cacus, who lies defeated on the ground.

This artist succeeded in making his features so familiar through his many self-portraits that identification of the sitter is not in doubt. Issues of attribution and dating, however, are not so clear-cut; there is no work with which to compare the portrait, since this is generally recognized as the only painting that can reasonably be attributed to the sculptor. Most scholars, however, accept this nearly monochrome painting as his:[3]

> Bandinelli is known to have painted, and to have painted badly, and the qualities of this picture are typical of those by sculptors trying an unaccustomed hand: the limited color divided into unbroken masses, the uninteresting quality of the paint itself. The large sweeping outlines of the figure are characteristic of Bandinelli's sculpture . . .[4]

Michelangelo's opinions were recorded by Francisco de Holanda:

> the sculptor will not be able to paint nor take a brush in his hand nor as a painter make a sketch worthy of a master, as I realized the other day on a visit to Baccio Blandino [sic], sculptor, for I found him attempting to paint in oils and not succeeding.[5]

And Vasari was careful to distinguish between Bandinelli's awkwardness in painting and his prowess in drawing: "His drawing [*disegno*] was praised by experts, but not his coloring [in painting]."[6]

Bandinelli initially planned a career as a painter, training with the little-known Girolamo del Buda before moving on to Rustici's sculpture workshop, and there is scattered evidence that he practiced briefly as one.[7] In his *Memoriale*, started in the

93 Attributed to Baccio Bandinelli, *Self-Portrait*, panel, early 1530s, Isabella Stewart Gardner Museum, Boston.

1550s, the artist mentions "some of my highly praised [*stimatissime*] paintings," and, perhaps making a direct reference to the Gardner work, asked his sons to take special care of "the panel that I leave you at home, where I painted myself by means of a mirror [*spera*]."[8]

The sculptor's family were stalwart loyalists of Medicean causes; the family ties went back to Cosimo il Vecchio, when Bandinelli's ancestors had worked in the Medici bank. His father's business as a successful goldsmith and jeweler had depended on Medici financing. Bandinelli's own career was just as heavily dependent on the connection, and, for a long time, he was *the* favored sculptor of the Medicean papal and Florentine courts. They were the source of most of his major sculpture commissions; it was Clement VII who gave him the huge block of marble ($9\frac{1}{2} \times 5$ braccia) reserved for the sculptural pendant to Michelangelo's *David* outside the Palazzo Vecchio, that Bandinelli eventually used for his *Hercules and Cacus*.[9]

Bandinelli's major attribute in the Gardner self-portrait is the insignia of the military Order of Santiago. In his own words:

> Being desirous to bring splendor to my lineage, I took the occasion offered by Charles V's trip to Italy . . . to ask the emperor to induct me into the Order of Santiago. I was a courtier in the suite of the pope, who testified that I was born into the very ancient and very noble house of the Bandinelli of Siena . . . many princes and lords of the Order ignorantly opposed my nomination, saying that as a sculptor I did not deserve it . . .[10]

Once again, Bandinelli owed perhaps *the* important event in his life, his imperial knighthood, to his Medici patrons. Already created a papal Knight of St. Peter by Clement VII, in 1529–30 he succeeded, against all the odds, in becoming the first artist to be inducted into a major chivalric Order, the Spanish Order of Santiago or St. James, as confirmed by the elegant cockleshell with overlaid cross that hangs on his breast. The Order may have been easier to enter in the sixteenth than the seventeenth century, when Velázquez had so much difficulty in being accepted. Possibly papal support made all the difference. To "prove" his nobility, Bandinelli fabricated aristocratic ancestors as far back as Charlemagne, claiming descent from a noble Sienese family, and changing his original name, Brandini, to theirs.[11] In what must have been a pro-forma search, he managed to obtain sufficiently convincing "proof" of this new genealogy to pass muster with the Spanish bureaucrats of the Order.[12]

The art milieu of the Florentine court was both competitive and hostile. Neither Bandinelli's new signature, BACCIUS BANDINELLUS FLORENTINUS SANCTI IACOPI EQUES FACIEBAT, nor his knighthood were well received by his peers, as testified to by the first line of one of the many poems written to vilify the artist's *Christ* in the Duomo: "O Baccius faciebat Bandinello."[13] Bandinelli's use of the imperfect, rather than the past, tense in his signature was unusual. It was based on Pliny who said the best artists used the imperfect, as in *Apelles faciebat*, "Apelles has been at work on this," suggesting that the work were still on-going; Bandinelli's choice of tense must have seemed pretentious to his vilifier.[14] Other lampoons give a further idea of the possible play of words surrounding his title:

> Io son quel nominato Cavaliero,
> Baccio scarpellator de' Bandinelli . . .

(I am one nominated Knight, Baccio de' Bandinelli, stonemason).

> Fu fatto gentilhuom in due hore:
> non ti crepa el cuore
> Veder un scarpellin commendatore?[15]

(He was created a gentleman in two hours. Doesn't it make your heart croak to see a stonemason as "commander?").

The second major attribute in the Gardner painting is the very large *modello* that Bandinelli holds, in which a much muscled Hercules stands with straddled legs, holding a club, gazing down at an equally muscled but supine Cacus. The composition is related to the gigantic *Hercules and Cacus* by Bandinelli that was site-specific as pendant to Michelangelo's *David* outside the Palazzo Vecchio in the Piazza della Signoria. Hercules' exploits in Antiquity, his physical strength and fortitude in the face of adversity, made him an exemplar of courage; as an embodiment of this virtue, in the Middle Ages he also became a symbol of Christian fortitude.[16] The traditional founder and protector of Florence, this symbol of the Florentine Republic had been appropriated by the Quattrocento Medici. By the mid-Cinquecento the connotations of Hercules' name had shifted from a positive symbol of Florence itself to a focus for resentment against the Medici regime.[17]

Even if Bandinelli's unpopular politics and obsequious loyalty to the Medici had not already alienated those of his peers who abhorred the return of the Medici to power in Florence in 1512 and 1530, the artist's abrasive personality, prickly vanity, and unbridled social ambitions made him greatly disliked, and he invariably attracted a bad press.[18] The Florentine artistic and literary world was very vocal: when Bandinelli's sculpture of *Hercules and Cacus* was first installed in the piazza in 1534, the "jealous and malicious," (*invidiosi e maligni*), in Bandinelli's view, harshly criticized it, almost certainly as much for its Medicean political implications, and for personal dislike of its maker, as for its alleged aesthetic shortcomings.[19] It was always, as one scholar put it, more prudent to attack the artist than the patron.[20]

The relationship between the painted "drawing" in the Gardner work (which does not survive, if it ever existed) and the *Hercules and Cacus* group as it was carved is still unresolved. The republican regime had wanted this pendant to the *David* also to be carved by Michelangelo, whereas Clement VII had been determined to give the commission to Bandinelli. With the fall of the Medici in 1527 the block of marble reserved for the Hercules sculpture had been removed from Bandinelli's aegis and given to Michelangelo. With the change of political regime in 1530 the block once again traversed the city to Bandinelli's workshop.[21] Thus 1530 was a very important year in the artist's career, both in social and artistic terms: he received his knighthood, on the one hand, and on the other, the Medici returned to power in Florence and, with them, the prestigious commission and the precious marble.

The composition for the sculpture as proposed in this *disegno* in *colore*, painted drawing, is markedly unlike the finished work that still stands today in the piazza. Hercules has a similar stance with straddled legs, but in the drawing he directs his glance downward at Cacus, instead of gazing meditatively across the piazza. The configuration given to Cacus, symbol of anti-Medicean factions in Florence, is totally dissimilar. Instead of crouching as a compact mass at Hercules' feet, looking up to him beseechingly, Cacus sprawls across the ground, with one simian arm still resting on the hero's hip bone. The Cacus myth, a seldom represented episode in Hercules' career, tells of the hero's liberation of a herd of cattle from a monstrous thief.[22] The moment proposed in this version of the composition – the very moment of Hercules' victory – is thus vividly narrative, whereas the sculpture as carved, from which all movement is banished, is static and iconic. An even more active configuration of the two men is a small sculptural model in Berlin, attributed to Bandinelli. Showing Hercules savagely beating Cacus to death with his club, it may reveal an earlier stage in the design.[23] Clement VII evidently preferred the solution ultimately adopted. By presenting Hercules as sparing Cacus's life in an act of *clementia* worthy of the Medici pope of

that name, the work minimized the impression of violence – which would only have reminded Florentines of the savagery with which the Herculean Medici could subdue their enemies.[24] The hero's iconic stance may also refer to the establishment of the perpetual cult of Hercules – read, Herculean Medici – that resulted from his victory over Cacus.[25] Is it possible that the Gardner painting preserves the record of an intermediate version of the composition between the Berlin wax model and the sculpture as it stands, an *invenzione* in which Hercules is shown – not unlike the configuration in Andrea Pisano's Trecento relief on Florence Campanile – savoring the moment of his triumph? Alternatively, the drawing was perhaps intended to be understood as one of the many singular Herculean inventions produced by the indefatigable draftsman, one of whose earliest sculptures had, as it happens, depicted Hercules and the dead Cacus.[26] The muscular hero's head can be said to somewhat resemble Bandinelli's own, as he too conquers the alien art of painting and plans his victory in stone.

The suggested date of around 1540 for the painting proposes that, six years after the installation of his marble Hercules group, Bandinelli sought to promote a different solution to the composition of this sculpture, the work that was so important for him because it pitted his talents against those of Michelangelo, and had already attracted a barrage of critical abuse from his peers when it was installed.

A dating closer to 1530, however, when Bandinelli was at the apex of his career, would place the Gardner painting closer in time to the sculptor's two most prominent attributes in it: a drawing representing Bandinelli's continuing involvement with the Medicean iconography of Hercules, perhaps an early stage in the design for the sculptural group that was finished in 1534, and the Order of Santiago bestowed on him in 1529–30. Why indeed would Bandinelli wait ten years before celebrating in painting his triumphant promotion into the nobility? The painting can be interpreted as foregrounding the artist's triumph at finally having wrested the marble block away from Michelangelo as well as flaunting his recently acquired nobility.

Bandinelli probably also chose a drawing as attribute because *disegno* was his strong suit. At an early date, by 1512, the artist had established his reputation as a brilliant and most *singolare* draftsman. No matter how poorly his contemporaries evaluated his personality and his large-scale sculpture, everyone admired his talent in this medium. Even the prejudiced Vasari, who hated Bandinelli and resented his preferment, acknowledged his virtuosity in *disegno*: "Baccio had acquired the name of a great draftsman . . . [In *disegno*] no one could do better."[27]

No doubt Bandinelli also displayed his qualifications as draftsman rather than as sculptor because the physical work involved in the latter produced, in Leonardo's words, "a great deal of sweat, which combines with marble dust and turns into mud."[28] This sculptor's drawing thus reinforces the claim in his *Memoriale* that "all my concentration was focused on drawing" (*tutto il mio intento era nel disegnare*).[29] Indeed, Bandinelli's sensitivity to the different social levels accorded to the various arts even led him to declare that his real passion was for *literary*, not artistic, creation: "rather than wield my chisel, it would have been far more to my taste to immortalize my name with my pen, this being a truly congenial and *liberale* pursuit."[30]

Finally – and perhaps most to the point – the drawing in Bandinelli's painting carried yet another, more universal, meaning for the Cinquecento artistic community. *Disegno* was the key to the entire artistic process, the medium, at one and the same time, of the painter's thought as well as its concrete expression, the physical realization of the idea born in the intellect.[31] "No concept of Italian art criticism," Rosand has written, "was . . . so fruitfully ambiguous as *disegno*."[32] The ambiguity derived from its multiple meanings: as a graphic sign that referred to the technical, manual act of drawing on paper or similar support, and as the cognitive faculty embodying the fundamental theoretical principles that underlay the three arts. "*Disegno*," wrote Vasari, "father of our

three arts, architecture, sculpture and painting . . . is nothing else than an apparent expression and declaration of the *concetto* that is held in the mind."[33]

Given this twofold meaning, it is revealing that when artists did begin to use examples of their work as an attribute they specifically stressed their talent in *disegno*, the most conceptual of the visual media. Believing that "formal ideas were more essential to art than their execution," Bandinelli greatly desired to become a "concept-artist," one who worked out the conception on paper, and then left the execution of the sculpture to his assistants.[34]

In another portrait of an artist from these same years, Titian's painting of Giulio Romano in 1536–8, the sitter also draws the viewer's attention to a drawing with similar, if less aggressive, index finger rhetoric: a ground plan of a centralized temple (pl. 94). The selection of a ground plan – not to mention one based on the circle, most perfect of geometric shapes – rather than, say, a perspective rendering or an elevation, suggests Titian and Giulio's interest in stressing the latter's capacity for conceptualization, in this case abstract spatial relationships, which in turn could only be communicated by means of an abstract convention. Significantly, the recipient of this portrait was to be Duke Federigo Gonzaga, Giulio's patron.[35] Fifteen years later Titian would picture the self not holding a drawing but in the act of creating one.

By fashioning himself as sitting between two classical columns, whose grandiose proportions were inspired by the Roman past, Bandinelli sought to identify with the prestige of Antiquity.[36] Here they imply that the sculptor's natural setting was akin to that of a grand and noble palace, built for a wealthy patrician. Noble marble columns became a common motif in portraiture in the second half of the Cinquecento, serving to suggest the sitter's fortitude and secular power, as well as his erudition and close intimacy with the classical world.[37] It is, however, extremely unusual to find a column in a portrait from the first half of the Cinquecento. When one appears it ennobles the portraits of those of the highest rank, and the painting usually dates close to mid-century: Titian's portraits of Paul III with his grandsons from 1545–6 (Capodimonte, Naples), and the seated Charles V from 1548 (Alte Pinakothek, Munich), for instance. Thus Bandinelli's choice of motif *per se* was highly singular, but the sculptor's inclusion of *two* columns in his portrait is even more unexpected.

In legend, Hercules had raised two pillars on either side of the straits of Gibraltar, one in Europe, and the other in Africa. Marking the furthest reaches west of the two continents, they signified geographical boundaries that could not be surpassed. In 1516 Charles V adopted this device as his own.[38] Adding the motto *plus ultra*, the emperor claimed that, by conquering the Americas and extending his empire beyond the straits of Gibraltar, he had indeed surpassed the feat of Hercules.[39]

I propose that the two columns between which Bandinelli has positioned himself should be read as a further reminder of both his new noble status and his recent acquaintance with the Holy Roman Emperor by referring to the latter's emblem. Hercules, favored by the Florentine Medici, had been surpassed by Charles V, overlord of the Medici dukes. Just as the emperor has overtaken Hercules' feats, so Bandinelli must have hoped that his own work would one day be acknowledged as surpassing that of *his* herculean nemesis, Michelangelo. It has been argued that Hercules was as potent a symbol for artists as for emperors and dukes.[40] Not only was Dürer said to have taken on the guise of this hero in a self-image, but at the beginning of the next century, Goltzius would fashion the self as a nude Hercules, in a triptych featuring Mercury holding palette and brushes, and Minerva who, accompanied by owl, books, and inkstand, guaranteed the intellectual content of the work.[41]

Bandinelli's portrait is as innovative formally as it is iconographically. In Raphael's double portrait, the seated pose was interpreted as redolent of majesty and might, and the pose must have held many layers of meaning for the artist. It was very unusual at

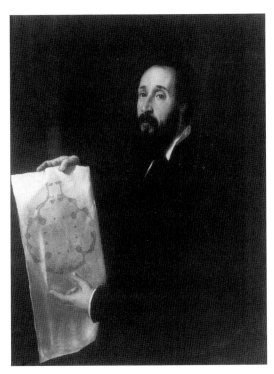

94 Titian, *Giulio Romano*, canvas, 1536–8, Private Collection.

this date to show a full-length seated figure. Few Italian portraits of the first half of the sixteenth century depicted the sitter, whether seated or standing, as full length. The earliest Italian standing figure in an autonomous portrait, a knight by the Venetian Carpaccio, was dated 1510, and the full-length pose did not reappear until 1526 in a portrait by another North Italian, Moretto da Brescia.[42] A date of around 1530 for the Gardner picture would make it the earliest surviving Italian full-length seated portrait, as Vasari's portrait of Alessandro de' Medici was not painted until around 1534.[43] The sitter's pose in Bandinelli's own self-likeness may accordingly anticipate that of the very public, official image of the Duke of Florence by the self-portraitist's former student Vasari. Bandinelli's glee on realizing that he had provided the prototype for Vasari's work may be imagined. Even if the Gardner picture is dated closer to 1540, the implications of Bandinelli's choice of model to emulate – Vasari's image of the Medici ruler – can be read as significant in its own way.

Bandinelli sits in extreme contrapposto, toes facing one direction, hands the other. His body, spread across the picture surface to the widest possible extent, forms the surface pattern of a diamond, a somewhat unstable one given its resting point on the toes of one foot. His head, one hand and two feet are each located near the edge of the canvas, with a vertical axis strongly emphasized by the artist's face, the Order insignia, and index finger pointing insistently to the Hercules drawing.

Some pointing fingers were, as suggested earlier, directed toward that indispensable accomplice, the artist's mirror. Bandinelli and Giulio Romano, however, point to a different artist's aid: the preparatory drawing. But, like Parmigianino, neither artist displays the self laboring on his work. Their index fingers rather direct the viewer's attention to the *product* of that toil. Unlike Giulio, however, Bandinelli also holds the piece of chalk *with which* he purportedly produced that drawing. The sculptor, adorned with the noble robes and insignia of the chivalric Order, surrounded by columns associated with the emperor, was one of the earliest artists to fashion the self holding one of the instruments of the trade.

For whom was Bandinelli's *finzione*, fictive illusion, produced, and where was it located? By analogy with the self-portrait mentioned in the *Memoriale*, which may in any case be the Gardner work, it probably hung in Bandinelli's spacious house in Via Ginori, where it would have primarily addressed a very small audience: its creator above all, and his family, followers, and friends – an amicable audience prepared to indulge the sculptor's pretensions. The function of this painting during Bandinelli's lifetime may have been diametrically opposed to that of his other self-portraits in media such as engravings and medals, each of which, but especially the engravings, was designed to reach a much larger public.

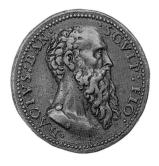

95 Leone Leoni, medal of Bandinelli, bronze, 1550s, obverse and reverse, National Gallery of Art, Washington, D.C., Samuel H. Kress Collection.

Bandinelli commissioned his medal from Leone Leoni (pl. 95).[44] On the reverse, he adopted Clement VII's personal motto, CANDOR ILLAESUS, "whiteness unsullied" or "innocence uncontaminated."[45] The Pope, Giovio explained, wished to demonstrate to the world that the innocence (*candore*) of his soul was not offended by slanderers, when his enemies plotted against his life during the papacy of Adrian VI.[46] With the exception of his own *Memoriale*, all the sources for Bandinelli, as the sculptor must have guessed, were bitterly prejudiced against him. Thus the sculptor's appropriation of Clement's device allowed him to identify his own detractors, like the detested Cellini and Vasari, with those of the pope. As Bandinelli put it for himself: "I became snow-white [*neve*] through the purity [*candidezza*] of my virtues and rank obtained."[47] The medal would in addition remind recipients, probably current or potential patrons, of Bandinelli's close ties to Clement VII and the Medici, ties that, for once, he could legitimately claim.

Bandinelli was one of the very few Italian artists who was astute enough to use the new media to his personal advantage. In Germany, self-portrait prints already

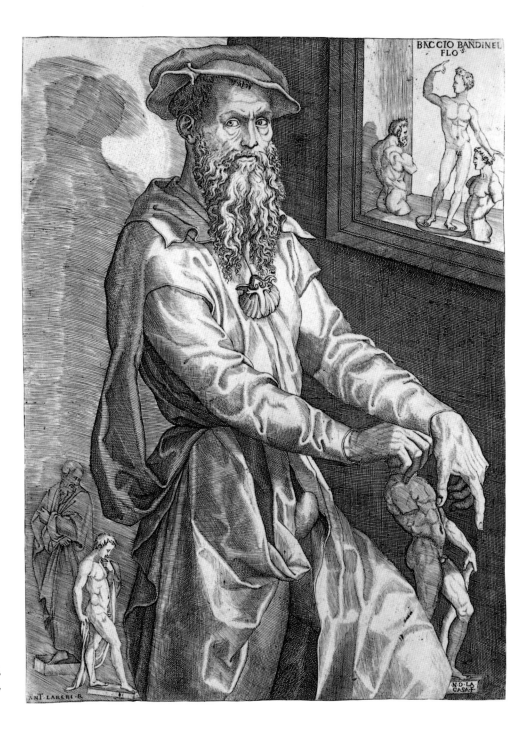

96 Niccolò della Casa, *Portrait of Bandinelli*, engraving, *c*.1540–45, National Gallery of Art, Washington, D.C., Ailsa Mellon Bruce Fund.

existed in the fifteenth century, but even Dürer, who made so many prints, failed to use the medium for his own self-image, perhaps because this popular medium lacked the status of other more expensive ones.[48] Plate 96 shows an engraving by Niccolò della Casa after a drawing by Bandinelli, that must date from the period of Niccolò's known activity, in the early 1540s. The image positions the artist in a corner of his studio surrounded by small sculptural models of male nudes in various conditions of incompletion, armlessness and leglessness; they can be read as the production of both Antiquity and Bandinelli, the one perhaps indistinguishable in quality from the other. Wearing a hat, a massively flowing, forked beard, and the insignia of the Order of Santiago, Bandinelli holds a sculpted Hercules in one hand, at which he points with the same insistent index finger of the other. On the window ledge one of the nudes directs

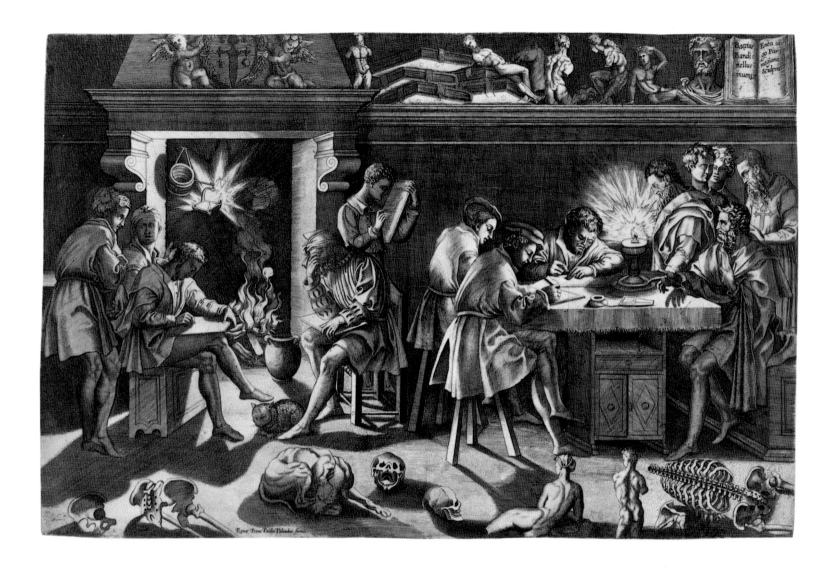

97 Enea Vico, *Bandinelli's Academy*, engraving after drawing by Bandinelli, *c.*1550, Museum of Fine Arts, Boston. Horatio Greenough Curtis Fund.

his own index finger up toward Bandinelli's signature. At a date later in Bandinelli's career than the Gardner self-image, he was less hesitant to show the self with sculptural models.

The print needs to be placed in relation to the two famous engravings, based on Bandinelli drawings, of his academy for budding young sculptors. One is by Agostino Veneziano (dated 1531) and the other by Enea Vico, (*c.*1550; pl. 97). "In my own Academy, [students] studied *disegno* under my [supervision] as can be seen in my drawing that I had printed."[49] The print shows a finely appointed room lit by oil-lamps, with Bandinelli's coat of arms over the chimney piece.[50] On the cornice, books represent the theoretical writings that Bandinelli claimed to have written: treatises on the *paragone* between painting and sculpture and on *disegno* which, if they ever existed, are now lost.[51] In the chamber some half a dozen youths and several bearded adults draw studiously from small sculptural models, probably both antique and contemporary, scattered on the floor, along with parts of a skeleton.[52] At extreme right, Bandinelli shares his knowledge of *disegno* with a small group that listens intently. Redolent of peaceful and diligent communal study, the print proposes that the art of sculpture was not heavy, manual labor, suitable only for those at the bottom of the social hierarchy, but rather a liberal art based on *disegno*. In Bandinelli's equivalent, in his own terms, of Filarete's *storietta* on the reverse of the doors to St. Peter's, the sixteenth-century

146

artist has transformed the fifteenth-century sculptor's noisy, dusty *bottega* into a quiet, clean *accademia*.[53]

Weil-Garris Brandt proposed the importance of the sociable Raphael as an exemplar for Bandinelli – the most charismatic and beloved of artists as role model for one of the least charismatic and most disliked. Bandinelli aspired – as surely did many others in the 1520s and 1530s – to follow Raphael's example as a prince among painters, one who lived the life of a great courtier in luxury in papal Rome.[54] Bandinelli must have longed for the ideal of "social, artistic, and personal acceptance," that was the myth of Raphael's workshop, attributable to the master's personal qualities and social skills, especially that of harmonizing rivalries – qualities in which the sculptor himself was so deficient.[55] It is paradoxical that the artist who was tortured by so much ambition, *invidia*, that it rendered him incapable of normal social intercourse should here construct himself as performing among youths eager to learn from his instructions and models. This *fintore* was the most prolific male self-portraitist of the century, but of all his self-projections this image may be the most revealing. Bandinelli, whose tormented soul and abrasive personality placed him in open conflict with his fellows – in Vasari's (admittedly hostile) words, "so strange and difficult [*fastidioso*] that neither indoors nor outdoors could anyone converse with him" – here wears a mask of peaceful and productive concourse with his fellows.[56]

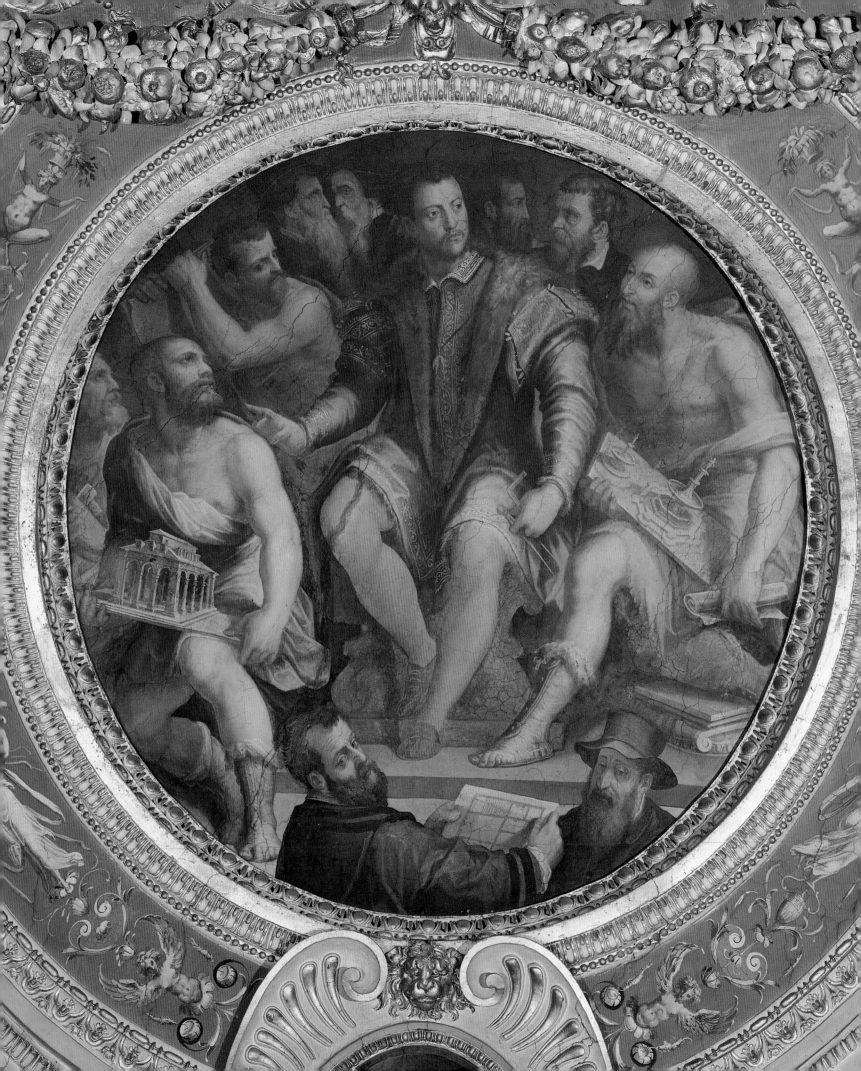

VASARI AND THE CINQUECENTO WORKSHOP

99 Circle of Vasari, *Giorgio Vasari*, panel, 1571–4, Galleria degli Uffizi, Florence.

By the end of his life, after an extraordinarily successful and busy career as painter, architect, and historian, Giorgio Vasari had decorated not one but two houses, written an account of his own career as well as the *Lives* of a host of others, created illustrious ancestors to whom he paid homage by founding a family funerary chapel in Arezzo, given himself a leading role in two group scenes decorating Cosimo I's Palazzo Vecchio, and founded the Accademia del Disegno. To the last, this indefatigable entrepreneur never ceased to work; he died in harness, as it were, on the scaffold of Florence cathedral.

Unexpectedly, however, he does not seem to have experienced the need to create an autonomous self-portrait, preferring to fashion the self surrounded by others – usually those in some way beholden to him; the portrait of Vasari that hangs at the head of the Corridoio Vasariano with the Uffizi collection of self-portraits was not painted by the artist himself (pl. 99).[1] Nonetheless, the *finzione* was produced by an artist from his circle, not long before he died, and must figure the artist as he wished. Resonating with well-earned authority, Vasari's dignified presence is emphasized by the gold chain of a papal Knight of the Golden Spur and St. Peter, and by the attributes of compass and ground plan required of the surveyor of the duke's works. Only a pen, however, not a copy of the book itself, makes reference to the second edition of the *Lives* issued a few years earlier.[2] Not surprisingly, this autonomous portrait by a close companion conforms to the self-image Vasari himself promoted in the group portraits in the Palazzo Vecchio, on which this chapter focuses.

The first scene is one of four tondos in the Sala di Cosimo I in the apartment of Leo X, 1555–8 (pl. 98), a room devoted to the career of the current Medici ruler.[3] Of the four, two dealt with military campaigns and a third with Cosimo's legal assumption of the dukedom. In this, the fourth, viewers were invited to ponder the political role played by the visual arts as an instrument of Cosimo's cultural and social policy. The richly dressed duke, seated in the midst of his architects, engineers, and sculptors, is presented under the guise of Architetto, holding compass and set square with ground plan folded over his knee. Vasari gave him a pose and gesture that can be read as echoing that of the seated Marcus Aurelius in the relief panel of *Liberalitas* from the Arch of Constantine.[4] Marcus Aurelius's patronage of the arts, not to mention his military successes, and his reputation for stoic probity, made him an role model for contemporary rulers with aspirations to empire. Indeed, it has been argued that he was an important model for the current Holy Roman Emperor, which would have further recommended him to Duke Cosimo and his artist.[5] It was Vasari's aim to persuade the duke that his love for the arts matched the glorious patronage of the past, whether that of the Roman emperors or his own Medici ancestors, and the theme of the *Liberalitas* relief was, appropriately, the emperor's donation of money to Roman citizens.[6]

Cosimo's architects, engineers, and sculptors surround him like satellite planets revolving around a sun god, the source of all artistic undertakings of merit in

98 Giorgio Vasari, *Cosimo I de' Medici surrounded by his Architects, Engineers, and Sculptors*, fresco, 1555–8, Sala di Cosimo I, Palazzo Vecchio, Florence.

Florence.[7] In Vasari's construction of the duke's immediate artistic circle, those artists who were already dead, and therefore no threat to the painter – G. B. di San Marino, Battista del Tasso, and Tribolo – are placed closest to Cosimo, and are largest in scale. Wearing scanty antique draperies and bearing architectural models, Vasari presents them as gazing beseechingly at their lord, seeking, on one hand, the duke's personal acceptance and, on the other, his approval of their designs. At the bottom of the tondo, below the duke's feet, and considerably smaller in scale, the impresario himself addressed the viewer – the same duke to whose exploits the room was dedicated – holding up a ground plan, probably connected to the Palazzo Vecchio renovation. The only figure to make eye contact with the viewer, Vasari has the stance of one who takes total credit for the actual and potential productivity of the other creators in the tondo, as if to say to the figure of Cosimo below, "*ecco*, behold what I alone can present you with."[8]

Vasari's real rivals were either, like Bronzino, omitted from the tondo or, diminished in scale, relegated to its darkest and least visible areas. Over Cosimo's left shoulder the heads of Luca Martini and Ammanati eye each other. Crowded into the smallest and murkiest area to his right are the profiles, nose to nose, beard to beard, of the two great enemies, Baccio Bandinelli and Benvenuto Cellini. Bandinelli died before he could protest Vasari's antagonistic *Life* of him, but he must have registered this visual insult with anger against its creator who was not fit "to shine my shoes," and Cellini must have been apoplectic to discover himself both so effectively dismissed as of no importance to the duke and forever linked to the hated "Buaccio" ("ugly ox").

Such was Vasari's wish-fulfilling pictorial presentation of the contemporary art scene at Cosimo's court. He established visually for all eternity his version of the relations among the duke's artists, and between them and their patron. Among the ten men portrayed, only three can be said to be the "self-portrait type," as we have previously defined this individual: one interested in self-declaration in autonomous portraiture, decorating his own house, creating his own tomb monument, writing an autobiography, forming an art collection, and/or pursuing titles of nobility, in this case Cellini, Bandinelli, and Vasari himself. Of these three, the viewer's attention is certainly not directed toward Cellini or Bandinelli, the two outstanding artists with whom Vasari could be compared – and compared unfavorably; the focus is instead on the late, minor artists in wispy, classicizing drapery.[9] By excluding other contemporary, eminent painters, such as Bronzino, from this charmed circle, Vasari further banished the competition.

Vasari here mediated between the (hopefully) munificent Cosimo and his artistic creators, just as throughout the *Lives* the author mediated between each artist and his readers. There Vasari sought to minimize the achievements of the court artists in the early part of Cosimo's reign, before his own appearance on the scene.[10] In planning the second edition of his *Lives*, he minimized or elided the careers of some of his contemporaries, while cleverly misrepresenting or openly maligning those of others. He used the *Lives*, in the words of one scholar, "to efface the careers of Tasso, Iacone, Foschi and Bachiacca, to slander the career of Bandinelli, to undermine that of Pontormo, and to diminish those of Bronzino and Tribolo."[11]

This strong Vasarian imprint on the visual and biographical configurations of his companions at court is mirrored in the autobiographical aspects of the *Lives*, by the propensity with which the character "Giorgio Vasari" turns up in the lives of other artists of the third period, so that his own career is interwoven into those of his peers. Thus, Vasari throughout the book presents his own triumphs, his travels and projects, his art collection, his antiquities, while ostensibly writing of others. His own trip to Mantua is included in the *Life* of Giulio Romano; the guided tour of Rome which he gave to Titian in that of Peruzzi; his work in Pisa in that of Perino del Vaga; his crucial role in the foundation of the Accademia del Disegno in that of Montorsoli; his

work in Camaldoli, Naples, and Rome in that of Giovanni da Udine; his recognition as a youthful prodigy in that of the Aretine Signorelli, a key forefather in Vasari's own artistic lineage. The gift from his fellow citizens of the principal chapel of the Pieve, the most revered church in Arezzo, is in that of Piero Laurati; their studies together in Rome, and "Vasari's" dedication to study, in that of Salviati; "Vasari's" modesty in that of Tribolo.[12]

Vasari would often contrast his own courtly elegance and worldly ease of manner with the foibles and peculiar habits of others.[13] In the life of Aristotile da Sangallo, for instance, he triumphs verbally over his enemy Iacone ("I used to dress in clothes of poor people, now in velvet. I once travelled on foot, now on horseback"). He would put his own praise in the mouths of others, even obtaining the "divine" Michelangelo's approbation in a letter purportedly written to Cosimo recommending Vasari's interior decoration program.[14] Vasari's *Lives* can be said to constitute one of the major autobiographical documents of the Renaissance; in many ways Vasari transformed the *Vite* of others into his own biography.[15] If the first edition was a monument to Michelangelo, the second has to be recognized as one to its author.

Vasari's emphasis on the dominance of *invidia* in the Cinquecento contrasts strikingly with his construction of relations among artists in the early Renaissance, when the true *fratellanza* or supportive brotherhood that pertained among the artistically talented, had, he claimed, been "untouched by envy."[16] By contrast, he drew a picture of the contemporary art scene as competitive, acrimonious, and vicious, in which artists of goodwill, like the character "Giorgio Vasari," suffer the malice of others. In his fictionalized account of Gaddo Gaddi, Vasari created a Trecento model of the generous artist, and proposed the existence then of an ideal community of the brotherhood of art. Again and again, this ideal, he implies, has been resurrected in himself.[17] Vasari stressed his own sense of brotherhood, his generous behavior toward competitors, and his genuine affection for friends and disciples like Gherardo, Mosca, Tribolo, and Salviati: "Was Vasari such a gentle, loving soul?" queries Barolsky,

> Who knows? Certainly "Vasari" was! . . . [He] portrays himself, as Michelangelo presents the self in his own autobiography dictated to Condivi, or as Cellini did . . . as a figure of courtly sagacity: a self-portrait in which "Vasari" is wise, superior, loving, above envy and greed.[18]

In the tondo Vasari's proximity to the duke – literally at his feet on the same vertical axis – forms a crucial part of the Aretine's aggrandized self-image. It was Vasari's strategy to stress his close family links with his Medici patron, a pedigree similar to those also claimed by Bandinelli and Cellini.[19] The antiquity of the ties was established in his fictionalized *Life* of his ancestor Lazzaro, who, far from being "famous as a painter in his day . . . throughout all of Tuscany," was a saddler, not an artist.[20] Lazzaro's son Giorgio, purported maker of terracotta pots, was invited by Lorenzo the Magnificent to enter into his family's service, where the Vasari had remained ever since, Giorgio – whose entire career had evolved under the protection of one Medici or another – being appointed *capomaestro* to Cosimo's court in 1555. Thus from humble beginnings in clay, Vasari positioned his family and himself at the feet of the ruling prince, at the summit of society. Vasari was without doubt the ultimate courtier-artist, *the* consummate sixteenth-century artistic self-fashioner, and his is an image that stressed his efficiency, physical stamina, political wiles and communication skills.

One would never guess from the impresario in the tondo or the portrait by his follower that Vasari was primarily a painter. In both, ground plans are prominently positioned, and the portrait features also a compass, attribute of the geometrician and the architect, as well as a paint brush. The compass was important as a symbol for Filarete, when he had not (yet) designed buildings, and for Bramante, in the guise of Euclid

the geometrician, who had (pls. 39, 67, 84). It was also the instrument with which God the Supreme Architect measured the universe in medieval miniatures to ensure *his* Creation's correct proportions (pl. 69).

In terms of social status, even at mid-sixteenth century, architecture was still ahead of sculpture and painting. The material factor of cost – the much greater expense of construction – entered into this equation, along with the undeniable fact that the creation of a building did not depend on the designer's hand wielding a chisel. By the mid-sixteenth century, architects were supposed to be learned in the sciences, to be trained, in the words of Vitruvius, in writing, drawing, arithmetic, optics, philosophy, medicine, music, jurisprudence, and astrology – or at least some of these.

Thus, the compass as symbol was sufficiently worthy to be held by Cosimo I in the tondo, where indeed it is implied that, like God designing the universe, he, too, has been wielding this instrument – perhaps to produce the ground plan folded over his knee – just as his ancestor Lorenzo the Magnificent did when designing a facade for Florence's Duomo. Indeed, in a scene in the Salone, the duke is actually shown plotting an attack on Siena by manipulating the compasses over a map of Tuscany.[21] There were accordingly many excellent reasons why painters who, like Vasari, also designed buildings, would present themselves exclusively as architects. Although Giulio Romano was always addressed as "Julio Pictor," and building was only one aspect of his many professional activities at the court of Mantua, he, too, holds up a ground plan in his portrait by Titian (pl. 94).

★ ★ ★

The other group portrait in the Palazzo Vecchio in which Vasari included himself is on the ceiling of the Salone, on the right side of the *Return of the Marchese of Marignano to Florence after the Conquest of Siena* (pl. 101).[22] Lining the route taken by the triumphant procession returning victorious from the battlefield are two superimposed rows of large male busts accoutered in contemporary dress. At center front, Vasari constructed himself leaning forward to show a paper to Vincenzo Borghini, the President of the Accademia del Disegno, at left, and the historian Giovanni Battista Adriani, the two programmers of the fresco decoration. Borghini, as he himself said, would "express my conceit," which Vasari and company would then translate into concrete images. Vasari grouped these assistants in execution immediately behind: the painters Battista Naldini, Giovanni Stradano, and Jacopo Zucchi, leaders of surely the most efficient workshop since that of Raphael, in terms of the hundreds of meters of wall frescoed. As artistic director of the whole enterprise, Vasari gave himself the privileged position at the center of the group, just as he was to give his own life the privileged position as the climax of the second edition of his history of Italian art, capping the careers of every other artist, dead or alive. The inclusion of the artistic portraits in this particular scene, over and beyond the appropriate context of triumphalist iconography for commemorating a union of humanists and artist, of intellect and hand, is not fortuitous. It was the central scene on the Salone's longitudinal axis, prominently located opposite the main entrance in the only site in the palace that was open to the public, hence accessible to a wide audience.[23]

The Salone is not symmetrical, and near a corner over the Udienza, Vasari was able to fit four portraits of his shop assistants, dressed up like gentlemen (pl. 102). Leaning over a fictive balustrade, mason, carpenter, gilder and grotesque painter observe with interest the visitors below as they turn to one another to point out acquaintances.[24] On either side of them, putti play on the balustrade, those at the corner supporting a plaquette with inscription, reminiscent of that in Mantegna's painted chamber.

100 Detail of pl. 101.

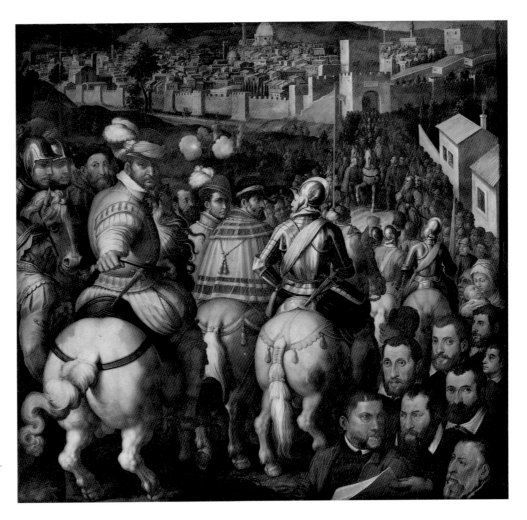

101 Giorgio Vasari, *The Return of the Marchese of Marignano*, fresco, 1563–5, Salone dei Cinquecento, Palazzo Vecchio, Florence.

These three group portraits in the Sala di Cosimo I and the Salone can be read as signs of descending social rank: at the apex, the duke, surrounded by *his* primary cast of architects; then Vasari surrounded by *his* primary team of advisors and painters; then, without Vasari, the mechanical workers without whom the decoration could not have been accomplished.

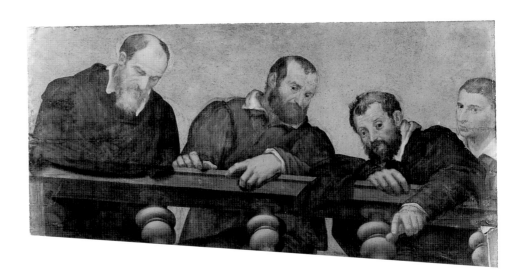

102 Giorgio Vasari, *Portraits of Members of the Artist's Workshop*, fresco, 1563–5, Salone dei Cinquecento, Palazzo Vecchio, Florence.

The two paintings in the Salone in particular join works by Filarete and Bandinelli as among the few visual references in Italian art to the many artists involved in the creation of art or artifacts. Filarete, on the back of his door into St. Peter's, gave an idealized picture of the relaxation of the shop workers, who still wear work aprons, at the end of the task (pl. 38). The Accademia engraving by Enea Vico after Bandinelli of around 1550 – surely influenced by the contemporary publication of Vasari's book – celebrated, as would be expected, a totally different aspect of the production of art: the intellectual work of the mind – the necessary *disegno* – before execution could begin (pl. 97). All is quiet as the master sculptor, his followers, and assistants bend over their drawings, absorbed in artifacts, antiquities, and, presumably, their own *invenzioni*.

Filarete cast the artistic self as a democratic *maestro* who joins the celebration of his subordinates, while Bandinelli fashioned the artistic self as another Raphael – the charming Urbinate as poetically conceived by Vasari.[25] Bandinelli's "academy" is presented as an extended family over which the Raphaelized master – whose personal relations were in reality so disastrous – hovers protectively as wise and indulgent paterfamilias. Bandinelli's engravings were autonomous works, and Filarete's plaquette too is separated physically from the obverse of the door to the basilica. Vasari's group portraits, on the other hand, are included *within* the palace decoration, and hence were visible to the patron and all who came to admire the Salone's renovation. Just as from the Trecento on, it finally became fitting for the master artist to include his own features among the witnesses to the holy stories in altarpieces, so, some two hundred years later, it was finally considered appropriate to include actual portraits of the *bottega* workers as "peripheral material" in scenes of a prince's secular decoration.

The distance between visual constructions of the mid-Quattrocento and the mid-Cinquecento are indicative of the rising status of the artist, who is conceived as all manual by Filarete, except for himself, but all intellectual by Bandinelli. Vasari, in his turn, had the pictorial space at his disposal to enable him to separate the craftsmen from the more educated *artefici* as well as to introduce a new category into the cast of characters who produced the art: the humanists who worked only with words, which others then translated into physical images. The fact that Vasari's commemoration of his manual team – albeit not so identified by their workclothes – was marginalized to a corner of the hall should not conceal the advance in social status claimed by the visual representations for even the most menial workers in the shop. It would have been inconceivable a hundred years earlier.

Chapter 16

CELLINI AND *INVIDIA* AT COURT

I have told the whole truth (*Ho ditto la pura verità*).
—Benvenuto Cellini[1]

Should Benvenuto Cellini, the Florentine artist who failed to create a visual self-image of *any* kind, be included here? How, on the other hand, to justify omitting, from a study of Renaissance artistic self-presentation, the *fintore* who wrote the most famous *literary* self-portrait of the entire early modern period? Cellini's *Life* ensures that we are better informed about his interpretation of his passage through this world than that of any other Renaissance artist. The word, long privileged in Florence, was particularly favored by the self-portraitists at the mid-century Medici court. As unique primary sources, the accounts of Bandinelli, Vasari, and Cellini will be used to explore the relationships among them, and between them and the center of power.

"I am rather hot-blooded by nature," wrote Benvenuto Cellini, an understatement from one not given to understatement by nature.[2] That "hot blood," the choleric humor that he espoused, led to bursts of vicious rage that caused him to commit a number of violent crimes. His fault, he said, lay in his stars (Mars in Scorpio) which drove him, against his will, to perpetrate acts of violence.[3] An eye-witness account of one of these fits of rage, when he was competing with Ammanati in 1560 for the marble *Neptune*, was written by that other Cinquecento court artist-assassin, Leone Leoni: "Benvenuto is flaring up and spitting out venom, flashing fire from his eyes, and flouting the duke with his tongue . . ."[4] Insolent, impetuous, ferocious, and boastful, this intrepid fighter might well have made his reputation as a *condottiere*, being "perhaps more inclined by nature to the profession of arms than to the one I had adopted."[5] Benvenuto Furioso, to use Barolsky's apt phrase, murdered at least four people, for one of which he was condemned to death; for other unsuccessful attempts at homicide, and for sodomy, he was sentenced to several prison terms, not all of which he served.[6]

He was, Vasari wrote, *prontissimo e terribilissimo*.[7] Signifying "alert, prepared for action," *pronto* in the superlative may be translated as "too jumpy, overreactive;" Benvenuto was too quick to leap into the fray and fling words or weapons at the enemy. As he wrote about an assault on Bandinelli: "I had resolved . . . I would hurl him to destruction . . . On the instant [that I saw him] I decided upon bloodshed."[8] *Terribile* referred both to the character of the artist and to the style, the implied grand manner he practiced. The term linked behavior and art, so that the artist's character, as manifested in his art, would be deemed *terribile*.[9] Vasari also used the term to characterize Michelangelo's Sistine frescoes, implying an association between artistic *terribilità* and the terror that God, the subject of so many of the scenes, could inspire. Again, Vasari's superlative form of the word in relation to Benvenuto made it all the stronger.

Cellini's autobiography is now regarded as a major contribution to early modern vernacular literature.[10] By dictating it, the author produced something that had not existed before he started: a commemoration of the speaking self. New to Italian literature was the Tuscan vernacular, which has the flow and immediacy of a spoken, not literary language, and the vigor that the colloquial tradition represented.

Despite his creation of a distinctive identity with the pen, however, Cellini's *singolarità* was such that he defied expectations by failing to experiment with visual self-imaging. Cinquecento sculptors seem to have done so less frequently than painters, no doubt because of the expense of the materials, whether marble or bronze, although such considerations did not inhibit Bandinelli. In addition, Cellini is not known to have shown interest in painting, and hence could not immortalize himself with the brush, as Bandinelli had done. Nonetheless, there is no totally satisfying explanation for Cellini's omission; the factors mentioned certainly did not prevent this medalist from creating his own medal, like Leoni, or, at the very least, getting a self-portrait drawing engraved by a professional, the means used by both Bandinelli and Titian to spread their fame and features across the world.

The role that a mythologizing text could play in self-celebration must have been an important factor underlying the veritable explosion of Florentine biography, autobiography, and autobiographical treatises in the 1550s and 1560s. Benvenuto's text, composed rather late within this sequence, has to be understood as part of the continuum. These literary self-projections all postdate publication of Alberti's treatise, *De Pictura*, in 1540 in Latin and 1547 in Italian. In 1550 the major event in the history of both art and letters was publication of Vasari's mammoth *magnum opus*. Following this event, Michelangelo, the only living artist included in Vasari's book, took immediate exception to the Aretine's interpretation of his life and work, and recaptured control over his own career – put his own spin on it, as it were – by dictating his own version to Condivi. Then Bandinelli, one of the no doubt many who felt he too had merited inclusion in Vasari's book, started writing his *Memoriale*. A few years later Cellini, stimulated by knowledge of the despised "Buaccio's" text, took control of *his* public image by dictating, just as Michelangelo had done. A few years later Vasari followed his example; and, like Ghiberti, inserted a long account of his *own* life into his second edition, which can be read as an astonishingly elaborate structure with which to highlight his own achievements as the last great Renaissance artist. The individuals who make up our cast of artist-performers accordingly manipulated not only art to project visual myths about the self but also words in order to *fabbricare*, as Michelangelo put it, fictions of historical personae.[11]

L'onesta invidia, "honorable Envy," wrote a critic, was what drove Cellini's *Vita*.[12] The book was born at one of the lowest points of Benvenuto's career, when he was serving a four-year prison sentence which had been commuted to house detention. The sculptor who told King Francis I that he would fall ill if deprived of manual work had been forced into inactivity – *scioperato*, he said, forced into striking. Out of favor with Cosimo I, he had little hope of future commissions to sustain him.[13] The final insult was the duke's refusal, when petitioned by French envoys from Catherine de' Medici, to allow Cellini to return to France to work on the tomb of King Henry II.[14] Mortified, bored, nursing grudges that made him deeply resentful of the patron who had insulted him by preferring Bandinelli and Ammanati, Cellini turned to the pen to avenge himself:[15] "Since I couldn't make [*fare*] things, I started to say [*dire*] them."[16] His was an enforced conversion from *homo faber*, as it were, to *homo dicens*.

Only one character in the *Vita* is fully rounded, the protagonist, an artist named Benvenuto Cellini. His is a pugnacious and aggressive nature, with a wicked tongue that cannot resist a cruel word. Nonetheless, he is the just man always in the right.[17] The other characters fall into two broad categories, the powerful rulers who become the protagonist's patrons, on the one hand, and those who became the protagonist's artistic rivals, on the other. These subsidiary characters, who are usually small-minded, wretched, and mean, appear only in terms of their interaction and confrontations with the protagonist, in the case of the patrons, or the often brutal verbal and physical assaults, in the case of artistic rivals. One of the most novel aspects of the persona of

the protagonist "Cellini" was his conviction that he was equal or superior to his regal and papal patrons. This conviction of parity with the ruling class led both author and hero to address the world with the authority of a prince, or, to render it more accurately, the authority of *ingegno*, artistic talent.

The book's thesis was the author's rehabilitation against these rivals. "I write not my exploits [*gestes*], but my self and my essence," wrote Montaigne.[18] Cellini wrote his *gestes*. The embattled performance of the hero, the "greatest man of his profession ever born" (*maggiore uomo che nascessi mai della sua professione*), a swaggering braggadocio, to use an Elizabethan ethnic slur, was intended to counteract the miserable rumors put out by his numerous *invidiosi* detractors at the Medici court.[19] It was the ideal portrait that the sculptor wanted to leave to posterity, with essentially the same aim as the painter who creates a self-image by employing brush or chisel rather than pen.[20]

★　★　★

"I have told the whole truth."[21] The reality of court life in Florence was, it seems, far removed from the picture of charm, grace, and decorum that Castiglione painted in his picture of Urbino in his book. Any court with more than a couple of artists competing for position and commissions as they gravitated around the center of power, must have become an artistic minefield.[22] In Florence, however, rivalries seem to have been especially acrimonious, artistic *invidia* particularly vicious, and, as was so often the case in that city, the situation is exceptionally well documented – in this case, by the participants themselves.[23]

It is difficult to imagine three other people who portrayed themselves as hating each other as much, were seemingly so uninhibited about committing their prejudices to paper, and whose paths at court must have crossed so often, as Cellini, Vasari, and Bandinelli. The rivalry of the two sculptors, Cellini and Bandinelli, competing for the same court commissions, might have been expected, but not the bitterness with which it was articulated, nor the license with which they engaged in loud, vituperative quarrels, which both Vasari and Cellini always imagined as occurring in front of Cosimo I, to whom each antagonist would in turn appeal for censure of the other. Thus, as Vasari makes clear, vilification of the rival was the norm:

> Baccio could not conceal his thoughts, but expressed them freely . . . saying many of his biting words [*parole mordaci*] to Benvenuto . . . [and] Benvenuto . . . took pains to be even with him. Thus arguing often . . . and pointing out each other's defects, they would utter the most slanderous [*vituperosissime*] words of one another in the presence of the duke.[24]

Cellini and the individual he dubbed "Giorgetto [or] Giorgino Vassellario" (little George, little maker of *little* vases), also thwarted each others' projects when they could.[25] Cellini did not take the Aretine painter seriously, and always associated his name with a belittling epithet.[26] Sensitive to physical appearances, Cellini also found Vasari physically disgusting, and hated the sight of what he described as the Aretine scratching his dry scabs with filthy, uncut finger nails.[27] This and other such statements understandably led to a *very* curtailed account of Cellini's career by Vasari in the 1568 edition of the *Vite*, where he also made a surely malicious reference to Cellini's autobiography, in the very years in which Cellini found it opportune to pretend that the pages on the Florentine period had been destroyed.[28]

The relations between Vasari and his first master, Bandinelli, were equally bad. For years Bandinelli held the determining artistic position in Florence as advisor to the ducal couple, before the wily courtier Vasari usurped his position. Vasari, wrote a furious Bandinelli, was not sufficiently competent in *disegno* to lick his shoes (*abile in disegno*

a sciorni le scarpe).[29] Vasari of course always had his *Lives* to hand as a convenient weapon, one that he did not hesitate to use. His poor evaluation of Bandinelli's sculpture subsequently became a canon of Renaissance art history. In art Vasari also had the ultimate revenge against both of his antagonists, placing them at very small scale, and in the most marginal location possible, in the roundel in the Sala di Cosimo (pl. 98).

Benvenuto Furioso's *Vita*, spoken with so much passion, has been interpreted as his vendetta, his revenge on the Medici duke who failed him, whom he fashioned as a small, mean, prince of a small principality (*piccolo principe di un piccolo principato*), one who "had the style of a merchant, rather than that of a duke," a close-fisted business-man rather than munificent prince – in short, a far cry from the duke's self-fashioning as the *optimus princeps* who reigned over prosperous Etruria. In his disappointment and rage, Cellini seems to have written for publication, an unlikely eventuality for a manuscript that vilified his ruler as lacking in passion, judgment, and taste, and who was usually bested in argument by his goldsmith – all this in passages that, albeit unpublished, were nonetheless so well known, that Cellini at one point had to pretend that he had destroyed the worst of them.[30] Indeed, Benedetto Varchi's decision not to "correct" Cellini's vernacular *stile semplice* may have been based as much on political prudence, and reluctance to become implicated in such dangerous material, as on the text's literary merit.[31] Paradoxically, the very circumstances that led to the *Life*'s composition and that provided a major iconographic theme – the artist's perception, and the author's projection, of the duke as hostile, or in our terms the artist's psychological need to turn all authority figures into enemies – also prevented its dissemination by publication, if not by clandestine circulation. If Cosimo had some inkling of the highlights of Cellini's portrait of him – and how could he *not* have known, given such an indiscreet author of a manuscript probably circulated in samizdat, and the intrigue-filled, in-bred art world of mid-century Florence – he certainly got his revenge, by neither giving Cellini work, nor allowing him to work for anyone else.[32] Inevitably, the patron, source of funds, had the upper hand.

The audience reached by many autonomous self-portraits, unlike those included as witness in religious compositions in churches, was limited. Bandinelli alone among Florentines had been sufficiently canny to exploit fully the new technology of printing, in order to increase the dissemination of his self-image. Had Cellini's *Vita* been published immediately, however, as the sculptor seems to have intended, his verbal self-depiction would have reached far more of his contemporaries than any painted or sculptural image.

Benvenuto was a new kind of court artist, an individual of outstanding talent who somehow managed to be successful despite his lack of tact, diplomatic skills, and political acumen, and his intimidating personal style. Particularly notable was his apparent inability to be subservient even when it would have suited his own best interests. Only his great talent can have made this determined non-courtier acceptable to princes, and his up-and-down career, and number of abandoned works, point up the dependence of sculptural *singolarità* on political power.

TITIANVS PICTOR ET EQVES

The study turns from Medicean Tuscany to consider three Italian artists, very different among themselves, who served the Habsburg dynasty in Spain, the Netherlands, and Germany: Tiziano Vecellio, Leone Leoni, and Federico Zuccari. They each indulged in copious autonomous self-imaging.

Titian was perhaps *the* pre-eminent court artist in Cinquecento Europe, in terms both of the numbers of works of art consumed by his royal commissioners, and of the worldly success and pensions that the *singolare* works engendered for him. Only Vasari came close to challenging Titian's supremacy in this respect. Titian produced over 150 paintings, the major part of his mature autograph work, for the Habsburg dynasty: Emperor Charles V, his son Philip II of Spain, Charles' sister Mary, Queen of Hungary and Governor of the Netherlands, and his brother Ferdinand, King of the Romans, and later emperor.[1] His other patrons were of the same high social rank: the papacy, the cardinalate, and the dukes of Mantua, Ferrara, and Urbino.

Titian sparkled and charmed in his role as courtier-artist/performer, a Venetian Raphael.[2] Vasari, who knew him personally, praised his *dolcissimi costumi e maniere*: "[He was] extremely courteous, with very good manners and the most pleasant personality and behavior . . ."[3] Like that other famous court artist, he knew how to make himself agreeable to the great, *sapeva trattenersi a farsi grato ai gentiluomini*. Dolce also hailed him as a charismatic and accomplished courtier:

> he is a brilliant conversationalist [*bellissimo parlatore*], with powers of intellect and judgment which are quite perfect in all contingencies, and a pleasant and gentle nature. He is affable and copiously endowed with extreme courtesy of behavior [*gentilissimi costumi*]. And the man who talks to him once is bound to fall in love with him for ever and always.[4]

This is what happened to the emperor, who was attracted to Titian from the outset: a special bond of sympathy seems to have developed between the most powerful ruler of Europe and the Venetian painter – resembling Pliny's account of the relationship between Alexander and Apelles – which is exceptional in the annals of patron–artist relations for its purported intimacy.[5] Titian's rooms in Augsburg, for instance, were supposedly located so that he and Charles V could "visit each other without being seen."[6]

Titian's career as a court artist was unique, in that, with the exception of his trips to Augsburg and Rome in the 1540s and early 1550s, he never lived at court. By refusing to leave Venice and by keeping his upscale patrons at a distance, he retained unprecedented freedom from harassment over works that were long overdue – Titian's delays were proverbial – and from the more burdensome tasks of the court artist: the banners, theatrical sets, and designs for ephemeral events, such as those that, in the fifteenth century, fell to the lot of Mantegna in Mantua and Leonardo in Milan.[7] In short, Titian attained a position that put him both in the service of all and in the servitude of none.[8]

The Venetian had Raphael's manipulative talents, as well as his courtly ease. The term used by Dolce to describe Titian's competitiveness was *giostrare*, to joust or tilt.[9] Titian

was very much the "self-portrait type," an indisputable careerist, avid for honors, power, and money, who used his social skills to forward his ambitions.[10] His long-entrenched family in Cadore were prominent administrators, merchants, lawyers; his father was overseer of the grain stores, inspector of mines, and captain of the militia; Titian, like any other merchant, also dealt in grain and lumber, and invested in real estate.[11] It may be noted that however courtly his manners or brilliant his conversation with the great, he did not always strike his social peers as a pleasant or generous man, a judgment that cannot have been helped by the fact that the standard of living for most Venetian artists did not go beyond that of a successful artisan.[12]

Titian produced multiple self-images – nearly as many as Bandinelli – including several autonomous self-portraits, of which two autograph paintings and a print survive. Like many self-portraitists, he seems to have been motivated to do so above all in late middle age. He also commissioned medals, included himself as a witness in many religious paintings for the Habsburgs, and can be seen kneeling piously, holding his mahlstick like a bishop's crozier, in an altarpiece that he donated to the family altar in his home town.[13]

The identity and attribution of the earlier of the two surviving autograph self-portraits (pl. 103), today in Berlin, has never been doubted – it is self-evidently by and of Titian – but the date has not been firmly established. It is uncertain whether the painting seen by Vasari in Titian's studio in 1566, supposedly painted four years earlier, was this work or the later self-portrait, now in Madrid – or, more likely, neither, but a self-likeness since lost. The facture of the Berlin painting differs quite radically from one part of the canvas to another: the face was painted with some care, the clothes rapidly, and the hands abandoned in a sketchy, seemingly unfinished, state. Most historians now date the work to around 1550, the same year as the self-portrait engraved by Britto (which will be considered in chapter 24), on the spurious grounds of what they interpret as the youthfulness of the artist's countenance and the vigor of his pose. Nonetheless, for the purposes of this study, it will be assumed that the earlier self-image in Berlin was painted in the first half of the 1550s, when Titian would have been in his early sixties, and the later Madrid work in the second half of the 1560s, after an interval of some ten to fifteen years, around the time of his eightieth birthday.

Titian fashioned the self as a richly dressed patrician, in cream-colored jacket and satin sleeves, over which he wears a dark brown coat with huge fur lapels and fur lining, clothes that had the same connotations of wealth, status, and power as those worn by the swordsman in Raphael's double portrait. The distinctive and rare skull cap that he wears in all representations resembles that worn by Bindo Altoviti in Cellini's bronze bust, where its symbolic significance, if any, is equally mysterious. In practical terms, however, it presumably protected the artist from Venice's dampness and/or concealed his baldness.[14] His only other attribute, the heavy gold chain that hangs across his breast in several strands, marks the approximate center of the composition.

This chain was almost certainly the earliest to be given by a monarch to a practitioner in the visual arts. Vasari also paraded a heavy gold chain, given to him in 1571 by the pope, but Titian's chain came much earlier, in 1533, when Charles V appointed him Count Palatine and raised him to the rank of a Knight of the Golden Spur, which also gave him the right to wear sword and spurs.

Held has established that gold chains held a well-defined set of associations for Renaissance intelligentsia.[15] Ripa listed the chain as an attribute of *onore*, an ancient sign of the honor with which the Romans rewarded those who fought bravely in war. The honor for Ripa was the esteem in which the recipient of the chain was held by the donor, always a higher authority, usually a prince. Those at the apex of the hierarchy of power in the sixteenth century revived this ancient custom, and started to bestow chains on artists, humanists, and others in recognition of their accomplishments.

103 Titian, *Self-Portrait*, canvas, early 1550s, Gemäldegalerie, Staatliche Museen, Berlin.

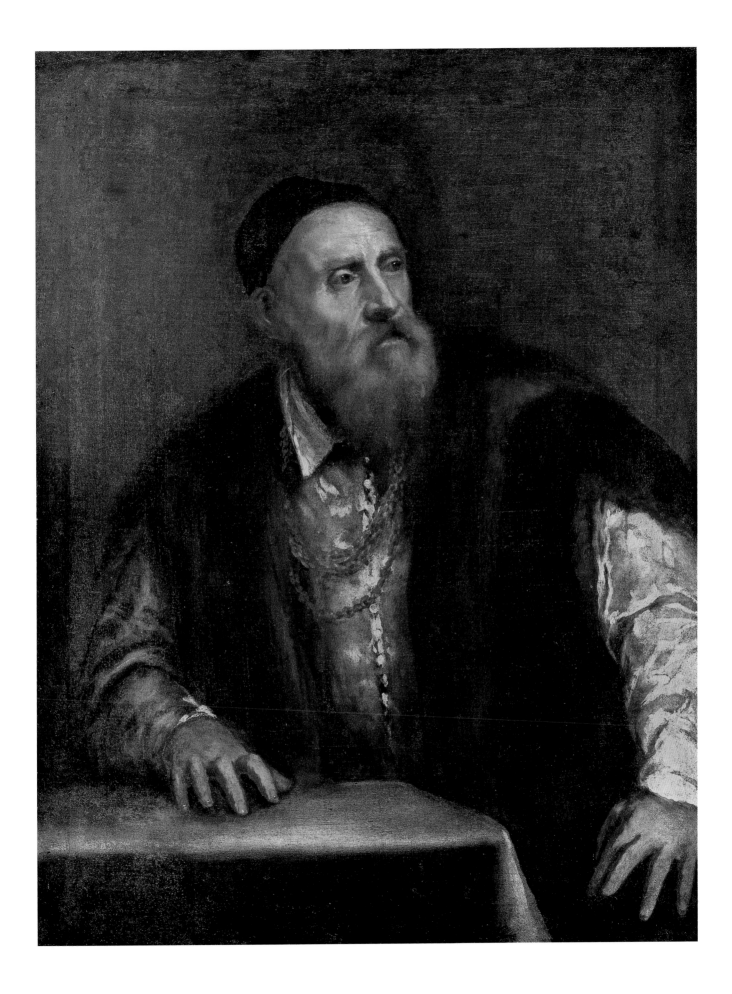

The custom became more frequent during the second half of the sixteenth and the early seventeenth century, when Rubens and Van Dyck collected several chains each from the rulers of Spain, England, and the Spanish Netherlands. The chains, much prized by the recipients both for their material value and their noble connotations, fulfilled two functions: as a real financial reward and as a spectacular demonstration of high recognition. An important precedent for the Venetian artist must have been the chain displayed by his eminent predecessor as painter to the Serenissima, Gentile Bellini, in the latter's prominent self-image, in the extreme foreground in scarlet toga, in his painting of *St. Mark Preaching in Alexandria* for the Scuola di San Marco (1504); the chain had come, also along with a knighthood, from the ruler of another empire, the Sultan Mehmet II.[16] Titian's chain thus bespeaks the recognition, in high places, of his artistic *ingegno*, in similar terms as those rewarded his Quattrocento predecessor.[17]

Titian's pose – a massive, powerful form seen frontally, hands poised tensely against table and knee, hooded eyes straining out toward some distant objective – is unprecedented for the genre and has defeated most attempts at interpretation. Wedged into a seated position (on an invisible support) between a neutral background and a small table, his torso swells to fill most of the available picture surface. The pose is ambiguous, but suggests imminent action, as if the artist were about to rise to his feet, the better to view some distant objective. Compositionally, his form is based on a pyramid in space or a triangle on the picture surface, his head at the apex and his hands at the two lower points.

The work recalls Leonardo's experiments with drama and movement in his portraits of Cecilia Gallerani (pl. 89) and Mona Lisa, and Giorgione's similar experiments with poses suggesting action or narrative, which Ridolfi later characterized as portraits *in atto di . . .* , that is, a pose that lent a fiction of movement, and hence life, to the figure portrayed. Titian's self-image can also be characterized as a portrait *in atto di* – one is tempted to add *alzarsi*, "in the act of rising," in that the artist concentrates on a vertical rising motion, rather than the lateral twist of the body that Giorgione gave to himself, or Raphael gave to his seated friend in his double portrait. Titian, however, jettisoned the element of allegory that Giorgione had added to his conception of portraiture and self-portraiture – just as he would consistently de-emphasize allegory throughout his career.

There is one major difference between Titian's self-image and those previously considered, a missing component that had been such a consistent feature of earlier self-portraiture as almost to constitute an attribute. Titian averts his eyes from the viewer. If we compare his pose to that of Parmigianino (pl. 92), who depicts himself seeking his own eyes in the mirror, the latter's apparent eagerness to communicate with the work's Medici papal recipient, to whom he offers his hand and its creative fruits, throws Titian's image into sharp relief. Titian's denial of eye contact – in effect, his refusal to be seen contemplating himself in the mirror – endows his image with a psychological reticence that is not unlike the effect of aristocratic distance given by the profile portrait to the Quattrocento prince, in that it suggests that the Venetian artist lived in a nobler realm, separated, like the patriciate, from the rest of mankind.[18]

Parmigianino presents himself at the same level as the seated viewer-recipient, toward whom he slides his hand across an expanse of table as if to push it beyond the picture surface into the sphere of that all-important source of future commissions. While hypothetically also seated at the level of the beholder, Titian, however, isolates himself from the viewer-recipient's spatial sphere by using the table behind which he sits as a repoussoir. Often employed as an attribute-bearing surface, Titian's table, deprived of that function, presents a vivid contrast to that in front of Leo X in Raphael's portrait of the pope (pl. 88).[19]

Titian's use of very large brushes and his fingers when painting his late works is

well known from the account that Boschini derived from Palma Giovane: "for the final touches he would blend the transitions from highlights to half-tones with his fingers . . . In the final stages, he painted more with his fingers than with the brush"; that is, the artist abandoned the mediating implement, the brush, to work directly with his hands.[20] At the risk of over-interpretation, I propose that Titian's hands, like Parmigianino's, were here intended to be seen as attributes – ones conceived by technique and style rather than iconography – and that the *non-finito* of their facture may have been deliberate.[21] The very placement of the tensely poised hands at the two lower points of the triangle on the picture surface seems almost designed to draw the viewer's attention to them. These unfinished fingers were after all those with which he literally created his late works. What more suitable style for the fingers than the style which only the fingers themselves could create? Here, style, albeit localized style, may be said to function as an attribute.

An artist needed solitude in which to concentrate on the conceptual sub-structure of his art. We may hypothesize that the imminent action depicted here is the artist's central task of creation. Hypothetically, the eschewal of eye contact and the active pose of compressed bodily force signified for Titian the process of creation, that is, the profound thoughtfulness and physical energy – the *furor* – that seized his mind and body when pondering the genesis of a painting. According to this proposal, that distant objective on which the artist struggles to focus is the embryo of a pictorial idea. Titian presents the self not as *looking at* something, but as *thinking about* something. In this interpretation, the three points of the pyramid may be read as revealing the relationship between Titian's brilliant *ingegno* at the apex, anchored by the skilled *arte* of his two hands at its base. At the heart of the triangle and the center of the composition is the reward of the golden chain that the correct balance of his conceptual and technical skills have earned him.

What was the social context of Titian's life at the time he conceived this self-portrait? At the end of his life Titian was the most famous living artist in Europe, but, even twenty years earlier, around the period that he painted this self-image, the esteem in which his art and his person were held by the ruling classes throughout Europe was unique, with the exception of his great rival Michelangelo. This work comes at the end of a decade, early 1540s to early 1550s, during which Titian was constantly sought after by the crowned heads of Europe – when, it has been said, his brush became an indispensable adjunct for the consecration of any grand event – when he did, in fact, leave Venice for substantial periods of time, to paint portraits in Augsburg, Rome, and Milan.[22] As the most eminent artist in European court circles, Titian, like Michelangelo, can be characterized as having achieved the social status that had been the goal of Renaissance painters since Alberti's first articulation of such a program in 1435.[23] The esteem in which he believed he was held and the confidence he had in his own powers can be said to be mirrored in this autonomous self-portrait.

To whom was this self-likeness addressed? According to Vasari, an earlier (lost) self-image created in 1545 was intended "to preserve his memory for his children."[24] The desire to address a private familial audience offers a generalized motivation for many Cinquecento self-portraits, including that in which Bandinelli commemorated his dual triumph, which probably hung on the walls of his house for the benefit of his descendants. In the case of Titian's Berlin work, however, it or a copy was widely known and available for (further) copying. Titian's unusual pose became the standard image of the artist, used for copies and pastiches. Since the artist addresses neither the viewer nor a participant within the painting, it proved to be an extremely awkward formula to integrate successfully into other works.

Vasari said that Giorgione's *Self-Portrait as David* was in the collection of Giovanni Grimani (pl. 82).[25] The majority of Titian's self-images also seem to have been

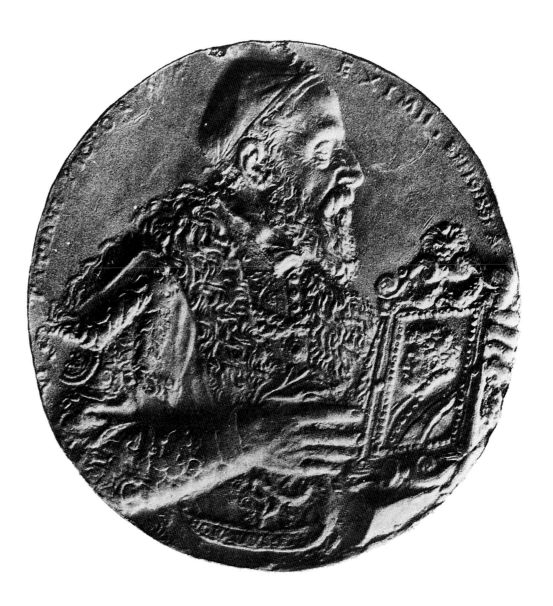

104 Attributed to Agostino Ardenti, medal of Titian with portrait of his son Orazio, bronze, c.1563, whereabouts unknown.

destined as gifts to his patrons, that is, for public rather than for personal use. His intimate friend Pietro Aretino was a great believer in the long-term benefits of sending unsolicited gifts to prospective or current patrons, and the courtier–artist sent one such, since lost, to Charles V in March 1550.[26]

Perhaps anticipating the emperor's abdication, Titian sent another (lost) self-portrait to the future Philip II in 1552/3, in which he held a small image of the Spanish monarch and which the king displayed in his "royal room of portraits." The composition may have resembled a medal made by Agostino Ardenti, in which a profiled Titian holds a profile portrait of his son, Orazio (pl. 104).[27] It must have been a very early instance of an artist conjoining in one work his own features with those of royalty. In his 1533 patent of nobility Charles V had characterized Titian as a modern Apelles, and himself as the current Alexander. Thus, *if* the self-likeness with image of future monarch resembled the compositional format of Ardenti's medal, the Venetian Apelles gave himself clear priority over the *next* Alexander, Philip II. Of the two profiles, that of the monarch would have been marginalized by its small scale and subsidiary location in relation to the artist's centralized and infinitely larger presence. Apart from medals, however, the profile portrait was little used in the second half of the Cinquecento, and it seems unlikely that Titian would have *painted* a double portrait in which both sitters were presented in profile.

164

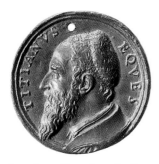

105a Attributed to Pastorino da Siena, medal of Titian, bronze, 1540s, obverse, British Museum, London.

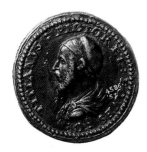

105b Unknown medalist, medal of Titian, bronze, obverse, Victoria and Albert Museum, London.

Titian signed the 1559 *Entombment* (Prado, Madrid) for Philip II as an imperial knight, AEQVES CAES., and two contemporary medals of the artist in profile, attributed to the circle of Pastorino da Siena, variously dated, but most probably from the early 1550s, also offer inscriptions that relate to the lost self-portrait of the artist with monarch: TITIANVS EQVES and TITIANVS PICTOR ET EQVES C., "Titian, painter and knight of the emperor," revealing his pride in his connection to Charles V, and his status as unofficial court artist to the Habsburg dynasty (pls. 105a and b).[28] In both medals, Titian is in imperial profile, on one even wrapped in a toga.[29] Two factors suggest that Titian may have requested the medalists to follow imperial rather than Italian models: the scale of the medals, which is much smaller than the Italian norm, and the configuration of the artist's skull cap. It takes on a new shape in these medals, as if a heavy braid of hair inserted around the back of the head created more volume under the thin material of the caps, not unlike the shapes of the caps worn by some of the patrons of Matthes Gebel of Nuremberg.[30]

In the Berlin self-image, the emperor's knight can be said to offer a painted self as finely dressed and accoutered as any Habsburg, one whose noble chain obviates the need for further courtly attributes of sword or spurs. This *fintore* succeeded in producing an image of an authoritative, self-motivating courtier whose potential for movement conveys his agency – his control of his own fate.[31] Exhibiting supreme self-confidence and autonomy, the masker projects the exalted sphere within the hierarchy of power to which he hoped his *ingegno* had carried him and, to put it on a material level, justified the high prices he asked.[32]

★ ★ ★

Everything about Titian's late self-portrait in the Prado is restrained and quiet: the tonalities, the stable pose, the gold chain that has been reduced in scale and importance (pl. 106).[33] Presenting himself half-length in (almost) profile, he is dressed in undifferentiated black, including the usual skull cap, relieved only by a touch of white at the collar which focuses attention on the head, above the hand discreetly holding a brush at lower left. Only the face is visible, the light pointing up the high, wide forehead that Aretino in a topos called noble.[34]

The profile pose in a portrait was by this date little used by either Venetian or Tuscan artists. What connotations may it have held for Titian? Presumably those of an old-fashioned, out-moded form, earlier patronized by princes, who preferred to limit their likenesses to a bust view seen in profile. Titian's use of it, in mid-career, in two portraits of rulers, was representative for the period: one of Francis I of France (1539) and a posthumous portrait of Pope Sixtus IV (1545); in each case, the likeness was only known from a medal, or from another profile portrait.[35]

The physical strength and mental acuity of the Berlin self-image were not sought here. The artist rather sought a pose that would justify his self-presentation as withdrawn, lost in a profound reverie. Since a sitter's character and humanity are above all conveyed by the eyes, the presentation of one eye only, seen from the side, tended to mask the sitter's personality and limit the portrait's expressiveness. The profile format bespeaks the sitter's psychological distance from the viewer by stressing the former's control and inaccessibility.[36] By allowing part of the far eye-socket to show, however, the artist succeeded in softening the rigidity of the pure profile.

At the end of the 1560s, around the time that this image was painted, the artist's age betrayed him; his sight became enfeebled, his hand started to tremble, and he seems to have relied on the workshop to get anything finished.[37] He could no longer depend on the famous hand and eye. These symptoms of old age must have greatly increased the frustration that the artist experienced in his search for harmony between the "ideas

[*concetti grandi*] he has in his mind and soul, and their execution with his brush and hand," to use his own words, the artist's difficulty in translating the abstract image formed in his mind into a concrete painted image.[38] Aretino had used Titian's name as if synonymous with the art of painting, and the artist here projected himself as the elder statesman of painting, a male personification of Pittura, as it were, but a Pittura seen deep in thought, not, as we will see her in chapter 22, painting with energy and vigor.[39]

Panofsky characterized Titian's late style as a coincidence of opposites: intense inner emotion combined with outward stillness.[40] If Titian's Berlin self-likeness can be said to refer to the rigor of conception that has to precede all execution, here the artist can be read as demonstrating a related condition but with a different outcome. He is still alone, still thinking, but his silent repose around the age of eighty is unlikely to lead to a personally executed work of art. It is not fanciful to characterize Titian's two surviving self-images as intended, respectively, to refer to the active and the contemplative lives. By contrast with the compressed energy of the Berlin work, Titian deliberately constructs the self in a liminal space between being and non-being, between life and death. Here the artist, whose images were said to be "none other than the dreams and shadows of our being" (*non essendo altro che sogni e ombre del nostro essere*), shows the self pondering and dreaming as he waits in the shadows for the end, reconciled with the inevitable, in a work in which the hand that trembled is steady, and the eyes that are the windows of the soul, the heart, and the mind could still – unlike those of the body – see with perfect clarity.[41]

106 Titian, *Self-Portrait*, canvas, c.1565–70, Prado, Madrid.

Chapter 18

LEONI *SCVLPTOR CAESAREVS*

After Caesar's painter, Caesar's sculptor. Trained as a goldsmith and medallist, Leone Leoni worked as engraver for the court mints of Ferrara, Milan, and the papacy, before becoming court sculptor to the Emperor Charles V in 1546, a post that he held for the rest of his life. Unlike Titian, Leoni initially lived at court, following Charles V to Brussels and Madrid.

Caesar's sculptor, like Caesar's painter, claimed to have found favor with Caesar. Pliny's fabrication or reiteration of the story of Alexander as frequent visitor to Apelles' studio may have influenced Leoni's own accounts of the emperor watching him at work.[1] "And so that I would be in better form and more rested, the emperor had me given a room in the palace below where he sleeps . . ."; "He asked for me, and enjoyed talking with me for a long time . . ."; "Often His Majesty stayed two or three hours talking to me and my [son] Pompeo."[2] Charles raised Leoni to the rank of imperial knight (still an uncommon honor) and granted him an annual stipend of 150 scudi in addition to another of 100 scudi.[3] Like many Quattrocento self-portraitists in narrative contexts – Gozzoli, Botticelli, Mantegna, Ghirlandaio – Leoni affirmed his social and professional status by linking the self closely to his illustrious patrons; to Andrea Doria in his early medallic self-image, and Charles V in his later visual self-projections.

More than "stubborn and unreliable" (*piuttosto testaciutto e capriccioso*), in the words of a contemporary, Leoni can be characterized as belligerent and prone to violence.[4] He had a strong psychopathic streak; in 1559, for instance, he tried, for no apparent reason, to murder his house guest, Orazio Vecellio, son of his friend Titian.[5] Thus, Leoni's life was, like that of his arch-rival Cellini, punctuated by a number of violent and murderous attacks on his peers, and by 1541, the date of his first self-portrait, his career had already been strongly marked by crime: in Ferrara he supposedly fled to evade an accusation of counterfeiting; in Rome he was apparently hired to assassinate Cellini in the Castel Sant'Angelo, but double-crossed his Farnese paymaster by substituting powdered glass for the deadly draft of powdered diamonds.[6] Eventually, his murderous mutilation of Paul III's favorite jeweler led to a sentence as a galley slave in the papal fleet.

This event formed the subject-matter of Leoni's first self-portrait medal, which is unprecedented in its frank self-revelation (pl. 108).[7] Its early chronological position within his medallic oeuvre must have allowed him to develop the iconography with fewer preconceptions and in a more experimental spirit than might have been the case later. After a year chained to an oar, in May 1541 Leoni's release had been secured by Andrea Doria, admiral of the imperial fleet and virtual ruler of Genoa, no doubt on the grounds that, in the words of Paul III, "men like [Leoni], unique in their profession, must not be subject to the law."[8] The medal reflects this dramatic moment, as Leoni put it in a letter to Pietro Aretino, "I got my freedom thanks to Andrea Doria, who gave the order in such a way that I was freed in Genoa."[9]

On the obverse, Leoni treated his escape as an event to celebrate, presenting the criminal self not masked as another but as an actual galley slave, encircling his otherwise unidentified profile with a "wreath" of manacles and chains, so composed that

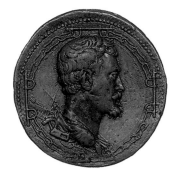

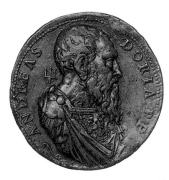

108 Leone Leoni, self-portrait medal, bronze, 1541, obverse and reverse, National Gallery of Art Washington, D.C., Samuel H. Kress Collection.

107 Leone Leoni, facade of Casa Omenoni, Milan.

the section over his head reads as a halo disc in sharp foreshortening. Behind this *finto* saintly profile, the image of a galley, and below his bust, a hammer, opened leg-iron, and grappling iron, other attributes of crime and punishment. They must have made him so immediately recognizable to the contemporary art world as to preclude the need for an identifying inscription. On the medal reverse, a handsome profile bust of an identified ANDREAS DORIA P[ater] P[atriae] wears cuirass, mantle, and Order of the Golden Fleece; behind his head the image of Neptune's trident; below a tiny dolphin, another symbol assimilating the admiral to Neptune.

This medal poses the question: when is an obverse (the side on which the portrait appears) an obverse? If there are portrait heads on both sides, that bearing the image of the more prominent individual is usually called the obverse. In the case of Leoni's medal, there is no uncertainty as to who is the more important; hence the medal is usually catalogued as that of Doria, implying that the admiral commissioned it.

Why would Andrea Doria have sought a medal reverse referring to what must have been a minor act of charity? All the more so in that the reverse focuses on the symbols of punishment alone with no reference to the artist's skill at his vocation, which was, after all, the justification for his release.[10] I prefer to argue here that this was Leoni's medal, that the side displaying his features was intended as the obverse, and that for his reverse he appropriated the persona of the duke as his attribute, identifying with a ruler even as he reveals his criminal self. The medal makes the startling claim of social equality by the equal juxtaposition of the two heads; here the galley slave is presented at the same scale and with the same dignity as the prince who saved his life.[11] Would the prince have seen the sculptor's appropriation of his features as a breach of decorum? Did the standing of the prince offset the sculptor's degradation? We shall never know. The medal is the most personal image so far encountered in this study, created in a medium that more generally encouraged obfuscating rhetoric than confession.

The relatively conventional imagery of Leoni's second medallic self-image casts the iconography of his first into even sharper focus (pl. 109).[12] As heavily bearded and as physically imposing as the previous image of Doria, the sculptor classicized himself by means of a prominently draped toga tied at the shoulder, and an inscription reading LEO. ARETINVS SCVLPTOR CAES[are]VS, "Leoni of Arezzo, sculptor to Caesar," in short, a typically self-aggrandizing Cinquecento self-portrait. It must date prior to November 1549 when Leoni was knighted, after which he habitually referred to himself as *cavaliere*.

As well as the pension and the knighthood, Caesar's favor translated into the gift of a confiscated house, later called the Casa Omenoni, "of the big men," in an upscale neighborhood in Milan (pl. 107). The palace, which is generally regarded as Leoni's major achievement and his masterpiece of self-fashioning, signals the *spirito bizzarro* that Aretino attributed to him.[13] In his struggle for social acceptance, Leoni here associated the self with his imperial patron.[14]

After the emperor's victory over the German Protestants at Mühlberg, Leoni had proposed the erection of a life-size bronze equestrian monument of Charles V in Milan, with the emperor's right arm extended with palm held downward, the gesture of command and authority derived from the Marcus Aurelius equestrian monument on the Capitoline Hill in Rome.[15] The key to the iconography of Leoni's house lies in the installation of a plaster cast of this very statue in his own courtyard, placed on an archaeological reconstruction of the late-medieval base as it had stood outside the Lateran.[16]

Over and beyond the identity of the rider, an equestrian monument had *per se* considerable symbolic power. From being a prerogative of the *eques*, knight, it became, during the Roman Empire, the exclusive privilege of the emperor. The mere location of the monument in Leoni's cortile not only assimilated it to the Roman Campidoglio

109 Leone Leoni, self-portrait medal, bronze, before 1549, obverse, whereabouts unknown.

but also associated the cortile's owner with its original Caesarian rider, Marcus Aurelius, whose imperium was in turn equated to that of the modern Caesar whom Leoni served.[17]

Charles V's choice of role model signaled a shift from the quintessential imperial models for Quattrocento princes: Julius Caesar (triumphant in arms and letters) and Augustus (ruler of the greatest empire). As military hero, patron of architecture, and philosopher, Marcus Aurelius made an attractive Cinquecento alternative. From 1528/29 onward, many editions and translations of the popular romances *Libro aureo de Marco Aurelio* and *Relox de Principes*, by Antonio de Guevara, the emperor's court historian, had been published; and in 1559 there appeared the first translation of the Roman emperor's original text.[18] By dedicating his palace to this most virtuous of ancient caesars, and placing him at the heart of his house, Leoni, whose reputation as a murderous criminal rivalled that of Cellini, devised a singularly elegant mask with which to present the self as a man of personal rectitude, by identifying simultaneously with his patron and his patron's model.[19]

In a letter written toward the beginning of his career as sculptor, Leoni had declared his ambition to execute *colosei*, and he punctuated his facade with six giant three-quarter length barbarian prisoners identified by inscriptions as six tribes conquered by Marcus Aurelius.[20] Most of these were central European, and may thus have been taken by contemporaries as symbols of the Protestant forces defeated by Charles V at Mühlberg in the late 1540s. There were local Milanese prototypes for the use of herms on a facade – although not on the ground floor – but Leoni's desire to inhabit a truly Roman monument led him to invent a dramatic new type; at six braccia high, these over life-size men had the physical heft of colossi.[21]

For the Cinquecento, colossal sculpture had an importance commensurate with the expense and effort they entailed.[22] Milan was the city in which the memory of Leonardo's colossal equestrian statue of Francesco Sforza, part of the trend toward the enlargement of forms at the beginning of the sixteenth century, still lingered. Pliny had mentioned classical statues of extraordinary size, and there can be no doubt that Leoni's "large men" were meant to emulate antique works. In 1504 Pomponio Guarico had outlined the hierarchy of statue dimensions: life-size was considered appropriate for men of *virtù* like Plato, three times life-size for kings like Augustus, heroes like Hercules, and gods like Jupiter – the company among whom Leoni placed himself.[23] On an imperial scale worthy of ancient Rome, these colossal barbarians assimilated Leoni's Milanese facade to such a monument as the Arch of Constantine. It is understandable why Vasari overflowed with admiration for the *capricciose invenzioni*, inventive conceits, of Leoni's *bello ingegno*: "the greatness of spirit . . . the beautiful talent . . . much expenditure . . . very fine architecture . . . a huge house full of the most unusual inventions . . ."[24]

Leoni fashioned himself after both Filarete and Bramante, his great predecessors as Milanese court architects; the Milanese palace, for instance, can be read as Leoni's version of Filarete's fabulous abode for Onitoan Nolivar in Sforzinda (pl. 56).[25] Unlike the facades of the houses designed or planned by Zuccari in Florence, Vasari in Arezzo, and – closer to home – Giulio Romano in Mantua, Leoni made no reference whatsoever on it to his vocation – any more than he had on his medals. His profession was only proclaimed in his Capitoline courtyard, by way of instruments of the arts of *disegno* in the friezes where sculpture, metalwork, and architecture were presented at the same level as the liberal arts of geometry and music.[26]

Leoni's prestigious Roman edifice housed another novelty: an impressive collection of casts after the Antique and of contemporary painting, in a period when only princes formed such collections. The collection included casts of Michelangelo's *Resurrected Christ* in S. Maria sopra Minerva and the early *Pietà* in St. Peter's, as well as a wax

model of a Hercules and Antaeus.[27] A fine collection of North Italian paintings included Correggio's *Jupiter and Io* (Kunsthistorisches Museum, Vienna) and *Jupiter and Danaë* (Borghese Gallery, Rome), which Pompeo had purchased from the emperor's collection for his father, and works by Leonardo (a book of drawings), Titian (an Andromeda, a Venus, a Coronation of the Virgin), Tintoretto (a St. Jerome), and Parmigianino (a St. George, a Madonna), in an ensemble of modern art that may well have surpassed those of most nobles.[28] It has even been argued that the palace had its origins in the pre-existing collection and was required as a frame for it, rather than vice versa. Decidedly, they were closely linked in Leoni's mind, since he expressed his desire that they be maintained together unaltered in his will.[29]

Emerging from deep poverty, without fixed *patria* or abode, from an apprenticeship to an unknown metalworker, and hampered by a tendency to erupt in psychopathic violence, this craftsman, like Cellini, made the transition from small-scale metalwork to large-scale sculpture, and rose to the highest pinnacle of success as sculptor to the Holy Roman Emperor. Leoni was very talented but also very lucky: even when his climb up the social ladder was interrupted by rapid descent into the condition of galley slave, he was given a fresh start. He is one artist for whom Vasari's standard accolade of living *da principe* seems particularly apt. Caesar's noble *cavaliere*-sculptor-collector-(criminal) lived in a palazzo with an iconography as complex and as grand as that of any lord, in which every detail displayed the classical erudition appropriate to his sought-after new status, surrounded by his personal collection of antique casts and contemporary painting.

Nonetheless, Leoni's most *singolare* creation in a widely circulated medium commemorated none of these professional successes or honors but the most disgraced moment in his life, a work that in eccentricity equals Filarete's plaquette on the inside of the doors to St. Peter's.

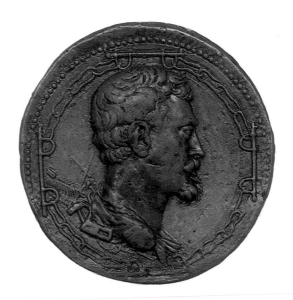

110 Leone Leoni, self-portrait medal, bronze, 1541, reverse (larger than actual size), National Gallery of Art, Washington, D.C., Samuel H. Kress Collection.

ZUCCARI AND FAMILY

"The King [of Spain] . . . brought Zuccaro from Rome, because he was the most famous painter in all of Italy."[1] The Urbinate Federico Zuccari, was another artist skilled at promoting his own gifts to prospective princely patrons, who developed an international reputation by working for the major courts of Europe, which he visited in person. Each new generation of Italian court artists seems to have travelled further afield: Cellini to the French court, Leoni to the Habsburg courts of Brussels and Madrid, and Zuccari not only to the Habsburg courts in the Netherlands and Spain – hence his designation here under the rubric "Habsburg artist" – but even as far as the English court in London.

Zuccari's didactic cast of mind led him to write extensively on artistic theory; in some respects, he was as much a theorist as a practicing painter.[2] Perhaps the most nakedly ambitious court artist of the century, Zuccari's work and life constitute the most conscious effort in intellectual self-promotion – a champion in metaphysical *disegno*, in Summer's words – thrown up by the art world.[3] Like Bandinelli, another "conceptual artist," however, his work was savagely criticized by his fellow artists, with whom he was often at odds; acrimony, conflict, and *invidia* are once more the leitmotifs of an Italian artist's career.

It was not until near the end of his life that Zuccari painted an independent self-portrait; it was stimulated by familial concerns as a pendant image to a portrait of his master and brother Taddeo, who had died prematurely at thirty-seven, and whose memory he energetically preserved, even succeeding in burying him beside Raphael in the Pantheon in Rome.[4] In the diptych the two brothers are seated in identical, mirroring three-quarter-length poses, facing each other, one elegant hand resting on a knee, the other holding a partially rolled sheet of paper in the lower inner corners, intended no doubt for a *disegno*, balanced by draped curtains hanging in the opposite outer corners (pls. 111 and 112). The only attribute that differentiates the brothers are the two gold chains and Philip II's medal around the neck of the living artist. The worn features of the aging Federico contrast so sharply with those of Taddeo, who lived on in his brother's memory with smooth, ever-youthful countenance, as to appear rather those of a father than a brother.

Another late portrait, in which Federico's features were so idealized that he could almost be seen as Taddeo, offers a bust-length autonomous simulacrum of the artist, signed and dated 1604, by a woman painter, Fede Galizia, who, like most of her sex, made her reputation as a portraitist (pl. 113). In this, the only surviving image of Zuccari in which no reference to family is made, the most prominent attribute, the large number of gold chains – no less than six – around the sitter's neck, amply testify to Federico's association with the rulers of Europe, and his standing at their courts. No other early modern image of the artist carries such social clout as these proudly displayed multiple chains. The portrait medallions reposing on Zuccari's breast refer to specific prestigious court commissions: the fresco cycles at Caprarola in the mid-1560s for Cardinal Alessandro Farnese; the high altar in the Escorial for Philip II during his

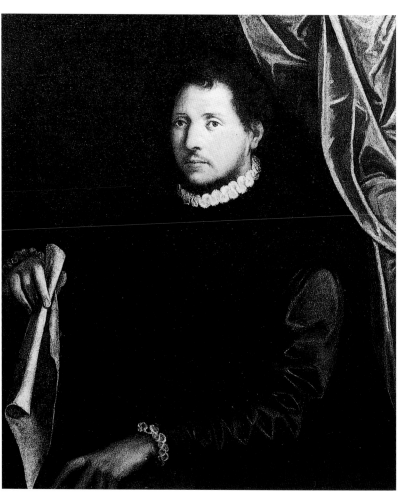

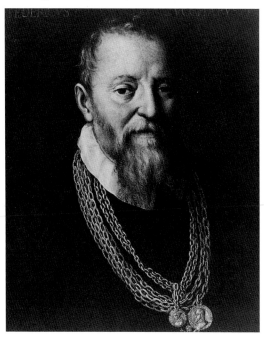

113 Fede Galizia, *Federico Zuccari*, canvas, 1604, Galleria degli Uffizi, Florence.

sojourn in Madrid in 1585–8; and the work in the Doge's Palace in Venice in 1604, perhaps the occasion that stimulated this particular commission.[5]

One of the chains, albeit lacking a Medici portrait medal, must celebrate the work that Zuccari regarded as his masterpiece: the Last Judgment frescoes in Brunelleschi's cupola of Florence cathedral, in which the artist's family features so prominently. After Vasari's death in 1574, Federico, as skilful as the Aretine in court intrigue, succeeded in wresting this enormous commission away from his Florentine competitors, of whom Alessandro Allori was the most prominent and the most incensed.[6] Vasari had made a strong beginning by frescoing about a third of the pictorial surface, and the terms of Zuccari's employment stipulated that he was to follow the humanist Borghini's carefully laid out iconographic program and Vasari's numerous drawings and cartoons for the rest of the vault.[7] The change-over in artistic direction, as envisioned by the authorities, is summed up in a drawing and painting by Zuccari, which show Borghini instructing the artist on the unfinished program, in the presence of Vasari slumbering in (metaphoric) death.[8]

Zuccari's bitter rivalry with, and antipathy toward "poor Giorgio" when alive – stimulated in part by Vasari's Tuscan *campanilismo* (patriotism), as it affected the *Life* of Taddeo in the 1568 edition of the *Lives* – had not been mitigated by the Aretine's death. Federico's Florentine sojourn in the second half of the 1570s, it has been suggested, was devoted to his continuing posthumous competition with the Aretine, indicative of Zuccari's own hopes of inheriting Vasari's mantle as the cultural czar of the art world, at the Florentine court as elsewhere.[9]

It was thus inevitable that Zuccari would find it necessary, if only for reasons of pride, to introduce his own variations and changes into Vasari's composition.[10] We shall focus only on the west compartment or *spicco* of the vault where, had Vasari still been alive, the holy people of God (*santo popolo di Dio*) would surely not have been represented exclusively by Zuccari's family and friends. This striking autobiographical reference was made in the vault compartment that was most clearly visible from the cathedral high altar, situated directly opposite the image of Christ the Judge (pl. 115).

Borghini's program for the fresco in the west compartment called for the holy people of God to include "the married, the widowed, the poor, the rich, the lazy, the workers, of every age, sex, and rank, who in their innocence live in the fear of God."[11] Vasari's drawings had foreseen generic biblical and pagan figures dressed in generic drapery, in place of which Zuccari provided a vivid gallery of contemporary portraits

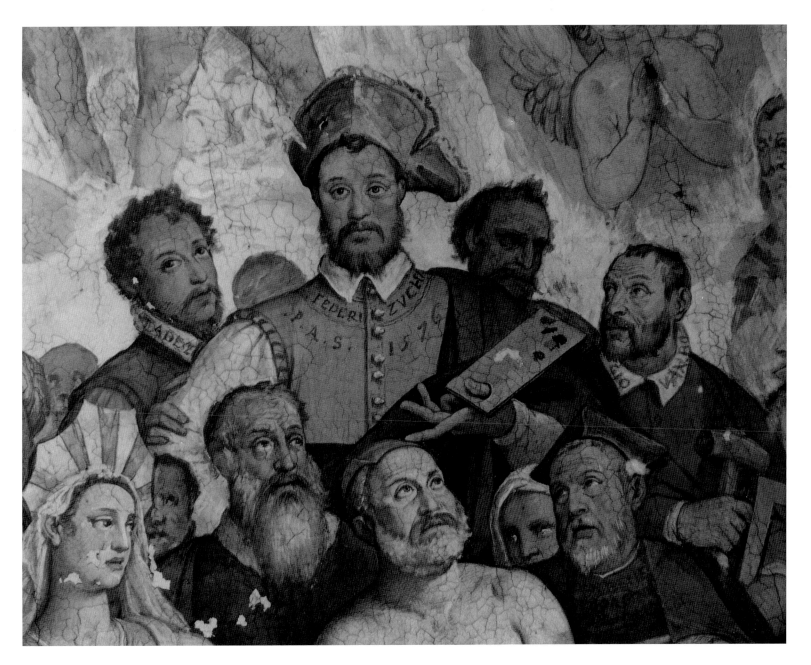

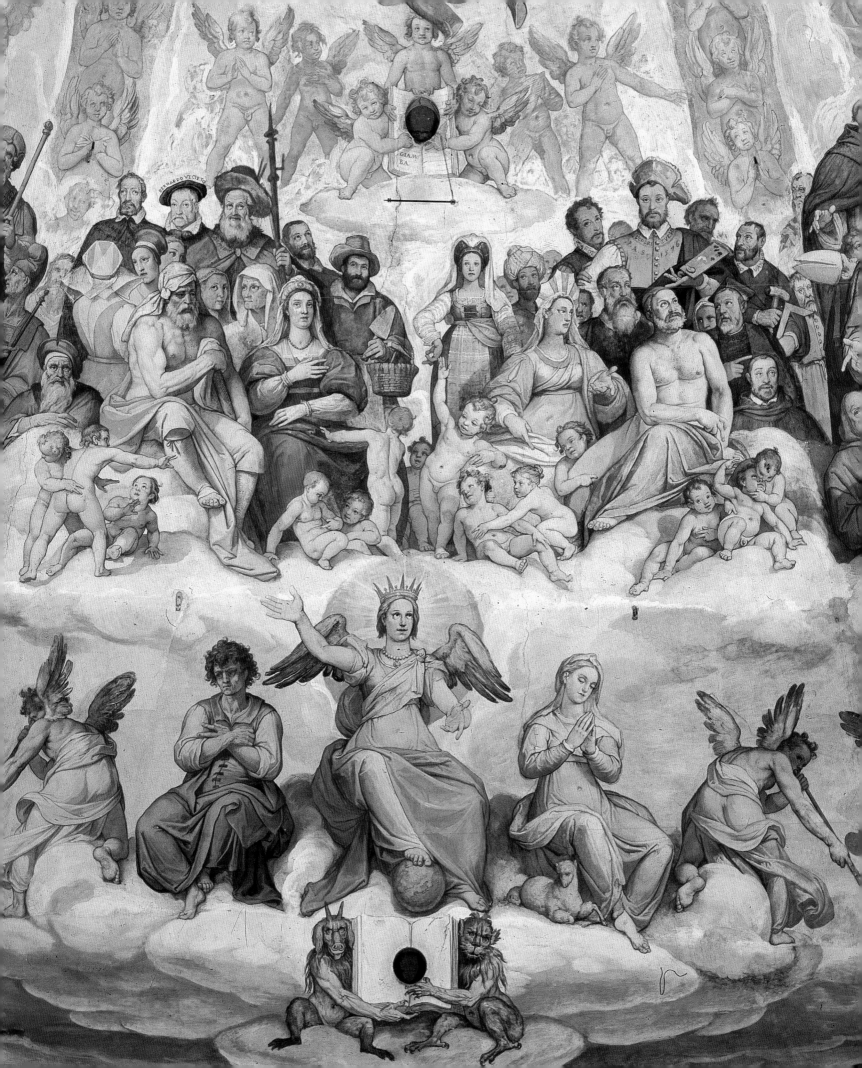

115 Federico Zuccari, cupola of Florence cathedral, detail of west compartment showing Holy People of God, fresco, 1579.

116a Style of Pastorino, medal of Federico Zuccari, bronze, c.1578–9, reverse, showing the cupola of Florence cathedral, British Museum, London.

116b Style of Pastorino, medal of Federico Zuccari, bronze, 1588, reverse, showing the high altarpiece in the apse of S. Lorenzo de El Escorial, Museo Nazionale del Bargello, Florence.

of family, friends, and Medici protectors. Holding – it should be noted – a palette, and identified by inscription and date, Federico placed himself at the center of the right group, surrounded by Taddeo, Vasari, and Giambologna, a lifelong friend, with Benedetto and Vincenzo Borghini. The group to the left is dominated by Federico's father, Ottaviano, dressed as a pilgrim, with Benedetto Busini, Bernardo Vecchietti (the grand-ducal counsellor who may have helped obtain the commission for Zuccari) and, below, Federico's mother. No doubt this corner of heaven also harbors other, unidentified members of the Zuccari extended family.[12] It is only a slight exaggeration to claim that Zuccari made this segment of the cupola vault into a monument, unique of its type, to honor himself and his family, as a pictorial guarantee of their salvation in the next world.[13]

In Spain Philip II sought artists to paint eight canvases for the vast high altarpiece with four registers, framed by jasper columns, that covered the entire height of the apse in S. Lorenzo de El Escorial. The iconography included scenes of Christ's infancy on the lowest level, surmounted by two registers of scenes from Christ's Passion, in turn crowned by a sculptural Crucifixion. The polyptych presented major problems of visibility, because of its scale and lighting conditions that no painter, no matter how famous, was able to overcome.[14] Philip II had asked his retainers to do some research in order to establish, as a court official wrote in 1583, "what effect [Zuccari's] hand [*mano*] produces beside that of Titian," but, whatever the response, Zuccari, unlike Veronese and Tintoretto, was the only Italian artist prepared to undertake the journey to Madrid.[15]

Inevitably, differences of opinion arose – albeit on matters of iconography rather than style – between the king and the painter. For so orthodox a patron, "correct" interpretation of the subject mattered.[16] The king focused on minute details, such as the number of eggs being carried by a shepherd in the *Nativity*; since the shepherd had arrived in haste at midnight, the king said, he would not have been able to find so many eggs unless he kept hens.[17] The artist, of course, sought rather to focus on the *invenzione* than in counting eggs. Although Philip resigned himself to accept Zuccari's paintings, they were reported as having "displeased" him, and he later ordered the faces repainted, "with the result that they are better than before."[18] Given the antagonism of the Spanish sources toward Italian artists, it is impossible to know whether the royal views were represented by the Hieronymite monk who called Zuccari's works *perverso*.[19]

In an apparent effort to ward off criticisms of his endeavors in these Florentine and Spanish commissions, Zuccari commissioned medals celebrating the Duomo vault and the Escorial high altar before the works were unveiled (pls. 116a and b).[20] In each case, the medal shows a profile portrait of Zuccari on the obverse and – an innovation in the history of Italian portrait medals – the artwork itself on the reverse, although in both medals, for reasons of scale, Zuccari was obliged to focus on the huge sites rather than his own *invenzioni*. Zuccari's pride in painting Brunelleschi's dome is nonetheless embodied in the inscription PINSIT below the depiction of the cupola. Artists such as Filarete, Bandinelli, and Leoni had hitherto occasionally used the medal reverse to associate themselves with prominent patrons. Those who were as firmly ensconced at the pinnacle of fame as Titian and Vasari, however, left it blank. The exception is Bramante, whose reverse image of St. Peter's may have been dictated by his medal's intended function as a foundation medal for the basilica.[21]

In neither Florence nor Madrid did Zuccari's medals inhibit criticism of his "masterpieces." Never was there an Italian artist whose self-image as a great painter was a concept so little shared by his professional peers. The frescoes in the *duomo* cupola were not unveiled until 1579, but Florentine artistic *invidia*, the critical murmurs of those who had failed to get the commission, started much earlier.[22]

As the artist himself later phrased it at his trial for libel in Bologna: "I have been persecuted by slander and envy wherever I have gone."[23] Given that Zuccari's sin lay above all in being an outsider, it was unfortunate that he should have reacted to local criticism so aggressively.[24] His polemical response to these invidious critical campaigns typically took the form of satirical cartoons and paintings, still relatively unusual at this time, that in turn calumnied his detractors. He had been planning an elaborate allegory, *The Lament of Painting*, since 1577, and in Florence he published it, in the form of a print by Cornelius Cort, before the cupola frescoes were finished.[25] When the Bolognese art world savagely criticized the altarpiece he painted for the papal courtier Ghiselli in that city in the early 1580s, he published another allegory, the *Porta Virtutis*.[26] Again, the reaction to the altarpiece must have been a foregone conclusion from the moment that the outsider, Zuccari, wrested the commission from envious local artists. Papal indignation over Zuccari's counterblast to his artistic and papal detractors, proclaimed publicly by the *Porta Virtutis*, resulted in Federico being sued for libel. During this trial, where the verdict inevitably went against him, he suffered the indignity of hearing himself characterized as "the worst painter . . . who ever took brush in hand."[27]

Yet, no other painter, Baglione would write, was "more loved by princes and [was given] so many honors."[28] How to disentangle the extent of *campanilismo*, local patriotism, in the Bolognese and Florentine artists' – not to mention the Spanish monks' – criticism of Federico's work, from what may have been their genuine disappointment at the poor level of execution in these works, which were largely painted by studio hands? It was, of course, the intellectual aspect of art that interested Zuccari, not the menial labor of production. This his peers occasionally acknowledged, Pompeo Leoni writing that "this Federico is the best man in what concerns *invenzione*." Like Bandinelli, Zuccari saw his strength as lying in his *singolarità* in conception rather than execution.

★　★　★

The allegorical decorations of Federico's houses in Florence and Rome, important as pictorial expressions of this artist's aspirations to rank and status, have recently received scholarly attention, as have the architectural designs.[29] Located in an upscale site on the Pincio, the Roman palace of Zuccari, an honorary citizen of the Eternal City, was the first artist-designed house to be built since Mantegna's. It represents its creator especially well as the most ambitious such abode of the period, its decoration embodying Zuccari's conception of the nature of art and artists.[30] The focus here, an aspect of Zuccari's decoration that has attracted relatively little attention, is, once again, the space devoted to the celebration of his family, both ancestors and descendants.

The pervasive familial theme goes back to Taddeo's inclusion of the artistic dynasty of Zuccari father and two sons, as they sustain the canopy over Cardinal Alessandro, Francis I, and Charles V in a fresco in the Room of the Farnese Deeds at Caprarola in the early 1560s (pl. 117).[31] In this "Florentine" type of "self-portrait as family in a narrative context," the Zuccari canopy-bearers, dressed in imperial livery, occupy an extremely prominent place in the center of the secular scene – not unlike that of the Ghirlandaio family firm in S. Maria Novella – and are at least as visible, if not more so, than the cardinal whom they were serving.[32]

The impulse to glorify one's own family was present everywhere in Renaissance society, and Zuccari devoted an important site to the theme in his new Roman edifice: the Sala Terrena or "garden room," which gave direct access to the entrance hall.[33] It was the most personal space in the house, and must have influenced the way in which visitors read the decoration of subsequent rooms. In the vault, the frescoes comprise

elaborate allegories relating to Zuccari's profession. Below, in the eight corner lunettes that support a pergola of roses, he placed half-length informal portraits of his ancestors and descendants.[34] In one lunette, Zuccari, luxuriously attired and wearing the gold chain given him by Philip II, depicted a double portrait of himself and his wife (pl. 118); in others, family members included his grandfather; his parents with his sister, Bartolomea; his brother Taddeo as a youth beside Federico as a child (pl. 119); his four sons; and his three daughters. Each member is identified by an inscription. Perhaps because of their apparent informality or their facture, exceptionally, by master, not studio, hand, these frescoes are among the Zuccari's most appealing secular works. The groupings have the same apparent spontaneity that informs his beautiful pen drawings of Taddeo's artistic career. Thus, where Vasari ennobled himself in his Aretine house with a frieze of portraits of famous *artists*, Zuccari here gathered images of his *family* into a portrait gallery of ancestors – as if he were a lord, and indeed these were the very years in which the artist was being addressed as *principe*, as the presidents of the Florentine and Roman academies were known.[35]

Family friends and colleagues entering the Zuccari palazzo and arriving in this garden room would have been welcomed by the assembled Zuccari clan, looking down from their rose-strewn opera boxes, as it were, while the audience, on stage, gazed at sets and backdrop designed for the first act of the artist's performance in the role of

117 Taddeo Zuccari, *The Meeting of Francis I, Charles V, and Cardinal Alessandro Farnese*, fresco, early 1560s, Caprarola, Sala dei Fasti Farnesi.

118 Federico Zuccari, detail of self-portrait with his wife, fresco, early 1590s, lunette, Sala Terrena, Palazzo Zuccari, Rome.

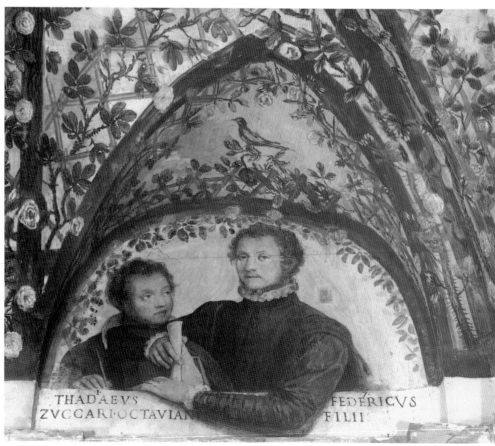

119 Federico Zuccari, detail of self-portrait with Taddeo, lunette, fresco, early 1590s, Sala Terrena, Palazzo Zuccari, Rome.

god-like artist. Zuccari's forebears and offspring mediate between the viewers and their central focus: the apotheosis of the artist, masquerading as a divinity, in the center of the vault (pl. 120). Here, the *principesco* painter, holding brush and pen and escorted by the Sun and Moon, ascends on heavenly clouds to the realm of that other creator, *Deus artifex*, toward whom his eyes are raised. Below him, Chronos writes in the Book of Life, and the serpent of immortality bites its tail. To either side, *Calumnia* and *Invidia* are thrown to earth by the force of the trumpets of winged genii representing Fame.[36] The inscription reads VIRTUDE DUCE, "virtue leads." Between the family portraits and the center of the vault stand many symbolic figures of the virtues and qualities which, stressing knowledge, spiritual values, and hard work, were needed by the successful artist.[37] The similarity between this room and Vasari's own account of his Aretine Sala della Fama, painted some fifty years earlier, is such that it seems highly likely that, in the Sala Terrena, Federico was engaged in another, posthumous, competition with his *quondam* rival.

★ ★ ★

Possibly in emulation of the altarpiece that Vasari had placed in his family chapel in the Pieve in Arezzo, Federico Zuccari also introduced his own features into an altarpiece, not, as so often in Florence, in a work commissioned by someone else, but for his own family altar in a church at his birthplace in the Marche.[38] In it Zuccari celebrated the house of the illustrious Zuccari by giving some of its members roles of saints, just as Quattrocento Medici had taken on the roles of kings in Botticelli's altarpiece (pl. 34) and Cinquecento ones those of saints in an altarpiece by Giovanni Maria Butteri.[39]

The Madonna and child are flanked by saints Catherine, Anthony, and Judas Thaddeus; St. Francis, depicted with the features of the Franciscan Angelo Zuccaro, and St. Lucia with those of Zuccari's late wife (pl. 121). Dated 1603, the work was painted for S. Caterina in S. Angelo in Vado, where his sister was a nun. The cast of familial donors

121 Federico Zuccari, *Virgin and Child with Saints and Members of the Zuccari family*, canvas, 1603, S. Angelo in Vado, formerly S. Caterina, now Palazzo Communale.

is identical to that depicted in the cupola of Florence cathedral and in the Sala Terrena in Rome: father Ottaviano, brother Taddeo, sister Bartolomea, and his own seven children, with the addition of Taddeo's illegitimate daughter Maddalena.[40] Since Federico's offspring are not depicted at their actual ages in 1603 but as very young children, it has been plausibly suggested that the altarpiece was started in the early 1590s, that is, contemporary with the frescoes celebrating his family in his Roman palace.[41]

Italian altarpieces of the sixteenth century show no comparable consecrations of an *artist's* family, with the exception of Vasari's depiction of himself and his wife as Saints Lazarus and Mary Magdalen in his own altarpiece for his family chapel in Arezzo.[42] Consecrations of patrician families such as the Pesaro family altarpiece by Titian, for example, or that by the same artist showing members of the Vendramin clan adoring the relic of the true cross, were common, but female family members were usually excluded.[43] Zuccari's altarpiece signals its donor's aspirations for his family's

salvation in the hereafter, to which the depiction of the Zuccari family clan in the Duomo vault already bore witness.

This late work accordingly proclaims its creator's ancestry and sepulchral family presence in a form that had hitherto been used only by aristocrats. Like the houses decorated by the artist-theorist, the altarpiece announced a conception of its creator's social rank that differs fundamentally from that prevailing at the beginning of the Renaissance. The manual worker of the early Renaissance had become a princely living and divinely inspired artist-writer-theorist, who claimed intellectual space equal to that of poet or humanist, and the right to be accepted in society at the rank hitherto reserved for the ruling classes. Autonomous self-portraiture was only one way among others to establish one's social ascent.

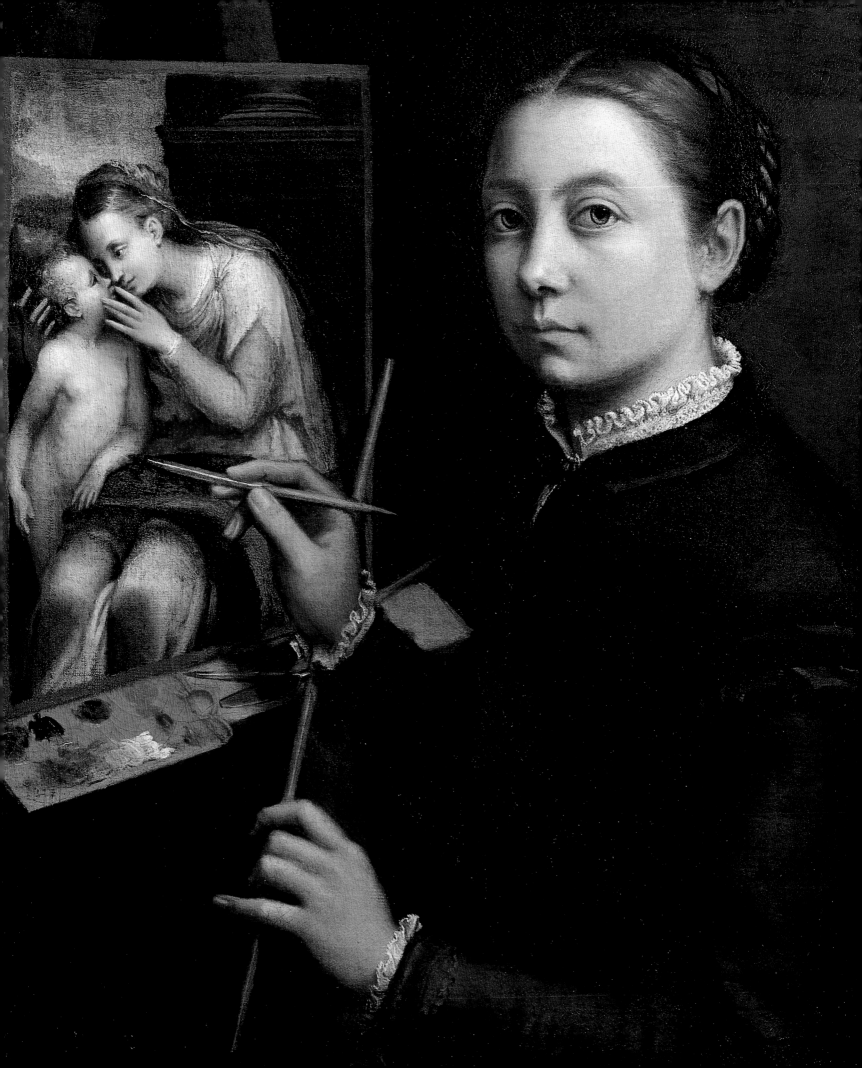

THE SELF AS *PICTRIX CELEBRIS*

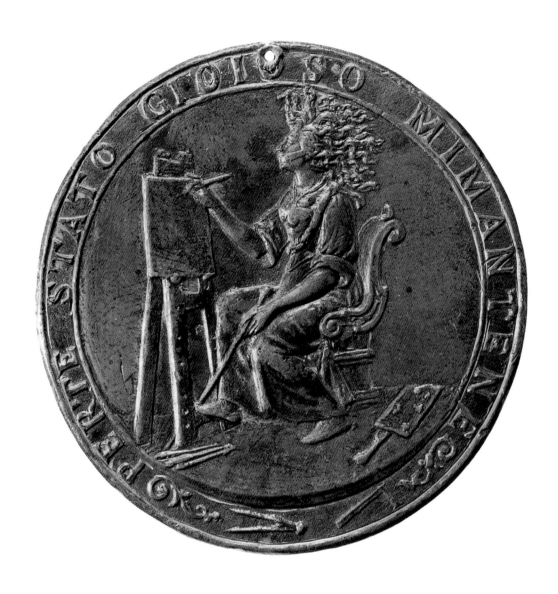

INTRODUCTION: THE FEMALE SELF

> It is true that the Lord did not endow [women] properly with
> the faculty of judgment, and this he did in order to keep them
> restrained within the boundaries of obedience to men, to
> establish men as supreme and superior, so that with this lack,
> women would be more docile, more amenable to suggestion.
> —Giovanni Battista Passeri.[1]

It will not have escaped the observant reader that no women were present among those wending their way to the farewell feast on Filarete's plaquette, or the diligent students in Bandinelli's academy, or the humanist advisors and workshop *dipintori* that Vasari included in his Palazzo Vecchio frescoes. All the artists in the study so far have been male, and hence the generic artist has been referred to throughout as "he." The following four chapters, however, are concerned with the careers of Sofonisba Anguissola and Lavinia Fontana, two talented women whose male relatives enabled them to pursue the vocation of painting, and whose ambitions were tolerated by the Cinquecento art world. How did these "she's" – female others – negotiate a safe passage through the shoals of the patriarchal art world?

An extreme view of the ideology of gender in the Renaissance is encapsulated in a passage from a treatise on sculpture published in 1504. "One [sex]," wrote Pomponius Gauricus, "is noble, just, intrepid, audacious, equitable, magnanimous, kind, constant, courageous, honest, liberal, magnificent. The other [sex]," he continued, "is base, unjust, fearful, rash, intemperate, indolent, cruel, trying, fickle, always inconstant, dishonest, greedy, good for nothing."[2] Pomponius did not consider it necessary to define for his readers which sex was noble and which base, since he was articulating a conviction held by virtually everyone in early modern Europe: that women were created inferior to men. Hence, the relations between the two sexes, of male dominance and female dependence, was seen as naturally ordained.

Understandably, the philosophy, art, and literature of Western civilization reflect this hierarchy of gender. No body of writing or corpus of art in the West was left untouched by pervasive patriarchal values. Moreover, art and literature not only *articulated* the ideology of the culture that produced them, but also actively helped to *shape* that ideology – in this case, to perpetuate gender stereotypes. Thus, pressured to conform to a social role considered appropriate to her sex, Western woman had always lived in male-defined societies. The effect, unsurprisingly, was to teach woman to see herself in terms of the dominant male interests.

There were always, of course, the few, remarkable exceptions, but most of those who attempted to fashion their *own* identity or to question society's values were inevitably influenced by that society's low evaluation of them in ways that affected their own habits of thinking and feeling about themselves. Self-empowerment is difficult for those who have always been taught to undervalue their abilities and their ideas. Those who did survive that particular obstacle race and who succeeded in raising a voice were

123 F.A. Casoni, medal of Lavinia Fontana, bronze, 1611, reverse (larger than actual size), British Museum, London.

necessarily restricted in the audiences for their ideas. To sum up in the words of Bynum:

> theological, scientific and folk traditions associated women with the body, lust, weakness and irrationality; men with spirit or reason or strength . . . woman (or Eve) represented the appetites, man (or Adam) the soul or intellect.[3]

<p style="text-align:center">★ ★ ★</p>

It was unthinkable for a female to become an artist. Just as poetry, if we follow the logic of gendering in Western languages, was conceived as a masculine activity, so artistic creative powers were a male prerogative, the three arts were gendered male on Florence Campanile (pl. 6), and in the sixteenth century art was defined as a "profession di gentil*uomo*."[4] For obvious phallic reasons the paintbrush was also habitually gendered male, and the act of painting often identified with the male artist's sexual prowess.[5] "The painter's brush is manly," wrote Boschini, and the visible marks made by the sketchy brush, impasto and scumbling, were also gendered masculine, by the use of descriptive terms denoting male vigor and aggression. The pornographer Pietro Aretino exploited the brush as a metaphor: the paintbrush as phallus consummates the sexual act by being dipped into the (female) recipient for the paint pigments: "placing his paintbrush in . . . her tiny color cup, he made her twist and turn . . . The artistic act," writes Sohm, "thus becomes an act of procreation, with man and his paintbrush manipulating the passive pigment in the 'color cup' of woman."[6]

What was Aristotle's theory of procreation, and the Renaissance understanding of the respective contributions, active and passive, of male and female to this process? The embryo was male-generated, since the male stood for the effective, active principle. What the female provided to this joint enterprise was solely passive flesh on which the male semen could work. Just as the male represented the active principle in this, as in so many other human activities in the early modern period, so the female's role was essentially passive: "the female always provides the material, the male that which fashions it."[7] Given the similarity seen between the procreative process and the artistic creative process, it was assumed that, just as only the man could generate life, so only the male artist could generate great art. Significantly, Vasari's highest praise, the topos from Antiquity that a given artist had succeeded in producing images "that appear to be breathing and truly alive," was couched in procreative terms.

Even without Aristotle's theory of procreation, however, woman's perceived intellectual inferiority to man would have suggested that she did not have the capacity to engage in an intellectual discipline like the *arti del disegno*, which involved the development of an idea born in the mind.[8] This conviction of female incapacity was so embedded in the culture that, even in a book specifically written to celebrate great women, Boccaccio could not resist writing that "art is alien to the mind of women, and these things cannot be accomplished without a great deal of talent, which in women is usually very scarce."[9] Frescoes, for instance, were gendered male because they demanded decisiveness and prompt action, capacities conventionally denied to women.[10] Finally, should all obstacles be overcome, the woman's family might well consider the occupation of manual artist to be beneath the attention of a talented but well-born girl. In sum,

> in the Renaissance, a society whose cultural and theological spokesmen defined women as intellectually . . . inferior, women who took up the visual arts were thought to be doing something biologically unnatural, especially around 1500, when the practice of art was increasingly identified with intellectual ability.[11]

Women were, of course, excluded from institutional affiliation such as apprenticeship

in workshops, or membership in guilds. Most Cinquecento women artists were the daughters of painters, for example Lavinia Fontana, Marietta Robusti, Barbara Longhi, and the northerner Katharina van Hemessen, all of whose fathers played crucial roles in their daughters' career. One of our two women artists, Anguissola, was, however, an exception to this rule.

<center>★ ★ ★</center>

"Humanism, which did much to enhance the dignity of man, was long in liberating [the female] from her subordinate status."[12] Although Alberti had in 1435 stated that in Antiquity it was considered an honor for women to know how to paint, it was not until a century had passed that the winds of change started to blow very softly through the prejudices of the Italian artistic community.[13] In the eighteen years alone between the two editions of Vasari's *Lives*, the number of women artists he included increased thirteen-fold, from one to thirteen. This slow shift in attitudes on the proper relation between woman and the visual arts is marked by comments – both progressive and retrogressive – in the sixteenth-century literature on art. For every negative comment, there is a positive one, and vice versa, leading to the realization that attitudes toward the cultural aspirations of women and their involvement in the visual arts did, almost imperceptibly, evolve in the period.

One of the earliest to speak, an author who had the rank and familiarity with princes and courts that commanded respect, was Castiglione, in a passage written long before the publication in 1528 of his *Book of the Courtier*.

> I want this [court lady] to be competent in letters, music, and painting, to know how to dance and be merry, all performed with . . . *discreta modestia* [discreet modesty, or what we might call "low profile"] . . . being most graceful in conversing, laughter, playing games, creating mottoes, and in everything she undertakes.[14]

Castiglione, however, was advocating that the lady should know enough *about* painting (which was placed after letters and music) not to be able to *practice* it, but, *should the occasion arise*, to be able to discuss it intelligently in society. This situation did not in fact arise within the court of Urbino as it was construed by the author, since none of his female protagonists was given a participating role in the discussions.[15]

Chronologically, the next comment was probably that made in 1548 by one of Paolo Pino's interlocutors in his *Dialogo*, who reacted to similar ideas by grumbling, "It does not please me to hear women equalled to the excellence of men in [painting]; and it seems to me that the art is debased by this, and the female species [is] drawn outside what is proper to it, for nothing suits women save the distaff and the spindle . . . ," to which his opponent responded hopefully, ". . . these were women who partook of the masculine . . . and deserve to be appreciated as women who, seeing their own imperfection, attempted to imitate the nobler being, man."[16]

Two years later Vasari faced just such a situation vis-à-vis Properzia de' Rossi, the sole female artist included in his first edition. His comments reveal admiration, but also profound misgivings about the suitability of the art of sculpture for a woman. On the one hand, he saw Rossi as "prodigious, great miracle of nature, unique, marvelous" (*prodigo, grandissimo miracolo della natura, singolare, meraviglioso*); on the other, he did not try to conceal his disapproval of her choice of medium, especially the thought of the juxtaposition of her "tender and very white hands" with mechanical instruments, rough marble, and harsh iron.[17]

Before Vasari could issue his second edition, with its marked increase in the number of women artists, Lomazzo's *Libro de Sogni* (1564) had presented a more positive picture, albeit his concern was painting, not sculpture. He used Sofonisba Anguissola, whose

works and career were well known in Milan, as an example.[18] "I bring to your attention," says Leonardo da Vinci, who represents modernity in the treatise, to Phidias, who represents Antiquity,

> the miracles of a Cremonese woman called Sofonisba, who has astonished every prince and wise man in all of Europe by means of her paintings, which are all portraits, so like life that they seem to conform to nature itself. Many valiant [professionals] have judged her to have a brush taken from the hand of the divine Titian himself; and now she is deeply appreciated by Philip King of Spain and his wife, who lavish the greatest honors on the artist.[19]

Thus, a slight change in attitude toward women and their artistic capacities slowly emerged around mid-century. Anguissola's father's revolutionary decision to apprentice her to a painter in the second half of the 1540s in itself testifies to this new opening. Women's own sense of themselves and their potential for creativity gained slight momentum toward the century's midpoint, before the culture as a whole was overwhelmed by Counter-Reformation fears and prohibitions.[20] Women poets had already seized the limelight; the first edition of Vittoria Colonna's *Rime* was published in 1538, and the Venetian courtesan-poets Veronica Franco, Gaspara Stampa, and Veronica Gambara were also publishing. In Cremona the name of the painter Anguissola was paired with that of a brilliant young humanist Partenia Gallerati in 1550, as "two of the most talented maidens of our city" (*duas praeclarissimas virgines cives nostras*), implying that, where women were concerned, the discipline of painting was as liberal as that of literature.[21]

124 Detail of pl. 130.

Chapter 21

THE CAREER OF A *DONNESCA MANO*

> She executed by herself very rare and very beautiful paintings;
> wherefore she well deserved that King Philip of Spain, having
> heard of her abilities and merits from the Duke of Alba, should
> have sent for her and had her conducted honorably to Spain,
> where he keeps her with a rich allowance in the Queen's
> retinue, to the admiration of the whole court which admires
> Sofonisba's excellence as something miraculous.
>
> —Giorgio Vasari[1]

After Michelangelo and Titian, Sofonisba Anguissola may have been the best-known artist – certainly the best-known court artist – in the Cinquecento. Her career forms a pattern quite different from that of any of the male artists in this study. Because it was in itself the motivating factor underlying her self-imaging, the circumstances determining her amazing trajectory from the minor nobility in provincial Cremona to a prestigious appointment at the foremost court of the age will be considered first. Her self-portraits will be explored in light of Anguissola's gender, talent, rank, education, personal appearance, choice of artistic genre and subject matter, father, self-portraits as gifts, court patronage, and pension.

Anguissola benefited greatly from her position as the first female painter to master a "*man*'s profession," that of *gentiluomo* – or, at any rate, the first so recognized by the Cinquecento artistic community.[2] Her novelty value was such that her male contemporaries did not scrutinize her work as closely as they would that of her female successors. Any Renaissance female who achieved competency in a cultural endeavor was initially considered a prodigy or a freak of Nature, as the response of Vasari, among others, to Anguissola's work testifies: "astonishment, marvel, miracle" (*stupore, meraviglia, miracolo*).[3]

The genuine, if minor, talent, which, had Anguissola received the rigorous training given to aspiring male artists, might well have become a major talent should also be acknowledged. She was a child prodigy who had instruction in the rudiments of painting for only three years from two local painters, of whom Bernardino Campi, an artist judged by Vasari as unworthy of inclusion in his second edition, was the more influential. Given the minimal period and the provincial nature of the tuition she got, the quality of her best work *is* nothing short of a "miracle of Nature."

Anguissola's rank and education were crucial factors in her success. Most of the male self-portraits considered in this study were motivated by a yearning for greater status and respect, both as professional artists and as social individuals. Social insecurity was not Anguissola's problem; she was not only the "first female" but also a female of rank, with the social status to which all her male colleagues aspired. Indeed, Vasari was well aware that without her noble birth, Anguissola would not have had a career, to the point of stating her rank as *nobilissima, very* noble, which was not the case.[4]

To become a *doctus artifex*, the artist had to acquire close familiarity with the world of the imagination created in poetry and literature.[5] As the daughter of a noble,

191

Anguissola received a sound humanist education, and discovered that she was gifted in letters and music as well as art. Baldinucci mentioned her "sweet singing . . . good [knowledge of] literature" (*suavissimo cantare . . . la sua buona letteratura*) that were perhaps encouraged by Boccaccio's description – albeit formulaic – of her namesake, the Carthaginian queen, as practiced in letters and music.[6] Anguissola was also extremely intelligent, and had, as Van Dyck noted, a *cervello prontissimo*, an "ever-ready brain," even at the end of her long life.[7]

It would be naive to think that this talented young woman's personal appearance played no role in her success. Baglione described her as "noble by birth, beautiful in appearance, graceful in every feature and gesture" (*nobile di nascita, bellissima d'aspetto, graziosa in ogni suo tratto e gesto*).[8] In the patriarchal world of the Cinquecento, it must have helped Anguissola that her appearance was pleasing – even when allowance is made for the extent to which she surely idealized her features in her self-portraits. To be sure, convention dictated that any account of a woman who was talented in one of the humanities should focus on her *bellezza*.[9] Muzio Manfredi, for instance, wrote to Lavinia Fontana in 1591 about his desire to have an "example of a [work by a] beautiful and very talented woman" (*un esempio di bella, e raremente virtuoso donna*). Anguissola's first audience must have been enchanted with the early self-images of this seductive adolescent, her soft features, blooming cheeks, and gleaming, intelligent eyes.

In the metaphoric terms of the Cinquecento, feminine beauty had a special connection to art, in that art was often symbolized by an image of a beautiful woman.[10] While a beautiful female was a marvel of Nature, the *image* of female beauty was a marvel of *art*, and in the sixteenth century a painting of a beautiful woman became a synecdoche for art itself. The dilemma of the woman artist in the Renaissance was how to differentiate a portrait of her own specific features, painted to display her skill and beautiful style, from the image of a generic beautiful female created by the male artist as a metaphor for the art of painting.[11] As it was, Anguissola's several self-images in the *act* of painting were understood by contemporaries as embodying *two* "marvels," as the humanist Annibale Caro put it: the rarity of a work created *by* a female, and a simulacrum *of* its prodigious creator.

The mere existence of a female artist threatened the myth that artistic creativity was an exclusively masculine province. To survive in a patriarchal culture, a practicing woman artist or poet had to minimize her achievement so as not to excite male jealousy (*invidia*). The achieving woman needed to present the self in such a way as to win respect for her attainments without eschewing "appropriate" female demeanor.[12] Anguissola, for instance, was never in a position to compete with male colleagues for a public work like an altarpiece. By retaining her status as a dilettante and restricting her work to private commissions, she succeeded in winning a room of her own, as it were, without transgressing the traditional decorum of chastity, virtue, and modesty needed for a lady of rank in society.[13]

A further factor of Anguissola's career was the artistic genre to which her work belonged: portraiture. In the Renaissance portraiture was regarded as a minor genre, a conclusion first reached by Leonardo on the grounds that the portrait painter was generally unskilled in portraying emotion: "among those who profess to portray faces from life," he wrote, "he who paints the best likeness is the worst of all composers of history paintings."[14] "Even an artist of mediocre talent," echoed Armenini a century later, "can master this art [of portraiture] . . ."[15] The portrait of a living individual required, proclaimed theoreticians, only an ability to replicate, transcribe, copy, that is, *ritrarre*, the surface appearance of Nature. The copying involved in *ritrarre*, a record of an individual's superficial physical appearance, demanded only technical proficiency, the physical coordination of hand and eye – the result being a "mechanical" work, as it were.[16] Successful history painting, on the other hand, required that the artist possess

sufficient creative *invenzione* to produce a pleasing, effective, and, so to speak, "liberal" composition. Like *disegno*, an idea born in the mind, *invenzione* had its origin in abstract thought or conceptual *idea*. Renaissance theory thus created another opposition between an intellectual invention and a manual replication, an opposition that resulted in a hierarchical distinction between the genres of *istoria* and portraiture. Indeed, Armenini went so far as to claim "that the more accomplished an artist is in *disegno*, the less he will know how to make portraits."[17] The supreme exemplar of this distinction between genres was of course Michelangelo, who disdained portraiture, and produced hardly any.[18]

Already in Antiquity, the inferior genre of portraiture was perceived as a suitable domain for women painters, since their intellectual inferiority disqualified them from working in the more prestigious genres. Most of the women artists mentioned by Pliny were portraitists.[19] While portrait specialists were relatively rare in the Cinquecento, those that existed were from the Po Valley, and the precedent established by an artist such as Giambattista Moroni of Bergamo, for instance, must have been crucial for the young Cremonese painter.

Thus, all of Anguissola's self-images were necessarily autonomous because she painted virtually no religious or mythological narratives in which she might have included herself. Most of the self-likenesses were painted when she was still young, that is, *before* she found a position at court – unlike the male self-images so far considered, many of which were created as the direct outcome of a long and successful career at court. The artist tended to internalize the princely values to which he had for long been exposed, and to develop a more upscale visual definition of the artistic self than that understood as the societal norm. By contrast, Anguissola's early self-images were not so much the outcome of court experience as *directed toward* a hoped-for court appointment. Her many self-portraits were a means to this end, and they played a major, even crucial role in *enabling* Anguissola to have a career at all. The production of these images revealing both her artistic talent and her attractive persona was accordingly intended to stimulate a demand in princely circles for a female resident court painter.

Anguissola's artistic career was her father's idea. Possibly inspired by Pliny's pages on Marzia, Anguisssola's self-imaging strategy was devised by Amilcare, a rather remarkable Cinquecento father who played a central role in his daughter's career. A dilettante of *disegno* with cultural aspirations, Amilcare's perception of his eldest daughter as a prodigy must have determined his truly revolutionary step of sending her out of the house to get instruction from a painter, an act that had neither precedents nor successors. Using Sofonisba's small self-likenesses to promote her talent in court and artistic circles, Amilcare became as innovative and talented a promoter of his daughter's skills as any good Hollywood agent today, writing politically astute letters to potential patrons, including Michelangelo, the most famous living artist, on the subject of "my daughter whom I caused to begin to practice the most honorable virtue of painting." With some exceptions among artists – Bandinelli, Michelangelo, Vasari, and Zuccari come to mind – Amilcare was perhaps the most astute public relations propagandist of the sixteenth-century art world.

Thus the many self-portraits from the beginning of Anguissola's career, which were conceived and designed to present the artist to court society as an attractive, high-class, talented young woman, had a precise function. The intended audience for an Anguissola self-portrait was in effect limited to rulers and their entourages. Amilcare tapped into this court "gift-giving culture," which entailed sending paintings as gifts to those of higher rank, in the hope or expectation of receiving some favor in return. An object defined as a gift was never freely given without putting the recipient under some obligation, which was indeed the whole point of this "economy of favors." In an exchange between unequal parties, as one scholar put it, "the superior party

Faict a Rome par Pierre Du Monstier Parisien, Ce dernier de Decemb 1625
aprez la digne main de l'excellente et sçauante Artemise gentildone Romaine $

125 Pierre Dumonstier le Jeune, *The Hand of Artemisia Gentileschi*, drawing, 1625, British Museum, London.

must give one better because he who gives last gives best by keeping the upper hand."[20]

A *dono*, or gift, of one of Anguissola's self-images was particularly welcome to collectors, whether as art or as curiosity. An object made by a "ladylike hand" (*donnesca mano*), was considered "precious" (*pretioso*), to use the words of Annibale Caro, secretary to the duke of Parma.[21] Bizarrely, the manual craft that society had condemned as base when undertaken by its usual *male* practitioners, was nonetheless perceived as valuable on those rare occasions when it was practiced, against enormous odds, by *female* hands (*le mani d'una donna*).

A visual celebration of just such a *donnesca mano* was produced by a French artist in Rome in 1625 (pl. 125). The drawing depicts Artemisia Gentileschi's right hand delicately holding a (gendered) paintbrush. The hyperbolic inscription claims that, while the hands of the goddess Aurora were famous for their beauty, Artemisia's hand was capable of creating marvels that could ravish the eyes of the most knowing connois-

seur. The conceit sets up a *paragone* between the natural light brought into the world by the hands of dawn, and the marvels of intellectual light produced by Artemisia's even more creative hands.[22] Once again Art claimed superiority over Nature.

Cremona had no court. Had the Anguissola lived in Ferrara, Mantua, Parma, Piacenza, or even Urbino, Sofonisba's career might have taken another, less spectacular route. Amilcare established contacts, by way of painted gifts and obsequious letters, with the courts across the Po Valley. Not until he caught the attention of the King of Spain, however, half a dozen years later, did this P.R. strategist get results. Whether or not an Anguissola self-image ever reached the Spanish court, Amilcare was the driving force behind the diplomatic exchange between the dukes of Alba and Sessa and King Philip II that led to the king's invitation to the young woman painter to join the fourteen Spanish and five French ladies-in-waiting in the household of his French bride, Isabelle of Valois. The paternal strategy had been spectacularly successful. Without this regal patronage, Anguissola's critical *fortuna* in the Cinquecento would have been quite different, and she would have remained a minor figure in the history of Italian art.

The specifics of Anguissola's patronage were unique to this particular set of circumstances. Philip II's fourteen-year-old bride, for whose entourage Anguissola was recruited, was half Italian, and that half was Medici blood. A long family tradition of passionate involvement with the arts manifested itself in a desire to practice painting – hence the search for a noble female artist as teacher. The only Italian among the queen's ladies-in-waiting, Sofonisba was also the only *dama* who was not from the highest rank. In the lists of the queen's ladies, the Spanish were given the title *dona*, and the French *madamisela*; only Anguissola was entered without a title, appearing either last on the Spanish list or first on the French.[23]

The queen, who seems to have greatly enjoyed the experience of learning how to paint, was lucky to obtain an experienced teacher who had already passed on her own skills to her younger sisters. Anguissola, however, seems to have found the instruction taxing. A phrase in a letter to her old master, Bernardino Campi, suggests that the lessons could be onerous and left her with little time to do her own work: "The queen wants a great part of my time so that she can paint, [and] does not have the patience for me to paint [my own works], [in case] she should be deprived of the convenience [of my working with her]."[24]

Finally, what were the financial arrangements surrounding Anguissola's court appointment? Whether at home or at court, she never sold a single painting. Indeed, at the Spanish court – at any court, for that matter – the status of a noble and of a painter were hierarchically too far apart to be conjoined. There was no category into which to place a "noble woman who used her hands," since aristocrats by definition did not do manual work. This factor of status may also explain the lack of signatures on Anguissola's work in Madrid: a lady of rank at the Habsburg court could not position herself at the level of a craftsman. Anguissola did not, in fact, need remuneration for her art, since she was paid as a lady-in-waiting, *dama*, for her services to the queen, if not for the exceptional artistic talent that had occasioned her entrée to court. Indeed, Anguissola's activity as an artist is never once referred to in any court document. Payment for her art would not in any case have been in Anguissola's best interests. As long as she stressed her social rank, which in itself precluded any direct remuneration for her hand-work, she was handsomely provided for by Philip II – much more so than she could ever have been as a mere artist – as *Nobili Sofonisbe Anguissole, serenissimae uxoris nostrae familiari, et intima aulica* ("courtly intimate in the household of our Most Serene consort").

As it happens, Amilcare's shrewd promotion of his daughter's artistic career was not entirely disinterested; he and her brother benefited financially from her sojourn in Spain. Amilcare was a small entrepreneur or merchant who invested in new business

ventures, and was the partner of a bookseller who also traded in leather, silk, and art supplies; his economic situation was often precarious.[25] Indeed, it may have been Amilcare's straitened circumstances that caused him to ask Annibale Caro to return the Anguissola self-portrait that the humanist had received only the previous year – sent by the donor no doubt in the expectation of a monetary gift or favor in return but who, according to this hypothesis, received fine words instead of cash.[26]

Besides gifts of jewelery and lengths of cloth, Philip II assigned Anguissola an annual stipend of 200 ducats from the revenue deriving from a toll on wine in Cremona; it was characterized by Vasari as a *grosso provvisione*.[27] This stipend was always drawn in Cremona by Amilcare, "father and legitimate administrator for his daughter," and, after his death in 1577, by her brother Asdrubale. The latter seems to have been in even worse economic straits than his father, being referred to in 1578 as "a very poor gentleman in great misery" (*poverissimo gentiluomo in grande miseria*). Merely by having once resided at court, Anguissola was her male relatives' major financial resource for the rest of her life.[28] Amilcare's early investment in his adolescent daughter had paid off.

Nothing succeeds like success. The news of a precociously talented female noble at court, dedicated to painting, understandably gave rise to curiosity in the art world. Anguissola's patron was of the highest possible rank: daughter of one king, wife of another, her desire to paint in itself ennobled the art of painting. Anguissola's talent, her chronological priority among women artists, her court appointment, her regal patrons, and the reports of her success at court in the mid-1560s were all arguments that compelled Vasari to undertake a special trip to Cremona before the 1568 edition of his book with the express objective of viewing Anguissola's work.

★ ★ ★

> She labored at the difficulties of *disegno* with greater study and better grace than any other woman [artist] of our time, and succeeded not only in drawing, coloring [painting], and copying from Nature, and in making excellent copies of works by others, but has also executed by herself some very rare and very beautiful paintings.[29]
>
> Ci e' ancora invenzione. (There is also invention).[30]

Vasari included at least thirteen women artists in the second edition of his *Lives*. They were defined as authors of works "small in scale and modest in ambition," and, with the exception of Anguissola, most were praised for their diligence rather than their invention.[31] Not only did Vasari exempt Anguissola from his pronouncement that only male artists had the creative power to produce figurative images that appeared to live and breathe, but another connoisseur, Tommaso Cavalieri, in a 1562 letter to Cosimo I, used the term *invenzione* in connection with this female practitioner of an activity supposedly gendered male.

Wherein lay Sofonisba's *miglior grazia* for Vasari and her *invenzione* for Cavalieri? Leaving aside for a moment her contributions to the history of self-portraiture, her inventions constituted two aspects of her early work, both of which were firmly imbedded in North Italian tradition. Paradoxically, neither was of much use to her as a court painter who produced state portraits. Stretching back to Leonardo da Vinci in Milan, and continuing through the Carracci in Bologna at the end of the century, was the study of expressive facial features, primarily of the lower classes, an interest initially inspired by Leonardo's passion for *istoria*, and his conviction that the emotions of the mind could be communicated by the movements of the body, not to mention the configuration of the features of the face. Only two relevant drawings by Anguissola survive that show the extremes of human emotion: laughter, on the one hand, and disap-

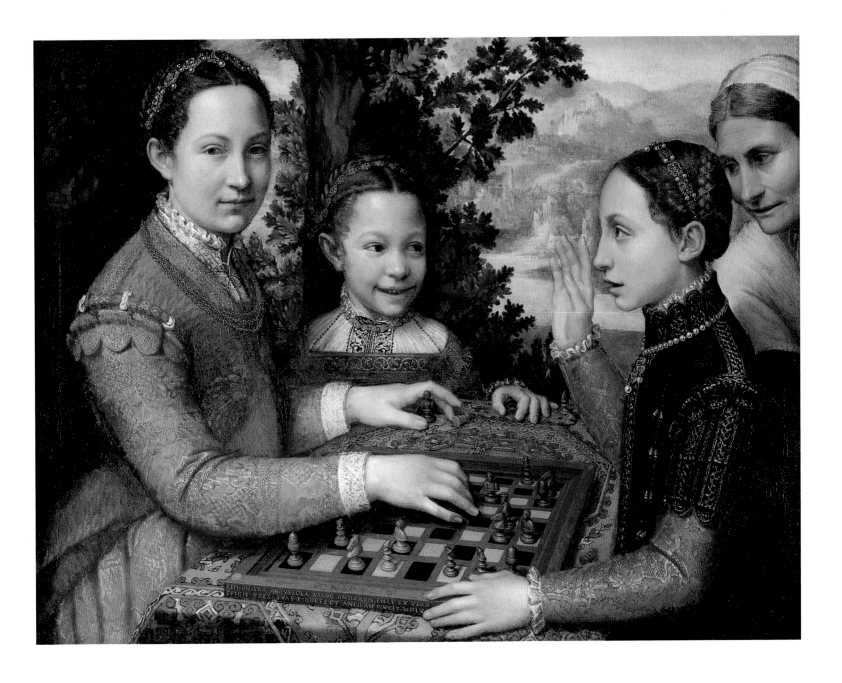

126 Sofonisba Anguissola, *The Chess Game*, 1555, Muzeum Narodowe, Poznan.

pointment or fear, on the other, specifically a study of a crying child that was suggested to her father by Michelangelo. Inventories, however, and prints (some on the unedifying subject of an aristocratic young woman mocking an old woman from the other end of the social spectrum) suggest that Sofonisba painted several studies of laughing or smiling children and adults, in paintings described as "people laughing" (*persone che ridono*), and "a painting of laughing people" (*un quadro delli ridenti*), praised as "rare works" (*cose rare*).[32] The type may derive from fantasies surrounding Leonardo's *Mona Lisa*, who was described by Lomazzo as *in atto di ridere*, laughing.[33]

The second component of Anguissola's singularity as an artist, the resolution of portraiture into genre or narrative, again a subject pioneered in Lombardy, can be demonstrated in only one surviving work, *The Chess Game* (pl. 126). Had the painting been created by a man, it would have probably attracted little attention. Being by a woman, however, it has been exhaustively studied, beginning with Vasari, who saw it in the Anguissola home in Cremona.[34]

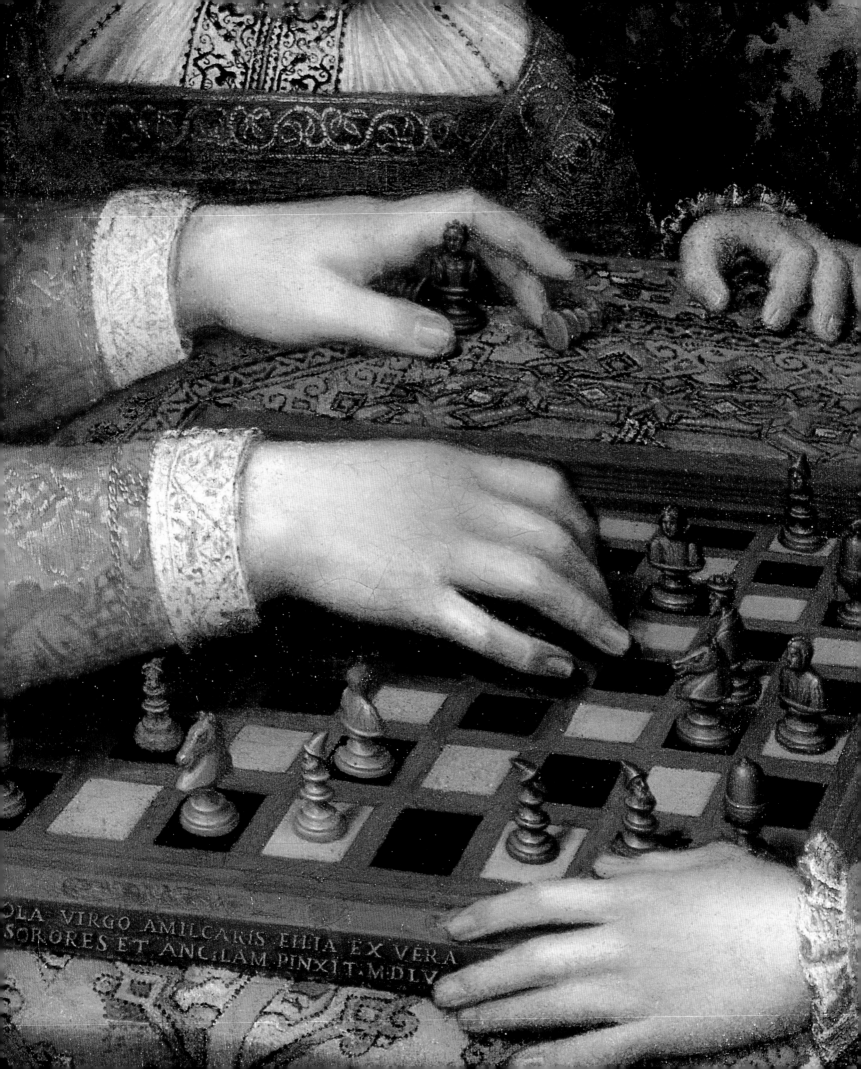

...OLA VIRGO AMILCARIS FILIA EX VERA
...SORORES ET ANCILLAM PINXIT MDLV

Access to the public sphere in this period was gender-specific: it was the domain of male activity. Unwed females, expected to live cloistered lives, were restricted to the private and domestic realm. Decorum, for instance, dictated the circumstances surrounding Anguissola's early *Portrait of a Lateran Monk* (Brescia). The inscription states that it was painted in her father's presence; for the sake of her reputation he could not leave his daughter alone with a male sitter.[35] Anguissola had therefore to find her subject matter within the home and the family, such as the events of everyday life among her sisters. The unusual domestic iconography of *The Chess Game*, and its all female cast, was thus in a sense forced on the artist, but she showed much ingenuity at exploiting the limited possibilities available to her. This is a group portrait in action, with several young women informally engaged in a unifying activity, a game of chess.[36] It was even called by one early source a narrative (*cosa storiata*), a portrait group that became a genre scene, and by another as going from "portraits to compositions and narrative" (*dai ritratti ai componimenti e storie*).[37] The work can thus be said to transcend the sphere of *ritrarre*, the copying of the surface of Nature, to enter that of *invenzione*, the conceptual activity called *imitare* that involved artful presentation of narrative.[38]

Anguissola's three sisters are posed around a table as if playing chess, an intellectual pursuit in that the game required considerable intelligence to master, and therefore one that not many women were expected to play.[39] As it happens, the sisters are depicted with wide, high foreheads, regarded in the culture as a sign of the large intellect that lay behind. The narrative is played out through the children's glances: a smiling Europa in the center looks across to Minerva, who concedes the game to Lucia by raising her right hand. Lucia, however, does not acknowledge Minerva's concession but instead directs her attention outside the picture space to her elder sister, the artist, who sits, as it were, at the fourth side of the table. In many ways Sofonisba's participation in the scene is so strongly felt that the work might almost be called "Self-Portrait with Sisters," the sisters to whom she would teach the art of painting, and who would thus become Anguissola's *fatture*, professional "achievements," or attributes, just as Anguissola was dubbed the *fattura*, creation, of Bernardino Campi.[40] The primary audience for this painting was the artist and her sitters, in that only those familiar with the close-knit family group could fully comprehend the nuances of interaction between the artist-mentor and her sisterly attributes.

Anguissola's informal group portrait of known individuals in the guise of a domestic narrative, belongs to a type that was to become a North Italian specialty, which would be taken up, for instance, by the young Annibale Carracci. It is clear that the manual skills taught Anguissola for the purpose of *ritrarre* coexisted with considerable creative imagination, the *invenzione* that was recognized and recorded by one Cinquecento connoisseur. Could this painting have been created by a male artist? How many other group portraits comprising only women were created in this century? None that comes immediately to mind. The iconography thus marks this work as one that *could* of course have been created by a male artist, but never was, precisely because the limitations on the unwed Sofonisba's liberty did not apply to men, who had therefore no need to seek their subject matter within the domestic domain.

127 Detail of pl. 126, showing female hands engaged in playing the intellectual game of chess.

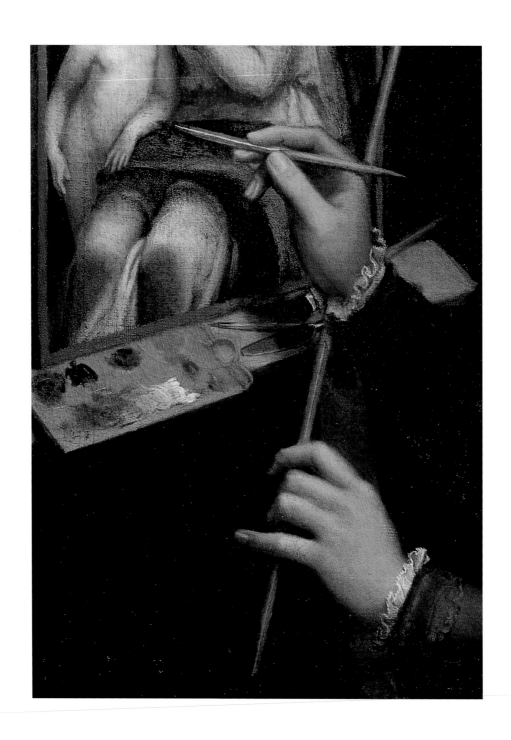

Chapter 22

THE SELF-PORTRAITS OF
A *DONNESCA MANO*

The precise date of each of Anguissola's self-portraits painted in Cremona in the 1550s is impossible to establish to everyone's satisfaction. They will be considered here in four groups, in what I believe to be their approximate chronological sequence: the small self-portraits, those with the easel as attribute, those with the keyboard as attribute, and those painted after her arrival at court.[1]

Anguissola's corpus of self-portraits reveals a clear progression: from a very simply attired sitter in a static pose, presented on a very small scale; to larger works in which the sitter is depicted undertaking some significant cultural action; to works in which the sitter is identified by her attire and bearing as a female courtier. The paintings can thus be read as a progression from the noble but modest practicing craftswoman to the court lady who would never have undertaken manual work – in some respects the opposite sequence to that of many of her contemporary male colleagues, who often presented themselves in early self-portraits as if well-established aristocrats, images that contrast with their later constructions of a simpler, less pretentious, and more artisanal, self.

The self-portraits created during Anguissola's Cremona years offer various solutions to the visual definition of the artist as female, as *pictrix*. They project a remarkably consistent self-image. Most show the artist at bust-length or half-length, wearing an identical black gown with maroon sleeves, the somber tonality of which is relieved only by the lace collar and cuffs of a white chemise at neck and wrists – even the ornamentation of buttons is eschewed. In all, her hair style is identical: pulled tightly back from her face and braided around the back of her head, so that it is relatively invisible. She fashions the self as wearing little jewelry and no bright colors. The dark, sparse accouterments give an overall impression of a sober, reserved, modest, and submissive young woman who appears actually to obey the sumptuary laws. The male courtier who aspired to a "modest elegance," such as Raphael and his friend (pl. 87), had been instructed by Castiglione to wear sober or black clothing; and, as Garrard points out, Anguissola avoided any association with vanity or luxury, the flamboyant or indecorous, which might have suggested the negative image of a woman of easy virtue.[2] This is a self-effacing young woman anxious to convince her viewer that she has experienced a very sheltered upbringing. Inventing an image for the woman artist, Anguissola stressed the one quality that Castiglione believed to be crucial for the court lady: discreet modesty (*discreta modestia*). Her first viewers must have been enchanted with the seductive adolescent; the consistent dark green background against which her head is silhouetted points up her soft, youthful features, the healthy bloom of her cheeks, her gleaming and intelligent eyes, and hint of smile on her lips.[3]

One early attribute was a small book, held open so that the signature and date, SOFONISBA ANGUISSOLA VIRGO SE IPSAM FECIT 1554, can be read, making it possibly the earliest signed and dated autonomous painted self-portrait in Italian art (pl. 129).[4] Curiously, this is the first book to be seen in conjunction with a self-image, regardless of

128 Detail of pl. 132.

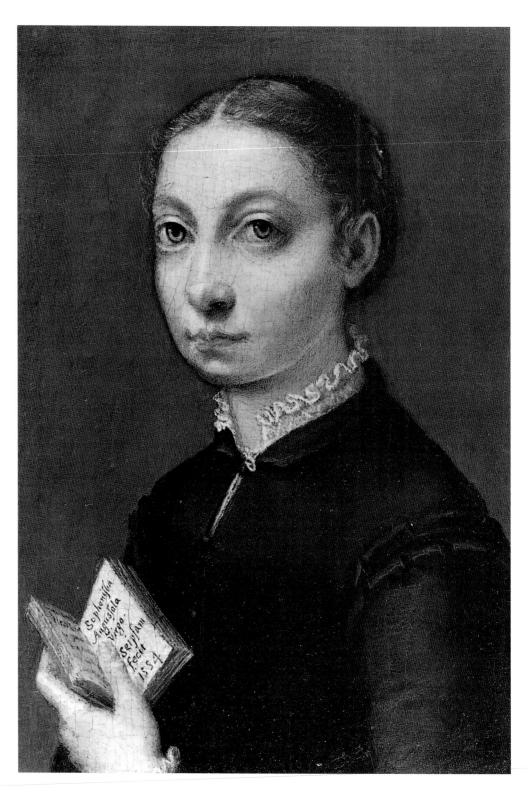

129 Sofonisba Anguissola, *Self-Portrait with a Book*, 1554, Kunsthistorisches Museum, Vienna.

the artist's gender.[5] Anguissola's art accordingly starts outright with what can be defined as an invention, one that was peculiarly appropriate to an artist who had received a humanist education, one of the few Renaissance self-portraitists to have done so. In mid-century Italy, humanists often suggested their erudition in portraits by having the artist place a book in one hand. Learned women also occasionally used the book as an attribute of their life style; in paintings by Andrea del Sarto and Bronzino the book

202

130 Sofonisba Anguissola, *Self-Portrait holding a Medallion inscribed with the Letters of her Father's Name*, vellum, early 1550s (actual size), Museum of Fine Arts, Boston. Emma F. Munroe Fund.

in female hands has been identified as a *petrarchino*, a volume of Petrarch's sonnets. When placed in the hands of an individual wearing clerical garb, however, the volume tends to be read as signifying the sitter's Christian piety.[6] Since Anguissola is not wearing a crucifix, as Fontana was later to do (pl. 144), we may hazard a guess that she here foregrounds her secular learning rather than her religious devotion.

In another painting, a very small oval miniature bearing a tiny self-portrait, Anguissola holds a medallion that takes up half the pictorial surface (pl. 130).[7] Functioning like a large shield behind which she shelters, the medal bears the initials of her father's Carthaginian given name, A M I L C A R E, entwined in a monogram. Unlike Luca Cambiaso (pl. 152), Anguissola chose not to paint a portrait of her father but to honor him with the abstract letters of his given name. The border inscription SOPHONISBA ANGUSSOLA VIR[GO] IPSIUS MANU EX [S]PECULO DEPICTAM CREMONAE, "painted from a mirror with her own hand by the Cremonese virgin Sofonisba Anguissola," expands on her earlier inscription to include the indispensable instrument of pictorial self-representation, the mirror, that also guaranteed the "truth" of any self-likeness.[8]

The mirror symbolized, among other things, reflection upon, and consideration of, one's identity, which was also one of the ostensible functions of a self-portrait. Like transparent glass, the unspotted mirror, *speculum sive macula*, was a metaphor for the Virgin's unspotted purity, or in this case Sofonisba's own chastity. Whatever cultural activity a lady might engage in, her chastity remained the prime concern of her male relatives in the early modern period. Boccaccio, for instance, deliberately praised the vestal virgin Marcia's chastity, in which she was merely conforming to society's expectations, as one of her achievements. As it happens, the earliest pictorial reference to the use of a mirror to create a self-image depicts not just a female painter, but this particular one, Boccaccio's Marcia, in a miniature from an early fifteenth-century French manuscript of his *De claris mulieribus* (Of Famous Women), considered in chapter 3 above. Pliny had claimed that this same Marcia used a mirror for her self-image, and in plate 14 we see her studying her own features in a tiny convex oval mirror, which Boccaccio called her counsel (*consiglio*), before putting the finishing touches to a life-size self-portrait, in which the artist frames her very small mirror-image between her profiled self and her tightly framed full-face *finzione* on the easel.

The verisimilitude of Marcia's self-image was stated in an early sixteenth-century German chronicle to be "so like its model that no contemporary who knew Marcia was in any doubt [as to] who was represented in it." According to the chronicle, Marcia, said to have become a painter to avoid the "usual feminine occupation," allowed her virginity to play as major a role in her choice of subject matter as Anguissola did:

> It is said that [Marcia] preferred painting and sculpting women rather than men. The cause of this habit lay in her bashfulness . . . Marcia found it more decorous, more appropriate to her virginity to represent only the upper bodies of her sitters, leaving out the lower half. That way she did not have to bother herself with the lewd parts . . .[9]

If self-portrayal was recognized as the proper occupation for a vestal virgin, because she could practice it alone and without offending her virginity, how much more appropriate must it have appeared for a young, sixteenth-century Italian noblewoman? The mirror used by Anguissola reinforced the noun VIRGO by further guaranteeing her purity.

The next grouping of Anguissola self-portraits follows the classical example of the woman known as Timarete to Pliny and Thamar to Boccaccio who was christianized into a painter of the Virgin and Child in another miniature in a 1402 manuscript of Boccaccio's compilation of famous women.[10] Three extant paintings display the woman artist seated before the easel on which rests a small Correggesque composition of the Virgin and Child in an intimate embrace; a later print displays the same scene as framed by a triumphal arch (pl. 132).[11] Delicately holding brush and mahlstick, but balancing the oblong palette on the easel shelf, Anguissola gazes steadily at the viewer, who stands in the same location as the posing Virgin. The inscription, recorded as SOPHONISBA ANGUSCIOLA VIRGO CREMONENSIS SE IPSAM PINXIT, confirms that Anguissola was picturing herself at work, as if undertaking the action that Titian is only contemplating in his Berlin self-image. As the daughter of a nobleman, Anguissola had less to fear from the stigma of manual labor being attached to her name: "noble" and "manual" were mutually exclusive terms.

The composition cannot be dated more precisely than the second half of the 1550s. As will be seen in part V, this is the first decade in which Italian artists finally claimed the tools of their trade pictorially: whether pencil, palette, brush, or mahlstick. In chronological order, Titian, Allori, and Mor, each in his own center, fashioned the visual self in this same decade: Titian, accoutered with gold chain, as if sketching (pl. 148); Allori as if creating a self-portrait on the easel (pl. 149); and Mor as if sitting before a blank canvas adorned with a Greek poem (pl. 150). All these artists, including Anguissola, were however pre-empted by Katharina van Hemessen, who in 1548 signed and dated her *Self-Portrait at the Easel* (pl. 131), in which the painted head is so much smaller than that of the artist, assuming a pose identical to that taken by Anguissola half a dozen years later. Was van Hemessen's invention known in Italy? Given the provincial centers in which each young artist worked, it seems unlikely, and yet the Italian's identical pose raises questions of chronology that can probably never be satisfactorily answered.[12]

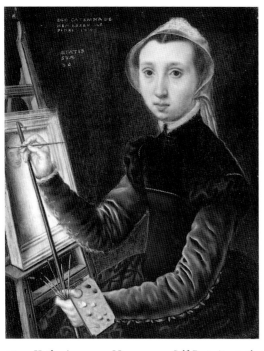

131 Katharina van Hemessen, *Self-Portrait at the Easel*, canvas, 1548, Öffentliche Kunstsammlung, Basel.

132 Sofonisba Anguissola, *Self-Portrait at the Easel, painting a Devotional Panel*, late 1550s, Muzeum Zamek, Lancut.

A male artist shown painting the Virgin and Child in the Renaissance is usually interpreted as St. Luke the Evangelist, who was believed to have painted the first portrait of the Virgin. In the North, the number of self-representations as St. Luke in the act of painting the Virgin increased dramatically throughout the Renaissance, usually as altarpieces intended for guild headquarters or chapels maintained by the guild. St. Luke was adopted as patron saint of craftsmen at the same time, the beginning of the fifteenth century, that artists started to seek recognition as intellectuals rather than artisans.[13] The self-image as St. Luke underwent modifications that in themselves mirror

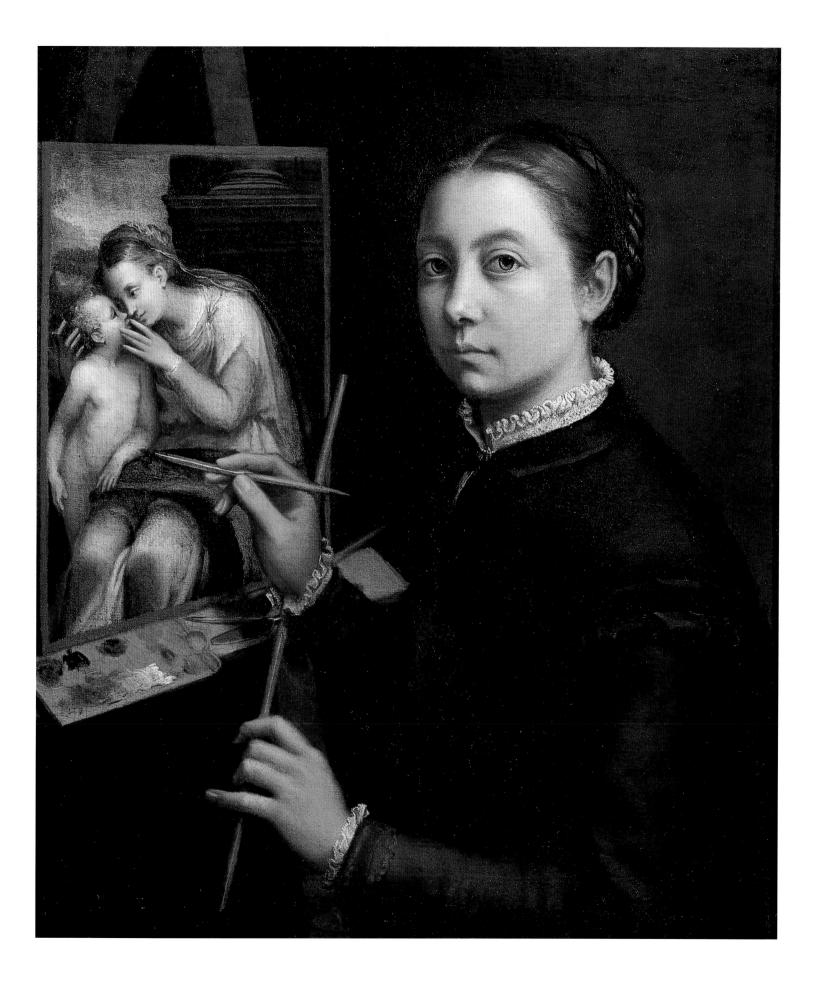

133 Anonymous medallist, medal of Diana Scultori (who married Francesco Volterrano in 1576), bronze, *c*.1576, obverse and reverse, British Museum, London. The reverse shows a hand holding an engraving burin.

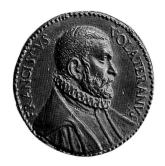

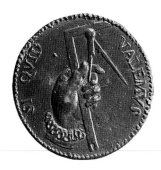

134 Anonymous medallist, medal of Francesco Volterrano (husband of Diana Scultori), bronze, *c*.1576, obverse and reverse, British Museum, London. The reverse shows a hand holding a square and compass.

135 Giorgio Vasari, *Pittura*, fresco, 1542, Casa Vasari, Arezzo.

contemporary changes in the artist's self-conception.[14] Thus, whereas the fifteenth-century figure of the painter-saint, with the features of his modern follower, was often constructed as a pious artisan, by mid-sixteenth century his figure had become a convenient vehicle for the expression of the artist as a humanistically trained scholar and scientist. Rogier van der Weyden (Museum of Fine Arts, Boston) seems to have been the first to exploit the scene as an opportunity for self-portrayal, followed by important fifteenth-century works by Bouts (Private Collection, Bangor), the Master of the Holy Blood (Fogg Art Museum, Cambridge, Mass.), and the sixteenth-century Gossaert (Narodni Gallery, Prague, and Kunsthistorisches Museum, Vienna), Heemskerck (Frans Hals Museum, Haarlem, and Musée des Beaux-Arts, Rennes), and Frans Floris (pl. 146). Anguissola's conceit, that her outward glance cannot but be directed at the posing Virgin, who is thus located outside the picture frame and beside us, the viewer, is echoed in the scene as rendered in the same decade by Frans Floris in which he familiarly uses his attribute, the ox, as a footrest.[15]

There are a few instances of self-portrayal as St. Luke by the Italian self-portraitists discussed in this study. Vasari painted one for the Cappella di San Luca in the cloister of SS. Annunziata later in the 1560s (pl. 9), and another depiction, in which a visitor to the artist's studio has been given Raphaelesque features, is attributed to Zuccari. Thus Anguissola's painting is almost unique in Italian culture for her deliberate inclusion of an image of the Virgin and Child in a self-portrait, which otherwise occurred only in situations when the male artist assumed the role of the male saint. Anguissola cannot have intended her image to be read in these terms; she was the wrong gender, for one thing, and minus the ox, for another, but she nevertheless can be said to have made reference to the painter-saint, who was after all as much the patron saint of the *pictrix* as that of the *pictor*. Such a reference to the Virgin and Child could also be seen as circumventing any implications of unseemly personal hubris on the artist's part.[16] She was not the only female artist to find the Virgin and Child useful: the reverse of Diana Scultori's medal shows a hand engraving the same subject (pl. 133).[17]

If the image of Anguissola cannot be read as a female St. Luke, should she be read as Pittura, the (female) personification of painting? Antiquity had produced no personification of the visual arts, and the earliest surviving image of Pittura was that painted by Vasari in his house in Arezzo in 1542 (pl. 135). The Renaissance followed the classical tradition of symbolizing personifications by a female figure, with which only a woman painter could properly identify, since in that case the representation of the (female) artist could be elided with the (female) representative of her art.[18] By fusing the two types of the allegory of painting and the self-portrait, Artemisia Gentileschi was later to conflate into a single image two themes that male artists were obliged to treat separately.[19]

According to Ripa, the attributes of the personification of painting included garments with changing colors, a golden chain with pendant mask, arched eyebrows, gagging band covering mouth, and unruly locks of hair symbolizing the divine frenzy of the artistic temperament.[20] There was some latitude in the choice of attributes to be included. The eyebrows, gag, mask, and, especially, her great mane of electrically disheveled hair, are emphasized on the reverse of the medal created for Lavinia Fontana in 1611, where Pittura sits before an easel bearing a small canvas, which she tackles with "fire, fury, and pride" (*fuocco, furia, e fierezza*) (pl. 136).[21] The unused palette abandoned on the floor demonstrate that this Pittura is still engaged in the planning stages of *disegno*, the intellectual, creative aspect of painting, rather than the subsequent execution of the work, and indeed the canvas appears to be blank. "Painting," said Ripa, "is a noble exercise that cannot be done without application of the intellect," and his statement is confirmed by the calipers and T-square, symbols of geometry and scientific learning, in the medal's border.[22] In his fresco in Arezzo Vasari omitted the untidy

hair and the mask but was able to capitalize on his medium to produce the beautiful purple and yellow shot silk from which Pittura's garment was cut. Beautiful as Vasari's Pittura is, however, her figure does not convey the joy and energy of creativity as eloquently as the personification on Fontana's medal, which, echoing Filarete's *hilaritas* on his plaquette, is appropriately inscribed PERTE STATO GIOIOSO MIMANTENE, "through you, oh joyous state [of creativity] I am sustained."

There were no models for Sofonisba to emulate in the creation of a self-image as Pittura in the 1550s, and her image of a woman with her own features seated at the easel bears little relationship to the images by Vasari or Fontana's (much later) medal. Every hair is in place. The garment worn is still the same plain black gown with maroon sleeves with ruff and cuffs of white chemise. She wears no gold chain or mask. She is certainly not so stimulated by the divine frenzy of creativity as to have become totally absorbed in her art; on the contrary, unlike the medallic and Aretine personifications of the art, who concentrate fully on the task at hand, Anguissola's figure is primarily concerned with her own pose, and its impact on her audience.

Anguissola may have felt that a forthright image of the self constructing the self – rather than an image of the Virgin – might have been too daring for contemporary male sensibilities, but that it would not be considered aggressive to show *another* artist painting her portrait. In Anguissola's other self-portrait featuring an artist before an easel, the Virgin is replaced a large, half-length image of Sofonisba herself on a canvas almost as big as the actual work, in which her self-portrait masquerades as a portrait by a male artist (pl. 137).[23] Like the self-image just considered, the ostensible male author is putting the finishing touches to "his portrait" of the "sitter." He turns toward the viewer – ostensibly his model – who is in reality the painter herself standing back from this double portrait to view her own (intellectual) handiwork.

Who is the male artist? He is generally accepted as Bernardino Campi, Anguissola's mentor who taught her the rudiments of painting in the second half of the 1540s, and whose likeness survives in a medal and a print. This identification initially created problems with the dating of the painting, since Campi was known to have gone to Milan in 1549 and supposed not to have returned to Cremona during the following decade. For this reason, the work was usually dated to the very beginning of the sequence of self-portraits under consideration, which was clearly unlikely for such an accomplished *invenzione*. The work could however be dated to 1559, when Anguissola stayed in Milan on her way to the Spanish court, and where the two artists must certainly have met again.[24]

The *discipula* lives as object with her *maestro* as subject in a carefully equilibrated composition, the two figures on the same scale but the male protagonist slightly marginalized to one side. Anguissola gave emphasis to her own image by positioning her body on the same central axis as her mentor's right hand (whose position is better characterized as resting on the general area of Anguissola's heart rather than her breast), and placing her own head higher than his so that her effigy may be said to dominate the work.[25] The gloves that she carries in her *donnesca mano* signify her rank as a lady who does not use her hands, a passive creature being acted upon – in contrast to the active role she took on as protagonist in her *Self-Portrait at the Easel* in plate 132.

Garrard has argued that the painting should not be read in these terms, that is, as if endorsing Renaissance "masculinist ideology," whereby the active male subject was empowered while the passive female object was diminished, but rather as a subversive work intended to expose that ideology.[26] Grounds cited include Campi's outward gaze (which is however the norm for the painter in self-portraits of this type, as will be shown in part v), and a suggestion that the self-image within this painting already existed as an autonomous self-portrait (which is unlikely in that it differs from Anguissola's other self-images as defined here). The strongest argument against this reading is

136 F. A. Casoni, medal of Lavinia Fontana, bronze, 1611, obverse and reverse, British Museum, London.

208

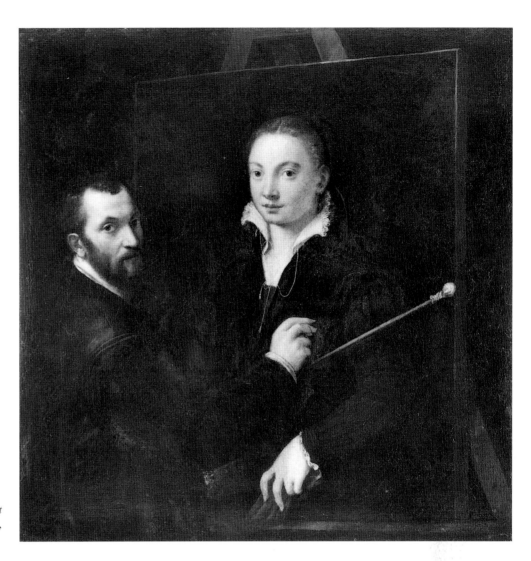

Garrard's construction of Anguissola as able to step outside the prevailing "masculinist ideology" and consciously construct a Cinquecento "feminist" response "designed to problematize the topos of the woman artist."[27] Although the ideology is transparently patriarchal to the twentieth century, it would surely not have been seen in these terms by an individual living at that time. Ideology veils overt power relations by making them seem part of natural law to all, including those victimized by it.[28]

On the hypothesis that the work was painted in Milan, it can be interpreted as reflecting the transition in the life and career of the twenty-something Anguissola as she bids farewell to her past and contemplates her future as *maestra* to a queen. She is balanced on the cusp, as it were, between her early apprenticeship and work as a beginner, on the one hand, and, on the other, her imminent exchange of country, compatriots, and family for glory abroad.[29] The painting can be read as signifying a moment of uncertainty between the known past and the uncertain future of a sheltered and protected young woman. Neither actual nor fictive sitter could have foreseen that Anguissola's unique gender-centric fame would spread throughout Europe, whereas the reputation of Campi, who never made it past Vasari's Tuscan-centered prejudice to be vouchsafed a *Life* in the second edition of his book, would remain local to Lombardy. Referring back to her apprenticeship a decade earlier, the disciple here shows herself still being formed, as it were, by her mentor. This remarkable image is accordingly at once a homage to her master, and an affirmation of her own emancipation from

apprenticeship, a *pictrix* who here reveals herself to be as accomplished in *ingegno* as in *arte*.[30]

The painting can also be read as a pictorial analogue for Salviati's verbal characterization of Sofonisba's artistic persona as Campi's achievement. Just as she will later be defined as King Philip II's social or courtly "creation" (*creata*), or "dependent," so Anguissola was characterized by the art world as Campi's *fattura*, his artistic achievement — an interpretation with which she herself would immediately have concurred. Anguissola offers her self-image within an image as Campi's attribute, and indeed she may well have been his greatest claim to fame in the sixteenth century.

The work in plate 153, which is now believed to be a portrait of the painter's parents, represents a similar conceit in which the Flemish Oostsanen shows his mother as a canvas being painted by his father (pl. 153).[31] Both parents, the father in the picture and the mother at a further remove in the picture within the picture, look sternly out at their offspring, the creator of this unnerving construction of perpetual parental scrutiny.

Anguissola's self-portraits in Lancut and Siena are of course "action portraits," in which the artist introduces the conceit of the self *in atto di dipingere*. In two further self-portraits from her Cremona period, the artist fashioned the self as musician, *in atto di sonare*, playing the virginals (pl. 138).[32] The paintings reiterate the problem of Anguissola's "inventive" relationship to Katharina van Hemessen, who in 1548 painted her sister in a similar pose, hands poised on keyboard. Anguissola's smaller, simpler painting in Naples (56 by 48 cm.) is clearly earlier than that in Althorp (83 by 75 cm.). The latter, where the usual austere dress has undergone some minimal embellishment at the shoulders and down the front, may be dated by its scale and increased painterly self-confidence to shortly before the artist's departure for Spain (pl. 138).

The Althorp version of the subject constitutes another double portrait. The light green ground against which the musician is silhouetted darkens behind the strong features of the same female servant who appeared at the periphery of the family group in *The Chess Game*, obviously a well-loved family retainer, hypothetically a housekeeper, whose inclusion is another invention. Here the head and bust of the older woman loom from the dark ground and hover like a mirage, without any defined spatial or functional relationship to a body of her own, or to the figure of the protagonist; her features are lower than, and somewhat uneasily posed in relation to, those of the musician-artist — almost a spectral presence as if this were a posthumous portrait.[33] Curiously, the head and bust of the same woman were inserted just as awkwardly into an inadequate space between Minerva's head and the frame in *The Chess Game* (pl. 126) in such a way as to register as an addition to the composition, another instance of Anguissola's lack of training in compositional creation, the art of relating one figure to another.

The two self-likenesses whose compositions survive from Anguissola's Spanish period are quite distinct in tone from those created earlier. The limited number of Spanish self-images highlights the precise function of the earlier works as gifts to the powerful, a function by then rendered unnecessary by Anguissola's court appointment. In the place of the withdrawn and modest girl from the provinces, the self-images created at court construct a high born, elegant, self-possessed woman, dressed at the height of court fashion in a tall lace ruff and richly worked brocade, embellished with such visible signs of success as glittering jewels, gifts from her regal patrons. In the small self-portrait in Chantilly, Anguissola's appearance has been transformed by the long string of pearls entwined around the braid at the back of her head, and the tightly curled ringlets framing her face (pl. 139). She displays the self in a black velvet dress with gold embroidery and, around her neck, a precious gold chain set with intertwined diamonds.[34] The proportional relationship of motif to picture surface and the tight

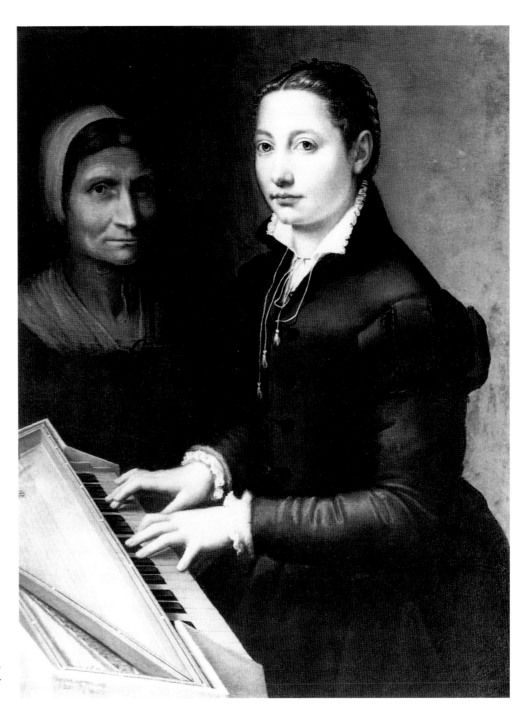

138 Sofonisba Anguissola, *Self-Portrait at the Key-board, with Female Retainer*, canvas, late 1550s, Spencer Collection, Althorp, Northamptonshire.

framing of the head are both unusual for Anguissola, and the canvas may have been cut down. It has a *terminus ante quem* of 1564, the date inscribed on the copy later commissioned from Bernardo Castello for the Accademia di San Luca in Rome.[35]

The other composition, formerly in the Leuchtenberg collection, is known only from a print by Johann Muxel published in 1851 (pl. 140).[36] Garbed in magnificent gown, the artist stands at three-quarter length, with visible signs of success: spectacular jeweled collar from which a large pendant hangs, one ringed hand carrying gloves, the other drawing attention to a double gold chain, similar to that given to Titian by Charles V in 1533.[37] The embellished gown, richly embroidered with pearls, is probably that described as "a valuable dress . . . a jewel-encrusted necklace, pearls and

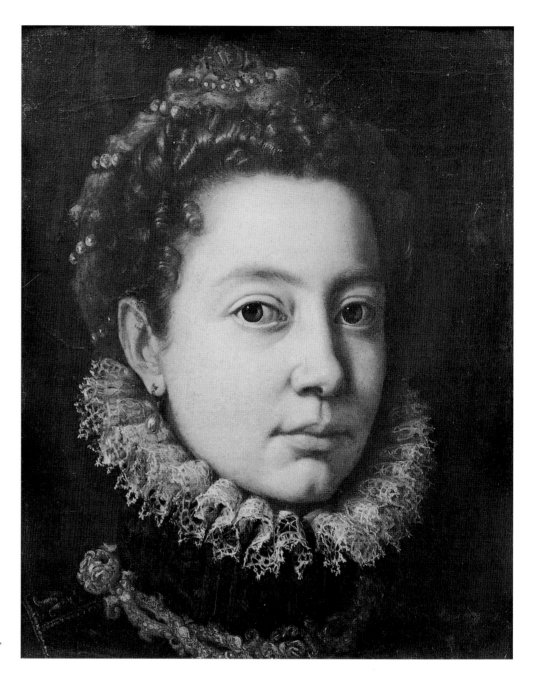

139 Sofonisba Anguissola, *Self-Portrait*, canvas, before 1564, Musée Condé, Chantilly.

other royal presents," valued at 900 scudi and given her by the queen.[38] The artist has internalized her identity as a court lady, and the image offers an aristocratic presentation and poise similar to the state portraits that she was painting of the Spanish royal family in those years. Her active gesture in holding out the gold chain for the viewer's *stupore*, admiration, as it were, can be seen as symbolizing her new-found autonomy as courtier-artist. Yet her indoctrination in modesty is still apparent in the omissions of certain attributes: not only does she not portray herself at full-length, but, if the print is to be believed, she eschews the fluted columns, high column bases, table and/or chair, and draped curtains usual in contemporary Spanish state portraits. When compared with the self-presentation by Titian (pl. 103), another richly accoutered and "enchained" Habsburg court portraitist, painted in the 1550s, the relative directness of Anguissola's work is striking.

62.

ANGUISSOLA.

140 Engraved copy of Sofonisba Anguissola, *Self-Portrait at Three-quarter Length*, 1560s, formerly Leuchtenberg Collection.

This self-portrait may have been intended to commemorate Philip II's highly charged gift of the gold chain. Even for a male artist, such a gift was still at this date exceptional. To be honored as Titian had been, to be given the same prestigious and financial reward as her great compatriot, with whose portraits her own work was so often rhetorically compared, must be seen as representing the moment of apotheosis in the career of this artist. In the dialogue in Lomazzo's *Libro dei Sogni*, Leonardo da Vinci, reflecting on her fame in 1564, is imagined telling Phidias that many professional artists believed that her brush had been lifted from the hand of the divine Titian himself.[39] Just as the double portrait of Campi "painting" his former student may be said to encapsulate her career at the end of her Cremona self-portrait period, so the regal attributes of gold chain and sumptuous clothes, not to mention the subliminal references to Titian, whose work was so much admired in Spain, were all attributes that this internationally acclaimed woman could justifiably appropriate as integral elements of her image as *pictrix* at the climax of her career. Such an image was not just a self-construction. Like Titian and Vasari, Anguissola can be said to have reached the pinnacle of her profession. There was nowhere higher or greater for the "first" woman artist to go.[40]

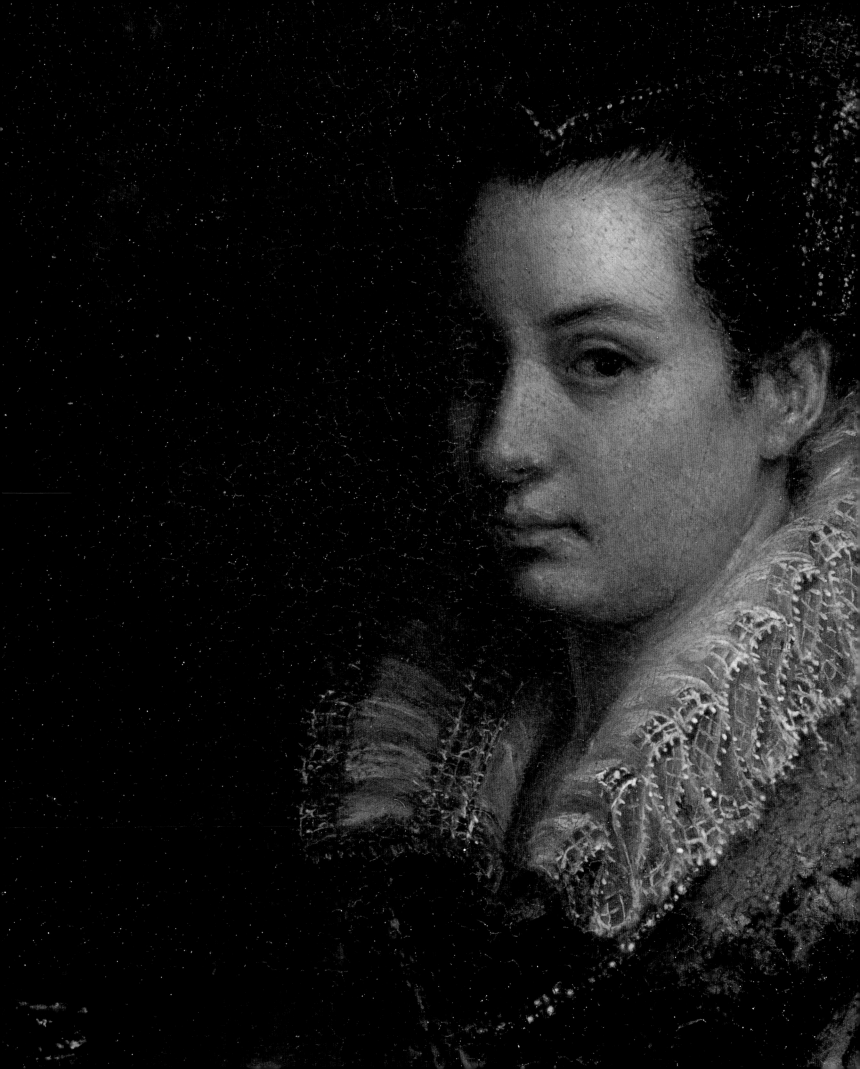

Chapter 23

"L'IMPERFETTIONE . . . DEL MIO RITRATTO"

Sofonisba Anguissola, along with Bolognese artists like Properzia de' Rossi, served as a role model for Lavinia Fontana. Sofonisba's "beauty and talents" (*bella* [*sic*] *e doti*), probably caused Fontana to feel what one man called "virtuous envy" (*virtuosa invidia*), when a woman was involved, the gendered, and presumably more benign, equivalent of unqualified, male *invidia*.[1] Fontana's professional relationship to the art world, however, differed dramatically from that of the earlier painter. Not of noble rank but the daughter of the successful Bolognese painter Prospero Fontana, Lavinia received a professional training in the only way possible for a woman in the Renaissance: from her father. Where Anguissola was a professionally trained dilettante, an aristocratic amateur who was never defined as an artist in official documents, was never paid for her art, had no workshop, and had little contact with professional artists, Fontana (1552–1614) was one of the first professional woman artists in Italy, running a workshop, seeking commissions on the same basis as her male colleagues, and receiving handsome remuneration for her work. Her name, however, never appears on the lists of the Company of Painters; like the Carracci brothers, she must have worked outside that institution.[2]

Producing over a hundred paintings, Fontana was the family wage-earner. Together, she and her father selected Gian Paolo Zappi, a minor painter but a distant member of a noble family in Imola, as her husband, thus increasing her social standing.[3] One of the conditions in the marriage contract stipulated that Lavinia should continue to practice the art of painting after her marriage.[4] The career of Zappi, a better painter "with the word than with the brush," became subordinate to that of his wife; he was her assistant and managed the business end of the shop. If Anguissola's "agent" was her father, Fontana's was her husband – and indeed some kind of male support was essential for the otherwise isolated woman artist.

The pioneering Fontana tackled an impressive range of subject matter, including male and female nudes, and was the first woman to carry out a large number of religious public commissons.[5] Whereas the modest and ladylike Anguissola never transgressed the boundaries of decorum appropriate to her rank and gender, Fontana seems to have been a strong-minded woman, whose utterances were characterized by her father-in-law as "like those of a judicious man and not of a woman" (*de homo iudicioso et non da dona*).[6] Despite her professionalism, however, her work in the public arena did not always meet with the approbation of *invidia*-prone male peers. Whereas Anguissola's work was never subjected to stringent art criticism, the work of the daughters of professional artists was treated less generously.[7]

Whereas Anguissola's early self-portraits were a continuous and steady stimulus toward creating a demand for her work, Fontana's two surviving self-portraits seem to have been produced in response to specific requests. Like those of Anguissola, both self-portraits were created early in her career – just before and shortly after her marriage, but Fontana's intended audiences were at two opposite poles; one painting was probably addressed to an extremely limited family audience, the other to a

141 Detail of pl. 144.

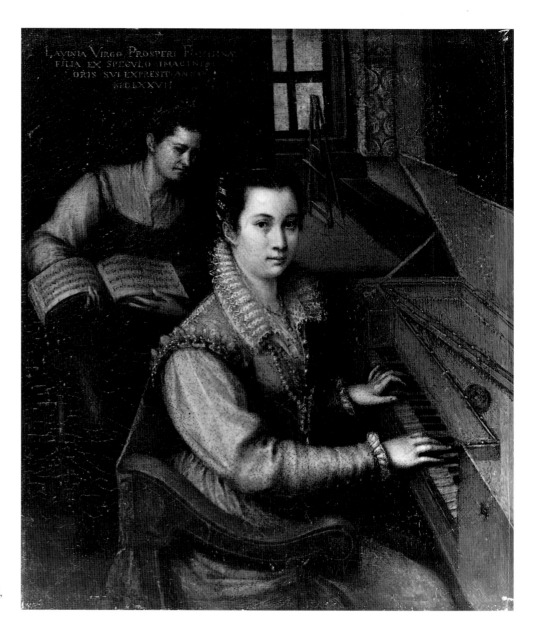

142 Lavinia Fontana, *Self-Portrait at the Keyboard*, 1577, Accademia di San Luca, Rome.

public of European dimensions.[8] "I have two of her self-portraits [*ritratti fati di sua mano*], which are rather pleasing, as you will see on my arrival,"[9] wrote Lavinia's future father-in-law in 1577 to his wife, who had not yet met the prospective bride, and his son, the prospective groom, referring, it is believed, to the tiny painting in plate 142. The bride's self-representation had apparently been her father-in-law's idea. How did she introduce herself to her groom and unknown in-laws? She quoted directly from what may have been, in North Italian artistic circles, a famous painting: her Cremonese predecessor's self-image as instrumentalist with duenna (pl. 138).

Presenting herself in the foreground *in atto di sonare*, as if playing the *cembalo* or *virginale* – the self as musical performer – she is richly and elegantly dressed in the Petrarchan colors of love: red brocade robe, white lace ruff open at the neck, wide white sleeves, and two coral necklaces. Fontana's portraits often included an elaborate setting with multiple props that complemented the sitter's status and/or profession, and her own portrait was no exception. She added the setting that was missing from Anguis-

sola's Althorp self-portrait at the keyboard. Behind the protagonist the room extends in sharp perspective back to a window, the principal light source, before which stands an empty easel. The interior setting is constructed as if the narrow front stage on which the play or opera takes place, and on which the two protagonists pose, had a backdrop implying deep space behind.[10] Developing Anguissola's invention of the motif of a female retainer as duenna, Fontana gave the older woman a role to justify her presence on the stage. Far from hovering awkwardly and passively in the background like the Anguissola family housekeeper, Fontana's servant carries a musical score to her mistress, the bride as musician.

Although Fontana's artistic career was well established by this date, she espoused a pictorial identity that stressed her musical talent, making only an offhand reference to her skill in her professional calling. Why? Poetry and music, both of which had been highly respected in Antiquity, held a correspondingly higher place than painting in the early modern period, although only music was included among the liberal arts and in the university curriculum.[11]

The visual hierarchy accorded to the arts of painting and music in terms of the vastly different scales of easel and clavichord within this composition could not be clearer: the easel is banished to the furthest possible point in the room while the musical instrument takes up a third of the foreground. The tiny easel's neglected state − not unlike the abandoned easel that Annibale Carracci would later use in his self-portrait of 1604 (pl. 161) − in this homage to music and musicianship conveys Fontana's doubts about its social acceptability. Fontana's painting also brings to mind the reverse configuration in Rembrandt's painting on the theme of the artist in the studio, where the location of the artist's small figure in the background, as far as possible from the easel, which looms threateningly large in the foreground, can be interpreted as suggestive of the painter's uneasy relationship to his art (pl. 11).

The *cembalo* was an instrument usually found in domestic settings, and hence generally used for secular music. It tended to be owned and played by upper-class women rather than professional musicians, being attractive to the former because the only part of the body to move was the fingers. Hence the lady could create beautiful sounds without sacrificing either grace or her reputation for virtue, as necessitated by such instruments as the violin, which caused the body to move violently, or the trumpet, which distorted the face. The *cembalo* nonetheless required technical skill and that is one of the many meanings intended for Fontana's new family. The painting conferred on its maker the status of a professional artist who had also mastered the technical and expressive skills necessary to claim accomplishment in musical performance.[12]

The Shakespearean adage, "If music be the food of love," makes musical performance an eminently suitable "marriage" motif. We have already noted that Fontana was dressed in the Petrarchan colors of love, white and red, and her gift of her image promises the gift of the woman herself in due course. Not only the presence of the duenna but also the particular musical instrument, also known as the virginals, denied the erotic implications present in much musical performance. Linked to intellectual exercise and the harmony of moral order, the instrument reassured the artist's new family that her chastity had not been compromised by her unusual calling.[13]

Anguissola and Fontana, women of different generations, were not alone in their exploitation of the status of music. Musical iconography was used also in what purports to be the self-image of another contemporary female painter: Tintoretto's daughter (pl. 143). A large portrait of a woman is attributed to Marietta Robusti, identified as a self-portrait, and dated around 1580.[14] The young woman is awkwardly posed beside a *cembalo*, one hand on the instrument, the other holding open a book so that the vocal music in it is legible to the viewer. The music has been identified as

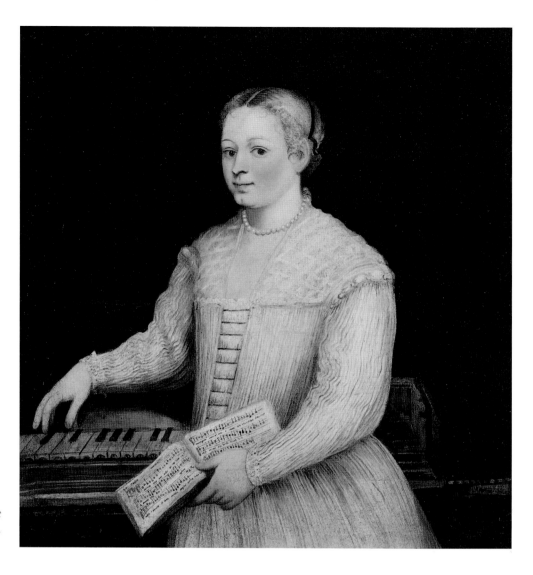

143 Attributed to Marietta Robusti, *Self-Portrait at the Keyboard*, canvas, *c*.1580, Galleria degli Uffizi, Florence.

144 Lavinia Fontana, *Self-Portrait in the Studiolo*, 1579, Galleria degli Uffizi, Florence.

a well-known madrigal, *Madonna, per voi ardo* (Lady, for You I Burn), by a well-known composer, Philippe Verdolet.[15] Even the specific edition in question has been identified.

When Marietta was a child Tintoretto is said to have dressed her as a boy so that he could take her everywhere with him.[16] As an adolescent she had been trained in drawing and painting in his studio (*allevata nel disegno e nel colorire*), but she was also, according to Ridolfi, erudite in music, having had a Neapolitan tutor *nel canto e nel suono*. In art she was primarily gifted, Ridolfi continued, in painting portraits.[17]

More is known about Tintoretta's musical, than her pictorial, accomplishments, treated only briefly and inconclusively in the 1930s.[18] There appears to be no secure basis for attributions to her hand.[19] The attribution in this case is traditional; an eighteenth- or nineteenth-century print reproduces the painting and identifies the sitter as "Maria Tintoretta." If Robusti was indeed trained by her father so as to be "expert in portraits" (*saper fare bene i ritratti*), one might almost be inclined to deny this mediocre work to her, so lacking is it in elementary skills, notably foreshortening and anatomy.

If Fontana's *Self-Portrait at the Keyboard* as a richly dressed lady dedicated to music and love, was based on Anguissola's work, her other *Self-Portrait in the Studiolo* signed with her new name LAVINIA FONTANA TAPII FACIEB[at] in gold and dated 1579, presents her own solution to the problem of the depiction of the artist as *pictrix* (pl. 144).

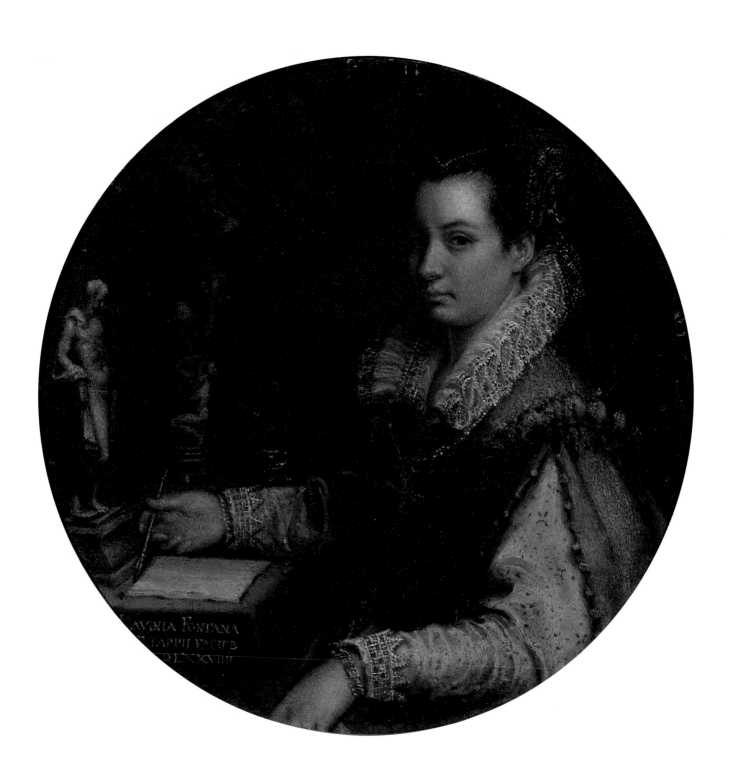

Fontana's use in the signature of the imperfect tense instead of the past was unusual, but Pliny had written that the best artists used a "provisional signature," by employing the imperfect tense, as in "Apelles faciebat" ("Apelles has been working on this"), as though the work were not yet finished, but still "in progress."[20]

A portrait of the woman artist offered the collector an object of double beauty, that of the picture and of the sitter, and in 1578 Fontana received a letter from the Spanish Dominican humanist Alfonso Ciaconio in Rome,[21] asking her

> to send me a tiny little portrait . . . to enable a panel from life to be made, to accompany the [self-portrait] which I have from Sofonisba, so that you can be seen, and contemplated, and recognized by everyone, and I will also [place] it among the 500 illustrious men and women which will be engraved, at the expense of the most serene archduke Ferdinand of Austria . . . I think of celebrating and propagating you for centuries . . .[22]

Fontana's self-image, "by your talented and glorious hands" (*per le sue ingeniose et gloriosi mani*), was to be included among the portraits of other illustrious men and women on the model of the collection created in the 1520s and 1530s by Paolo Giovio in his villa on Lake Como.[23] For once, the precise nature of the intended audience for which this self-portrait was created is known: it was to hang among a vast collection of portraits of the most illustrious individuals in Cinquecento Italy (and perhaps beyond). The audience, then, for her second self-image was as different from her first, directed exclusively to family, as it possibly could be. Furthermore, Ciaconio's entire collection, including Fontana's image, would, through publication, be disseminated to a cultivated public of potentially European dimensions. Finally, an intimidating *paragone*, or competition, was planned between her image and that with which it would be juxtaposed: a (unidentifiable) self-portrait by her famous predecessor.

How did Fontana respond pictorially to the formidable challenge represented by this particular assignment? Using the format of a tondo that had also been favored by another North Italian predecessor, Parmigianino, Fontana constructed herself seated, *not* in a workshop, but, like a scholar, at a desk in a handsomely appointed *studiolo*, surrounded by an extensive collection of antique marble and bronze fragments, perhaps from her father's famous study – torsos, feet, hands – displayed in an armoire. The lady herself, whose head must coincide with the vanishing point, is sumptuously garbed in a richly embroidered grey-violet gown, wide white sleeves, and lace ruff; jewels adorn her hair. A very large crucifix hangs on her breast, assuring her Dominican patron of her post-Tridentine devotion and piety. A sheet of paper lies on the desk in front of her and a pen in her fingers. Conceptual *disegno* and the intellect it required is Fontana's focus here, reminiscent of the earlier self-images by Bandinelli and Giulio Romano. Unlike these two men, however, each of whom exhibited a finished drawing, Fontana, like Antonis Mor (pl. 150), has not yet started to draw: the paper before her is virgin white. Whereas most painters who depicted themselves at work focused on the actual execution of the work, Fontana – like the image of Pittura on her future medal reverse – chose *disegno*, the initial stage of creation, the act of thinking imaginatively on paper, which depended solely on the intellect (pl. 136). There is some ambiguity here, no doubt intentional, in that Fontana could also be interpreted as writing, be it verse, treatise, or theoretical criticism, the act of writing being still a more effective form of self-ennoblement than the visual arts.

What is the intended subject of the work she is about to begin? What ideas or thoughts, whether by means of word or image, are to be projected on the white paper? She may derive her inspiration from the sculptures lined up in rows behind her, precious marble fragments wrested from the classical world, emblematic of the glorious Roman past that had taken place on the same Italian soil. Fontana presents the self to

the learned of her day in the guise of an erudite intellectual studying classical art. She may have been very well educated in actuality; the University of Bologna accepted female students, and a seventeenth-century source states that Fontana earned her doctorate.[24] The image thus introduces the artist to European intelligentsia and art lovers as a lady of means, of humanist erudition, well versed in *disegno* and intellectual creativity, perhaps also a budding theorist, and last but surely not least, a demeanor redolent of social and religious conformism, as she also presents herself on the obverse of the medal created for her in 1611 (pl. 136). Unlike the reverse, which shows Pittura in a state of creative fury, Fontana's portrait as a hefty, middle-aged matron may be read as the epitome of respectability.

Twice Ciaconio mentioned his desire for a *paragone* between the two woman painters of Cinquecento Italy. Although the particular Anguissola self-portrait in his collection is not known and may not have survived, is it possible nonetheless to reconstruct some sense of the impact on the viewer conveyed by juxtaposition of the two female self-images, dating respectively from the 1550s and 1570s? If Fontana's first self-image developed Anguissola's ideas, her second one pursues a discourse of erudition and Antiquity that was never developed by her predecessor. Like Bartolommeo Passerotti, another Bolognese painter, Fontana had a propensity for placing motifs on a table so as to define the intellectual orientation or professional interests of the sitter. Here she stressed both the details of the surrounding *studiolo* and the nature of the attributes. Anguissola, on the other hand, never gave a spatial context to any self-image, preferring to present herself in isolation; even the chair supporting her is usually invisible, and only one attribute in one painting connoted learning: the book that she holds in the early self-portrait in Vienna (pl. 129).

Fontana reformulates the image of the female artist as a prestigious and cultivated lady. Her wardrobe is infinitely richer than Anguissola's, whose reticence in this respect and preference in her early work for sober and austere outfits is so marked. If Anguissola's consistent choice of somber garb was deliberate as emblematic of the modesty and humility appropriate to a woman, then perhaps Fontana, trained in a professional workshop and accepted within Bolognese artistic circles as a professional painter – *una donna così famosa et tanto excelente artifice*, in Ciaconio's words – felt fewer constraints in this respect – although she never acknowledged her vocation as manual painter in visual form, despite existing models by Anguissola. In some senses, the only Anguissola self-portrayal that can be compared with Fontana's is the lost three-quarter-length painting, known only from Muxel's print, in which the artist displays her rich court wardrobe and gold chain, and addresses her audience with a new self-confidence (pl. 140).

This is a tiny painting. Ciaconio had requested a *retratino piccola*, but he may not have expected a miniature on the tiny scale of 15 cm. diameter. But Fontana knew what she was doing: the scale conveys modesty, and the Renaissance woman artist who eschewed the restraint and humility that became a lady did so only at tremendous cost. As the poet Spenser put it, "vertuous women know that they are born to base humilitie." For a woman artist to venture into the public arena which men regarded as their exclusive field of action was to provoke *invidia*. Under no circumstances did a woman leave herself open to an accusation of pride or boasting in a way that might stimulate male *invidia*, as Prosperzia de' Rossi had foolishly done in 1525. At that time, the artist Amico Aspertini, envious of Prosperzia's talents, testified against her when she was accused of assault (*aggressione*) against a painter, and sought to discredit her with the specific aim of ensuring that her work on S. Petronio "would be very badly paid" (*le fu pagato un vilissimo prezzo*).[25]

Fontana herself felt that bite after completing a historiated altarpiece, the *Stoning of St. Stephen* commissioned by the pope for S. Paolo fuori le Mura, that was heavily

criticized by Baglione. Thereafter, says Baglione, Fontana renounced public commissions in favor of (private) portraits, since "being a woman, in this kind of painting [the lesser genre of portraiture], she did quite well."[26] "The works of Lavinia are valued in all Italy," wrote another critic, "and . . . it is true that they do not have the excellence and valor to be found in such things by great men, because they are after all by a woman who has left the usual path and all that which is suitable to [her] hands and fingers . . ."[27] Castiglione had articulated what the talented woman with professional aspirations needed: *discreta modestia*. As it happens, the professional woman artist's letter to Ciaconio accompanying the self-portrait is an *exemplum* of the rhetorical formulae of female modesty. Feigning great humility, the artist declares herself unworthy of appearing beside the works of those greater than herself:[28]

> you do me too much honor, whether with your overflowing praises or your intention of giving my portrait such an honored place; the first I attribute to the excess of your love, the other makes me think that you judiciously want to make the virtue and honor of the lady Sofonisba . . . whom I am unworthy of serving, to shine all the more. Your Excellency has thought to use the imperfection and the shadows of my portrait with which to illustrate all the better your most noble museum . . . [*V. S. ha pensato con l'imperfettione et con le tenebre del mio ritratto illustrare tanto maggiormente il suo nobilissmo Museo*].[29]

Part V

"HABBIAMO DA PARLARE CON LE MANI"

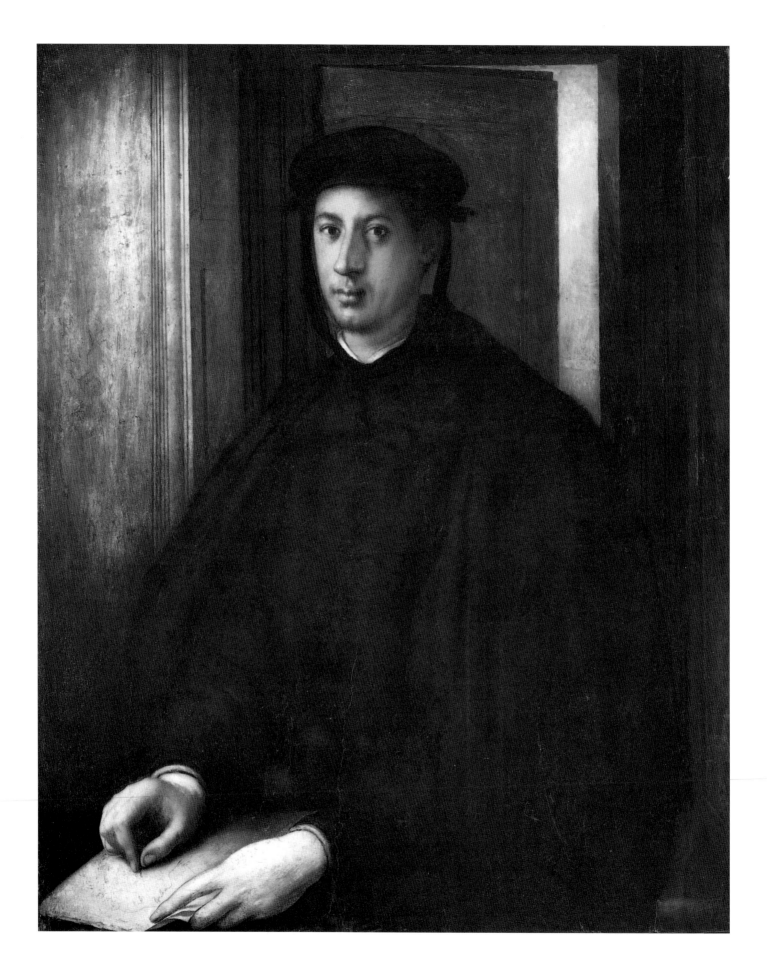

THE SELF AS CRAFTSMAN

INTRODUCTION

"We must speak with our hands," said Annibale Carracci. There are half-a-dozen works from the second half of the sixteenth century in which the male artist, having developed confidence in his professional standing, depicts himself holding the tools of the trade — palette, brushes, mahlstick — that defined him as a manual worker. The compositions by Titian, Allori, Cambiaso, Palma Giovane, and Annibale Carracci are the *only* known instances of Italian artists offering visual proof of the skill of their hand as well as the power of their intellect.

Several decades earlier, however, paintings were produced at the courts of Florence and Ferrara that displayed a Medici prince and an Olympian god offering evidence of their own sleight of hand. Pontormo's portrait of the first Medici duke of Florence in the 1530s, and an *istoria* by Dossi, court painter to the Este, in the 1520s, embody the concept of the *arti del disegno* as an appropriate activity for the powerful on earth and in Olympus.

Pontormo's portrait of Alessandro de' Medici gives credence to this ruler's pretensions in the arts by showing him drawing the head of a lady in silverpoint, just as Castiglione's *Book of the Courtier*, published in these same years, said a prince should (pl. 145). It is known that Alessandro gave Pontormo's portrait, painted in the Malaspina residence where the duke paid his inamorata daily visits, to the lady Taddea herself.[1] Pontormo's ducal likeness was accordingly created as a private image, in which the duke declared his devotion to the lady. The painting suggests several conceits at once: that the ruler posed in person for Pontormo during the portrait's execution; that his lady love was also physically present during the sitting(s); and that, while Pontormo portrayed the duke in full face, Alessandro busied himself in rendering Taddea in profile.[2] Alessandro gazes searchingly before him, not, as happens so often in this study, at the Self, but at the beloved, the Other. Like Frans Floris's *St. Luke painting the Virgin* (pl. 146), there is little ambiguity as to the identity of the person outside the picture frame, whose spirit, if not body, needs to be incorporated within the painting's interpretation.[3] The lady Taddea, who posed for Alessandro's work of art, was both the prince's sitter *and* the portrait's primary — perhaps only? — viewer; she may often have sat beside the duke's likeness in actuality to commune with his portrait, as he continued to draw her image in eternity.

"Thou shalt be the god of painting under great Jupiter," Janus Pannonius had written to Mantegna in 1458.[4] In the 1520s Dosso Dossi created a painting showing Jupiter, classical deity and ultimate role model for so many Cinquecento rulers, exploring the creative artistic impulse (pl. 147).[5] Exchanging his fiery thunderbolt for a paintbrush, the omnificent god is painting butterflies against a blue sky.[6] The canvas is otherwise empty and the subject of Jupiter's painting is unclear, given that a composition limited to fluttering butterflies would, in the Renaissance, have been an extraordinarily modernist invention. Beside Zeus, Mercury, in his role as patron of the arts, holds his finger against his lips in the traditional gesture for silence, addressing a petitioning young

145 Jacopo Pontormo, *Alessandro de' Medici*, 1534, Museum of Art, Philadelphia, The John G. Johnson Collection.

146 Frans Floris, *St. Luke painting the Virgin*, 1556, Koninklijk Museum voor Schone Kunsten, Antwerp.

woman whose head, neck, and arms are wreathed in garlands of flowers. Sansovino identified her as Virtue, and the painting's unusual iconography is believed to have been based on a dialogue by Lucian, published in 1497, in which Mercury refused to admit Virtue to Zeus's presence, on the grounds that the gods are busy "making gourds bloom on time, painting the wings of [real] butterflies, and other such duties."[7] Chastel identified the Virtue as Eloquentia, and proposed that the painting contributed to the time-honored *paragone* between word and image. The art of rhetoric here attempts to intervene in the creative act, which is instead accomplished solely by the art of painting in the person of Jupiter. The painting can accordingly be said to propose an unusual thesis, in that Mercury imposes silence on the art of speech, at the same time that Jupiter celebrates the mute art of the painter.[8]

Garbed in brilliant red and wielding the mahlstick and brush with professional aplomb, Jupiter is shown as painter of the world who creates magnificently illusion-istic butterflies, time-honored symbols for the human soul (the Greek term for but-terfly was *psyche*).[9] Butterfly wings were also associated with evanescent time, and a particular species, *necrofora* (bearer of death) symbolized the life hereafter.[10]

The performing artist must no doubt have identified with the depicted artist; Dossi

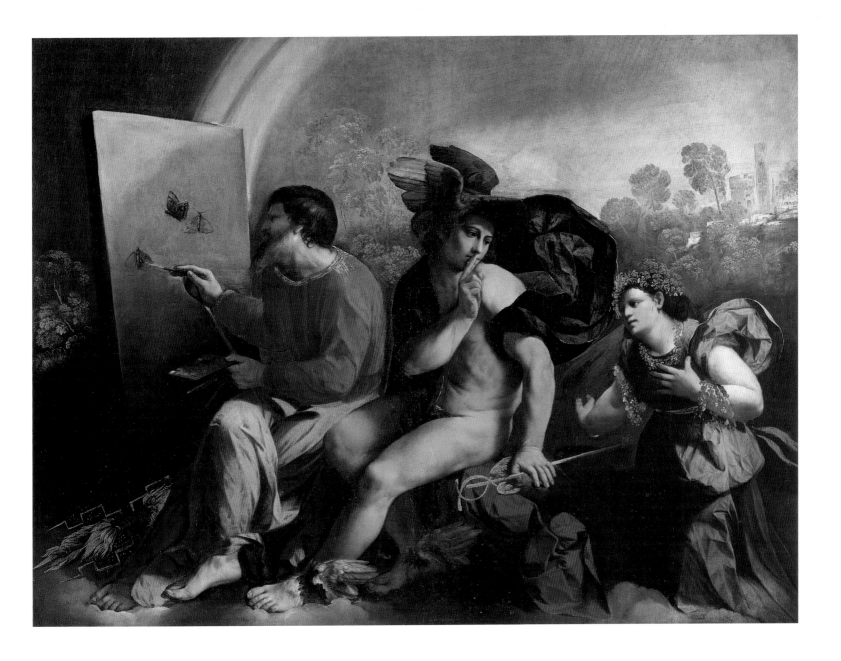

Dosso Dossi, *Jupiter painting in the Presence of Mercury*, 1520s, Kunsthistorisches Museum, Vienna.

here compared the creations of his *mano* with those of Jupiter, also stressing the importance of solitude – protected by Mercury – for the intellectual conceptualization of his art. This glorification of the labor involved in the pictorial arts, contemporaneous with the publication of Castiglione's book, is rendered all the more powerful by virtue of the scene's location above the earth on the clouds of Olympus.[11] These paintings by Pontormo and Dossi must have implied to their viewers that, as Steinberg put it, there was no one in heaven or earth too good to paint.[12]

THE CINQUECENTO *MANO*

Within a few years of mid-century, two autonomous self-portraits of painters at work were produced in Venice and Rome, by, respectively, the greatest court artist of the period, and a young painter who had hardly started his career: Tiziano Vecellio, court painter to the Habsburgs, and Alessandro Allori, future court painter to the Medici.

148 Giovanni Britto, *Titian sketching* (copy of Titian self-portrait), 1550, woodcut, Rijksmuseum, Amsterdam.

In a painting seen by Sansovino in the collection of Niccolò Renier, Titian presented the self working manually: "By Titian his own portrait on panel of cypress, while drawing [*in atto di disegnare*], with a bronze statue of the Medici Venus behind him, as if in his workshop."[13] Although the original of this particular work is lost, a composition showing the artist *in atto di disegnare*, survives in at least four different painted versions, not all of them Cinquecento; it survives also through a woodcut signed by Giovanni Britto and dated to 1550 by the poem by Aretino appended to it (pl. 148).[14] In the woodcut, which is related compositionally to his Berlin self-portrait (pl. 103), but in which the configuration is, as usual, reversed, Titian constructs the self at half-length, gazing out of the work, the head facing in the opposite direction, but at a

similar angle. Although the artist's body here is not poised for movement toward the left, two strands of (much larger) heavy gold chain still sway to the right. In his right hand he balances a tablet against a horizontal surface, in his left a pen or chalk-holder. The small statuette of the Venus Pudica in the painting has been replaced in the woodcut by a swag of curtain in the opposite corner.[15] Aretino's poem draws attention to Titian's role as portraitist to Charles V, Philip II, and Pope Paul III.

This print is another self-portrait *in atto di . . .* Here, however, the action being undertaken is both unambiguous and novel to the vocabulary of Italian portraiture. The grand old man of Venetian art, who, by this date, had garnered most of those financial and social rewards that artists had been seeking for the last 150 years, shows himself using his hands. The very author of "Titianesque" paintings may thus have been the first Italian artist to articulate visually the *arte*, skill of hand, that enabled him to create them. This bold and unexpected move for the date must be related to his elevated artistic standing in court circles. The artist was at the apex of his career; a professional self-definition that included the mechanical side of creation could no longer harm him.

In atto di disegnare: how paradoxical that Titian should have presented himself in this particular creative mode, given the historical circumstances surrounding the *paragone* between "Florentine" *disegno* and "Venetian" *colore* that reflected such a profound difference in the attitudes of the two centers toward the art of painting. It was precisely on the grounds of *disegno* in its concrete, technical sense of draftsmanship, that Titian's work was criticized in Central Italy. This criticism of the major exponent of the Venetian school, made by Vasari, the critical voice of Tuscan tradition, was credited by him to the major exponent of the Florentine school, Michelangelo: "it was a pity that in Venice they didn't learn from the beginning how to draw well . . ."[16] Vasari was particularly critical of Venetian painters who used the "superficial allure of coloring to hide their inability to draw."[17] Titian had never come to Rome as a young man and without that experience, said Vasari et al., he could not expect to improve upon the things he "copied" (*ritrarre*) from life. Without *disegno* and Roman study, Rosand has written, the Venetian painter was condemned to practice a lower form of art, to be merely a faithful copyist of Nature.[18]

Taking the term in its more abstract, theoretical meaning as an esthetic principle, *disegno* – the conception and planning of a work – was also considered the strength of Florentines in opposition to Venetian expertise in *colore*, the physical process of applying paint. As one scholar summarized the debate, for Tuscans the value of a painting lay primarily in its conception, whereas Venetians were more preoccupied with the actual process of painting.[19]

Yet here Titian claims *disegno* for his own, and, since Britto's composition originated in a painting by Titian, it cannot be argued that expertise in *disegno* was chosen because it was more suited to the print medium. We may hypothesize that the choice of activity at this date – almost immediately after Vasari's criticism of his methods, and still a few years before Dolce came to Titian's defense in his *Dialogo della Pittura* (1557) – was deliberate, as was his decision to have this particular composition engraved, so that his and Aretino's response to, and challenge of, Vasari's criticism could be disseminated in Florence, Rome, and elsewhere.[20]

★　★　★

Within a couple of years, a very young Florentine artist, barely twenty years old, who would follow his mentor to become official court painter to the Medici regime, started his career as a portraitist by using the self as model, just as Parmigianino had done half a century earlier. Allori painted himself painting his self-likeness, that is, observing himself observing himself in the mirror, in a work considered one of his earliest, and

usually dated to 1554–5, the beginning of his sojourn in Rome – where he, unlike Titian, went to study the works of Michelangelo and Antiquity (pl. 149).[21] The painting introduced the new attributes of brush and palette into the vocabulary of Italian self-portraiture.

In a *finzione*, in its own way as elegant and as carefully calculated as Parmigianino's, Allori depicted himself as if the canvas on which he worked was placed at exact right angle to the frame of the self-portrait showing him at work, similar to the solution utilized by Paggi in his self-image (pl. 90). Allori's head and bust are shown in extreme close-up, and his hands are posed at the place where the left edge of the painting on which he works meets the surface of the picture on which he is seen at work. The artist faces left, and the location of his right hand flush with the picture surface gives the strong illusion that his left shoulder has broken through the picture plane into the viewer's domain.

This viewer's sense of the most intimate rapport with the artist is increased by the short distance between Allori's head and the canvas that he is shown painting, creating the illusion that we are as close to him as he is to that canvas. Indeed, he is too close to the canvas to have been able to focus on it. What his eyes do focus on, of course, is his mirror image – which we should imagine as identical in size and format to the painting – and, beyond, to his public, with an expression that is both appealing and forceful, both limpid and self-confident.

Painting in Rome, at a distance from home, Allori rejected the Florentine tradition of complex portraiture established by his master Bronzino, whose sitters were endowed with much regality of bearing and chilly restraint, given many beautifully designed accessories and attributes, and often placed in elaborate, architectural settings. There was of course no prototype of an independent self-image among these. Paradoxically, Bronzino, who much enjoyed including his own features, and those of his friends, the leading artistic and literary figures of mid-century Florence, as witnesses to the holy events in his major religious altarpieces, is not recorded as having produced an autonomous self-portrait.[22] Be that as it may, this work may be read as a declaration of artistic emancipation on Allori's part, in terms of ideology, style, and, possibly also, genre, a declaration all the more powerful given the strong Bronzino influence in the portraits he painted soon afterwards, of Ortensia de' Bardi da Montauto (1559; Uffizi) and Paolo Capranica (1561; Ashmolean, Oxford).[23]

Like Parmigianino, then, Allori's interest in communicating with his public, in his case one of his earliest audiences, is palpable. Did Allori send this clever, cogitated work back to the Florentine court as proof of the increasing sophistication of his artistic *ingegno*? The prospective audience for this work could have been a home-based, Florentine one, a highly critical public which would have been most interested to see a work so cleverly intricate and so removed from Bronzino's world as to communication between sitter and audience.

On the other hand, Titian's composition showing himself sketching makes no concessions to the viewer. Once again, the artist does not wish to be seen contemplating himself in the mirror; his eyes gaze off to some distant motif or vista of far greater interest than the beholder. Unlike the youthful Allori's avid search for the connection between self and viewer, the aging Titian once again acts out the fiction that he is unaware of the public's scrutiny. The extent of his evasive strategy vis-à-vis the viewer is pointed up by comparison with the self-image of a worthy rival, the Netherlander Antonis Mor, who succeeded the Venetian artist as portraitist to the Habsburgs in 1554, when he was appointed court painter to Philip II.

Although Northern artists had fewer pretensions than Italians, and were less reluctant to accept the tools of the trade as appropriate attributes, it is surely significant that among the earliest to display the self in conjunction with easel, canvas, mahlstick,

149 Alessandro Allori, *Self-Portrait*, c.1555, Galleria degli Uffizi, Florence.

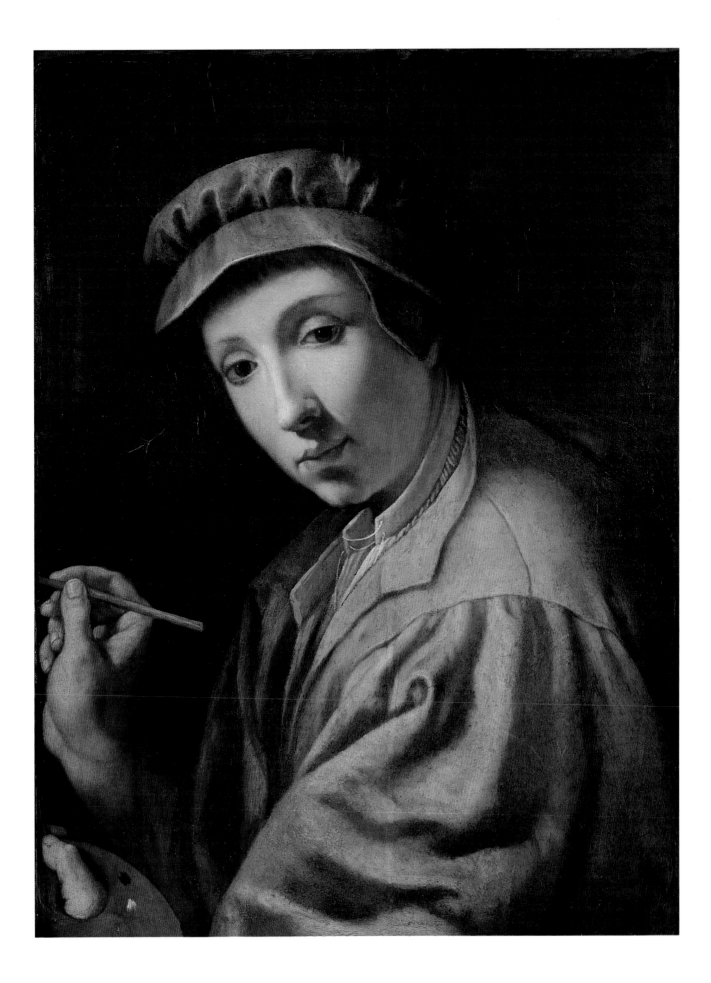

palette, brush, and rag, was one of the most successful Netherlandish artists of the day (pl. 150).[24] Antonis Mor's open reference to the messy, manual component of his art, was, however, offset by the discreetly placed Latin inscription on the edge of the easel, PHILIPPI HISP. REG. PICTOR, "painter to Philip, king of Spain," and the fine clothes, of satin, velvet, and fur, that bespeak his noble status as intimate of the king.[25] Although Mor significantly does not portray the self *using* his tools, his sumptuous dress nonetheless recalls Cennini's declaration 150 years earlier that painting was the "nicest and neatest occupation that we have in our profession . . ."; "really a *gentleman's* job, for you may do anything with velvets on your back."[26] In his famous passage concerning the lesser physical fatigue involved in painting as opposed to sculpture, Leonardo da Vinci also stressed the *signorile* conditions under which the "well-dressed" painter could practice, "adorned with such garments as he pleases."[27]

Mor's canvas is completely blank but for a poem in Greek in which the work of Apelles and Zeuxis is compared unfavorably to his own:

> By Jove, of whom is this painting?
> Of the best among painters.
> Who, above Apelles and Zeus,
> And all the other ancients and moderns,
> Has obtained mastery by means of his art.
> Yes, he has made this portrait of himself.
> He painted it with his own skilled hand.
> He studied himself in a metal,
> In front of the mirror.
> Oh what an excellent artist!
> The counterfeit Mor which you now behold,
> Mor, . . . presently speak![28]

A visual image of the regal features was accordingly substituted by a literary work written by a humanist praising not the sitter-monarch but the agent-*artist*, in words that provide a center of interest in the upper right of the canvas to balance and reinforce the painter's intellect at left. The pictorial surface is dominated not only by *poetry*, respected by all as if a liberal art, but *Greek* poetry, on axis with the "mechanical" implements of palette and brushes below, just as the crucial implement, his right hand, is on axis with his intellect. What the palette, brushes, and mahlstick have produced is high humanist praise of a craftsman in the most prestigious of forms – a language that most viewers, including the artist, would not have been able to read. No features, however regal, could have competed with this small Greek poem, which dominates the entire canvas, as a carrier of hidden signification. Greek verse is clearly worth more than any image, however praiseworthy that image may be of Greek verse. Indeed, even without a translation, the classical language is itself the message. Thus the "liberal" word, sole tenant of an otherwise empty canvas, triumphs over the potential, but nonexistent, image. In her self-image Artemisia Gentileschi also placed herself in front of a blank canvas, but she constructed the self as poised for action, at the very moment when the concept is about to be translated into art by virtue of the hand's dexterity.[29] Mor, on the other hand, still conceptualizing, displays the mastery that puts Apelles' work in the shade only in that part of his work that resides outside the painting within the painting.

A close connection was seen between the acts of writing and drawing, in that both activities shared a common instrument, the pen. Nonetheless, despite this similarity, only one was designated as noble by the culture, the pen that shaped the letters, not the pen that drew the line. Indeed, in Britto's woodcut portrait of Titian with sketchpad and pen, the artist may be writing rather than drawing, since the thin pen can be

150　Antonis Mor, *Self-Portrait at the Easel*, 1558, Galleria degli Uffizi, Florence.

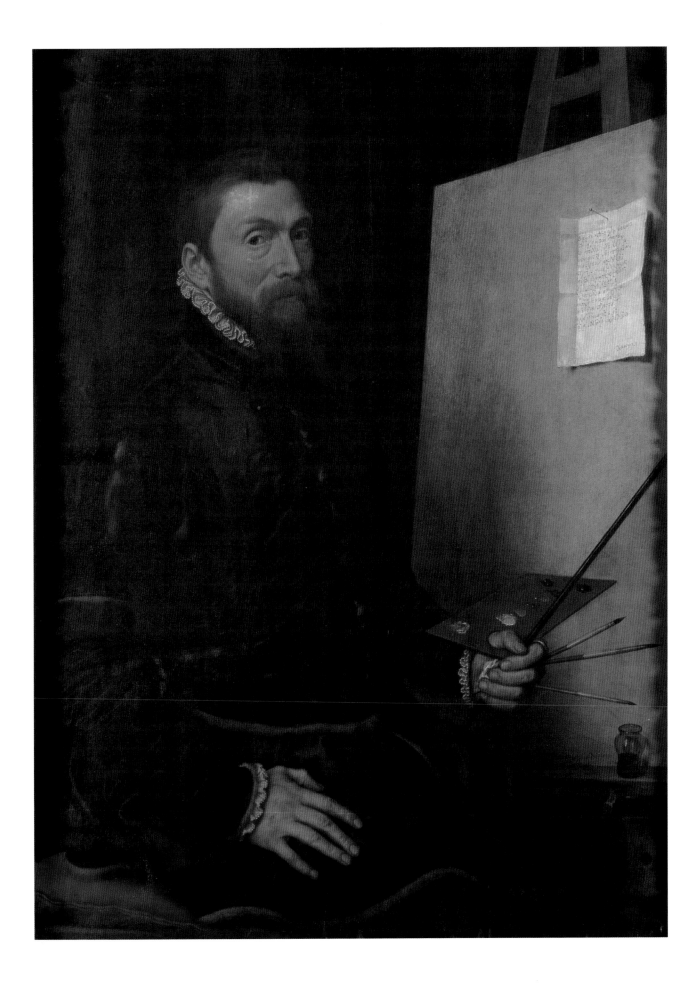

151 AD OMNIA, *The Divine Creator holding Palette and Brushes in front of a Virgin Canvas.* Emblem 2 from Diego de Saavedra Fajardo, *Idea de un principe politico cristiano,* Madrid, 1640, I, 82.

read as a Italian *stile* (Latin *stylus*), meaning a poet's pen as well as a painter's pen or brush.[30]

An impresa from *Idea de un principe politico cristiano* (The Ideal Christian Prince), a seventeenth-century Spanish contribution to the copious exemplary literature on the Mirror of Princes, seems peculiarly relevant to this conceit created by the man who was painter to the sixteenth-century Spanish king. Under the rubric AD OMNIA, a canvas as blank as that before Mor stands on an easel; in this case it is the hand of the Divine Creator that, issuing from a cloud, holds palette and brushes (pl. 151).[31] The image is, in part, glossed by the text, which points up the relation between art and ideality in this period:

If painting [with brush and colors] is not Nature itself, it is very similar to it . . . Art cannot imitate bodies, but it does confer grace, movements, and even the affections of the soul upon them . . .

The artist was supposed to represent the subject both as he observed it in Nature and as perfected by him; that is, the function of art was to complete the work initiated by Nature. "A natural prince is an imperfect one, whereas a prince who aspires to Christian virtue must be 'cultivated,' and the process of cultivation is preeminently the process of art."[32]

Mor, the painter whose mastery puts the work of Apelles and Zeuxis in the shade, awaits the arrival of his royal subject. In his portrait of the regal features, Mor's art, the self-portrait affirms, will further develop and improve the work initiated by Nature, by presenting Philip with an image of a "perfected" self. Just as the literary Mirror of Princes revealed the exemplary qualities – the ideal norms of conduct, character, and thought – considered necessary for the perfect prince, so Mor's imaged Mirror of Majesty will fashion for his sitter a likeness of his exemplary regal persona, a vision of the ideal monarch that the prince supposedly sought to become through his own self-fashioning.[33] Mor's *finzione* of the self should have reassured Philip II that he was employing an able *fintore* of royal portraiture. Since at least one self-portrait by Mor was displayed in the "royal room of portraits," Philip may well have known this particular self-image.[34]

Returning briefly to Sofonisba Anguissola's self-portrait at the easel (pl. 132), it is clear that her self-likeness as a craftswoman differs quite fundamentally from the self-consciously clever self-portraits by Titian, Allori, and Mor. She does not hide the work on hand, like Titian; she does not wear her best clothes, like Mor; nor does she play with an ingenious *invenzione*, like Allori. Anguissola does not display poetry in Greek, like Mor, although she might in fact have been able to read it. The ease with which she is seated at work, the straightforward tone, the frank acknowledgment of the artisanal basis of her identity as an artist, an innocent and almost artless quality, points up the extent to which Titian and Mor each created a grand and magisterial icon of the self, the artist in his maturity, great masters by virtue of their own merit, not to mention the awesome rank of their imperial and regal patrons. Anguissola's interpretation reflected her own Cremonese origins: in the 1550s she was a very young woman, working exclusively within the domestic sphere in a provincial town, whereas Titian and Mor, sought after by the world's leaders, had already earned their laurels in the greatest courts of Europe.

THE FILIAL SELF

When the artist reveals the self as a practicing painter, what iconography does he wish to be seen working on? There are a number of answers, since few followed Titian's

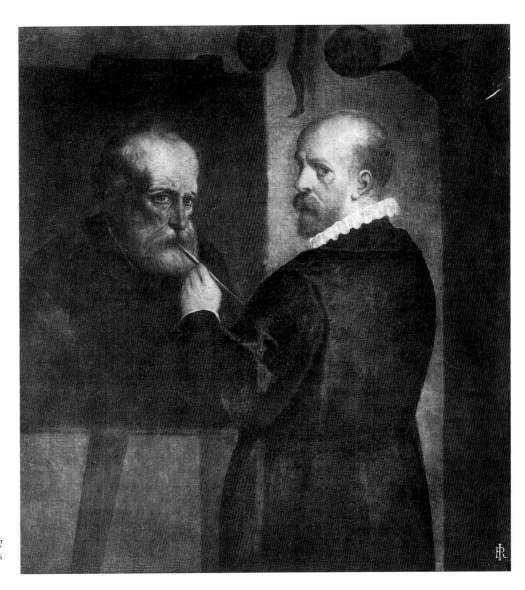

152 Luca Cambiaso, *Portrait of the Artist painting a Portrait of his Father*, 1575–80, whereabouts unknown.

example in concealing their work. In the case of Allori's equally invisible canvas, it may be assumed that the unseen picture is identical to the painting of Allori at work. On Mor's canvas the image has been temporally downgraded and replaced by a work in another discipline. The iconography of the paintings included within two later self-portraits, however, have broader ramifications that overlap with other spheres of sixteenth-century life: family history in the case of Cambiaso who showed himself with his father (*c.*1575–80), and personal piety in that of Palma Giovane (*c.*1590), who juxtaposed the self with the Resurrection.

The only portrait apparently attributed to Luca Cambiaso who, like Zuccari, was called to work at the Escorial, is a self-image of the artist painting a portrait of his father, a composition known in two versions (pl. 152).[35] While the forms of the painting within the painting amply testify to Cambiaso's lack of interest in, or study of, the art of portraiture, his choice of iconography is startlingly original. Depicted at three-quarter length, Cambiaso stands at an easel in a studio with sculptural models, his back to the viewer but head turned in profile to study his model, ostensibly his father, whose bust-length portrait, in a canvas that is proportionally too large for the scale of the likeness, is almost finished. The elder Cambiaso was a painter, the son

learned the trade in his father's *bottega*, and the two often collaborated on commissions.

This portrait, perhaps the only one that Cambiaso was moved to paint, presents two men at different points in their life cycles: son in middle age and father in old age. The father's head in the painting within the painting is on a larger scale than the son's, suggesting the moral weight of the paternal presence in the son's life and psyche. Over and beyond the obvious features of bald heads, moustaches, and beards, father and son share a remarkable family likeness. The composition could almost be read as an picture in which the artist portrayed himself twice – a double self-portrait, as it were – as he was at the time of painting, and again in extreme old age, as he will soon become.[36] The father's death, soon after 1579, could have been the stimulus for this *invenzione*.

Renaissance people believed that the father–son relationship was a pivotal one in society, even after the son was fully grown.[37] Legislation determined that the two formed a "community, almost personal unity" (*communanza, quasi unità personale*), or as Marsilio Ficino put it, "the son is mirror and image [*specchio et immagine*] in which the father after death almost remains alive for a long time," which could hardly be more apt for the interpretation of this "double portrait," where the son is indeed the *immagine* of the father as he once was, and the father a mirror of the son as he will become.[38] The son was, in theory, the father's immortality, enabling his identity to continue, just as in practice the son in this painting visually endows his father with immortality. Elsewhere, Ficino likened the father to a "second God," whose commands sons should fearfully and reverently obey.[39] In his *Zibaldone*, Giovanni Rucellai outlined the ideal sequence for the father–son relationship: until eighteen, the son remained "obedient and reverent" to the father; between eighteen and thirty he and his father were like brothers; when the father became older, "he should want to become the son, and the son should take the father's place and run everything."[40]

Cambiaso serves as the mediating agent between the viewer and his father. An image of the Antwerper Jacob Cornelisz. van Oostsanen that shows him working on a portrait of his wife, formerly dated to around 1530 and believed to be a self-portrait, seems to present a similar situation to Cambiaso's (pl. 153).[41] The heads of man and wife are at the same level, so that both pairs of eyes could be interpreted as directed toward the image of Jacob in the mirror. The painting, now dated to the 1550s and attributed to Oostsanen's son Dirck, is currently interpreted as a double portrait of the artist's parents, in which his father is seen as painting his mother, the sitter toward whom his father Jacob looks, whereas the mother's eyes are directed out toward her son. The sitter for Jacob's painting is Dirck's mother, while that for Dirck's portrait is his father. The viewer must identify with Dirck or Dirck's mother, who, according to this conceit, occupy the same space. In the Italian self-portrait, on the other hand, the artist's mother plays no role; as we know, even in family altarpieces, women in Italy were seldom included among the male donors.

Very little is known about the relation of Cambiaso's self-image to his life and work, or the real-life affective and working relationship between father and son. Giovanni, the elder Cambiaso, a provincial artist of modest talent and weak technique, taught his son. Luca, whose artistry and *ingegno* was ranked by Lomazzo at the same level as Tintoretto and Barocci, and whose draftsmanship is greatly admired today, had therefore, for all practical purposes, no master.[42] Writing a hundred years later Soprani recorded the father's *invidia* when his teenage son – called *miracolo di Liguria* – incited comparisons with Michelangelo by introducing stylistic inventions into the workshop production.[43] Since Luca's envious father was titular head of the *bottega*, generational tension must have been rife on the worksite. However, since they continued to collaborate as Cambiaso and Son, so to speak, compromises on one side or the other must have been made. In any case, this double portrait dates from the 1570s, when the artist

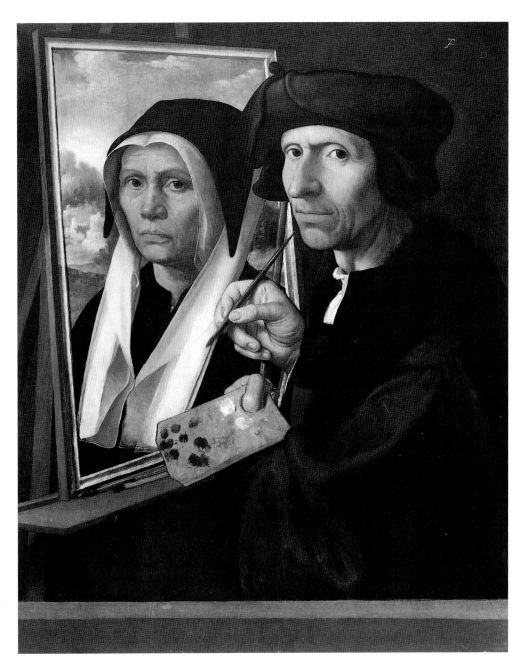

153 Dirck Cornelisz. van Oostsanen, *Portrait of the Artist's Father painting a Portrait of the Artist's Mother*, 1550s, Museum of Art, Toledo, Ohio. Gift of Edward Drummond Libbey.

was already considered old and the sitter (if there was one physically) was *extremely* aged, comes out of a different temporal context.

We can merely draw attention to the potentially rich interpretation possible if more were known about the relations between father and son in actuality. Only then will it be possible to offer a hypothesis about the relation of the silent pictorial dialogue that takes place between the two to the perhaps less silent communication between the generations in historical actuality, in a work of great iconographic originality, without predecessors or successors, in which the elderly self-portraitist uses the paternal features as his prime – his only – attribute.

★ ★ ★

Given the pervasive influence of the Church in every corner of life, particularly in the last quarter of the century following the Council of Trent, it is difficult to believe that Jacopo Palma il Giovane was the only Italian artist to identify himself with the holy doctrines, with which, like most artists, his work was overwhelmingly concerned (pl. 155). Small in scale (128 by 96 cm.) for a work on a religious theme, the painting must have been intended for private consumption only. It shows Palma at work on a history painting, in a successful fusion of this high-status genre with the lower one of portraiture.[44]

The iconography of Palma's early self-image is unique in this study: he declares the self a pious believer in the post-Tridentine world by presenting himself putting the finishing touches to a magnificent image of Christ's Resurrection.[45] The artist, considerably larger in scale than Christ, is very much the lead performer of this work, and, like the modern film director, his gesture implies a call for action that sets the narrative into motion.[46] Wearing sumptuous – and supremely impractical – furs, and indulging in a grandiose rhetorical flourish, Palma turns to look over his shoulder, as if the viewer had just interrupted him by entering his workshop. The Resurrected Christ raises his right hand in benediction of the artist and miraculously rises above the tomb. Dominating the upper areas of both the painting and the painting within the painting, he looks down at the three Roman soldiers who try to protect themselves from the horrifying natural disaster that has overtaken their world.[47]

The painting is beautifully composed around a series of diagonals that include Palma's two arms. The painting of the Resurrection is placed at a diagonal to the left, juxtaposed by the artist who, leaning to the right, achieves an intimate and symbiotic relationship to the Savior. The juxtaposed upper bodies of Christ and Palma both seem to spring from Palma's torso, with Christ issuing from the region of the artist's heart. The Resurrected Christ promised eternal life, and the contemporary viewer would have read the self-portrait as an expression of faith in Salvation: Palma will be saved, by virtue of his belief in the Christian doctrines of Incarnation and Resurrection.[48]

The choice of the Resurrection, message of hope and joy, the moment of the final accomplishment of Christ's task on this earth, in lieu of some other event in the Savior's life, is indicative of the exuberance and optimism that inform this painting. By contrast, in the 1630s of the next century, the Spanish Zurbarán would depict himself as a generic painter at the foot of the Cross in a composition that focused solely on the figures of the dead crucified Savior and the living artist below, replacing the Virgin and St. John, or perhaps the kneeling, weeping Magdalen (pl. 154). God and Man are conveyed as isolated, abandoned entities in an empty, desolate world. The poignant figure at the foot of the cross has also been identified as St. Luke, Every-artist, gazing up in grief and horror at the reality of the scene to which so much of his – and every other Renaissance artist's – work was devoted.[49] If compared to the early Italian type of non-autonomous self-imaging within religious narrative, with which this study began, the seventeenth-century work may be seen as representing the ultimate extension: from being one among many witnesses, the artist has become the *sole* spectator to the climax of the holy story (pls. 28–37).

To what precisely is Palma applying the finishing touches? At the risk of over-interpretation, we note that it is an outline, that Palma is reinforcing the contour of one of the soldiers' bodies, in short, although a brush is being used, it is a gesture closer to drawing, *disegno*, than to the process of painting and applying *colore*.[50] Like Titian forty years earlier, Palma can be said to have made a decision to stress what was regarded as the more intellectual aspect of creation. As a prolific and ambitious draftsman, Palma was unusual as a Venetian for the extraordinarily large number (over one thousand) of

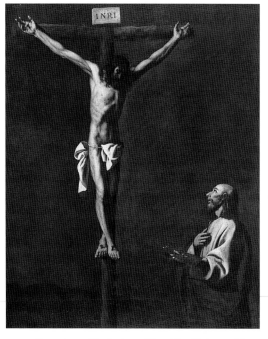

154 Francisco Zurbarán, *The Crucifixion with a Painter*, canvas, *c.*1630–35, Prado, Madrid.

155 Jacopo Palma il Giovane, *Self-Portrait painting the Resurrection of Christ*, canvas, 1590s, Brera, Milan.

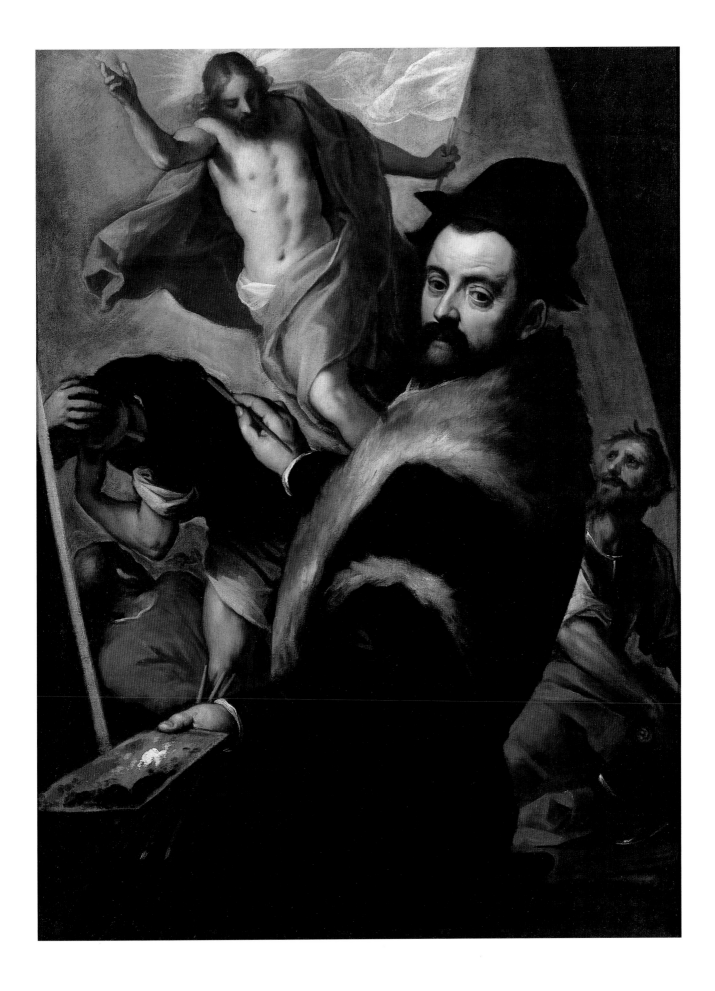

156 Palma Giovane, *Self-Portrait as a Crociferi Monk*, canvas, c.1606, Bardisian Collection, Venice.

drawings to his credit.[51] Almost certainly responsible for this output was Palma's training – rare for a Venetian artist – in Central Italy where the stress was on *disegno*. It led Palma toward the end of his life to collaborate on not just one drawing manual but two: Fialetti's *Il vero modo et ordine per dissegnar tutte le parti et membra del corpo humano* in 1608, and Franco's *De excellentia et nobilitate delineationis libri duo* in 1611.[52] That these primers, the first such to be published in Italy, should have been produced in Venice, under the aegis of the city's reigning painter, is a historical irony.

The piety proclaimed here is reinforced by the iconography – again unique for the genre – of a later independent self-portrait (*c.*1606), in which Palma, now in his sixties, shows the pious self in the robes of a monk or tertiary, probably those of the Crociferi, an Order with which he had close ties (pl. 156).[53] The name of the Crociferi (crutched or crossed friars in English) derived from their custom of carrying a cross in their hands or on their grey habits. In the late Middle Ages, the Order ran over two hundred hospitals in Italy alone, of which one of the most important was that in Venice; in the Quattrocento, however, the Order was reduced to running a hospice for twelve indigent women. Nonetheless, it continued to be a house with some prestige, since both the papacy and the Venetian government showed it unusual favor.[54] The Crociferi were Palma's most important and most frequent patrons, and the paintings he did for them were among his best: a cycle in the oratory of the Crociferi and another one in the sacristy of their church, the Gesuiti; he also painted for the Crociferi church in Rome.

The contrast of the 1606 self-image with the self-portrait created only twenty years earlier is striking; hand on breast, the artist fashions himself as tired and sad, with heavy rings around his large eyes, as disillusioned here as he was optimistic earlier, sustained only by the example of the Order, to which, according to Ridolfi, he "was always devoted because they had protected him from childhood."[55] Although Palma seems to have been the only Italian artist to associate the self in an autonomous portrait with either a major church doctrine or a specific Order, there is no reason to doubt the authenticity of his religious conviction, which harmonized with official church doctrine in these years of Catholic reform.[56]

The Venetian Palma had as a young man experienced court life for three years at the Court of Urbino. Like other self-portraitists, he seems to have been well-off, being described in 1602 as living "regally, like the great, very comfortably."[57] He was one of the few Venetian painters to build himself an important tomb monument.[58] His last resting place was not in the Gesuiti, as might have been expected, but the more prestigious Venetian site of SS. Giovanni e Paolo. He exploited his tomb, erected in his lifetime, to associate himself with his ancestor Palma il Vecchio and his mentor, the foremost painter of the Venetian school, Titian, who was given the place of honor.[59] Three portrait busts outlined against the cockleshells of the Resurrection stand above the door to the sacristy, Titian at a higher level in the center, Palma Vecchio on the heraldic dexter, the individual whose tomb this was consigning himself to the less honorable heraldic sinister. In the inscription as well, Titian comes first: TITIANO VECELLIO/IACOBO PALMA/SENIORI IUNIORIQ/ . . . On his own funerary monument Palma played a subsidiary role, in order to link his reputation to that of his celebrated ancestor, and to associate his *fortuna* with that of the most venerated painter of the century.[60] The monument can be read as reflecting Palma's acute self-awareness of his historical place within the Venetian artistic continuum, and his aspiration to be seen as heir to the great masters of the Cinquecento.[61]

Chapter 25

THE CRAFTSMAN IN THE WORKSHOP

With Annibale Carracci's work at the turn of the century, this study ends with a singularly talented artist who, according to the sources, sought – exceptionally – to *retain* his artisanal identity. Annibale Carracci is the only Cinquecento self-portraitist known to have denied harboring the usual social aspirations for self and craft. Becoming, despite himself, "court artist" to the Farnese in Rome, this taciturn, anti-social loner was unwilling or unable to adopt the required courtly social graces. As is well known, his social inadequacies and unwillingness to conform to the cultural norm took its own psychological toll.

Annibale Carracci's self-likeness with other male figures, offers a consideration of the self as practicing craftsman within the craft context of a family-run *bottega* (pl. 157). The artist is usually identified as the young man in the foreground *in atto di dipingere*, as was recorded when the work entered the Brera in the nineteenth century.[1] Behind him, further back in space, a bearded old man peers curiously over his shoulder at the invisible work in progress. Like Titian, this *fintore* once again conceals his canvas from the viewer. To the artist's right, a young boy focuses on the hands of a fourth male figure, whose head is cropped by the edge of the self-portraitist's canvas. This second painter bends over a manual task that cannot be deciphered, but that may involve a spatula bearing pigment.[2] The painting is strongly lit from the left, the light entering through a window or open door behind the old man.

While the work is generally conceded to have been painted in the second half of the 1580s, there is no agreement on the identity of the background figures.[3] Ricci was the first to identify the oldest and youngest figures as Annibale's father, Antonio, and his nephew, also called Antonio, son of the artist's brother Agostino, another painter.[4] The date of young Antonio's birth is unknown, and the possible birthdates proposed by the early sources suggest that he may not have been old enough around 1590, that is between ten and twelve, to be identified with the child in the painting.[5] The boy could alternatively be Baldassarre Aloisi, a Carracci relative and lifelong friend, who seems to have been thirteen in 1590. Apprenticed to the Carracci workshop, Baldassarre became the artist known as Galanino, who inherited the Carracci annotated copy of Vasari's *Lives* after young Antonio's death.[6] Although the identity of the oldest man as Annibale's father is also impossible to verify, he bears a resemblance to an old man who recurs in Carracci drawings, and hence is believed to have formed part of the Carracci artistic circle.[7] For the purposes of this study, he will be read as Antonio, the father who played an important role in his sons' choice of vocation, and who must have spent many hours in their workshop. As for the second painter, whose cropped nose, eye, and brow recall Annibale's delight in *indovinelli*, pictorial riddles in which motifs were cropped so heavily by framing edges as to be almost illegible, he is possibly either the artist's brother Agostino or his cousin Lodovico, both of whom worked in the *bottega*, more likely the former.[8]

The problems surrounding the precise identity of the boy and second painter will not be resolved here. They will be read as members of the Carracci family, the boy as either Antonio or Baldassarre, and the second painter as Agostino or Lodovico. What

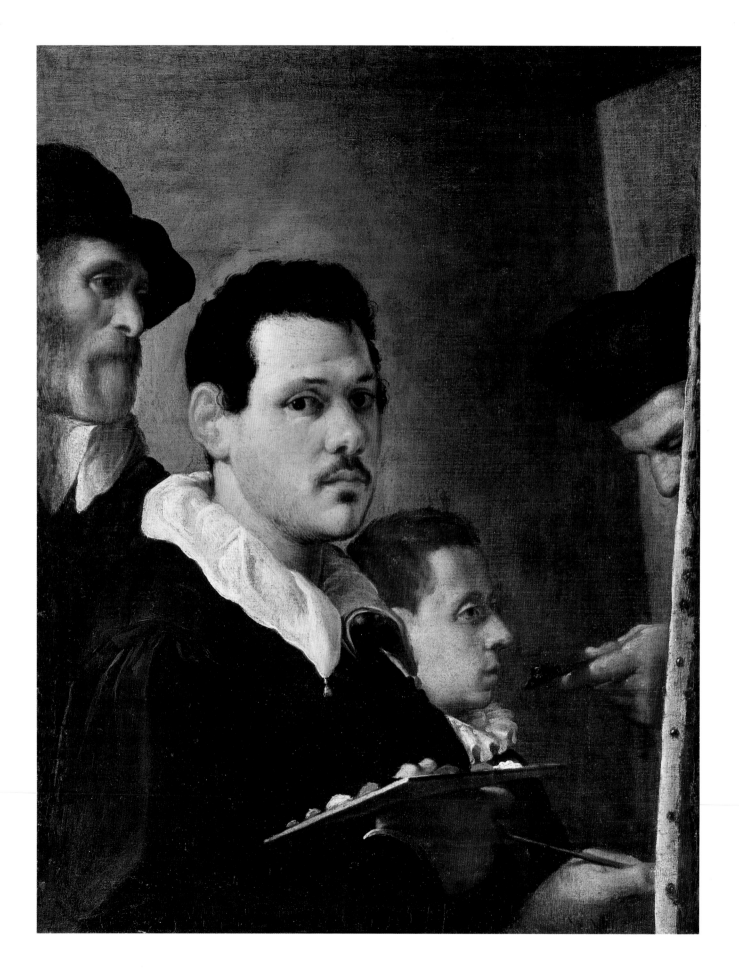

seems uncontrovertible is the artist's self-representation in the midst of close relatives – his father or other mentor, another painter of his own generation, and an apprentice of the next generation – within the spatial context of a workshop – a self-portrait with family while engaged in family business. The painting thus shares the preoccupation with family that also informs the self-likenesses of two other end-of-century self-portraitists: Cambiaso and Zuccari. Indeed, Annibale's choice of family artists as attributes implies that they constituted as essential a facet of his professional identity as Cambiaso's father did to his. The artist's self-construction amidst family – his self-framing between the heads of the old man and the young apprentice – may in addition be interpreted as a statement of the self in relation to the generations preceding and following his own. The self-portraitist's own life cycle, as it were, is adumbrated: his past in the young nephew or relative standing at his side, and his future in his aged father, so positioned behind him that he can only glimpse his fate fleetingly in the mirror.

The artist used the three family members further back in space to create a surface pattern that locked his own image into place on the foremost picture plane. The heads of the old man, the self-portraitist, and the boy create a forceful diagonal that leads down to the invisible canvas, terminating in Annibale's hand holding the brush in the lower right corner. This diagonal is emphasized by another at almost right angles, created by the edge of Annibale's palette and the second painter's hand. On the right, the strong vertical of the canvas is emphasized by the superimposed hands of the two painters and the head of the second one, all on the same axis. This vertical thrust is reinforced by another at a similar angle on the back wall, created by the light flowing through the window. Locking the second painter's cropped features firmly into place, these two diagonals terminate in *his* hand.

The close-up view that crops the bodies of all three background figures, and the heads of the old man and the second painter, accords with the framing of earlier genre paintings by Annibale, and gives an air of modernism to this tightly controlled compositional structure.[9] At the beginning of his career, Annibale, whom Malvasia claimed liked only *gente bassa*, "common people," was absorbed by genre or low-life subjects, in which he studied the actions of the lower classes as they pursued their everyday lives.[10] This self-image within the confines of a workshop is, like Annibale's early portraits, closely related to his low-life scenes.[11] By showing such workshop tasks as a painter using his hands, a *garzone* learning by example, and a visitor or sitter observing the process, the work can in itself be said to be an extension of his studies of everyday life, the artistic equivalent of such subjects as eating and drinking that Annibale found so compelling.[12]

Hemmed in on one side by the boy and, on the other, by the old man, Annibale gave himself uncomfortably little room in which to manoeuver, recalling the tight framing in Paggi's contemporary, and Allori's earlier, self-portraits (pls. 90, 149). What is the relationship between the self on guard on the foremost plane, and those behind who were inserted into his space – which is so confined as to make the workshops seen earlier in plates 11, 12, and 14 seem palatial? Should the suggestion of physical claustrophobia be read as a metaphor for the intellectual suffocation that Annibale is said to have suffered?[13] It is possible only to speculate whether the pictorial proximity between the three generations embodied Annibale's sentiments toward his father's ambitions.

These ambitions are said to have played a major role in the Carracci brothers' professional lives.[14] Indeed, the "togetherness" that pertains within this family group must reflect a reality within the family circle in these years, if this pictorial construction is correctly dated to the end of the 1580s. The tailor Antonio not only encouraged one son to move up the social ladder by becoming a goldsmith, and the other to achieve

157 Annibale Carracci, *Self-Portrait with other Male Figures*, canvas, *c.*1588–90, Brera, Milan.

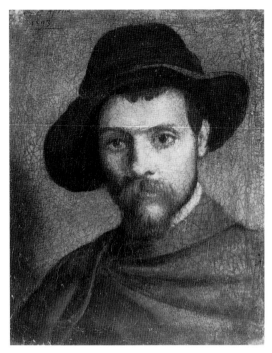

158 Annibale Carracci, *Self-Portrait*, canvas, 1593,
Pinacoteca Nazionale, Parma.

the same end by studying painting, but in December 1588 he also registered in, and paid dues to the painters' guild in Bologna. This was presumably an attempt to legalize the relations of his sons, neither of whom had taken the same step, to the previous artistic generation of Bologna, which had become critical of their work. Their cousin Lodovico found it wise to do the same the following year.[15] In the Brera painting, however, the old man is conspicuously given the role of onlooker, not performer.

The clothes given to each protagonist reveal subtle class distinctions. The old man wears the kind of hat habitually worn in Bologna by artisans, one that Annibale would portray himself wearing in a later self-portrait (pl. 158), and the artist and the old man wear the same wide white collars.[16] The apprentice, however, has been given a conspicuous white ruff, an accouterment that connotes other settings than that of a *bottega* — shop *garzoni* did not normally wear ruffs to work. The collar of the second painter is not visible, but his hat has the shape of an amplified beret of a kind often worn by upper-class sitters in northern Italian portraits, such as those by Giovanni Battista Moroni of Bernardo Spini and the so-called lawyer, today in Bergamo and London.[17] Both of these sitters combine this shape of black *berretto* with black garments highlighted with elaborate, gleaming ruffs at neck and wrists. It may accordingly be said that the artist positioned himself between garments that frankly acknowledge the old man's artisan status, and garments that imply the higher social class of the boy and the second painter. Identifying the second painter as Agostino on the grounds of his "intellectual" beret, Zapperi constructs a seductive hypothesis to the effect that the sartorial imagery — the choice of headgear and neckwear that is associated with each protagonist — expresses Annibale's acceptance of the artisan class into which he was born in comparison to Agostino's (more common) hankerings after higher social rank.[18] If the boy is to be identified as Agostino's son, he has been fashioned as wearing grander clothes than those habitually worn by his grandfather and uncle.

In the self-portrait now in Parma (pl. 158), Annibale, donning a hat similar to that worn by his father in the Brera work, again failed to exploit sartorial signs of social prestige. The Parma self-portrait is, perhaps significantly, dated the year of the old man's death in 1593.[19] The usual white collar is visible under the mantle in which Annibale has swathed himself.[20] The level of Annibale's identification with the social rank and life style of his father even, it seems, extended to a moustache and short beard similar to those of the old man in the earlier painting.

The social status of the Carracci brothers, with a tailor father and a hatter brother, was firmly on the artisanal divide of the social hierarchy, and that of their cousin Lodovico, whose father was a butcher, at its very bottom. The three Carracci painters were not only born into the ranks of craftsmen, they had themselves been apprenticed to trades in their youths: Lodovico as butcher, Agostino as goldsmith, and Annibale as tailor in his father's shop.

The particularly degrading trade of butcher was perceived as little less than a kind of executioner. So ignoble was the trade considered that Malvasia felt obliged to conceal the Carracci's connection with it, and Lodovico and Agostino themselves never referred to the source of their own or their relatives' income. Annibale, on the contrary, almost as if attempting a kind of pictorial rehabilitation of this degrading activity, chose to make trade in a butcher's shop the subject of two of his earliest low-life scenes at the beginning of his career.[21] Thus, where his brother and cousin concealed their despised family origins, Annibale can be said to have sought to record and/or celebrate them pictorially.

Study of the trades engaged in by members of the Carracci family offers a new perspective of the differentiation among the ranks of artisans, from the viewpoint of those practicing crafts that were low on the social pyramid. It transpires that even a career as a mediocre painter of banners and furniture was in itself a step upward for the

offspring of a tailor. By becoming painters, the three young Carracci immediately improved their social standing, regardless of the degree of success that they achieved in that endeavor.[22] However, as Annibale's work became more widely known, enhancing the possibilities of his further upward movement, the artist became, if anything, even more determined to hold firmly to his artisanal roots. Later in life, having already traveled a long distance from his days as a tailor's apprentice, Annibale, when lodged in the Farnese Palace, is represented by the sources as refusing or unable to use his self-evident artistic talents to integrate himself into a higher rank in society. This study ends with an artist who, perhaps because of the rapid pace at which he was moving up the social ladder, apparently felt the ground slipping so fast beneath his feet that he stubbornly clung to his given social rank as if it were a birthright.

In Rome the brothers offered a vivid contrast in self-fashioning in life. The elder, Agostino, quick witted and gregarious, characterized by Malvasia as "clean and neat in his dress, gallant in speech, learned and erudite," much enjoyed the company of the Farnese courtiers and had no difficulty in holding his own among them.[23] Agucchi, who must have heard him, makes much of his verbal fluency and Titian-like social skills: "he had the ability to converse well upon everything . . . bringing great delight to those who heard him . . . They went eagerly to hear him talk."[24] Along with the music that he played, sung, and composed, Agostino exploited his superficial learning in natural philosophy, mathematics, geography, and history in his endeavor to advance from the status of an artisan to that of a post-Vasarian *artefice*.[25] Avid for worldly success, he sought the approval of a highborn Roman public with his grace and charm. A portrait in the Uffizi is illuminating on this point, if Agostino is correctly identified as its subject and object (pl. 159). Where Annibale deliberately chose a humble mode of self-presentation in artisan's clothes in the works in Milan and Parma, Agostino based his elegant self-image, hand and head on diagonal to frame, on an ennobling Venetian model. Dressed in gleaming ruff and ample sleeves, the artist reminds the viewer of his wide reading and verbal fluency by offering his outstretched hand, palm up, with grand rhetorical flourish.[26]

Such social aspirations seemed intolerably pretentious to the taciturn Annibale, who felt more at ease among artisans than the upper classes. Malvasia saw him as an unkempt bohemian: "barely clean, dressed in the worst way, collar awry . . . mantle crumpled, beard uncombed."[27] He is depicted as a solitary eccentric who never failed to make a poor impression in person. His social inadequacy was such that, if Annibale saw Cardinal Odoardo approaching, he was said to run away when he could and, when he could not, cheeks burning, and tongue-tied, behaved gauchely.[28]

Two anecdotes, whatever their basis in fact, reveal the rival siblings' profoundly different attitudes toward their family background, and offer metaphors for Annibale's strong attachment to his artisanal roots.[29] Annibale was apt to react to his elder brother's humanist aspirations with sardonic aphorisms and poisonous barbs. On one occasion, having told his brother, "remember, Agostino, that you are the son of a tailor," he followed up by drawing their father, carefully identified by name, wearing eye-glasses and threading a needle, beside their mother holding a pair of shears. According to Malvasia, Annibale sent the sketch in the form of a folded letter to Agostino, who opened it in the presence of his courtier friends, only to be overcome by mortification at having the social station into which he was born so openly revealed to all.

In another such tale, Agostino was waxing eloquent on the beauties of the Laocoön in the company of his Farnese courtier friends.[30] When Annibale was asked for his opinion, he silently started to sketch the antique sculpture on an adjacent wall. Discomforted by his brother's silence, Agostino continued to charm his friends with his verbal description, but when Annibale had finished sketching, the assembled courtiers were overwhelmed by the beauty of his drawing. Agostino was obliged to admit that

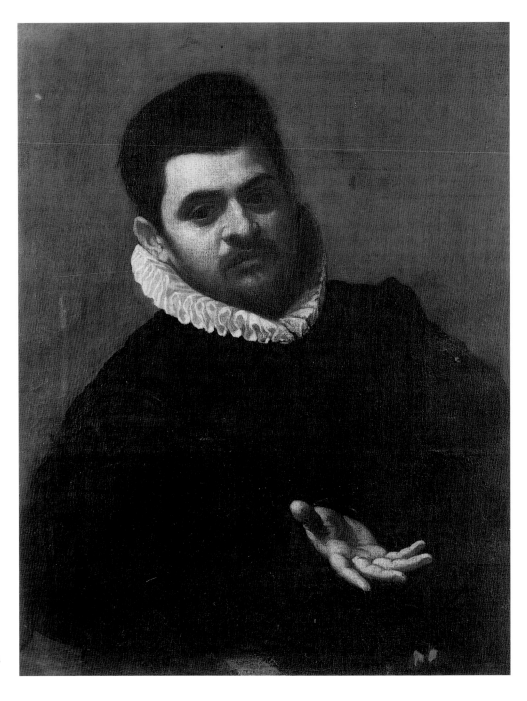

159 Attributed to Agostino Carracci, *Self-Portrait*, canvas, 1580s, Galleria degli Uffizi, Florence.

his brother's image had bested his words, obtaining in reponse the famous dictum attributed to Annibale, "we painters must speak with our hands" (*noi altri dipintori habbiamo da parlare con le mani*).[31] A *paragone* on the relative value to be accorded to literary and artistic creations was thus resolved, for once, in favor of the latter, Annibale using his image to undermine the privilege previously accorded to Agostino's words.

Although created in northern Italy and chronologically earlier than these fables, Annibale's highly idiosyncratic self-portrait as protagonist within the family *bottega* can be said to embody some of the concepts and affect that underlie such stories. Among sixteenth-century self-portraitists, only Cambiaso and Annibale celebrate the manual craft of painting within the workshop. Annibale's painting's double focus at lower right is the menial, manual activity being performed by the two painters: the self-portraitist's

246

brush about to be applied to canvas in response to the observations made in the mirror, and the activity undertaken by the second painter in which he and the boy are engrossed, toward which the old man can be seen to glance, and which holds the self-portraitist's attention in the mirror. The painting can be interpreted as making reference to the respective roles played by intellect and execution in artistic creation. Deliberately or no, heads and hands dominate this composition. From the heraldic dexter of the work, the three pondering intellects of old man, painter, and apprentice lead sequentially and inexorably down to the concealed canvas. Both artists, their hands on axis adjacent to the work in progress, are deeply involved in the artisanal process, although the second painter's cropped features and location to one side significantly marginalize him vis-à-vis the figure of the self-portraitist.[32] Whatever the identity of the figures accompanying the artist, his self-presentation offers a glorification of the craft of painting within the site in which the labor was accomplished. By revealing his professional values, that is, by stressing the dignity of manual work and by replacing the humanist ideal of artist-courtier with a craftsman, Carracci's self-construction here suggests a significant shift in the Renaissance concept of artistic identity.

Annibale's work belongs to the same type of master's self-representation with an entourage as Filarete's plaquette of celebration at the completion of the basilica doors, Bandinelli's idealized engravings of students and followers peacefully sketching as a community, and Vasari's portraits commemorating those responsible for the Salone ceiling in the Palazzo Vecchio (pls. 38, 97, and 102). The earlier works emphasized the joint collaboration of artists in community. Annibale's contribution to this iconography, on the other hand, adumbrates man's essential loneliness, *even* in community. Despite the close proximity of the protagonists' bodies within the confined space, the painting may be read as reflecting the psychological isolation of each. Communication among them, including the second painter's instruction of the boy, can be said to take place in a ruminative silence. The pervasive mood is contemplative as the family members seem to meditate on this moment in existence, its relation to the meaning of their lives, and the role played in them by art.

Where were these records of artists in community depicted as occurring? Filarete's *garzoni* celebrate the satisfactory completion of a huge task by moving outside the *bottega* into the street (pl. 38); Filippo Lippi's workshop stands quietly in the presence of death (pl. 43); Ghirlandaio's artistic partners – the closest earlier analogy to the Carracci family – parade in public through a magnificent urban context (pl. 45); Vasari's crew are themselves spectators in the prestigious site where they spent so many hours painting (pls. 101, 102). Only Annibale constructs the members of his artistic family as working artists in the very location in which they produced their art. The space of the *bottega* is openly acknowledged at the very moment when, and in the very place where it starts being defined as an *accademia*. Whereas a *bottega* craftsman by definition fabricated artifacts, an academy artist could be said to produce what the culture had started in these years to characterize as art.

The scale of the self-portrait in Parma is so small (24 by 20 cm.) that it has been suggested that the piece was painted as a gift for a friend. Although the Brera painting is somewhat larger (60 by 48 cm.), it was surely not destined for a patron. Throughout his life Annibale regarded portraiture as a pleasurable studio exercise, an extension of his studies of everyday life.[33] These are surely such studio exercises, exploratory sketches that are painted rather than drawn. Thus, the intended audience for this challenging, ambiguous, and highly *singolare finzione* may have been very restricted, limited to a small circle of intimates.

★ ★ ★

160 Annibale Carracci, preparatory sketches for *Self-Portrait on Easel in Workshop*, *c.*1604, Royal Collection, Windsor Castle.

161 Annibale Carracci, *Self-Portrait on Easel in Workshop*, *c.*1604, Hermitage Museum, St. Petersburg.

After 1595 Annibale made very few portraits of any kind, which made the nature of his late self-imaging, after his great Roman successes, all the more significant. In a work probably not addressed to anyone but himself, a small unframed canvas bearing a portrait of a somber Annibale, wearing a dirty version of the same wide, white collar, stands on an easel in a space that has been abandoned by humans but still, like Johannes Gumpp's self-portrait in plate 13, harbors a lurking cat and dog and, in the background, what appears to be a shadowy statue against a square pool of light (pl. 161).[34]

The painting is usually dated to around 1604 on the grounds of the preparatory sketch at Windsor Castle, drawn in a style characterized as typical of Annibale's pen

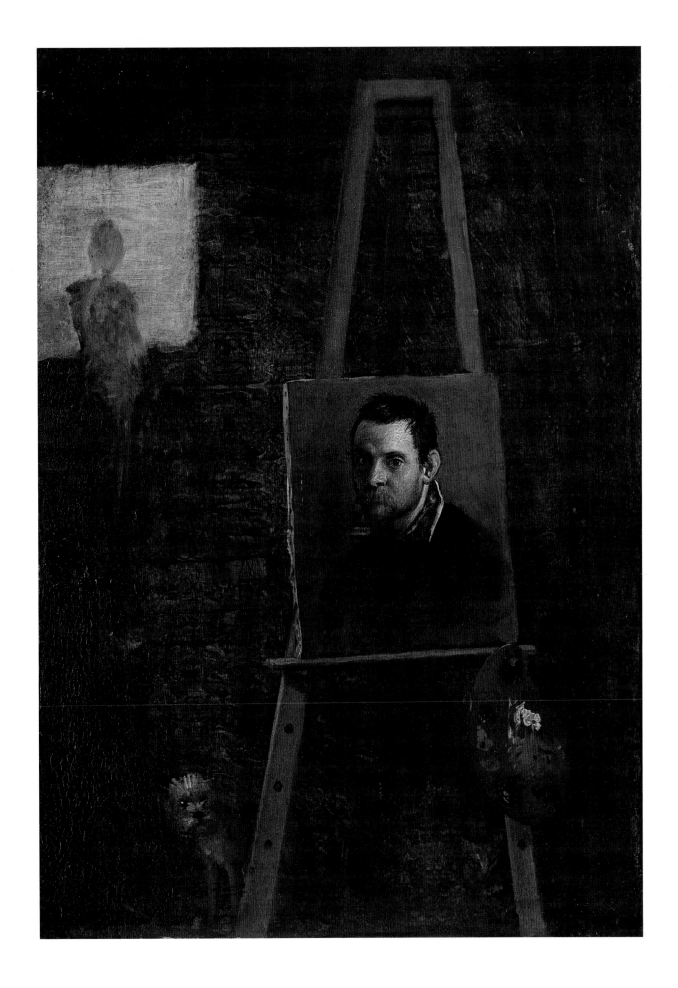

sketches around this time (pl. 160).[35] The drawing shows two earlier ideas for the composition. In both, the portrait on the easel is much more elaborate, figuring the artist's body at half-length, in profile to the left, arms crossed, right hand over heart, and face turned toward his own image in the mirror. In the upper sketch a decision to make the portrait a picture within a picture has not yet been taken. What looks like a circular, perhaps convex, mirror on the wall in the upper left background may reflect the artist's body from the back, recalling the interest of early Cinquecento Venetians in using reflective surfaces to obtain many different views of the central figure in order to weight the *paragone* between sculpture and painting in favor of the latter.

The lower image on the Windsor sheet reflects a later stage in the development of the compositional idea. The artist's portrait has become a self-contained canvas placed on an easel, as if barely finished; the circular mirror at upper left has become a square niche or window, on the sill of which stands a portrait bust (but which could also be read as a painting of a frontal half-length figure).[36] A cat dozes between the legs of the easel, and several greyhounds stand in the mid-ground. In the painting, of course, the dogs have been reduced in number and in scale: one small dog and a lone cat each peer out from behind a leg of the easel, from which a palette hangs like the family coat of arms that it was, affirming the easel painting both as a painted image, and as a recent one. The portrait bust on the window sill has been exchanged for a vertical sculpture, whose presence is felt rather than seen, which stands against a square of light so dazzling that its medium seems to be in the process of dematerializing.[37] Another significant difference between sketch and painting is loss of definition of space. The room goes from a recognizable measurable space with a beamed ceiling to an undifferentiated void.

Should a *paragone* between painted portrait and painted sculpture have been intended here, there can exist no doubt as to the work that was intended to win the palm. By juxtaposing his recognizable painted self-portrait in the foreground with a sculpture placed at such an indefinite point in space that its height cannot be calculated, and against such a strong light that neither significant features nor medium can be definitively identified, Annibale weighted the balance heavily toward his own image.

What should we make of this sculpture? Building on Posner's interpretation of the shadowy armless statue as a herm, Winner made the intriguing, if unverifiable, suggestion that it represents the god Terminus, the Roman deity of boundaries in both physical and metaphorical senses, both spatial and spiritual, that is, representing both the boundary stone at the end of the field and that at the end of life.[38] Such a determination offers rich interpretive possibilities. Of other representations of the god, *Il Morbetto* (The Little Plague), Marcantonio's engraving after a design by Raphael is the most useful (pl. 162).[39] In it the central Terminus that divides day from night is very close to the configuration in Annibale's painting. Terminus's links with Death seem to have been widely known in the sixteenth century, since it appears as one of six emblems signifying death in Alciati's *Emblemata*.[40] Usually envisaged as a head of a bearded man on top of a vertical stone block, this was the emblem used by Erasmus, who had Matsys depict it on his medal reverse, flanked with the inscription CONCEDO NVLLI, "I yield to no one" (pl. 163). On the medal obverse, two inscriptions, one from Horace, MORS ULTIMA LINEA RERV[m], "death is the ultimate limit of things," and the other in Greek, "keep the end of a long life in view," encircle Erasmus's profile portrait.[41] In a story well known at the time, Terminus was the only god to refuse to make way when Jupiter decided to have his sanctuary on the Capitoline Hill. Erasmus seems to have initially used the motto to claim a similar position vis-à-vis the contemporary religious forces that tried to push him in different directions. Years later, however, he wrote that the mottoes should be understood as pronounced not by him but by Death, that it was Death, the boundary of life, who yielded to no one.[42] The two reverse inscriptions on

Erasmus's medal, when merged, can be seen as producing the following moral: "He who looks upon Death as the boundary of Life, and keeps the ultimate end of Life in view may well take Terminus as his emblem, for he refuses to place his temporal welfare higher than his eternal one."[43]

★ ★ ★

Agostino Carracci died suddenly in 1602 at the age of forty-five. At his funeral an inscription on one of the paintings celebrating his fame read: "Mors terminus mortis perennis vitae principium," "Death is the end (terminus) of Death and the beginning of eternal life." The loss of a sibling – especially that of an older brother with whom relations had been strained by bitter rivalry – gives death a special reality for the survivors. It seems very plausible that the inspiration for Annibale's self-likeness with Terminus, if Terminus this statue is, was Agostino's premature death and the allusion at his funeral to eternal life as the outcome of his passage beyond his shadowy Terminus, the same Terminus hovering ominously in the background of Annibale's life, as represented by the isolated image abandoned on the easel.[44]

This work is hypothetically another essay on the life cycle theme, one that deals with the end of that cycle. On the front plane all is dark, unknown, and nightmarish. The workshop, once so full of figures jostling and competing for space, is now shadowed and empty, leaving the already abandoned imaged memory of Annibale even more isolated. The only living creatures, the painting's small protectors from the animal kingdom, take cautious refuge behind the easel legs, and seem as alienated from the world upon which they gaze, as the self-portraitist placed metaphorically between them, his bitter and accusing eyes confronting those of his critical Roman public.[45]

"Annibale was so melancholic and apprehensive by nature . . . that he could never be merry, and he took the decision not to paint any more."[46] This self-portrait in St. Petersburg is traditionally related to Annibale's last years when, suffocated by *una estrema malinconia*, he was so unhappy that he produced little work.[47] He suffered from the illness that, combining physical debility with psychological depression, felled so many painters in the Renaissance. His contemporaries called it Melancholia, and attributed it to the ascendancy of the planet Saturn at his birth, an idea going back to Antiquity. Aristotle had asked why so many eminent men in the arts were born under Saturn, that is, why so many were melancholics suffering from diseases caused by black bile. In the early Renaissance Ficino put a positive spin on the issue by arguing that the melancholic temperament of those born under Saturn should be welcomed as a side-effect of the divine gift of creativity. Be that as it may, Annibale may have suffered all his life from what was defined as melancholia, but its typical symptoms of sensitivity, moodiness, solitariness, and eccentricity increased greatly after the turn of the century and his fortieth birthday, in what today might be characterized as a mid-life crisis.[48]

In 1988 it was convincingly suggested that the saturnine melancholia to which artists were so prone had a concrete physiological basis. A recently identified malady, called plumbism or lead-poisoning, isolates the toxic mineral by which painters were then, and still are today, poisoned on a daily basis:

> It seldom happens that painters look . . . healthy . . . [and the immediate cause is] the materials they handle and smell constantly, such as red lead, cinnabar [containing mercury], white lead . . . [In short, all] the numerous pigments made of various [toxic] mineral substances . . . Moreover, at work painters wear dirty clothes smeared with [lead-based] paint.[49]

Perhaps the ancients almost got it right: Saturn's mineral was traditionally lead, and artists were also known as the children of Mercury.

Only Annibale, sojourning temporarily amid the chaotic blurred world of the empty workshop, is easily recognizable in the painting. The difference in degree of finish between the artist's face on the painted canvas and everything else in the work is striking. The picture within the picture, the abandoned portrait without frame, is in a different style from the hastily and roughly indicated physical surroundings that contain it. Can the carefully rendered *al naturale* physical shell of Annibale in one style be read as standing amid the confused maelstrom of his psyche in another?

At the risk of over-interpretation, this work might be understood as the late Renaissance equivalent of Munch's *The Scream*, by an artist living in a pre-Freudian society and constrained by the rules of social decorum from himself screaming. Annibale could have sought to convey the horror of his loss of psyche, the nightmare in which he, Annibale, or the memory of Annibale, lived in these years, by the use of two different painterly styles.

Despite the pervasive air of desolation, however, the light distribution in the painting allows a reading that offers a glimmer of hope. In Marcantonio's engraving, Terminus divides night from day (pl. 162). In Annibale's painting, the front plane, if read as the present, may indeed be a confused nightmare in which all is dark, unknown, and dreadful. But in the distance – who knows how close or far the light square and sculpture were intended to read? – the future, and the terminal end, hovers. Here lives Death but, unlike the haunted world of the foreground, the future is bathed in light, light symbolic of eternal life, a vision that appears infinitely preferable to the wasteland of the present.

If the sculpture represents Terminus, Wind's interpretation of Erasmus's use of the god and motto is apt:

> To the Christian mind eternity begins when time is ended. Death is the gateway to eternity, hence Erasmus could claim . . . that Terminus . . . [as] Death . . . is not a

gruesome spectre, a threat of destruction to the living but, on the contrary, the vital force that gives them strength and direction. . . . Therefore the words "concedo nulli" . . . as spoken by Death would also be spoken by him who lives in the hope of eternity. Death in the sense of a new life was not only his goal, but also his model.[50]

This interpretation of Terminus offers a religious meaning valid for all in the late sixteenth and early seventeenth centuries, irrespective of whether Annibale was personally pious.

This artist's apparent refusal to join his brother and his peers in their search for higher social rank, and his lack of pretension in his self-fashioning both in life and art, is *sui generis* for the date. Mediating between the artist and his public, his late self-portrait can be interpreted as a comment on the proper relations between the artist and society. When Annibale finally arrives at his personal bourne, that journey from which no traveller returns, all that will be left of his sojourn on this earth will be the art that he created while here. By offering himself, in a brilliant *invenzione*, as the memory of an artist preserved in a fictive work of art, Annibale implied that ultimately the artist's status will depend on how a given painting's concept and execution are evaluated by his contemporaries and successors. The physical act of placing pigments on a support, as we know, can only occur after the imaginative concept has been worked out. Nonetheless, however developed the painting's concept, its distinguishing characteristic resides in its invisibility until that artisanal act of manipulating line and color on canvas or wall has begun. Only by using the manual tools of art to embody the fruits of his *ingegno* can the artist attain nobility. He will not succeed in staking a claim to greatness for his art by either a show of erudition in other, supposedly more liberal, disciplines, or a display of courtly life style and graces.[51] How the artist fashioned the self in life was secondary to the work he produced, as Annibale must have frequently told Agostino; that is, painters must indeed speak with their hands, rather than with their voices or their personal appearance.[52] "It is the thing done that counts, and in the long run this is all that counts, and that is what Annibale was saying to his brother: stop talking and start painting."[53]

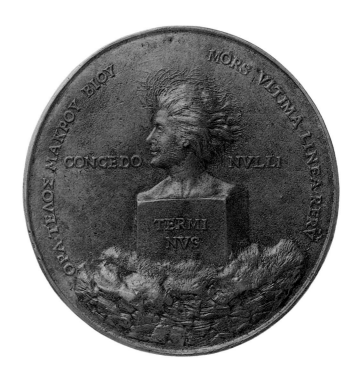

163 Quentin Matsys, medal of Erasmus, bronze, 1519, reverse, Fitzwilliam Museum, Cambridge.

Coda

MICHELANGELO: "CAPO, PADRE E MAESTRO DI TUTTI"[1]

164 Leone Leoni, medal of Michelangelo, bronze, 1561, obverse, National Gallery of Art, Washington, D.C., Samuel H. Kress Collection.

Paradoxically, Michelangelo, the artist who did the most to effect a change in the social status of his peers, did not produce an autonomous self-portrait. Despite his many references to self in his art, Michelangelo seems never to have created a conventional self-likeness, even within the context of a wider narrative – the Nicodemus who supports Christ's body in the Florentine *Pietà*, and the flayed skin of St. Bartholomew in the *Last Judgment*, for instance, should surely be understood as self-referential rather than as self-portraiture.[2]

Michelangelo's well-known aversion for portraiture led one heroizing nineteenth-century historian to write that "whereas other professional artists took care to make themselves famous by creating their own portraits, such a small vanity never occurred to Michelangelo."[3] It has recently been shown, however, that such was not the case, that the sculptor was one of the most sophisticated self-fashioners of the Italian Renaissance, and that he consciously went to great lengths to forge a glorifed image of self for contemporaries and posterity.[4] By dictating his own life to Condivi, by sitting for at least two portraits by close followers, Giuliano Bugiardini in the early 1520s, and Jacopino del Conte in the 1530s, and by acquiescing in the production of printed and medallic portraits of himself, Michelangelo played an important role in his own *fortuna* (pl. 21).

"I have never been either a painter or a sculptor who kept a workshop (*bottega*)."[5] For once, an artist's social pretensions – as a "citizen descended from a very noble lineage" – had real foundations; Michelangelo's claims that his family had paid taxes in Florence for three hundred years, and that many of his ancestors had been elected to the Signoria were not empty boasts.[6] There had been Simone-Buonarroti priors in Florence in 1343, 1355, 1366, 1371, 1390, 1397, 1404, 1426, 1456, and 1469, as well as many consuls of the Wool Guild.[7] Even his descent from the noble Canossa was, according to Wallace, convincing by the standards of Renaissance genealogy. Both Bonasone's 1546 print, inscribed "patrician," and the obverse of Leoni's 1561 medal, which shows a dignified, noble old man wrapped in a voluminous toga, could be termed "self-portraits" in that they project this *signorile* rank (pl. 164).[8]

Michelangelo's career as a sculptor was certainly unique for the sixteenth century. As we know, the two different cultures in the Renaissance consisted of the "mechanical" artists, recruited mainly from the artisan class, who belonged to the world of the workshop, and the "liberal" humanists, recruited from the upper classes and functioning primarily in Latin, who belonged to the world of the university.[9] Michelangelo was never apprenticed to a master sculptor; his education was that of the upper classes, a factor of crucial importance for his own construction of his relationship to what was still (by others) termed his "craft." Florentine sculptors had to matriculate into the guild of stone and woodworkers, but, having never experienced a workshop apprenticeship, Michelangelo never matriculated into the guild. Thanks to his early connections to the Medici, his contacts among the aristocracy in Florence and Rome supplied him with

enough commissions early on so that he never had to establish a business practice in a fixed location, and was hence able to avoid coming under guild control.[10] The same thing happened in Rome; when the guild of stone and marble workers objected to the fact that Michelangelo was not inscribed in their ranks, Paul III responded by exempting the sculptor from membership in, or dues to, the guild which was supposed to define his "craft" and regulate his "trade," with the result that the sculptor was able to practice his calling under the most exceptional circumstances for his time and place.[11]

It was the first *explicit* recognition on the part of a powerful patron of the intellectual value of the visual arts, in particular laborious sculpture – which had, of course, always been seen as the very one that was most mechanical. The difference between a Michelangelo sculpture and the work of a stonecutter was now recognized as residing in the former's intellectual quality; the amount of physical fatigue involved was no longer relevant to the art's classification. Sculptors were *viri studiosi et scientifici*, men of learning and science, who did not mingle among those who were *artefices mecanicos*, mere mechanical workers.[12] Transformed into the only "independent" artist of his day, Michelangelo, stimulated by Vasari's Life in his 1550 edition, fashioned the self into the first "modern" artist: one for whom art was an inner calling, not a trade that could be taught.[13]

As early as 1516 Michelangelo had already been dubbed *il divino* in Ariosto's *Orlando Furioso*. By the time of his death, he was universally accepted as the ultimate symbol of artistic achievement, overshadowing the ancients as much as the moderns. Certainly, the sculptor's career was a prime reason why the narrative being outlined in this study was a "success" story. As Wittkower put it, he was the venerated, almost canonized, master of all three *arti del disegno*, who did more than anyone else to free his profession from the odium of manual labor.[14]

One of the key ideas of postmodernism is the demythologizing of artistic agency, known as the "death of the author": Foucault and Barthes's assertion that the "idea" of "the author" – in our case, the visual author – is not a transhistorical category but a cultural construct associated with the beginnings of authorial accountability which goes back to the early modern period explored here.[15] To locate this study on self-portraiture within a wider perspective of contemporary theoretical thought, it could be said to explore the "birth" or "invention" of the *concept* of transcendental artistic greatness that arose half a millennium ago, as embodied in the sculptor who was himself responsible for what has been dubbed the myth of "Michelangelism."[16]

This phenomenon can be seen as framed by the efforts of two remarkable patrician Florentines: Alberti at its inception, and Michelangelo toward its culmination, in the dictates of the former and the career and example of the latter. If the mid-Quattrocento Alberti can be defined as the first artistic self-fashioner as embodied in an autonomous self-likeness, Michelangelo in the mid-Cinquecento consecrated himself as the Albertian artistic ideal. By virtue of their immense contributions to the furtherance of the artists' social ideal, these two men, both Florentine, both from patrician families that had fallen on hard times, both suffering from metaphysical anxiety, stand out from the rest of their class or category. Paradoxically, in this study of court artists, the two most influential individuals were neither of them conventional court employees. Alberti was not really an artist at all and Michelangelo can be forced into no neat category.

Notes

INTRODUCTION

1 As cited in Blunt 1940, 52 (adapted).
2 The famous red-chalk drawing of an aged man in Turin, often claimed as a self-portrait, was recently characterized by Kemp (1992, 110) as "probably an idealized type;" for bibliography on it, see Brown 1994, 76 n. 6; for a school drawing at Windsor that may show Leonardo in profile, see Kemp and Roberts 1989, cat. 1.
3 Burke 1987a, 159, 189.
4 Onians 1988, 167.
5 See, now, McIver 1997.
6 Baxandall 1971, 15–16.
7 Koerner 1986, 417; Barocchi and Ristori 1979, IV, 150.
8 McMahon 1956, no. 19; Richter 1969, 52.
9 Mendelsohn 1982, 101; Alberti 1950, 75.
10 Frey 1964, 89, lxxxiii; Mendelsohn 1982, 103f.; Pope-Hennessy 1986, I, 170.
11 Wittkower 1962, 67.
12 Aretino 1609, v, 53*v*. (in 1548).
13 Barzman, forthcoming.
14 Alberti 1972, 103; Kemp 1989a.
15 Pease 1995, 105–17.
16 Kemp 1989a.
17 Herrmann-Fiore 1989; Rossi 1989.
18 Starn and Partridge 1992, 106–7.
19 Rosenthal 1984.
20 Ibid., 11, *passim.*
21 Ibid., 13.

CHAPTER 1

1 Greene 1968, 249.
2 Weintraub 1978, 295.
3 Chojnacki 1994; Brusati 1990/91, 170 n. 2.
4 Carrithers Collins, and Lukes 1985, vii.
5 Mauss 1985, 14.
6 Martin 1997, 1338.
7 Kristeller 1985.
8 Ibid.
9 Kristeller, 1979, 170.
10 Kristeller 1985, 9.
11 Nelson 1933.
12 Alberti 1950, 69. He was referring to the human figure as providing the scale of all other forms in a perspective picture. Kemp 1992b, 95.
13 Taylor 1989, 199.
14 Kristeller 1961, chap. 5, 129.

15 Kristeller 1979, 175. We should note however that God addresses these words to Adam *before* the Fall, leaving unresolved the problem of the extent of Adam's freedom post-Fall. See also the comment of Delumeau 1992, 13, on these frequently cited but hardly numerous texts.
16 Wind 1958, 191; Findlen 1994, 298–303.
17 Greene 1968, 243.
18 Garin 1965, 105.
19 Greene 1968.
20 Ibid., 44.
21 Kerrigan and Braden 1989.
22 Greene 1968, 43; Greenblatt 1980, 3.
23 Martin 1997, 1341.
24 Kerrigan and Braden 1989, 56; Machiavelli, *The Prince*, chap. 6.
25 Burke 1987b, 150–51.
26 Berger 1994, 97; Burke 1987b, 151.
27 Webhorn 1978, 14ff.; Findlen 1994, 300.
28 Starn and Partridge 1992, 120; Martin 1997, 1324.
29 Starn and Partridge 1922, 120.
30 Webhorn 1978, 18.
31 Burckhardt 1958, chap. 2; Huizinga 1959, 257.
32 Olney 1972; Weintraub 1978; Eakin 1985.
33 Chojnacki 1994.
34 Campbell 1990, 149.
35 Canuti 1931, I, ch. 21.
36 Lavinia Fontana was so described.
37 Barolsky 1994, 107.
38 Ibid.
39 Ibid., 108.
40 Ibid., 125–8.
41 Bullard 1994, 72, 97; Barolsky 1995b, 255.
42 Petrarch, *Rerum Senilium*, XII, 2, in *Opera Omnia*, Basel, 1554, II, 1001.
43 Baxandall 1971, 10.
44 Alberti 1950, 55; Lecoq 1975, 226–7.
45 Lecoq 1975, 236.
46 Shearman 1992, 115.
47 Lecoq 1975.
48 Barolsky 1990, 1; Lecoq 1975, 225.
49 Lecocq 1975.
50 Chastel 1978, II, 76. Since he gave no source, I assume that the tag is his.
51 Barolsky 1994, 108.

CHAPTER 2

1 As cited in Huizinga 1959, 245, n. 5.
2 Thompson 1932, 2.
3 Wittkower 1950. For the liberal arts, see also

Silver 1983; Mâle 1958, 64–97; Van Marle 1932, II, chap. 3; Verdier 1968; Katzenellenbogen 1961; Garrard 1984.
4 Summers 1987, 235–65; Evans 1978, 305–39; Parker 1996, 46.
5 Van Marle 1932, II, 255–7, 203.
6 Trachtenberg 1971, chap. 4.
7 Alberti 1988, 3; Alberti 1966a, 7 ff.
8 Alberti 1972, 95, para. 53.
9 Heydenreich 1954, 98–9.
10 Boskovits 1975, 162, 258.
11 Reynolds 1974, 14.
12 Rossi 1980, 45; Reynolds 1974, 15.
13 Rossi 1984, 377.
14 Kristeller 1965, 173.
15 Garrard 1984, 339; Levenson, Oberhuber, and Sheehan 1973, 40.
16 Kidson 1981, 417.
17 Kristeller 1965, 176.
18 McMahon 1956, I, 12.
19 Burke 1987a, 50–51.
20 Burke 1987a, 51, 58, 61.
21 Roman 1984, 81; Farago 1992, 125.
22 Barzman forthcoming. See now Goldstein 1996.
23 Vasari-Milanesi 1906, VI, 655.
24 Barzman 1986–7, 14.
25 Goldstein 1975, 146–7.
26 Barzman 1985, 347.
27 Wittkower and Wittkower 1964.
28 Stewart 1990, 65. See also Roebuck 1969; Wittkower 1973; Pollitt 1974, 32–111; Bianchi Bandinelli 1979; Kidson 1981. I wish to thank Alice A. Donohue for bibliographic references.
29 Stewart 1990, 70.
30 Anatagi 1591, 35 and 36, as cited in Schutte 1991.

CHAPTER 3

1 Regosin 1977, 189: "Il n'est description pareille en difficulté à la description de soymesmes."
2 Rousseau 1959, I, 174–5: "J'ai promis de me peindre tel que je suis . . ."
3 Brilliant 1991, 142.
4 Schiff 1984, 344–8.
5 Brilliant 1991, 142.
6 Chapman 1990, 84.
7 Woods-Marsden 1994, 295.
8 Berger 1994.

9 See pp. 74–5, below, for Alberti's use of the imperial eagle.

10 Brilliant 1991, 159–61.

11 Ringbom 1984, 40.

12 See also Koerner 1993, 110.

13 Lejeune 1989, 111–12.

14 Barocchi 1971–7, II, 1270; McMahon 1956, I, 48.

15 "Il suo ritratto, fatto da lui stesso . . . guardandosi in una spera." Vasari/Milanesi 1906, II, 185, of Luca della Robbia. "il ritratto stesso di Masaccio, fatto da lui medesimo, allo specchio." Vasari/Milanesi 1906, II, 297.

16 Vasari 1982, 351, no. DCVII, 20 Sept. 1567.

17 Schweig 1940; Schwartz 1952; Schwartz 1959; Eng 1962; Schwartz 1967; Bialostocki 1977; Bialostocki 1980; Baltrusaitis 1981; Goldberg 1985; Bussagli 1987, 193–9; Rivasecchi 1987, 204–19.

18 Belsey and Belsey 1990, 31.

19 Goffen 1991.

20 Bialostocki 1977, 70.

21 Schwartz 1967, 217–18.

22 Goldberg 1985, 121–2.

23 Marrow 1983, 157.

24 Koerner 1993, 268, 497 n. 35.

25 Bialostocki 1977, 65.

26 Alberti 1972, 89.

27 Leonardo da Vinci 1924, I, 200, no. 401, *passim*.

28 Lacan 1977, 1–7; Gusdorf 1956/1980, 32; Moxey 1994, 46.

29 Lacan 1977; Gallop 1985, 79.

30 According to Eng (1962, 1046), the use of a mirror could be a threat to identity. "The use of a mirror as a means of naturalistic self-observation [may] have resulted in the realization of latent self-images, previously held in memory, that were markedly different from the viewer's present experience of self. As we know, differences between the way in which persons experience themselves and the way they experience themselves in the presence of their mirror image are often characteristic of conditions of anxiety passing over into extreme psychopathology."

31 Vishny 1986, 93.

32 Koerner 1986, 410–11.

33 Luzio 1913, 247 (quoting the Duke of Ferrara); Paoletti 1992, 431. For the date, see Vasari/Barocchi 1962, IV, 1739.

34 Pliny, *Natural History*, XXXV, 145; Jex-Blake and Sellers 1968, 168–9.

35 Wittkower 1973, 299.

36 Filedt Kok, Halsema-Kuber and Kloek 1986, II, cat. 148.

37 MacLaren and Braham 1970, 71, no. 6153; Mallory 1990, 253.

38 Lecoq 1974b, 46; Koerner 1993, 96; Nesselrath 1993.

39 Ferino Pagden 1990, 165; Weil-Garris 1981, 227.

CHAPTER 4

1 Barolsky 1996; Maginnis 1993, 403.

2 Barolsky 1996; Maginnis 1993.

3 Maginnis 1993, 388.

4 Vasari/Milanesi 1906, I, 606; Ghiberti, in Gilbert 1980b, 79. The most recent discussion of the work is that of Kreytenberg 1994.

5 Elsewhere Orcagna inscribed his paintings as a sculptor.

6 Partridge and Starn 1980, 97.

7 See n. 27, below.

8 Wolters 1953–6; Solberg 1991, 519.

9 Chomentovskaja 1938.

10 Hatfield 1970.

11 Ahl 1996, 96.

12 Lightbown 1978; Hatfield 1976.

13 Hatfield 1976.

14 Vasari/Milanesi 1906, V, 16; Freedberg 1963, II, 14; Shearman 1965a, II, cat. 21.

15 Vasari/Milanesi 1906, II, 455.

16 Cannata 1988, 35–53.

17 Ibid.

18 For other interpretations, see Seymour 1966, 115; Parlato 1988a, 123 n. 48; Cannata 1988.

19 CETERIS OPERE PRETIV FASTVS (MVM)MVS VE MIHI HILARITAS. For different, if unconvincing, interpretations, see Piola Caselli 1982; King 1990.

20 Filarete 1972, 231, as translated in Holt 1957, 249.

21 Gilbert 1968, 28 n. 3; Langedijk 1981, 165.

22 Chenault Porter 1988, 193, 201 n. 45.

23 Friedman 1974, 121.

24 Summers 1981, 336; Barasch 1985, 226; Lavin 1992, 163.

25 Chenault Porter 1988, 193.

26 For a different interpretation, see King 1990.

27 Vasari/Milanesi 1906, II, 628; Ruda 1993, 293ff.; Schwartz 1997, 476, pl. 11.

28 Ruda 1993, 422–6, cat. 36. Ruda also suggests other self-portraits.

29 Ruda 1993, cat. 66.

30 See Ruda 1993, 143, for Lippi's self-portrait in the Maringhi *Coronation*.

31 See chapter 5, below.

32 Other self-portraits of Ghirlandaio are said to figure in *The Funeral of S. Fina*, S. Gimignano, *c*.1475; *Crossing of the Red Sea*, Sistine Chapel, *c*.1482; *St. Francis Raising the Spini Child*, S. Trinita, *c*.1484 (Borsook 1980, 117–19); *Adoration of the Magi*, Ospedale degli Innocenti, 1488 (Schwartz 1997, 477 n. 55).

33 Vasari/Milanesi 1906, III, 263. See Kecks 1995, 126–34; Hatfield 1996; Simons 1985, 291–4. For a discussion of the iconography as a didactic Thomist program, see McClure Ross, 1983.

34 Vasari/Milanesi 1906, III, 263 n. 2. A century

earlier, in the choir of S. Croce, Agnolo Gaddi had claimed a similar site.

35 Simons 1987, 235.

36 When interpreted according to Hope's hypothesis (Hope 1986, 806) that the bystanders were not part of the religious story when wearing contemporary costume, then the painters here participate in the drama, unlike the patrons opposite in anachronistic dress.

37 See also Spicer 1991.

38 Sleptzoff 1978, 115–17.

39 Simons 1987, 236.

40 Simons 1987, 242.

CHAPTER 5

1 Vasari/Milanesi 1906, II, 238.

2 Watson 1990, 82.

3 Barolsky 1992, 35; Watson 1990, 82.

4 Herrmann-Fiore 1992, 250–51; Paoletti 1992, 432 n. 21.

5 Plutarch 1914–26, III, 1916; Pliny, *Natural History*, XXXIV, 83; Wittkower 1973; Filarete, in Spencer 1965, 265. For the "jealousy" stimulated among Phidias's peers by the hubris underlying the impious act of having placed his own image in the Temple's holy of holies, and which led to his incarceration, see Richter 1929, 224–5.

6 R. Panzanelli-Clignett, "Ghiberti's bronze self-portraits, or the artist as an artistic prophet," UCLA, 1990, art history seminar report.

7 Vermeule 1965.

8 Barolsky 1994, 66, and 1990, 107, identifies a figure of a bald old man holding a stone at the extreme left of the *Battle of the Centaurs* by Michelangelo, similar to Phidias's supposed self-portrait on Athena'a shield, as a sign of the sculptor's identity as "a new Phidias, a modern Phidias . . . a 'Phidias redivivius.'"

9 Conti 1979, pl. 78. The mid-century French artist Jean Fouquet's tiny circular self-portrait in black enamel and gold was also originally part of a frame: that of the Melun Diptych (Reynaud 1981, cat. 6).

10 Holt 1957, I, 152ff.

11 Barolsky 1991, 93.

12 In book III, Ghiberti planned a survey of the liberal arts which he believed were necessary for the sculptor.

13 Gilbert, 1980b, 3.

14 Even 1989, 1–6.

15 See Pope-Hennessy 1966, 71–3; Krautheimer 1970, 9–10.

16 Ghiberti did not use the term *mano*.

17 Spencer 1979, 553.

18 Spencer 1978.

19 Filarete 1972, 679.

20 Spencer 1978, 43.

21 Krautheimer 1970, I, 9–11; Pope-Hennessy 1966, 72.

CHAPTER 6

1 "Suos vultus propriumque simulacrum aemulatus . . . Ingenio fuit versatili, quod nullam ferme censeas artium bonarum fuisse non suam." Alberti 1961, 480, 488, adapted; Fubini and Gallorini 1972, 68, 73.

2 The most recent interpretations of this work include Lewis, forthcoming, cat. 1; Smith 1994, 454, cat. 41; Lewis, in Scher 1994, 41, cat. 3; Schneider 1990, 264ff.

3 Hill 1930, 161; Pasini 1987, 150; Rome 1988, cat. 4.

4 Prinz 1971, 1, pl. 16.

5 Alberti 1950, 55; Alberti 1972, 37.

6 Alberti 1972, 55; Alberti 1950, 65, 72; Watkins 1957.

7 Alberti 1961, 480, 488, adapted.

8 Landino 1974, 117; Alberti 1972, 143; Beck 1989, 16.

9 Alberti 1972, 143.

10 Vasari/Milanesi 1906, II, 547.

11 Middeldorf 1978, 314.

12 Vasari/Milanesi 1906, II, 546.

13 The claim of *docta manus* derives from Nicola Pisano's inscription on his pulpit in Pisa (Pope-Hennessy 1986, I, 170).

14 Radcliffe, in Darr and Bonsanti, 1985, 163, cat. 48; Radcliffe, in Darr and Bonsanti, 1986, 214, cat. 82.

15 Alberti 1972, 67; Alberti 1950, 81.

16 Baxandall 1990–91, 33–6; Alberti 1966–73, II, 182.

17 Woods-Marsden 1993, 54–6.

18 Krautheimer 1970, 322.

19 See Schapiro 1973, 38–9.

20 Baxandall 1990–91, 35.

21 Richter 1971, cat. 474; Lewis, forthcoming, cat. 1. I am most grateful to Dr. Lewis for making his manuscript available to me in advance of publication.

22 For much of the following, see Schnieder 1990; Schneider Adams 1993, 144–51; Lewis, forthcoming, cat. 1; Lewis, in Scher 1994, 42; Chastel 1975, 110.

23 Danesi Squarzina 1988, 46–7, cat. 2–3; Badini 1991, 172, cat. 42, fig. 125. There is no agreement on either the exact meaning of the motto or the literary source. In the manuscript (Florence, B.N., MS II, IV, 38, c. 92r.), which is dated by Grayson to 1438, the device was drawn in the same ink as a postscript written in Alberti's hand. The winged eye with thunderbolt seems to have been fully developed by 1436–7, the date at which Alberti's MS of *Fabula Philodoxeos* (Modena, Biblioteca Estense, Lat. 52), in which the device was drawn, was sent to Leonello d'Este.

24 McMahon 1956, 34, cited from Rosand 1986, 53. On the eye, see Kemp 1977b; Ackerman 1978.

25 Alberti 1987, 213; Watkins 1960, 257.

26 Jarzombek 1992, 49 n. 7; Horapollo 1551, 222; Wind 1958, 231; Alberti 1966a, 695–7.

27 For Filarete the winged eye symbolized virtue (Filarete 1972, f. 145r., pl. 106).

28 Ripa 1986, I, 214.

29 Danesi Squarzina 1988, cat. 2; Lewis, in Scher 1994, 42; Lewis, forthcoming, cat. 1.

30 An antique parallel can be found in fifth-century Greek coins of Zeus on which the reverse features a thunderbolt that is not only winged but also placed within a laurel wreath. Danesi Squarzina 1988, 46, cat. 2; Lewis, in Scher, 1994, cat. 3.

31 Alberti 1987, 213; Watkins 1960, 257.

32 Alberti 1966a, 844.

33 Alberti 1972, 61; Alberti 1950, 77.

34 Marsh 1985, I, 364.

35 See, for example, Hill 1930, I, cat. 360.

36 Wind 1958, 232; Facio, in Borsi 1977, 363.

37 Jarzombek 1989, 80–81.

38 Marsh 1985, I, 364; Dezzi Bardeschi 1974, 33–67.

39 Watkins 1960, 257.

40 Cox-Rearick 1984, 185.

41 Marsh 1985, I, 365; Beck 1989.

42 For astrology in the Renaissance, see Cox-Rearick 1984, 159ff.

43 Cox-Rearick 1984, 185 n. 23.

44 Schneider 1990, 266, figs. 4, 5.

45 Danesi Squarzina 1988, 46, cats. 2, 3.

46 Jarzombek 1989, 3.

47 Baxandall 1990–91, 31; Garin 1959, 209.

48 Jarzombek 1989, 70–71. Baptista makes his first literary appearance in *Della Famiglia* (1433–4).

49 Jarzombek 1989, 110.

50 Ibid., 72.

51 Cervigni 1979, 70ff.

52 Alberti 1966b, 118; Baxandall 1990–91, 34.

53 Jarzombek 1989, 150.

54 Parker 1996, 46.

55 Wallace 1992b, 167; Barolsky 1990, 125; Wilde 1978, 14.

56 See Coda, pp. 254–5, below.

57 Krautheimer 1970, 315.

58 Barolsky 1994. See Coda, pp. 254–5, below.

CHAPTER 7

1 The most recent discussions are by Parlato 1988a, cat. 42, 133–4; Warnke 1992, 101–12. Acidini Luchinat 1995, 369, identifies a portrait of Filarete on the walls of the Medici Palace chapel.

2 Already in 1482 the artist was named *maestro Antonio Philarete* in Lorenzo de' Medici's *Ricordi*.

3 Vasari/Milanesi 1906, II, 457–8; Vasari/De Vere 1912–14, II, 5–6.

4 Onians 1988, 158.

5 Ibid.

6 Ricci 1902, 236; Pope-Hennessy 1966, 208, on the grounds of the sitter's supposed age.

7 Hill 1930, I, cat. 158.

8 Adapted from Pope-Hennessy 1966, 208.

9 Virgil 1983, intro.

10 Alberti praised the bees in similar terms in *Della Famiglia*: "bees unite in obedience to a single leader and are all busy for the sake of the general good." Schneider 1990, 268; Watkins 1960, 206.

11 Ianziti 1988, 20–29, 127–44.

12 Spencer 1965, I, 78; Filarete 1972, 175.

13 Spencer 1965, I, 246, adapted.

14 Filarete 1972, 509.

15 The pool of honey is juxtaposed with a pool of filth at the base of the figure of Vice (Filarete 1972, II, pl. 106, f. 143r.; Spencer 1965, 246). Filarete also mentions bees elsewhere in the treatise.

16 Seneca 1962, LXXXIV, 163ff.

17 Pigman 1980, 4ff.

18 Onians 1988, chap. 11.

19 See p. 76, above.

20 Ricci 1902, 234.

21 Ibid., 235.

22 Warnke 1992, 105.

23 Ricci 1902, 234.

24 "Che ogni uomo sia ben pagato." Filarete 1972, 98–9.

25 See p. 73, above.

26 Starn and Partridge 1992, 110.

27 Welch 1995, 140.

28 Alberti 1988, 3.

29 Hollingsworth 1984, 396–8; Long 1985, 274.

30 Spencer 1965, I, 146ff., 258ff.

31 See p. 132 and 170–72, below.

32 Filarete 1972, II, 561, pl. 115; Spencer 1965, I, 258–9.

33 Filarete 1972, I, 42.

34 Spencer 1965, I, 259, (bk. XIV, f. 109r.); Filarete 1972, I, 414.

35 Spencer 1965, I, 140, 146.

36 See pp. 85–8, below.

37 Welch 1995, 148.

38 Onians 1988, 169–70.

CHAPTER 8

1 Janus Pannonius, 1458, on his own portrait together with that of a friend. Adapted from Lightbown 1986, 459–60.

2 Barocchi 1960–62, I, 125.

3 Martindale 1976.

4 Lightbown 1986, cat. 10.

5 Kristeller 1902, 235.

6 Battisti, in Signorini 1985, 15. The adjective can be translated also as "fine" or "subtle."

7 Starn and Partridge 1992, 91. See now Starn 1995.

8 Signorini 1976.

9 Ibid.; Signorini 1985, 181–6.

10 Lightbown 1986, 387ff., cat. 1 (as a frowning Roman centurion within the *Trial of St. James*

on the left wall, and as a giant head in monochrome on the left front face of the apse arch).

11 Lightbown 1986, 405, cat. 7.

12 See also Signorini 1985, 181–6; Signorini, in Pastore 1986, 38–9.

13 Martin 1993, 73.

14 For the chapel as a whole, see Pastore 1986; Lightbown 1986, cat. 58; Christiansen, in Martineau 1992, 253–4, cat. 64.

15 Lightbown 1986, cat. 62; Signorini, in Pastore 1986, 23–42; But see now Christiansen 1994.

16 Radcliffe, in Martineau 1992, cat. 1.

17 The funerary slab in the pavement below bears an epitaph placed there by his grandson, which reads OSSA ANDREE MANTINIE FAMOSISSIMI / PICTORIS CUM DUOBUS FILIIS IN SEPUL/CRO PER ANDREAM MANTINEAM / NEPOTEM EX FILIO CONSTRUCTO / REPOSITA / MDLX, "the bones of Andrea Mantegna, the famous painter, were laid out with [those of] his two sons in the tomb built by Andrea Mantegna, a grandson through his son."

18 Lightbown 1986, 131.

19 Lightbown 1986, cat. 62; Radcliffe, in Martineau 1992, 90, cat. 1, attributed the casting to Mantegna. See also Luchs 1995, 62, 235.

20 Middledorf 1978, 314.

21 Pliny, *Natural History*, XXXV, 2–5.

22 Vermeule 1965, 361–97.

23 Ostrow 1990, 254 n. 4, for an analogous case of the marble cladding being feigned in fresco.

24 Goffen 1989, 191ff.; Goffen 1975, 494.

25 Martineau 1992, 8.

26 Prinz 1962.

27 Meller 1963; Summers 1978.

28 Forster 1971, 79.

29 Chambers and Martineau 1981, cats. 62, 98.

30 See Summers 1978; Partridge and Starn 1980, 27–8.

31 Martineau 1992, 8–30.

32 Filipczak 1987, 26.

33 Kristeller 1902, 551, doc. 115.

34 The independent portraits, which date between *c.*1460 and 1475, include those of Cardinal Lodovico Trevisan, Francesco Gonzaga as a boy, and the so-called "Carlo de' Medici" (Lightbown 1986, cats. 11, 12, 19; Martineau 1992, cats. 100, 101, 102).

35 Woods-Marsden 1987, 210.

36 Tietze-Conrat 1955, 19.

37 Signorini 1974, 228, 230; Signorini 1985, 171.

38 Lightbown 1986, 120, 159.

39 Ibid., 120.

40 Rosenthal 1962, 327–48; Marani 1961, 147–57; Kraitrova 1992, 43–8; Lightbown 1986, 120–24.

41 Lightbown 1986, 124; Kraitrova 1992, 44–6.

42 Lightbown 1986, *passim*.

43 Van Os 1977.

44 Lavin 1977–8, 37, 14.

45 Venturi 1908, 939–69; Egger 1927, 122–36.

46 Signorini 1981, 3–14.

CHAPTER 9

1 Hill 1930, 657; Syson, in Scher 1994, cat. 33, 114–15.

2 Vasari/Milanesi 1906, IV, 161: "come ancora si vede la medaglia di Bramante fatta da lui molto bello . . ." The confusion arises as to whether the "lui" refers to Caradosso, the subject of the previous clause, or to Bramante.

3 Herrmann-Fiore 1992, 251.

4 Syson, in Scher 1994, 115.

5 Scher 1994, 102–3, cat. 27; Waddington 1993.

6 For a purported self-portrait by Pisanello, see Woods-Marsden, forthcoming 1998.

7 See Blunt 1938–9; De Tervarent 1958, 109–12; Mâle 1958; Shelby 1965; Gould 1968, 626; Friedman 1974, 419–29.

8 Friedman 1974, 123; Blunt 1938–39.

9 Gould 1968, 626; Davies 1961, 50, no. 1213; Heinemann 1962, 272, cat. V, 378 (attributing it to Titian). For another sitter identified as Giovanni Bellini in a work by Titian (Copenhagen), see Rapp 1987; Wethey 1969–71, II, cat. 43.

10 Hill 1930, I, 116, cat. 438; Wilchusky 1994, cat. 28.

11 Pevsner 1942, 549.

12 Alberti 1988, 3.

13 Winner 1986, 93 n. 20.

14 Cheles 1986, 90.

15 He was called *architecto doctissimo* in 1510 for his ability to interpret Dante for Julius II (Bruschi 1971, 721).

CHAPTER 10

1 Valcanover 1969, cat. 403.

2 For a panel of three bust-length *portraits* of artists, *Imaginary Portraits of Taddeo, Gaddo, and Agnolo Gaddi* (Uffizi, Florence) by an anonymous painter of the early Quattrocento, see Ladis 1982, frontispiece. For a similar panel of five bust-length portraits of artists, identified as Giotto, Uccello, Donatello, Antonio Manetti, and Brunelleschi (Louvre, Paris), attributed in the first edition of Vasari's *Lives* to Masaccio, and, in the second, to Uccello (Vasari/Milanesi 1906, II, 213–14), see Pope-Hennessy 1966, fig. 21, where the panel is given the title *The Founders of Florentine Art*.

3 Ferino-Pagden 1989, 63; Castellenata and Camesasca 1969, cat. 16.

4 I concur with Meller (1974, 270) and Ferino-Pagden (1989, 66) that the fifth figure from the right in the *Donation of the Keys to St. Peter* was *not* intended to portray Perugino.

5 They are identified in Scarpellini 1984, cat. 98.

6 Juren 1974b, 24–6.

7 Chastel 1983, 130. The inscription reads PETRVS PERVSINVS EGREGIVS / PICTOR / PERDITA SI FVERAT PINGENDI / HIC RETTVLIT ARTEM / SI NVSQVAM INVENTA EST / HACTENVS IPSE DEDIT. The verse appeared among Maturanzio's unpublished papers in the Perugia Biblioteca. The use of the remote past has puzzled scholars.

8 For a possible antecedent in the baptistery of Castiglione d'Olona, where Vecchietta (Lorenzo di Pietro) painted the bust of a young man on the dado looking through a window toward a scene of *The Martrydom of St. Lawrence*, the artist's name saint, see Van Os 1977, 449, fig. 8.

9 Rosand 1982a, 35 n. 41.

10 Carli 1960, 61.

11 Scarpellini 1984, 46.

12 Kemp 1989, 38

13 Canuti 1931, I, ch. 21.

14 Chastel 1983, 120–37; Bellosi 1987, 410.

15 The exception, by Giorgione, is discussed on pp. 117–19, below.

16 Shearman 1983, cat. 217. For additional comments on the inscription and underdrawing, see Shearman 1990, 9–10.

17 Pouncey and Gere 1962, cat. 1

18 Becherucci 1968, I, 64.

19 It is not however certain that the inscription dates from the early sixteenth century. See von Sonnenburg 1983, 106–13; von Sonnenburg 1990, 77–8.

20 See Fredericksen 1990, 105–9, for another similarly Raphaelesque portrait of a young man in the J. Paul Getty Museum, L.A.

21 Fredericksen 1990, 108–9, questioned the authenticity of the Budapest portrait.

22 Florence 1984, 47–57, cat. 1; Wagner 1969, 62ff.

23 See pp. 121–4, below.

24 Ferino-Pagden 1986, 95, 100, 102. In the case of the religious works, she estimates a time lag of one to five years between Raphael's execution of a work and its copying by other artists.

CHAPTER 11

1 Anderson 1996, 306.

2 Sheard 1992; Anderson 1996, 306–7. There is no agreement on the attribution of the self-portrait head in Brunswick.

3 Luchs 1995, 73. Shearman 1992, 24–5, argues that the head of Goliath, not that of David, is Giorgione's self-portrait.

4 Anderson 1979; Huse and Wolters 1990, 241.

5 Goffen 1989, chap. 3; Grubb 1994.

6 Huse and Wolters 1990, 241.

7 Luchs 1995, 72.

8 Koerner 1986, 416.

9 Herrmann-Fiore 1992, 261.

10 Thomson de Grummond 1975, 349; Rosand 1983, 97.

11 See p. 93, above; Meller 1963.

12 Summers 1978. In the biblical account, David refused to wear Saul's armor before the combat, but accepted that belonging to Jonathan afterwards. Anderson 1996, 206. I Samuel 17:38–9; 18:4.

13 Lomazzo 1973, II, 434.

14 Anderson 1996, 18–19.

15 Another, lost, (?)self-portrait as David with the figures of (?)Jonathan and (?)Saul, known only in a copy, shows the head of Goliath appropriately depicted in much larger scale. Anderson 1996, 319.

16 Shearman 1992; Sheard 1992; Summers 1978; Wind 1969, 10–11, 33 n. 57.

17 Wind 1969, 10–11, 33 n. 57.

18 Lavin 1992, 168.

19 Anderson 1996, 306–7.

20 Summers 1978, 117.

21 Vasari/Milanesi 1906, IV, 92.

22 Gaston 1983; Anderson 1996, 317.

23 McIver 1997, 47, fig. 1; McIver 1993, 51, fig. 4.

24 Taddeo di Bartolo took on the guise of a New Testament apostle.

25 Barolsky 1994, 107, *passim*.

CHAPTER 12

1 *Naturae ille Deus, tu Deus artis eras*; Ferino-Pagden 1990, 175.

2 The *Triumph of Camillus* by Salviati in the Palazzo Vecchio, Florence, is another secular fresco that includes a self-portrait as witnessing bystander.

3 Vasari/Milanesi 1906, IV, 332; Oberhuber 1984; Winner 1986, 83–94.

4 Vasari/Milanesi 1906, III, 169; Redig de Campos 1954–5.

5 Reiss 1995, 16–18.

6 Vasari/Milanesi 1906, VI, 383–4.

7 Paul Watson, oral communication.

8 Oberhuber 1977; Oberhuber 1986.

9 Oberhuber 1986, 156.

10 Edgerton 1975, 110ff.

11 Cheles 1986, 93–4, *passim*.

12 C. Ptolemy, *Geography*, as cited in Kelly-Gadol 1969, 71.

13 Winner 1986, 86ff.

14 Ibid., 93 n. 20. See now Rowland 1997, 131–70.

15 For another self-portrait, one of the bearers of Julius II's litter in the *Expulsion of Heliodorus*, see Schwartz 1997, 471.

16 The case for the attribution was made by Shearman 1984, 107; Béguin 1983–4, cat. 13; Cordellier 1992, 492–4. The most recent discussion is Cox-Rearick 1996. It has been dated as early as 1516–17, since it shows stylistic affinities with the tapestry cartoons, but most recent criticism places it *c*.1519. Sofonisba Anguissola's self-portrait in pl. 138 and Cambiaso's in pl. 152 are other double portraits.

17 Gould 1966, 45–51.

18 For prototypes of the chair's oblique angle, see Partridge and Starn 1980, 54ff.

19 Shearman 1992, 128–9; De Vecchi 1981, 63ff.

20 Fried 1978, 93.

21 Freedberg 1971, 46.

22 Woods-Marsden 1993, 44–7 and *passim*.

23 Ripa 1764–7, I, 191.

24 Barocchi 1971–7, II, 2710.

25 Filipczak 1987, 98; De Tervarent 1958, 156–7.

26 Béguin 1983–4, 102.

27 Gould 1984; Cox-Rearick 1996, 218–22, 453 n. 176; Shearman 1992, abandoned his suggestion of Giovanni Battista Branconio dell'Aquila (1473–1522).

28 Shoemaker and Broun 1981, cat. 46, where it is dated, on grounds of style, *c*.1517–20. The inscription, however (in which Aretino declares himself the most vigorous demonstrator of virtue and vice) may link the engraving closer to Sebastiano del Piombo's portrait of Aretino of 1527–8, which bears the identical inscription.

29 Woods-Marsden 1994.

30 Neither is the work mentioned by Dolce in the passages in his *Aretino* in which the character Aretino praises the work of his *carissimo amico* Raphael. See Roskill 1968, 90–95. Winner's attractive identification of the sitter as the refined and learned Giuliano de' Medici, a friend of Raphael of the right age and status, would require the artist to have painted the work before Giuliano's death in March 1516; while the painting has been dated as early as that year, most recent criticism places it later, *c*.1519.

31 Kemp 1992c, 271–2. See now Simons 1995, 277–83.

32 Anderson 1979, 153–8.

33 Anderson 1996, 204.

34 Anderson 1979.

35 Shearman 1992, 140–41; Jones and Penny 1983, 171.

36 Chastel 1986; Chastel 1987.

37 McMahon 1956, I, 152, 60v, no. 248.

38 Herrmann-Fiore 1983, 35, *passim*; Lukehart 1996. For an earlier discussion of the mirror, see pp. 31–4, above.

39 Encouraged by his Genoese compatriot Cambiaso, Paggi may have been influenced by Cambiaso's self-portrait, for which see pp. 234–7, below. For the lost painting by Giorgione showing all four sides of St. George, see Bialostocki 1977, 71. For Savoldo's *Portrait of the So-called Gaston de Foix*, *c*.1530, which I do not read as a self-portrait, see Gilbert 1986, 426–34; Gilbert 1991.

40 Suida 1954, 160–64.

41 Brilliant 1991, 161.

42 Gilbert 1986, 426–34; Gilbert 1991.

43 Gusdorf 1991a, 339.

44 For another aspect of this painting, see now Simons 1997, 45–6.

45 Vasari/Milanesi 1906, IV, 316.

46 Weil-Garris 1990, 182.

47 Partridge and Starn 1980, 39.

48 Aretino, *La Talanta*, 1542, cited from Rubin 1995, 375.

49 Rubin 1995, 374.

50 Vasari/Milanesi 1906, V, 316.

51 Rubin 1995, 357.

52 See Beck 1986, 9; Schneider 1984, 9–22.

CHAPTER 13

1 See Freedberg 1950, 201–2; 104–6; Quintavalle 1969; Fagiolo Dell'Arco 1970, 31–5; Ashbery 1975; Chastel 1977a, 150; Freedman 1984; Marin 1995, 130–32.

2 Vasari/Milanesi 1906, V, 221–22; adapted from Vasari/De Vere, 1912–14, V, 245–6.

3 Freedberg 1950, 110; Barolsky, verbally.

4 See Koerner 1986.

5 Schwartz 1967, 219. Venice had a glass blowers' guild as early as 1224, Nuremberg by 1373. See also pp. 31–4, above.

6 Goffen 1991.

7 Bialostocki 1977, 70.

8 Zucker 1962, 243, 245.

9 Freedberg 1950, 109–11.

10 Land 1997b, 28.

11 Land 1997a; Barolsky 1995, 256. The quotation comes from Hughes 1997, 79.

12 Freedberg 1950, 105. For Fouquet's mid-Quattrocento self-portrait medallion, black enameling painted in gold, also derived from a circular mirror, and originally part of the frame of the Melun Diptych, see Reynaud 1981, cat. 6.

13 Edgerton 1975, 86.

14 Ibid.

15 Freedberg 1950, 146 n. 4.

16 Ibid., 104.

17 Cox-Rearick 1996, fig. 269.

18 Vienna 1991, 93.

CHAPTER 14

1 Gaston 1983; Cox-Rearick 1989. See also p. 1.

2 Weil-Garris Brandt 1990, 498. See also Weil-Garris 1981; Weil-Garris 1983.

3 Those who reject Bandinelli's authorship include Weil-Garris 1981, 248 n. 43, and Zeri, who attributes it to Jacopino del Conte (Cheney 1970, 38 n. 51).

4 Hendy 1974, 12.

5 De Holanda 1928, 35–6.

6 Vasari/Milanesi 1906, VI, 148.

7 He was commissioned to fresco the *Marriage of the Virgin* in SS. Annunziata, a commission

that was eventually carried out by Francia-bigio. Vasari records two other paintings from the mid-1520s, one of which, a *Deposition*, was exhibited in the Mercato Nuovo. Bandinelli was also commissioned to fresco a *Martyrdom of SS. Cosmas and Damian* and a *Martyrdom of St. Lawrence* in the Cappella Maggiore of S. Lorenzo. Vasari/Milanesi 1906, VI, 147; V, 418.

8 Colasanti, 1905, 433. See also Cox-Rearick 1989, 78 n. 35.

9 They included the *St. Peter* for the Duomo, the *Orfeo* for the Medici Palace, his copy of the Laocoön, the two giants for the gate of the Villa Madama, and the tombs of Leo X and Clement VII in S. Maria sopra Minerva.

10 Colasanti 1905, 423.

11 Ibid., 414.

12 Weil-Garris 1983, 404 n. 142.

13 Ibid., 404. The signature was on his copy of the Laocoön.

14 Baxandall 1971, 64.

15 Weil-Garris 1983, 404.

16 Ettlinger 1972, 120.

17 Bush 1980, 176.

18 Weil-Garris 1981, 223, 227, *passim*.

19 Waldman 1994.

20 Weil-Garris 1981, 237.

21 The male and female masks sculpted into the rock below the drawing in the Gardner painting were perhaps a reference to the *invidia* and fraud that surrounded this commission (De Tervarent 1958, 261–4).

22 Weil-Garris 1983, 398ff.

23 Bush 1980, pls. 18 and 20; Weil-Garris 1983, 398.

24 Bush 1980, 177–80; Weil-Garris 1983, 398.

25 Weil-Garris 1983, 402.

26 Vasari/De Vere 1912–14, VII, 57.

27 Vasari/Milanesi 1906, VI, 138, 190.

28 McMahon 1956, 36–8, #51.

29 Colasanti 1905, 433.

30 Ibid., 430.

31 Barzman 1985, 219; Vasari/Milanesi 1906, I, 168–9.

32 Rosand 1982a, 5.

33 Vasari/Milanesi 1906, I, 167.

34 Weil-Garris 1981, 235.

35 Crowe and Cavalcaselle 1877–8, I, 285. For the painting, see also Shearman 1965b.

36 Weil-Garris Brandt 1990, 497.

37 De Tervarent 1958, 106–7.

38 Ibid., 107; Rosenthal 1973, 201, 215, 221; Tanner 1993, 155.

39 See Hill and Pollard 1967, cat. 606, for medal by Hans Reinhart the elder.

40 Herrmann-Fiore 1992.

41 Ibid., 270.

42 Goffen 1983; Schwartz 1967. Dürer's almost full-length nude self-portrait drawing in Weimar dates 1500–1507.

43 Campbell 1985, 339–61.

44 Hill and Pollard 1967, cat. 428.

45 A possible portrait of Bandinelli in the Corsini apparently shows him holding a medal of Clement VII.

46 Perry 1977, 676–7.

47 Colasanti 1905, 425.

48 Gilbert 1980, 66 n. 140.

49 Colasanti 1905, 429.

50 Weil-Garris 1981, 236.

51 Colasanti 1905, 430.

52 Weil-Garris 1981, 236.

53 Wazbinski 1985, 327.

54 Vasari/Milanesi 1906, IV, 384–5.

55 Weil-Garris 1981, 235.

56 Vasari/Milanesi 1906, VI, 185.

CHAPTER 15

1 A. Cecchi, in Arezzo 1981, 311–13, cat. 4, as *Artista della Cerchia Vasariana*, perhaps Zucchi.

2 A copy of the painting in the Casa Vasari, which extends the space available for attributes, includes several volumes (Cheney 1985, fig. 310).

3 Kirwin 1971; Vasari/Milanesi 1906, VII, 206.

4 Kirwin 1971, 111, 114.

5 Mezzatesta 1985; Mezzatesta 1984, 630. See also pp. 170–71, below.

6 Wittkower and Wittkower 1964, 45.

7 Kirwin 1971, 114.

8 Cox-Rearick 1993, 8–9.

9 Kirwin 1971; Cox-Rearick 1993, 8–9.

10 Pilliod 1998.

11 Ibid., 49–50,

12 Barolsky 1992, *passim*.

13 Barolsky 1991, 95, 100.

14 Ibid., 103.

15 Ibid., 94; Cheney 1985, 304.

16 Vasari/Milanesi 1906, II, 15; Biagi 1972, 78–9.

17 Barolsky 1992, 16–17.

18 Barolsky 1991, 95, 100.

19 Barolsky 1992, 49.

20 Rubin 1995, 61.

21 Starn and Partridge 1992, 191.

22 Vasari/Milanesi 1906, VIII, 206, 219.

23 Starn and Partridge 1992, 210–11.

24 Ibid., 210.

25 Barolsky 1991, 39; Barolsky 1992, 75.

CHAPTER 16

1 Cellini in letter to Varchi 1559, cited in Butler 1954, 295.

2 Chastel 1986, iv; Cellini 1956, 37.

3 Rossi 1994.

4 Pope-Hennessy 1985, 273.

5 Ibid., 33.

6 Barolsky 1990, 119–122.

7 Vasari/Milanesi 1906, VII, 623.

8 Cellini 1983, 168.

9 Summers 1981, 234ff.

10 Cellini 1971, 35.

11 Barolsky 1994, 125.

12 Maier 1952, 52.

13 Cellini 1983, 193.

14 Pope-Hennessy 1985, 280; Cellini 1983, 206–7.

15 Maier 1952, 38.

16 Ibid., 38–39; Pope-Hennessy 1985, 281.

17 Goldberg 1974, 75.

18 Regosin 1977, 176.

19 Weintraub 1978, 140; Maier 1952, 38.

20 Maier 1952, 11, 18; Rossi 1994, 158.

21 See n. 1.

22 Cervigni 1979, 97.

23 Maier 1952, 52. See also Calamandrei 1950.

24 Vasari/De Vere 1912–14, VII, 93; Vasari/Milanesi 1906, VI, 183.

25 Cox-Rearick 1996, 293.

26 Calamandrei 1950, 195.

27 Rubin 1995, 53.

28 Maier 1952, 83–4 n. 127.

29 Colasanti 1905, 428–9.

30 Pope-Hennessy 1985, 281.

31 Borsellino 1972, 18–19; Pope-Hennessy 1985, 11–12.

32 Calamandrei 1950, 196.

CHAPTER 17

1 Hope 1979; Hope 1988.

2 Gilbert 1980a, 66.

3 Vasari/Milanesi 1906, VII, 459.

4 Roskill 1968, 194–5.

5 Rosand 1982a, 5.

6 Hope 1979, 7; Panofsky 1969b, 7. See also Barolsky 1994, 130.

7 Panofsky 1969b, 10. Unlike Vasari, Titian often took several years to finish his works. Hope 1979, 7–10; Hope 1988, 49–72.

8 Chastel 1977b, 45. These circumstances produced a considerable cache of "business letters" written by an artist to his patrons, that is unique for the period (Ibid., 43).

9 Kennedy 1964, 163.

10 Panofsky 1969b, 6.

11 Panofsky 1969b, 2; Hochmann 1992, 44.

12 Chastel 1977b, 18, 22; Hochmann 1992, 47.

13 For the current status of the late *Pietà*, not, it seems, for his own tomb after all, see Hope 1994.

14 For the Cellini, see Pope-Hennessy 1985, 221; for Moroni's *Portrait of Giovanni Bressani*, see Bergamo 1979, cat. 39.

15 Held 1969, 32–44.

16 Brown 1988, 233, pl. XLIII.

17 Held 1969, 32–44.

18 Woods-Marsden 1994, 296–7.

19 Shearman 1992, chap. 3. See also Rosand 1978, frontispiece.

20 M. Boschini, *Le ricche miniere della pittura veneziana*, 1674, quoted from Valcanover 1969, 9; Rosand 1982a, 24; Rosand 1986, 85.

21 See also Freedman 1990, 82.

22 Chastel 1977b, 44.

23 Rosand 1982a, 5.

24 Vasari/Milanesi 1906, VII, 446.

25 One by Titian was seen by Sansovino in the

collection of Niccolò Renier. Sansovino 1563, 377.

26 Woods-Marsden 1994.

27 Hope 1990, 60 and n. 29; Meller 1980, 333; Campbell 1990, 217, 272 n. 118. The inscription reads: TITIANI PICTORIS EXIMII EFIGIES A. A., and the portrait of Orazio was identified as HORATIVS FIL.

28 Hill 1912, 56–7.

29 Both medals lack reverses, although Titian had an appropriate impresa, a bear licking her still unformed cubs into shape, with motto NATVRA POTENTIOR ARS, "art is more powerful than Nature," the legend of maternal molding used as a metaphor of artistic creation (Rosand 1982a, 16, pl. 1).

30 Trusted 1990, cats. 31, 58, 61, 93. Both the scale and the possible imperial models were suggested by Luke Syson.

31 Gould 1976, 25.

32 See also Shearman 1992, chap. 3.

33 Wethey 1971, II, cat. 107.

34 Freedman 1995, 152.

35 Wethey 1971, II, cats. 36–8, 97.

36 Woods-Marsden 1994, 54–6.

37 Hope 1988, 64.

38 Titian 1977, 25, no. 16; Freedman 1990, 152.

39 Rosand 1982a, 5, 16.

40 Panofsky 1969b, 25.

41 Rosand 1982a, 37 n. 22. The citation comes from Speroni's *Dialogo d'Amore.*

CHAPTER 18

1 Barolsky 1994, 130.

2 "Et acciò ch'io abbia meglio animo, e più riposato, in servirlo, me ha fatto dare una camera in Palazzo sotto quella ove Sua Maestà dorme . . . ," Ronchini 1865, 26; "mi ha fatto domandare, et al longo s'è pigliato piacere di ragionare meco . . . ," letter from Leoni to Ferrante Gonzaga, Brussels, 30 March 1549, in Ronchini 1865, 26; "Soventi volte Sua Maestà sta due hore et tre ragionando meco et con Pompeo mio," Leoni to Ferrante Gonzaga, 29 June 1549, in Campori 1885, 288.

3 Mezzatesta 1980, xxv n. 43.

4 Celio Malaspini.

5 Leopold 1980, 198.

6 Rossi 1994, 183.

7 Atwood in Scher 1994, cat. 50.

8 Rossi 1994, 183. Paul III was speaking of Cellini.

9 Bottari 1822–5, V, 251–2.

10 Rossi 1994, 168.

11 Leopold 1980, 26.

12 Hill 1912, 53, cat. 31. The medal, known only in one specimen that is no longer in the Ambrosiana Library, had no reverse.

13 Leopold 1980, 190, n. 23.

14 Mezzatesta 1985, 233–49.

15 Mezzatesta 1980, xviii, 314.

16 Ronchini 1865, 25; Mezzatesta 1984, *passim.*

17 Janson 1973, 159-88.

18 Farquharson 1989, xxii.

19 Mezzatesta 1980, 269.

20 Plon 1887, 353–4.

21 Mezzatesta 1980; Leopold 1980; Gilbert 1990.

22 Bush 1976, 295.

23 Bush 1978, 57.

24 Vasari/Milanesi 1906, VII, 540–41.

25 Leoni's *Casotto* also refers back to two Bramante palace designs: the Palazzo Caprini in Rome and the Casa Fontana in Rome (Mezzatesta 1985, 236, 240). Mezzatesta 1980, 231.

26 Leopold 1980, 206.

27 Leopold 1980, 189–90; Boucher 1981; Vasari/Milanesi 1906, VII, 258.

28 Mezzatesta 1980, 237–42; Tronca 1995, 32.

29 Tronca 1995, 34–5.

CHAPTER 19

1 Fray Juan de San Gerónimo, "Memorias del Escorial," 1845, cited in Babelon 1920, 266.

2 Cast 1981, 149.

3 Summers 1987, 283.

4 The portrait of Taddeo entered the Uffizi collection as a self-portrait, a designation it still bears in Uffizi 1979, 1044, cat. A1039. There are said to be other late self-portraits or portraits of Federico in the Pinacoteca Capitolina, Rome, and the Accademia di S. Luca, Rome (Herrmann-Fiore 1979, 69, fig. 24).

5 Washington and Houston 1988, cat. 1. The inscription on Philip's medal reads PHILIPPVS NOVI ORBIS OCCIDIVI REX (Philip, King of the New World in the West).

6 Millon 1994, 589–91, cat. 264.

7 New Haven 1994, 48 (almost 1,000 sq. braccia).

8 See n. 6, above.

9 Wazbinski 1985, 291, 301, 307, 309; Coffin 1964, 204.

10 Acidini Luchinat 1988/89; Acidini Luchinat 1992. Zuccari "un-did" and "re-did" 834 sq. braccia of frescoes.

11 Guasti 1857, 138.

12 Heikamp 1967, 50.

13 Wazbinski 1985, 286.

14 Cloulas 1968.

15 Babelon 1920, 268; See also Cloulas 1968; Mulcahy, 1985.

16 Mulcahy 1987, 503.

17 Cloulas 1968, 195.

18 Mulcahy 1987, 504, citing Siguenza 1963, 318.

19 Cloulas 1968, 195 n. 3.

20 Pollard 1984, II, 709, 719, cats. 366 and 375.

21 See pp. 99–101, above.

22 Wazbinski 1977, 11.

23 Bertolotti 1876, 136.

24 Wazbinski 1985, 308.

25 Gerards-Nelissen 1983, 50 n. 29, 53 n. 41.

26 Partridge 1971, 470 n. 20; see also Zapperi 1991, 190 n. 65.

27 Zapperi 1991, 181.

28 Heikamp 1957a, 178.

29 Hermann-Fiore 1979; Leopold 1980; Müller 1992.

30 Leopold 1980, 265ff.

31 Partridge 1978, 516.

32 Ibid., 516 n. 119.

33 Barolsky 1992, *passim.*

34 Leopold 1980, 277ff.

35 Hermann-Fiore 1979, 65–72.

36 Leopold 1980, 287.

37 Ibid., 288.

38 For the Vasari work, see Frey 1941, 136; Florence 1980, cat. 22; Arezzo 1981, 309, cat. 2c; Isermeyer 1950; Barolsky 1992, 47, 50, 87.

39 Langedijk 1981, I, 118–19, 424.

40 Cleri, 1993, 164–67.

41 Ancona 1985, 158-60.

42 See n. 38, above.

43 Wethey 1969–71, I, cat. 55 and II, cat. 110.

CHAPTER 20

1 Passeri 1772/1934, 257; Harris and Nochlin 1976, 32.

2 Gauricus 1969, 133–5.

3 Bynum 1991, 202.

4 Junkerman 1993, 54. Caro, letter to Amilcare Anguissola, 1559, in Sacchi 1994a, 365; J. Paul Hunter, paper read at the National Humanities Center, Research Triangle Park, N.C., February 1996.

5 Sohm 1995.

6 Ibid., 799.

7 Jacobs 1994, 79.

8 Ibid., 85.

9 Chadwick 1990, 29.

10 Sohm 1995, 790.

11 Garrard 1980/81, 36.

12 Maclean 1980, 92.

13 Alberti 1972, 65.

14 Castiglione 1959, bk. III, ch. 9; King 1991, 272.

15 Kelly-Gadol 1987.

16 Pardo 1984, 322.

17 Graziani 1994, 131.

18 Lomazzo 1973, I, 95.

19 Ibid.

20 King 1991, 238.

21 Guazzoni 1994, 59.

CHAPTER 21

1 Vasari/De Vere 1912–14, V, 127–8, adapted.

2 Sacchi 1994a, 365.

3 Ghirardi 1994, 38.

4 Vasari/Milanesi 1906, VI, 498.

5 Bialostocki 1988, 150.

6 Baldinucci 1846, 630; Kusche 1995, 32.

7 Sacchi 1994a, 401.

8 Baldinucci, 1846, 630.

9 Garrard 1994, 568ff; letter from Salviati to Campi, 1554, in Sacchi 1994b, 408.

10 Cropper 1986.

11 Garrard 1994, 573ff.

12 Jacobs 1994, 11; King 1991, 192.

13 Graziani 1994, 139.

14 Kemp 1989b, 200.

15 Armenini, *De' Veri precetti della pittura*, 1587, as cited in Jacobs 1994, 88.

16 Freedman 1987, 70.

17 Cited from Jacobs 1994, 88.

18 Jacobs 1994.

19 Jex-Blake and Sellers 1982, 171.

20 Starn and Partridge 1992, 106.

21 Sacchi 1994a, 365–6.

22 Garrard 1989, 64.

23 Kusche 1994, 96.

24 Sacchi 1994a, 369: "voi vedete se io mi occupo in dipingere; senza che la Regina vuol gran parte del tempo per lei per dipingere, di maniera che la non può aver pazienza che io quasi dipinga, per non levarsi a lei la comodità."

25 Bonetti 1928, 296–7, *passim*.

26 Sacchi 1994a, 365–6.

27 See also Caroli 1987, 65, 67.

28 Sacchi 1994c, 72.

29 Vasari/De Vere 1912–14, V, 127, adapted.

30 Tommaso Cavalieri, letter to Cosimo I de' Medici, 1562, as cited in De Tolnay 1941, 117, 119; Jacobs 1994, 95.

31 Jacobs 1994, 77–8.

32 Gregori 1994, 17–18.

33 Lomazzo 1973, 378.

34 Vasari/Milanesi 1906, VI, 498–500; Jacobs 1994; Garrard 1994.

35 Gregori 1994, 44 n. 36.

36 Jacobs 1994, 94.

37 Soprani 1768, 413; Gregori 1994, 12, citing Baldinucci.

38 Jacobs 1994, 88–9.

39 Garrard 1994, 600–603; Simons 1993.

40 Sacchi 1994b, 408.

CHAPTER 22

1 The mediocrity of the supposed self-portrait painted at the age of twenty in the Uffizi collection of self-portraits leads me to suggest that it may be a early copy by one of her sisters or other follower. See also Gregori 1994, 23. King 1995 came to my attention only after this chapter had been written.

2 Castiglione 1959, 121–3; Garrard 1994, 583–6; Ferino-Pagden and Kusche 1995, 19.

3 Maclean 1980, 59–60.

4 Gregori 1994, cat. 2.

5 See Bialostocki 1988.

6 Woods-Marsden 1993, 31–62.

7 Gregori 1994, cat. 6.

8 Ghirardi 1994, 39ff.

9 Schwartz 1952, 110; Koerner 1993, 111, 124; Ringbom 1984, 40.

10 Kahr 1976, 186.

11 Gregori 1994, cats. 7 and 8. Of the three versions the canvas recently discovered in Lancut is the highest in quality and the best preserved.

12 In the next decade both artists worked at the court of Spain, Katerina being invited three years earlier in 1556 by Mary of Hungary, Charles V's sister. Meijer 1985, 25–32, 32 n. 44, giving reference to L. Guicciardini, *Descrittione di tutti i Paesi Bassi*, Antwerp, 1567, 100.

13 Schaefer 1983, 413, *passim*.

14 Ibid.

15 Steinberg 1981, 47.

16 Volk 1978, 85. A copy (Zeri Collection) of the Lancut painting is inscribed with a (?later) inscription in which Anguissola's handling of colors and performance is said to equal those of the Muses and Apelles (Gregori 1994, 200, cat. 8).

17 Hill 1912, 53–4.

18 Brusati 1990/91, 173.

19 Garrard 1989, chap. 6.

20 Garrard 1980/81, 97.

21 Schaeffer 1984, 232–4; Jacobs 1994, 81.

22 "Che la pittura é esercitio nobile, non si potendo fare senza molta applicatione dell'intelletto." Ripa 1603, 405.

23 Gregori 1994, 34, cat. 16; Garrard 1994, 556–66.

24 Kusche 1995, 54; Garrard 1994, 561, *passim*. See also Gregori 1994, 34.

25 Garrard 1994, 566.

26 Ibid., 56off.; Schneider Adams 1993, 83.

27 Garrard 1994, 56off.

28 Chadwick 1990.

29 Ghirardi 1994, 47.

30 Ibid., 46.

31 Langedijk 1992, 13ff.

32 Caroli 1987, 130–31; Ferino-Pagden and Kusche 1995, 28; Gregori 1994, 40, for the unverifiable and questionable reading in the eighteenth century of a (lost) inscription dating the work to 1561, despite the presence of the Cremonese retainer and the musician's habitual Italian apparel.

33 Harris and Nochlin 1976, 111.

34 Kusche 1995, 67.

35 Sacchi 1994c, 74; Gregori 1994, 40, pl. 5.

36 Gregori 1994, 40; Kusche 1994, fig. 5; Kusche 1995, 72.

37 Gregori 1994, 40.

38 Kusche 1994, 104.

39 Lomazzo 1973, I, 95.

40 Ferino-Pagden and Kusche 1995, 19.

CHAPTER 23

1 Schutte 1991, 52; Cantaro 1989, 305.

2 Ghirardi 1994, 43.

3 Murphy 1996, 193.

4 Fortunati 1994, 27; Graziani 1994, 139.

5 Harris and Nochlin 1976, 112.

6 Cantaro 1989, 302.

7 Ferino-Pagden and Kusche 1995, 11.

8 There were, in addition, a lost self-portrait on copper dated 1571 (Fortunati Pietrantonio 1986, 727) and a lost self-portrait dating to 1575 (Cantaro 1989, 746). The most recent discussion of these self-portraits is McIver 1998.

9 Cantaro 1989, appendix 5a.2.

10 Fortunati 1994, 32.

11 Kristeller 1965, 176; Anthon 1946.

12 I am deeply grateful to Evan Bonds, James Haar, and David Schulenberg for their advice on this subject.

13 Garrard 1994, 590, nn. 72, 73; Guazzoni 1994, 64.

14 For Robusti, see Chadwick 1990, 16–19.

15 Naples 1985, 262, cat. 8.9.

16 Ghirardi 1994, 51 n. 27, citing Ridolfi 1924, 79.

17 Slim 1972, 215.

18 Tietze-Conrat 1934, 258–62.

19 Humfrey 1996, 186.

20 Weil-Garris 1983, 405 n. 152; Baxandall 1971, 64.

21 Garrard 1994.

22 Cantaro 1989, 5a. 5.

23 Ghirardi 1994, 43; Zimmerman 1995, 207–8; 159–62.

24 Murphy 1996, 192.

25 Graziani 1994, 129.

26 Fortunati Pietrantonio 1986, 734; Baglione, in Malvasia 1841, I, 179; Jacobs 1994, 87–8.

27 Mazzolari in Malvasia 1841, I, 180, passage also cited in Harris and Nochlin 1976, 31. It is not known whether Ciaconio carried out his plan of getting the 500 images engraved but Fontana's miniature was published several times in the nineteenth century.

28 Ghirardi 1994, 45.

29 Cantaro 1989, no. 5a, 6, 306.

CHAPTER 24

1 Strehlke 1985; Costamagna 1994, cat. 72.

2 Steinberg 1975, 63–4.

3 Van de Velde 1975, cat. 91.

4 Kristeller 1902, 490; Lightbown 1986, 460.

5 Gibbons dates the work to the end of the 1520s, but Freedberg (1971, 210) to 1522 and Ballarin (1995, cats. 339, 433) to 1524. The painting's provenance is Venetian.

6 Gibbons 1968, cat. 78.

7 Ibid., 213.

8 Chastel 1984, 151–2.

9 Gerards-Nelissen 1983, 47.

10 De Tervarent 1958, 15.

11 Hüttinger 1992, 26.

12 Steinberg 1975, 62–5.

13 Sansovino 1563, 377.

14 Wethey 1969–71, II, cats. X–93, X–94; Freedman 1995, chap. 6.

15 Muraro and Rosand 1976, 120, cat. 56.

16 Rosand 1986, 69; Vasari/Milanesi 1906, VII, 447; Rosand 1982a.

17 Rosand 1986, 75.

18 Rosand 1982a, 13ff.

19 Hope 1979, 8.

20 Only four impressions are known (Fletcher, 1990–91, 53).

21 Pilliod 1989, 15; Pilliod 1992, 98; Uffizi 1979, 787, Inv. 1689.

22 Gaston 1983; Cox-Rearick 1989; Cox-Rearick 1993, 200–212, fig. 139.

23 Costamagna 1988; Langdon 1989.

24 Woodall 1989.

25 The whole inscription reads: "Antonis Mor, painter to Philip, king of Spain, painted by his own hand in the year 1558."

26 Thompson 1932, 64, 91.

27 McMahon 1956, 36–8.

28 Woodall 1989, 83.

29 Garrard 1989, chap. 6.

30 Freedman 1995, 155.

31 Snyder 1985, 560.

32 Ibid., 561.

33 Ibid., 558–9.

34 Campbell 1990, 217, 292 n. 118.

35 Suida Manning and Suida 1958, 101, 136, 157. The version in the Uffizi seems to have been cut down. The attribution of a second self-portrait composition showing Cambiaso in a sculptor's studio may be problematic.

36 Herrmann-Fiore 1983, 31.

37 Kent 1977, 45ff., 57ff., and *passim*.

38 Kristeller 1937, 113.

39 Ibid., 115.

40 Kent 1977.

41 Filedt Kok, Halsema-Kuber, and Kloek 1986, 197, cat. 74.

42 Suida Manning and Suida 1958, 254; Magnani 1995, 13ff.

43 Suida Manning and Suida 1958, 269; Soprani 1768, 34.

44 Huse and Wolters 1990, 291.

45 Mason Rinaldi 1984, cat. 148.

46 Huse and Wolters 1990, 291.

47 Cope 1979, 78–89.

48 Ibid., 80.

49 Madrid 1988, cat. 95.

50 Huse and Wolters 1990, 291.

51 Rosand 1970a, 148.

52 Rosand 1970b, 5.

53 Mason Rinaldi 1984, cat. 565. The work is in poor condition due to the slate support. Palma painted a number of bust-length self-portraits throughout his life: *c.*1606, Querini Stampalia, Venice (Mason Rinaldi 1984, cat. 561); *c.*1620, Uffizi, Florence (Mason Rinaldi 1984, cat. 98).

54 Lunardon 1985, 48.

55 Mason Rinaldi 1984, 152; Ridolfi 1924, 179.

56 Rearick 1990, 293.

57 Hochmann 1992, 65.

58 Veronese and Parrasio Michieli were among the others.

59 Hochmann 1992, 56–7.

60 Rosand 1965, 261; Rosand 1970a, 155; Hochmann 1992, fig. 2.

61 Fletcher 1990–91, 51.

CHAPTER 25

1 Posner 1971, cat. 25; Zapperi 1987, 12.

2 Zapperi 1989, 99.

3 Posner 1986, 275, cat. 89; Benati 1991, 158–60. Mahon 1957, dates it earlier.

4 Ricci 1907, 199–200, nn. 526, 522.

5 See Frisoni 1980, 34–5 n. 4; Posner 1986, 275, cat. 89; Zapperi 1987, 6, *passim*; Zapperi 1989, 29.

6 Dempsey 1986a.

7 Posner 1971, 13; Zapperi 1989, 112–13, pls. 24, 27; Benati 1990, 87.

8 Zapperi 1989, 111.

9 Posner 1986, 264–6.

10 Posner 1971, 17; Malvasia 1841, I, 327.

11 Posner 1971, 20.

12 Ibid.

13 Zapperi 1989, chap. 1.

14 Ibid.

15 Zapperi 1989, 114, and chaps. 4 and 5.

16 Ibid. 111, 113.

17 Bergamo 1979, cats. 64 and 69.

18 Zapperi 1989, 111.

19 Ibid., 131.

20 Posner 1971, cat. 75.

21 Zapperi 1989, 53.

22 Ibid., chap. 3.

23 Malvasia 1841, I, 328.

24 Agucchi, in Mahon 1947, 253.

25 Zapperi 1989, 30ff.; Ostrow 1966, 65–71.

26 Borea 1975, cat. 26, pl. 96; Zapperi 1989, 123, 125.

27 Malvasia 1841, I, 327.

28 Ibid., 328; Posner 1971, 146. See also discussion in Boschloo 1974, 49–53.

29 Bellori 1976, 82; Malvasia 1841, I, 327.

30 Zapperi 1989, 133.

31 Agucchi, in Mahon 1947, 253; Malvasia 1841, I, 343.

32 Zapperi 1989, 115.

33 Posner 1971, 20.

34 Ibid., cat. 143; Dempsey 1977, 73–4. In a copy in the Uffizi the artist's features were more clearly delineated and the relation of the motifs to the undifferentiated space was obfuscated by the increased scale of the easel in relation to the total picture surface (Uffizi 1979, cat. A185).

35 Wittkower 1952, 146, cat. 353; Benati 1990, 86, agrees with Posner's dating.

36 Winner 1989, 510, interprets it as a window frame or rectangular mirror.

37 Dempsey 1977, 73.

38 Posner 1971, 22; Winner 1989, 510.

39 Winner 1989, 513 n. 16; Shoemaker and Broun 1981, 118–19.

40 Bialostocki 1966, 56.

41 Scher 1994, cat. 157.

42 Panofsky 1969a, 215ff.

43 Wind 1937, 68.

44 Ibid., 68. For an early drawing of a youth contemplating Terminus, attributed to Annibale, see Winner 1989, fig. 9.

45 Wetenhall 1984, 54 n. 2.

46 Bellori 1976, 78. "Ma per essere Annibale di natura malinconico ed apprensivo molto, si aggravò tanto nel pensiero della sua disgrazia, non si poté mai più rallegrare; e cadde in umore di non più dipingere . . ."

47 Mancini 1956, 218.

48 Wittkower and Wittkower 1963, 102, 104.

49 Moffitt 1988, 209.

50 Wind 1937, 68.

51 Benati 1990, 87.

52 Ibid., 87.

53 Dempsey 1977, 2.

CODA

1 Pope-Hennessy 1985, 276.

2 See Barolsky 1990, 31, *passim*; Paoletti 1992; Barolsky 1994, 151–9.

3 Barocchi 1960–62, IV, 1743.

4 Barolsky 1994, 125–58.

5 Barocchi and Ristori 1979, IV, 299. see also Wallace 1994, Introduction.

6 Wallace 1992b, 152; Spini 1966, 113.

7 Spini 1966, 113.

8 Barolsky 1990, 44–9; Barolsky 1994, 3; Attwood in Scher 1994, cat. 52.

9 Burke 1987a, 43ff.

10 Wallace 1992b, 155.

11 Guasti 1886; Rossi 1984, 377.

12 Rossi 1984, 376; Burke 1979, 93; Barocchi and Ristori 1979, IV, 299.

13 Wallace 1992b, 167; Barolsky 1990, 125; Wilde 1978, 14; Barolsky 1994, 99.

14 Wittkower and Wittkower 1964. See also p. 23.

15 Markus 1992, 46.

16 Bal and Bryson 1991, 182, *passim*.

OTHER AUTONOMOUS SELF-PORTRAITS

Among the autonomous self-portraits that, had there been space enough and time, I would have included in the study, the great, late Tintoretto in the Louvre and the Federico Barocci head in the Uffizi stand out (*Jacopo Tintoretto: Ritratti*, exhibition catalog, Milan, 1994, cat. 41; A. Emiliani, *Federico Barocci (Urbino, 1555–1612)*, II, Bologna, 1985, 317, pl. 677). There are also two early Tintoretto self-images in the Victoria and Albert Museum, London, and the Philadelphia Museum of Art (*Tintoretto* 1994, cats. 3 and 4).

Other works include Lomazzo's eccentric self-likeness as the Abbott of the Accademia della Valle di Bregno in the Brera (Lynch 1964; Herrmann-Fiore 1989) and Andrea del Sarto's small self-image on tile in the Uffizi (Freedberg 1963, II, cat. 80; Shearman 1965a, II, cat. 87).

Finally, much as I longed to include a discussion of Savoldo's wonderful portrait of the so-called Gaston de Foix in the Louvre, I could not bring myself to accept the arguments in its favor as a self-likeness (Gilbert 1986, 426–34; Gilbert 1991; Cox-Rearick 1996).

Acidini Luchinat, C. 1988/89. "Per le Pittura della Cupola di Santa Maria del Fiore," *Labyrinthos* 13/16:153–61.

Acidini Luchinat, C. 1992. "Un aspetto imprevisto nella pittura della Cupola di Santa Maria del Fiore," *OPD Restauro* 4:132–9.

Acidini Luchinat, C. 1995. *The Chapel of the Magi: Benozzo Gozzoli's Frescoes in the Palazzo Medici-Riccardi Florence*. New York.

Ackerman, J.S. 1978. "Leonardo's Eye," *Journal of the Warburg and Courtauld Institutes* 41:108–46.

Ahl, D.C. 1996. *Benozzo Gozzoli*. New Haven and London.

Alberti, L.B. 1950. *Della Pittura*, ed. L. Mallè. Florence.

Alberti, L.B. 1961. "Self-portrait of a Universal Man" in *The Portable Renaissance Reader*, eds. J. B. Ross and M. M. McLaughlin. New York.

Alberti, L.B. 1966a. *De Re Aedificatoria*, trans. and ed. G. Orlandi. Milan.

Alberti, L.B. 1966b. *Tranquillità dell'anima*, ed. C. Grayson. Bari.

Alberti, L.B. 1966–73. *Opere Volgari*, ed. C. Grayson. 3 vols. Bari.

Alberti, L.B. 1969. *L. B. Alberti, The Family in Renaissance Florence*. trans. R. N. Watkins. Columbia, S.C.

Alberti, L.B. 1972. *On Painting and On Sculpture*, trans. C. Grayson. London.

Alberti, L.B. 1987. *Dinner Pieces*, trans. D. Marsh. Binghamton.

Alberti, L.B. 1988. *On the Art of Building*, trans. J. Rykwert, N. Leach, and R. Tavernor. Cambridge.

Anatagi, Dionigi, ed. 1591. *Rime di diversi nobilissimi et eccellentissimi autori in morte della Sig. Irene delle Signori di Spilimbergo*. Venice.

Ancona 1985. *Andrea Lilli nella pittura delle Marche tra Cinquecento e Seicento*. Pinacoteca Civico Francesco Podesti.

Anderson, J. 1979. "The Giorgionesque Portrait: From Likeness to Allegory," in *Giorgione: Atti del Convegno Internazionale di Studio per il V Centenario della Nascita*. Venice.

Anderson, J. 1996. *Giorgione: peintre de la brièveté poétique*, Paris.

Anthon, C. 1946. "Some Aspects of the Social Status of Italian Musicians during the Six-teenth Century," *Journal of Renaissance and Baroque Music*, I, 2:112–23; I, 3:222–34.

Aretino, P. 1609. *Cinque Libri delle Lettere*, VI, Paris.

Aretino, P. 1957. *Lettere sull'arte*, eds. F. Pertile and E. Camesasca. 3 vols. Milan.

Arezzo. 1981. *Principi, letterati, e artisti nelle carte di Giorgio Vasari*. Arezzo.

Armstrong, C. 1988. "Reflections on the Mirror: Painting, Photography, and the Self-Portraits of Edgar Degas," *Representations* 22:108–41.

Ashbery, J. 1975. "Self-Portrait in a Convex Mirror," *Art in America* 63:74–5.

Avery, C. 1996. Bandinelli, in *Dictionary of Art*, III, ed. J. Turner. London.

Babelon, J. 1920. "Un peintre italien de Philippe II: Federico Zuccaro à l'Escurial," *Revue de l'Art Ancien et Moderne* 37:263–78.

Badini, C., ed. 1991. *Le Muse e il Principe: arte di corte nel Rinascimento padano*. Milan.

Baglione, G. 1642. *Le vite de' pittori, scultori et architetti dal pontificato di Gregorio XIII del 1572 infino a' tempi di Papa Urbano ottavo nel 1642*. 3 vols. Rome.

Baglione, G. 1995. *Le Vite de' Pittori, Scultori, et Architetti*. Rome.

Bal, M., and N. Bryson, 1991. "Semiotics and Art History," *Art Bulletin* 73:174–208.

Baldinucci, F. 1846. *Notizie dei Professori del Disegno*, ed. F. Ranalli. Florence.

Ballarin, A. 1995. *Dosso Dossi: la pittura a Ferrara negli anni del ducato di Alfonso I*. Padua.

Baltrusaitis, J. 1981. *Il Specchio: rivelazioni, inganni e science-fiction*. Milan.

Barasch, M. 1985. *Theories of Art: From Plato to Winkelmann*. New York.

Barbaro, F. 1978. "On Wifely Duties (De re uxoria)," in *The Earthly Republic: Italian Humanists on Government and Society*, eds. B. G. Kohl and R. G. Witt. Philadelpia.

Barnes, S. 1989. "The Uomini Illustri, Humanist Culture, and the Development of a Portrait Tradition in early Seventeenth-Century Italy," *Studies in the History of Art* (*Cultural Differentiation and Cultural Identity in the Visual Arts*, eds. S. J. Barnes and W. S. Melion) 27:81–92.

Barocchi, P. 1960–62. *Trattati d'arte del Cinquecento fra manierismo e controriforma*, 3 vols. Bari.

Barocchi, P. 1964. *Vasari Pittore*. Florence.

Barocchi, P., ed. 1971–7. *Scritti d'Arte del Cinquecento*. 3 vols. Milan.

Barocchi, P., and R. Ristori, eds. 1979. *Il Carteggio di Michelangelo*. Florence.

Barolsky, P. 1990. *Michelangelo's Nose: A Myth and its Maker*. University Park, Pa.

Barolsky, P. 1991. *Why Mona Lisa Smiles and Other Tales by Vasari*. University Park, Pa.

Barolsky, P. 1992. *Giotto's Father and the Family of Vasari's Lives*. University Park, Pa.

Barolsky, P. 1993. "Cellini, Vasari, and the Marvels of Malady," *Sixteenth-Century Journal* 24:41–5.

Barolsky, P. 1994. *The Faun in the Garden: Michelangelo and the Poetic Origins of Italian Renaissance Art*. University Park, Pa.

Barolsky, P. 1995a. "The Artist's Hand," in *The Craft of Art: Originality and Industry in the Italian Renaissance and Baroque Workshop*, eds. A. Ladis and C. Wood. Athens, Ga.

Barolsky, P. 1995b. "A very brief history of art from Narcissus to Picasso," *Classical Journal* 90:255–9.

Barolsky, P. 1996. "Art History as Fiction," *Artibus et Historiae* 34:1–5.

Baron, H. 1957. "Fifteenth-century Civilization and the Renaissance," in *The New Cambridge Modern History*, I, ed. G. R. Potter. Cambridge.

Baron, H. 1960. "Burckhardt's 'Civilization of the Renaissance': A Century after its Publication," *Renaissance News* 13:207–22.

Barzman, K.E. 1985. "The Università, Compagnia, ed Accademia del Disegno." Ph.D. diss. Johns Hopkins University, Baltimore.

Barzman, K.E. 1986–7. "The Florentine Accademia del Disegno: Liberal Education and the Renaissance Artist," *Leids Kunsthistorisch Jaarboek* 5–6:14–32.

Barzman, K.E. 1988. Review of Wazbinski's "Accademia Medicea del Disegno . . ." *Burlington Magazine* 130:856–7.

Barzman, K.E. Forthcoming. *The Discipline of Disegno: The Florentine Academy and the Early Modern State (1563–1737)*. Cambridge.

Baskins, C.L. 1993. "Echoing Narcissus in Alberti's 'Della Pittura'," *Oxford Art Journal* 16: 25–33.

Bates, J.A.V. 1975. "The Communicative

Hand," in *The Body as a Means of Expression*, eds. J. Benthall and T. Polhemus. New York.

Baxandall, M. 1963. "A Dialogue on Art from the Court of Leonello d'Este: Angelo Decembrio's 'De Politia Litteria' Pars LXVIII," *Journal of the Warburg and Courtauld Institutes* 26:304–26.

Baxandall, M. 1971. *Giotto and the Orators: Humanist observers of painting in Italy and the discovery of pictorial composition.* Oxford.

Baxandall, M. 1990–91. "Alberti's Self," in *Imaging the Self in Renaissance Italy.* Symposium at the Isabella Stewart Gardner Museum, Boston, in *Fenway Court.*

Becherucci, L. 1968. *Raffaello: L'Opera, Le Fonti, La Fortuna*, II, ed. M. Salmi. Novara.

Beck, J.H. 1973. "Precisions Concerning Bandinelli 'Pittore'," *Antichità Viva* 12, 5:7–11.

Beck, J.H. 1986. "Introduction" in *Raphael Before Rome*, ed. J.H. Beck. Center for Advanced Study in the Visual Arts, Symposium Series V, in *Studies in the History of Art* 17:7–12.

Beck, J.H. 1989. "Leon Battista Alberti and the 'Night Sky' at San Lorenzo," *Artibus et Historiae* 19:9–35.

Becker, M.B. 1971. "An Essay on the quest for identity in the early Italian Renaissance," in *Florilegium Historiale: Essays presented to Wallace K. Ferguson*, eds. J.G. Rowe and W.H. Stockdale. Toronto.

Becker, M.B. 1972. "Individualism in the early Italian Renaissance: Burden and Blessing," *Studies in the Renaissance* 19: 273–97.

Béguin, S. 1983–4. *Raphael dans les collections françaises.* Paris.

Bellori, G.B. 1976. *Le Vite de' Pittori, Scultori, e Architetti Moderni*, ed. E. Borea. Turin.

Bellosi, L. 1987. "Un omaggio di Raffaello al Verrocchio," *Studi su Raffaello*, eds. M. Sambucco Hamoud and M.L. Strocchi. Urbino.

Belsey, A., and C. Belsey. 1990. "Icons of Divinity: Portraits of Elizabeth I," in *Renaissance Bodies: The Human Figure in English Culture, c.1540–1660*, eds. L. Gent and N. Llewellyn. London.

Benati, D. 1990. Review in *Bollettino d'arte* 64:84–9.

Benati, D. 1991. "Annibale Carracci, Autoritratto con figure," in *Pinacoteca di Brera. Scuola Emiliana.* Milan.

Benton, J.F. 1982. "Consciousness of Self and Perceptions of Individuality," in *Renaissance and Renewal in the Twelfth Century*, eds. R.L. Benton and G. Constable. Cambridge, Mass.

Bergamo. 1979. *Giovanni Battista Moroni (1520–78)*, eds. F. Rossi and M. Gregori. Exh. cat. Bergamo.

Berger, H., Jr. 1994. "Fictions of the Pose: Facing the Gaze of Early Modern Portraiture," *Representations* 46:87–120.

Bertolotti, A. 1876. "Federigo Zuccari: il suo processo ed esilio nel 1581," *Giornale di erudizione artistica* 5:129–49.

Bessone Aureli, A.M., trans. 1926. *I dialoghi Michelangioleschi di Francisco d'Olanda.* Rome.

Biagi, M.L.A 1972. "La Vita del Cellini. Temi, Termini, Sintagmi," in *Benvenuto Cellini: Artista e Scrittore.* Ser. Problemi Attuali di Scienza e di Cultura. Accademia Nazionale dei Lincei, Quaderno no. 177. Rome.

Bialostocki, J. 1966. "Rembrandt's Terminus", *Wallraf-Richartz Jahrbuch* 28:49–60.

Bialostocki, J. 1977. "Man and Mirror in Painting: Reality and Transience," in *Studies in Late Medieval and Renaissance Painting in Honor of Millard Meiss*, eds. I. Lavin and J. Plummer. New York.

Bialostocki, J. 1980. "Begegnung mit dem Ich in der Kunst," *Artibus et Historiae* 1:25–45.

Bialostocki, J. 1988. "The *Doctus Artifex* and the Library of the Artist in XVIth and XVIIth Centuries," in J. Bialostocki, *The Message of Images: Studies in the History of Art.* Vienna.

Bianchi Bandinelli, R. 1979. "L'artista nell'antichità classica," in *Archeologia e Cultura*, intro. E. Garin. Rome.

Birr, F., and J. Diez. 1982. *Autoportrait.* Paris.

Bizet, M. 1996. "The Reflection of the Other in One's own Mirror: The Idea of the Portrait in Renaissance *Imitatio*," *Romance Notes* 36:191–200.

Blunt, A. 1938–9. "Blake's Ancient of days: The Symbolism of the Compass," *Journal of the Warburg and Courtauld Institutes* 2:53–63.

Blunt, A. 1940. *Artistic Theory in Italy, 1450–1600.* London.

Boase, G. 1979. *Vasari: The Man and the Book.* Princeton.

Bohlin, D. DeGrazia. 1979. *Prints and Related Drawings by the Carracci Family.* Washington, D.C.

Bologna 1963. *Mostra dei Carracci: Disegni.* 2nd ed.. Bologna.

Bonafoux, P. 1984. *Les Peintres et l'autoportrait*, Geneva.

Bonafoux, P. 1985. *Portraits of Artists: The Self-Portrait in Painting*, New York.

Bonetti, C. 1928. "Varietà: nel Centenario di Sofonisba Anguissola," *Archivio Storico Lombardo* 55, 1:285–306.

Bonino, G.D. 1979. *Lo Scrittore, il Potere, la Maschera: Tre Studi sul Cinquecento.* Padua.

Borea, E. 1975. *Pittori bolognesi del Seicento nelle Gallerie di Firenze.* Florence.

Borsellino, N. 1972. "Cellini scrittore," *Problemi attuati di scienze e cultura* 177:17–31.

Borsellino, N. 1979. "Benvenuto Cellini" in *Dizionario biografico degli italiani*, XXIII. Rome.

Borsi, F. 1975. *Leon Battista Alberti.* Milan.

Borsook, E. 1980. *The Mural Painters of Tuscany: From Cimabue to Andrea del Sarto.* Oxford.

Boschini, M. 1674. *Le ricche miniere della pittura veneziana.* Venice.

Boschloo, A.W.A. 1974. *Annibale Carracci in Bologna: Visible Reality in Art after the Council of Trent.* The Hague.

Boskovits, M. 1975. *Pittura Fiorentina alla vigilia del Rinascimento, 1370–1400.* Florence.

Bottari, G. 1822–5. *Raccolta di lettere sulla pittura, scultura ed architettura scritte da' più celebri personaggi dei secoli XV, XVI e XVII.* Milan.

Boucher, B. 1981. "Leone Leoni and Primaticcio's moulds of antique sculpture," *Burlington Magazine* 123:934–6.

Bouwsma, W.J. 1990. "Anxiety and the Formation of Early Modern Culture" in *A Usable Past: Essays in European Cultural History.* Berkeley and Los Angeles.

Braunstein, P. 1988. "Toward Intimacy: The Fourteenth and Fifteenth Centuries," in *A History of Private Life. II Revelations of the Medieval World*, ed. G. Duby. Cambridge.

Brilliant, R. 1991, *Portraiture.* London.

Brown, C.M., and S. Hickson. 1997. "Caradosso Foppa (ca. 1452–1527)," *Arte Lombarda* 119:9–39.

Brown, D.A. 1994. "Leonardo's 'Head of an Old Man' in Turin: Portrait or Self-Portrait?" in *Studi di Storia dell'Arte in onore di Mina Gregori.* Milan.

Brown, J. 1986. *Velázquez: Painter and Courtier*, New Haven and London.

Brown, P.F. 1988. *Venetian Narrative Painting in the Age of Carpaccio.* New Haven and London.

Brusati, C. 1990/91. "Stilled Lives: Self-Portraiture and Self-Reflection in Seventeenth-century Netherlandish Still-Life Painting," *Simiolus* 20:168–82.

Bruschi, A. 1971. "Bramante," in *Dizionario bibliografico degli italiani*, XIII. Rome.

Bullard, M. 1994. *Lorenzo il Magnifico: Image and anxiety, politics and finance.* Florence.

Burckhardt, J. 1958. *The Civilization of the Renaissance in Italy.* New York.

Burke, P. 1979. "L'artista: momenti e aspetti," *Storia dell'arte italiana.* Parte 1a. *Materiali e problemi.* II, *L'artista e il pubblico.* Turino.

Burke, P. 1987a. *The Italian Renaissance: Culture and Society in Italy.* Princeton.

Burke, P. 1987b. "The Presentation of the Self in the Renaissance," in *The Historical Anthropology of Early Modern Italy.* Cambridge.

Burke, P. 1991. "The language of Gesture in Early Modern Italy," in *A Cultural History of Gesture from Antiquity to the Present Day.* eds. J. Bremmer and H. Roodenburg. Oxford.

Burke, P. 1992. "The Uses of Italy," in *The Renaissance in National Context*, ed. R. Porter and M. Teich. Cambridge.

Bush, V.L. 1976. *The Colossal Sculpture of the Cinquecento.* New York.

Bush, V. L. 1978. "Leonardo's Sforza Monument and Cinquecento Sculpture," *Arte Lombarda* 50:47–68.

Bush, V. L. 1980. "Bandinelli's Hercules and Cacus and Florentine Traditions," *Memoirs of the American Academy in Rome* 35:163–206.

Bussagli, M. 1987. "Lo Specchio strumento dell'artista," in *Lo Specchio e il doppio: dallo stagno di Narciso allo schermo televisivo*. Milan.

Butler, K. T. 1954. *The Gentlest Art in Renaissance Italy*. Cambridge.

Bynum, C. W. 1982. *Jesus as Mother: Studies in the Spirituality of the High Middle Ages*. Berkeley and Los Angeles.

Bynum, C. W. 1991. *Fragmentation and Redemption: Essays on Gender and the Human Body in Medieval Religion*. New York.

Bynum, C. W. 1995. "Why All the Fuss about the Body? A Medievalist's Perspective," *Critical Inquiry* 22:1–33.

Calamandrei, P. 1950. "Sulle relazioni tra Giorgio Vasari e Benvenuto Cellini," in *Studi Vasariani: Atti del Convegno Internazionale per il IV Centenario della prima edizione delle Vite di Vasari*. Florence.

Calamandrei, P. 1971. *Scritti e Ineditti Celliniani*. Florence.

Campbell, L. 1990. *Renaissance Portraits: European Portrait-Painting in the Fourteenth, Fifteenth and Sixteenth Centuries*. New Haven and London.

Campbell, M. 1985. "Il ritratto del Duca Alessandro de' Medici di Giorgio Vasari: contesto e significato," in *Giorgio Vasari tra decorazione ambientale e storiografia artistica*, ed. G. C. Garfagnini. Florence.

Campbell, S. J. 1996. "*Pictura* and *Scriptura*: Cosmè Tura and style as courtly performance," *Art History* 19:267–95.

Campori, G. 1885. *Gli artisti italiani e stranieri negli Stati Estensi*. Modena.

Cannata, P. 1988. "Le Plaquette del Filarete," in *Italian Plaquettes*, ed. A. Luchs (Center for Advanced Study in the Visual Arts, Symposium Papers IX) in *Studies on the History of Art* 22:35–53.

Cantaro, M. T. 1989. *Lavinia Fontana bolognese: "Pittore Singolare," 1552–1614*. Milan and Rome.

Canuti, F. 1931. *Il Perugino*, 2 vols. Siena.

Carli, E. 1960. *Il Pinturicchio*. Milan.

Carli, E. 1974. *Il Sodoma a Sant'Anna in Camprena*. Florence.

Carli, E. 1979. *Il Sodoma*. Vercelli.

Caroli, F. 1987. *Sofonisba Anguissola e le sue sorelle*. Milan.

Carrithers, M., S. Collins, and S. Lukes, eds. 1985. *The Category of the Person: Anthropology, Philosophy, History*. Cambridge.

Cassidy, B. 1988. "The Assumption of the Virgin on the Tabernacle of Orsanmichele," *Journal of the Warburg and Courtauld Institutes* 51:174–80.

Cassidy, B. 1992. "Orcagna's Tabernacle in Florence: Design and Function," *Zeitschrift für Kunstgeschichte* 55:180–211.

Cast, D. 1981. *The Calumny of Apelles*. New Haven and London.

Castellaneta, C., and E. Camesasca. 1969. *L'Opera completa del Perugino*. Milan.

Castiglione, B. 1959. *The Book of the Courtier*, trans. C. S. Singleton. Garden City, N.Y.

Cavazzini, P. 1989. "The Porta Virtutis and Federigo Zuccari's Expulsion from the Papal States: An Unjust Conviction?" *Römisches Jahrbuch der Bibliotheca Hertziana* 25:167–77.

Cecchini, N. 1975. *Dizionario Sinottico di Iconologia*. Bologna.

Cellini, B. 1954. *Vita*, ed. E. Camesasca. Milan.

Cellini, B. 1956. *The Autobiography*, trans. G. Bull. London.

Cellini, B. 1967. *La Vita, I Trattati, I Discorsi*, ed. P. Scarpellini. Rome.

Cellini, B. 1971. *Opere di Benvenuto Cellini*, ed. G. G. Ferrero. Turin.

Cellini, B. 1983. *The Autobiography*, ed. C. Hope and A. Nova. London.

Cellini, B. 1986. *La Vie de Benvenuto Cellini*, intro. A. Chastel. Paris.

Cellini, B. n.d. *The Autobiography of Bevenuto Cellini*, trans. J, A. Symonds, N.Y.

Cervigni, D. 1979. *The Vita of Benvenuto Cellini: Literary Tradition and Genre*. Ravenna.

Chadwick, W. 1990. *Women, Art, and Society*. London.

Chambers, D., and J. Martineau, eds. 1981. *Splendours of the Gonzaga*. London.

Chapman, P. 1990. *Rembrandt's Self-Portraits*. Princeton.

Chastel, A. 1959. *Art et humanisme à Florence au temps de Laurent le Magnifique*. Paris.

Chastel, A. 1964. "Art et Humanisme au Quattrocento," in *Umanesimo Europeo e Umanesimo Veneziano*, ed. V. Branca. Venice.

Chastel, A. 1973. "Vasari économiste," in *Histoire économique du monde méditerranéen, 1450–1650: mélanges en l'honneur de Fernand Braudel*. Paris.

Chastel, A. 1975. *Marsile Ficin et l'art*. Geneva.

Chastel, A. 1977a. *The Sack of Rome, 1527*. Princeton.

Chastel, A. 1977b. "Titien et les Humanistes," in *Tiziano Vecellio: Convegno indetto nel IV Centenario dell'artista* (Atti dei convegni Lincei 29). Rome.

Chastel, A. 1977c. "Titien," in *Tiziano nel quarto Centenario della sua Morte, 1576–1976*. Venice.

Chastel, A. 1978. "Le Tableau dans le Tableau," in *Fables, Formes, Figures*. 2 vols. Paris.

Chastel, A. 1978. "Masque, Mascarade, Mascaron," in *Fables, Formes, Figures*. 2 vols. Paris.

Chastel, A. 1980. "Sémantique de l'Index," *Storia dell'Arte* 38–40:415–17.

Chastel, A. 1982. "The Arts during the Renaissance," in *The Renaissance: Essays in Interpretation*. London.

Chastel, A. 1983. *A Chronicle of Italian Renaissance Painting*. Ithaca, N.Y.

Chastel, A. 1984. "Signum Harpocraticum," in *Studi in onore di Giulio Carlo Argan*. Rome.

Chastel, A. 1986. "Gesture in Painting: Problems in Semiology," *Renaissance and Reformation* 22:1–22.

Chastel, A. 1987. "L'art du geste à la Renaissance," *Revue de l'art* 75:9–16.

Chastel, A. 1988. "L'Artista," in *L'uomo del Rinascimento*, ed. E. Garin. Bari.

Chastel, A. 1990. "Le corps à la Renaissance," in *Actes du XXX colloque de Tours 1987*. Paris.

Cheles, L. 1986. *The Studiolo of Urbino: An Iconographic Investigation*. University Park, Pa.

Chenault Porter, J. 1988. "Rembrandt and his Circles: More about the Late Self-Portrait in Kenwood House," in *The Age of Rembrandt: Studies in Seventeeth-Century Dutch Painting*, eds. R.E. Fleisher and S. S. Munshower, University Park, Pa.

Cheney, I. 1985. "The parallel lives of Vasari and Salviati," in *Giorgio Vasari tra decorazione ambientale e storiografia artistica*. Florence.

Cheney, I. H. 1970. "Notes on Jacopino del Conte," *Art Bulletin* 52:32–40.

Cheney, L. 1985. *The Paintings of the Casa Vasari*. New York.

Chojnacki, S. 1994. "Social identity in Renaissance Venice: The second *Serrata*," *Renaissance Studies* 8:341–57.

Chomentovskaja, O. 1938. "Le Comput digital: histoire d'un geste dans la Renaissance italienne," *Gazette des Beaux-Arts*, 6e per., annee 84, 20:157–72.

Christiansen, K. 1994. "Mantegna's Legacy," in *Studi di Storia dell'Arte in onore di Mina Gregori*. Milan.

Ciardi, R. P. 1971. "Le regole del disegno di Alessandro Allori e la nascita del dilettantismo pittorico," *Storia dell'Arte* 12:267–86.

Clark, T. J. 1992. "The Look of Self-Portraiture," *Yale Journal of Criticism* 5:109–18.

Cleri, B. 1993. *Per Taddeo e Federico Zuccari nelle Marche*. Sant'Angelo in Vado.

Cloulas, A. 1968. "Les Peintures du grand retable au Monastère de l'Escurial," *Mélanges de la Casa de Velasquez* 4: 175–202.

Coffin, D. R. 1964. "Pirro Ligorio on the Nobility of the Arts," *Journal of the Warburg and Courtauld Institutes* 27:191–210.

Colasanti, A. 1905. "Il Memoriale di Baccio Bandinelli," *Repertorium für Kunstwissenschaft* 28:406–43.

Conti, A. 1979. "L'Evoluzione dell'artista," in *Storia dell'Arte Italiana*, II, *L'Artista e il Pubblico*. Turin.

Cope, M. E. 1979. *The Venetian Chapel of the Sacrament in the Sixteenth Century*. New York.

Cordellier, D. 1992. *Raphaël, son atelier, ses copistes*. Musée du Louvre, Cabinet des Dessins, eds. D. Cordellier and B. Py. Paris.

Corti, L. 1989. *Vasari: Catalogo Completo*. Florence.

Costamagna, P. 1988. "[Allori] Seconda Parte. Les Portraits," *Antichità Viva* 27:23–31.

Costamagna, P. 1994. *Pontormo*. Milan.

Cox-Rearick, J. 1984. *Dynasty and Destiny in Medici Art*. Princeton.

Cox-Rearick, J. 1989. "From Bandinelli to Bronzino: The Genesis of the *Lamentation* for the Chapel of Eleonora of Toledo," *Mitteilungen des Kunsthistorischen Institutes in Florenz* 33:37–84.

Cox-Rearick, J. 1993. *Bronzino's Chapel of Eleonora in the Palazzo Vecchio*. Berkeley and Los Angeles.

Cox-Rearick, J. 1996. *The Collection of Francis I: Royal Treasures*. New York.

Cropper, E. 1986. "The Beauty of Woman: Problems in the rhetoric of Renaissance Portraiture," in *Rewriting the Renaissance: The Discourse of Sexual Difference in Early Modern Europe*, eds. M. Ferguson, M. Quilligan, and N. J. Vickers. Chicago.

Crowe, J.A., and G.B. Cavalcaselle, 1877–8. *Titian: His Life and Times*, II. London.

Crozier, W.R., and P. Greenhalgh. 1988. "Self-Porraits as Presentations of Self," *Leonardo: Journal of the International Society for the Arts, Sciences, and Technology* 21:29–33.

Cust, R.H.H. 1906. *Giovanni Antonio Bazzi, hitherto usually styled "Sodoma," the Man and the Painter, 1477–1549*. London.

D'Ancona, P. 1905. "Le rappresentazioni allegoriche delle arti liberali," *L'Arte* 5:137–55, 211–28, 269–89, 370–85.

Damisch, H. 1977. "Artista," in *Enciclopedia Einaudi*, I. Turin.

Danesi Squarzina, S. 1988. Cat. entry in Rome 1988.

Darr, A.P., and G. Bonsanti. 1985. *Italian Renaissance Sculpture in the Time of Donatello*. New Haven and London.

Darr, A.P., and G. Bonsanti. 1986. *Donatello e i suoi: scultura fiorentina del Primo Rinascimento*. Milan.

Davies, M. 1961. *National Gallery. The Earlier Italian Schools*. London.

Davis, C. 1976. "Benvenuto Cellini and the Scuola Fiorentina," in *North Carolina Museum of Art Bulletin* 13:4–70.

Davis, N.Z. 1986. "Boundaries and the Sense of Self in Sixteenth-Century France," in *Reconstructing Individualism*, ed. T.C. Heller, M. Sosna, and D.E. Wellbery. Stanford.

De Tervarent, G. 1958. *Attributs et Symboles dans l'Art Profane, 1450–1600*. Lausanne.

De Tolnay, C. 1941. "Sofonisba Anguissola and her relations with Michelangelo," *Journal of the Walters Art Gallery* 4:115–19.

De Vecchi, P. 1981. *Raffaello: La Pittura*. Florence.

De Vecchi, P. 1990. "La mimesi allo Specchio," in *G. G. Savoldo tra Foppa, Giorgione e Caravaggio*. Milan.

Delany, P. 1969. *British Autobiography in the Seventeenth Century*. London.

Delumeau, J. 1992. "Une Histoire totale de la Rénaissance," *Journal of Medieval and Renaissance Studies* 22:1–17.

Dempsey, C. 1977. *Annibale Carracci and the Beginnings of Baroque Style*. Glükstadt.

Dempsey, C. 1980. "Some Observations on the Education of Artists in Florence and Bologna during the later Sixteenth Century," *Art Bulletin* 62:552–69.

Dempsey, C. 1986a. "The Carracci *Postille* to Vasari's *Lives*," *Art Bulletin* 68:72–6.

Dempsey, C. 1986b. "The Carracci Reform of Painting," in *The Age of Correggio and the Carracci*. Washington, D.C., and New York.

Dempsey, C. 1990. "Introduzione" in *Gli Scritti dei Carracci*, ed. G. Perini. Bologna.

Deswartes, S. 1987. "Considérations sur l'artiste courtisan et le génie au XVIe siècle," in *La Condition Sociale de l'artiste, XVIe–XXe siècles*. Actes du colloque du C.N.R.S., 1985. Paris.

Deswartes-Rosa, S. 1991. "*Idea* et le Temple de la Peinture. I: Michelangelo Buonarroti et Francisco de Holanda," *Revue de l'Art* 92:20–41; "II: De Francisco de Holanda à Federico Zuccaro," *Revue de l'Art* 94:45–65.

Dezzi Bardeschi, M. 1974. "Sole in Leone. Leon Battista Alberti: astrologia, cosmologica e tradizione ermetica nella facciata di Santa Maria Novella," *Psicon* 1:33–67.

Didi-Huberman, G. 1994. "Ressemblance mythifiée et ressemblance oubliée chez Vasari: la legende du portrait 'sur le vif,'" *Mélanges de l'École Française de Rome* 106:383–432.

Dionisotti, C. 1967. *Geografia e Storia della Letteratura Italiana*. Turin.

Doni, A.F. 1970. *Disegno: facsimile della edizione del 1549*, ed. M. Pepe. Milan.

Dülberg, A. 1990. *Privatporträts: Geschichte und Ikonologie einer Gattung in 15. und 16. Jahrhunderts*. Berlin.

Dussler, L. 1971. *Raphael: Critical Catalogue*. London.

Eagleton, T. 1991. *Ideology: An Introduction*. London.

Eakin, P.J. 1985. *Fictions in Autobiography: Studies in the Art of Self-Invention*. Princeton.

Eakin, P. 1992. *Touching the Words: Reference in Autobiography*. Princeton.

Edgerton, S.Y., Jr. 1975. *The Renaissance Rediscovery of Linear Perspective*. New York.

Egger, H. 1927. "Beiträge zur Andrea Bregno-Forschung," in *Festschrift für Julius Schlosser*. Vienna.

Eisler, C. 1987. "'Every Artist Paints Himself': Art History as Biography and Autobiography," *Social Research* 54:73–99.

Eng, E. 1962. "The Significance of the Mirror and the Self-Portrait in Renaissance Developments in Psychology," *Ithaca: Actes du 10ième Congrès International d'Histoire des Sciences* 8:1045–47.

Ettlinger, L.D. 1953. "Pollaiuolo's Tomb of Pope Sixtus IV," *Journal of the Warburg and Courtauld Institutes* 16:239–74.

Ettlinger, L.D. 1972. "Hercules Florentinus," *Mitteilungen des Kunsthistorischen Institutes in Florenz* 15:119–42.

Ettlinger, L.D. 1977. "The Emergence of the Italian Architect during the Fifteenth Century," in *The Architect: Chapters in the History of the Profession*, ed. S. Kostof. Oxford.

Evans, M. 1978. "Allegorical Women and Practical Men: The Iconography of the *Artes* Reconsidered," in *Medieval Women*, ed. D. Baker. Oxford.

Even, Y. 1989. "Lorenzo Ghiberti's Quest for Professional Autonomy," *Konsthistorisk Tidskrift* 58:1–6.

Fagiolo Dell'Arco, M. 1970. *Il Parmigianino: un saggio sull'ermetismo nel cinquecento*. Rome.

Falaschi, E. 1972. "Giotto: The Literary Legend," *Italian Studies* 27:1–25.

Farago, C. 1992. *Leonardo da Vinci's "Paragone": A Critical Interpretation with a New Edition of the Text in the "Codex Urbinas"*. Leiden.

Farquharson, A.S.L. 1989. *The Meditations of the Emperor Marcus Antoninus*. Oxford.

Fava, D. 1925. *La Biblioteca Estense nel suo sviluppo storico*. Modena.

Ferguson, W.K. 1948. *The Renaissance in Historical Thought: Five Centuries of Interpretation*. Cambridge.

Ferino-Pagden, S. 1986. "The Early Raphael and his Umbrian Contemporaries," in *Raphael Before Rome*, ed. J.H. Beck. Center for Advanced Study in the Visual Arts, Symposium Papers V, in *Studies in the History of Art* 17:93–107.

Ferino-Pagden, S. 1989. "Perugino al servizio dei Della Rovere: Sisto IV e il Cardinale Giuliano" in *Sisto IV e Giulio II: mecenati e promotori di cultura*, eds. S. Bottaro, A. Dagnino, and G.R. Terminiello. Savona.

Ferino-Pagden, S. 1990. "From Cult Images to the Cult of Images: The Case of Raphael's Altarpieces," in *The Altarpiece in the Renaissance*, eds. P. Humfrey and M. Kemp. Cambridge.

Ferino-Pagden, S., and M. Kusche. 1995. *Sofonisba Anguissola: A Renaissance Woman*. Washington, D.C.

Filarete, Antonio Averlino detto il. 1972. *Trattato*

di Architectura, eds. A. M. Finoli and L. Grassi. Milan.

Filedt Kok, P., W. Halsema-Kuber, and W. T. Kloek, eds. 1986. *Kunst voor de beeldenstorm.* The Hague.

Filipczak, Z. Z. 1987. *Picturing Art in Antwerp, 1550–1700.* Princeton.

Findlen, P. 1994. *Possessing Nature: Museums, Collecting, and Scientific Culture in Early Modern Italy.* Berkeley.

Fletcher, J. 1990–91. "'Fatto al Specchio': Venetian Renaissance Attitudes in Self-Portraiture," in *Imaging the Self in Renaissance Italy*, Symposium at the the Isabella Stewart Gardner Museum, Boston, in *Fenway Court.*

Florence. 1980. *Arte nell'Aretino.*

Florence. 1984, *Raffaello a Firenze.* Exh. cat. Palazzo Pitti.

Forster, K. 1971. "Metaphors of Rule: Political Ideology in the Portraits of Cosimo I de' Medici," *Mitteilungen des Kunsthistorischen Institutes in Florenz* 15:65–104.

Fortunati, V. 1994. *Lavinia Fontana, 1552–1614,* Milan.

Fortunati Pietrantonio, V. 1986. "Lavinia Fontana," in *The Age of Correggio and the Carracci.* Washington, D.C. and New York.

Fredericksen, B. 1990. "Raphael and Raphaelesque Paintings in California: Technical Considerations and the Use of Underdrawing in his pre-Roman Phase," in *The Princeton Raphael Symposium*, eds. J. Shearman and M. B. Hall. Princeton.

Freedberg, S. J. 1950. *Parmigianino: His Works in Painting.* Cambridge, Mass.

Freedberg, S. J. 1963. *Andrea del Sarto.* Cambridge.

Freedberg, S. J. 1971. *Painting in Italy, 1500–1600.* Harmondsworth.

Freedman, L. 1984. "Riflessioni sull'autoritratto in uno specchio convesso del Parmigianino," *Aurea Parma* 70:51–65.

Freedman, L. 1987. "The Concept of Portraiture in Art Theory of the Cinquecento," *Zeitschrift für Ästhetik und Allgemeine Kunstwissenschaft* 32:63–82.

Freedman, L. 1990. *Titian's Independent Self-Portraits.* Florence.

Freedman, L. 1995. *Titian's Portraits Through Aretino's Lens.* University Park, Pa.

Frey, C. 1941. *Il Carteggio di Giorgio Vasari dal 1563 al 1565,* ed. A. del Vita. Arezzo.

Frey, C. 1964. *Die Dichtungen des Michelagniolo Buonarroti.* Berlin.

Fried, M. 1978. "The Beholder in Courbet: His early Self-Portraits and their Place in his Art," *Glyph* 4:85–123.

Friedman, J. B. 1974. "The Architect's Compass in Creation Miniatures of the Later Middle Ages," *Traditio: Studies in Ancient and Medieval History, Thought, and Religion* 30:419–29.

Frisoni, F. 1980. "Antonio Carracci: Riflessioni e Aggiunte," *Paragone* 31, 367:22–38.

Fubini, R., and A. M. Gallorini. 1972. "L'autobiografia di Leon Battista Alberti. Studio e Edizione," *Rinascimento* 12:21–78.

Galicka, I., and H. Sygietynska. 1992. "A newly discovered self-portrait by Baccio Bandinelli," *Burlington Magazine* 134:805–7.

Gallop, J. 1985. *Reading Lacan.* Ithaca.

Garin, E. 1959. "L. B. Alberti," in *Encyclopedia of World Art*, 1:208–12. New York and Toronto.

Garin, E. 1965. *Italian Humanism.* Oxford.

Garrard, M. D. 1980/81. "Review of Laura M. Ragg, *The Women Artists of Bologna,*" *Woman's Art Journal* 1:58–64.

Garrard, M. D. 1984. "The Liberal Arts and Michelangelo's First Project for the Tomb of Julius II," *Viator* 15:335–404.

Garrard, M. D. 1989. *Artemisia Gentileschi: The Image of the Female Hero in Italian Baroque Art.* Princeton.

Garrard, M. D. 1994. "Here's Looking at Me: Sofonisba Anguissola and the Problem of the Woman Artist," *Renaissance Quarterly* 47:556–622.

Gaston, R. W. 1983. "Iconography and Portraiture in Bronzino's *Christ in Limbo,*" *Mitteilungen des Kunsthistorischen Institutes in Florenz* 27:41–72.

Gauricus, P. 1969. *De Sculptura 1504,* eds. A. Chastel and R. Klein. Geneva.

Geertz, C. 1973. *The Interpretation of Cultures.* New York.

Georgel, P., and A. M. Lecoq. 1983. *La Peinture dans la peinture.* Dijon.

Gerards-Nelissen, I. 1983. "Federigo Zuccaro and the Lament of Painting," *Simiolus* 13:44–53.

Ghirardi, A. 1994. "Lavinia Fontana allo Specchio: Pittrici e autoritratto nel secondo Cinquecento," in Fortunati 1994.

Gibbons, F. 1968. *Dosso and Battista Dossi.* Princeton.

Giddens, A. 1991. *Modernity and Self-Identity: Self and Society in the Late Modern Age.* Stanford.

Gilbert, C. 1968. "The Renaissance Portrait," *Burlington Magazine* 110:278–85.

Gilbert, C. 1980a. "Some Findings on the Early Work of Titian," *Art Bulletin* 62:36–75.

Gilbert, C. 1980b. *Italian Art, 1400–1500 (Sources and Documents).* Englewood Cliffs, N.J.

Gilbert, C. 1986. *The Works of Girolamo Savoldo.* New York.

Gilbert, C. 1990. "A New Sight in 1500: The Colossal," in *All the World's a Stage: Art and Pageantry in the Renaissance and Baroque*, eds. B. Wisch and S. Scott Munshower. University Park, Pa.

Gilbert, C. 1991. "Newly Discovered Paintings by Savoldo in relation to their Patronage," *Arte Lombarda* 96/97:29–46.

Gilbert, C. 1995. "Ghiberti on the Destruction of Art," *I Tatti Studies: Essays in the Renaissance* 6:135–44.

Goffen, R. 1975. "Icon and Vision: Giovanni Bellini's Half-Length Madonnas," *Art Bulletin* 57:487–518.

Goffen, R. 1983. "Carpaccio's Portrait of a Young Knight: Identity and Meaning," *Arte Veneta* 37:37–48.

Goffen, R. 1989. *Giovanni Bellini.* New Haven and London.

Goffen, R. 1991. "Bellini's Nude with Mirror," *Venezia Cinquecento* 2:185–99.

Goldberg, B. 1985. *The Mirror and Man.* Charlottesville, Va.

Goldberg, J. 1974. "Cellini's Vita and the Conventions of Early Autobiography," *Modern Language Notes* 89:71–83.

Goldscheider, L. 1937. *Five hundred self-portraits from antique times to the present.* Vienna.

Goldsmith, J. T. B. 1992. "Pieter Bruegel the Elder and the Matter of Italy," *Sixteenth-Century Journal* 23:205–34.

Goldstein, C. 1975. "Vasari and the Florentine Accademia del Disegno," *Zeitschrift für Kunstgeschichte* 38:145–52.

Goldstein, C. 1993. "The Image of the Artist reviewed," *Word and Image* 9:9–18.

Goldstein, C. 1996. *Teaching Art: Academies and Schools from Vasari to Albers.* Cambridge.

Gombrich, E. H. 1972. "Action and Expression in Western Art," in *Non-Verbal Communication*, ed. R. A. Hinde. Cambridge.

Gombrich, E. H. 1978. *Symbolic Images.* London.

Gombrich, E. H. 1982. "Ritualized Gesture and Expression in Art," in *The Image and the Eye*, Ithaca, N.Y.

Gordon, D. J. 1949. "Poet and Architect: The intellectual setting of the quarrel between Ben Jonson and Inigo Jones," *Journal of the Warburg and Courtauld Institutes* 12:152–78.

Gould, C. 1966. "Lorenzo Lotto and the Double Portrait," *Saggi e memorie di Storia dell'arte* 5:45–51.

Gould, C. 1968. "An Identification for the Sitter of a Bellinesque Portrait," *Burlington Magazine* 110:626.

Gould, C. 1976. *Titian as Portraitist.* London.

Gould, C. 1984. *Raphael's Portrait of Julius II: The Re-emergence of the Original.* London.

Graziani, I. 1994. "La leggenda dell'artista donna," in *La pittura in Emilia e la Romagna: il cinquecento*, ed. V. Fortunati. Milan.

Greenblatt, S. 1980. *Renaissance Self-Fashioning from More to Shakespeare.* Chicago.

Greene, T. 1968. "The Flexibility of the Self in Renaissance Literature," in *The Disciplines of Criticism: Essays in Literary Theory, Interpretation, and History*, eds. P. Demetz, T. Greene, and L. Nelson, Jr. New Haven and London.

Gregori, M. 1985. "Sofonisba Anguissola," in *I Campi e la cultura artistica cremonese del cinquecento*. Milan.

Gregori, M., ed. 1994. *Sofonisba Anguissola e le sue sorelle*. Milan.

Grote, A. 1963. "Cellini in gara," *Il Ponte* 19:73–94.

Grubb, J. S. 1994. "Memory and Identity: Why Venetians didn't keep *ricordanze*," *Renaissance Studies* 8:375–87.

Guasti, C. 1857. *Cupola di Santa Maria del Fiore*. Florence.

Guasti, C. 1886. "Due Motupropri di papa Paolo III per Michelangelo Buonarroti," *Archivio Storico Italiano* 4 ser., 18:153–61.

Guazzoni, V. 1994. "Donna, pittrice, e gentildonna: la nascita di un mito femminile del cinquecento," in Gregori 1994.

Guglielminetti, M. 1977. *Memoria e scrittura: l'autobiografia da Dante a Cellini*. Turin.

Gundersheimer, W. L. 1976. "The patronage of Ercole I d'Este," *Journal of Medieval and Renaissance Studies* 6:1–18.

Gundersheimer, W. L. 1993. "Clarity and Ambiguity in Renaissance Gesture: The case of Borso d'Este," *Journal of Medieval and Renaissance Studies* 23:1–17.

Gusdorf, G. 1956/1980. "Conditions and Limits of Autobiography," in *Autobiography: Essays Theoretical and Critical*, ed. J. Olney. Princeton.

Gusdorf, G. 1991a. *Auto-bio-graphie*. Paris.

Gusdorf, G. 1991b. *Les écritures du moi*. Paris.

Hale, J. 1993. *The Civilization of Europe in the Renaissance*, London.

Hamoud, M. S., and M. L. Strocchi, eds. 1987. *Studi su Raffaello*. Urbino.

Harris, A. S., and L. Nochlin. 1976. *Women Artists, 1550–1950*. New York.

Hatfield, R. 1970. "The Compagnia de' Magi," *Journal of the Warburg and Courtauld Institutes* 33:107–44.

Hatfield, R. 1976. *Botticelli's Uffizi "Adoration": A Study in Pictorial Context*. Princeton.

Hatfield, R. 1996. "Giovanni Tornabuoni, i fratelli Ghirlandaio e la cappella maggiore di S. Maria Novella," in *Domenico Ghirlandaio 1449–94*, eds. W. Prinz and M. Seidel. Florence.

Hay, D. 1961. *The Italian Renaissance and Its Historical Background*. Cambridge.

Hay, D. 1982. "Historians and the Renaissance during the last twenty-five years," in *The Renaissance: Essays in Interpretation*. London.

Heikamp, D. 1957a. "Vicende di Federico Zuccari," *Rivista d'arte* 32:175–232.

Heikamp, D. 1957b. "Rapporti fra accademici ed artisti nella Firenze del cinquecento," *Il Vasari* 15, IV:139–63.

Heikamp, D. 1964a. "Poesie in vituperio del Bandinelli," *Paragone* 15, no. 175:59–68.

Heikamp, D. 1964b. "Vincenzo de' Rossi disegnatore," *Paragone* 15, no. 169:38–42.

Heikamp, D. 1967. "Federico Zuccari a Firenze, 1575–79," *Paragone* 18, no. 205:44–68.

Heinemann, F. 1962. *Giovanni Bellini e i Belliniani*. Venice.

Held, J. 1969. *Rembrandt's Aristotle and other Rembrandt Studies*. Princeton.

Hendy, P. 1974. *European and American Paintings in the Isabella Stewart Gardner Museum*. Boston.

Hermanin, F. 1960. *L'Appartamento Borgia in Vaticano*. Vatican City.

Herrmann-Fiore, K. 1979. "Die Fresken Federico Zuccaris in seinem Künstlerhaus," *Römisches Jahrbuch für Kunstgeschichte* 18:32–112.

Herrmann-Fiore, K. 1982. "*Disegno* and *Giuditio*, Allegorical Drawings by Federico Zuccari and Cherubino Alberti," *Master Drawings* 20:247–56.

Herrmann-Fiore, K. 1983. "Due artisti allo Specchio: un doppio ritratto del Museo di Wurzberg attribuito a Giovanni Battista Paggi," *Storia dell'Arte* 47:29–39.

Herrmann-Fiore, K. 1989. "Il *Bacchino Malato* autoritratto del Caravaggio ed altre figure bacchiche degli artisti," *Quaderni di Palazzo Venezia* 6:95–134.

Herrmann-Fiore, K. 1992. "Il Tema 'Labor' nella creazione artistica del Rinascimento," in *Der Künstler Über Sich in Seinem Werk*, ed. M. Winner. Weinheim.

Heydenreich, L. 1954. *Leonardo da Vinci*. 2 vols. New York.

Hill, G. F. 1912. *Portrait Medals of Italian Artists of the Renaissance*. London.

Hill, G. F. 1930. *A Corpus of Italian Medals of the Renaissance before Cellini*, 2 vols. London.

Hill, G. F., and G. Pollard, 1967. *Renaissance Medals from the Samuel H. Kress Collection at the National Gallery of Art, Washington*. London.

Hochmann, M. 1988. "Les Annotations marginales de Federico Zuccaro à un exemplaire des *Vies* de Vasari: la réaction anti-vasarienne à la fin du XVIe siècle," *Revue de l'Art* 80:64–71.

Hochmann, M. 1992. *Peintres et Commanditaires à Venise (1540–1628)*, Rome.

Holanda, Francisco de. 1928. *Four Dialogues on Painting*, trans. A. F. G. Bell. Oxford.

Hollingsworth, M. 1984. "The Architect in Fifteenth-Century Florence," *Art History* 7:385–410.

Holsten, S. 1978. *Das Bild des Künstlers: Selbstdarstellungen*. Hamburg.

Holt, E. G., ed. 1957. *A Documentary History of Art*. 2 vols. Garden City, N.Y.

Hope, C. 1979. "Titian as a Court Painter," *Oxford Art Journal* 2:7–10.

Hope, C. 1985. "Historical Portraits in the 'Lives' and in the Frescoes of Giorgio Vasari," in *Giorgio Vasari tra decorazione ambientale e storiografia artistica. Convegno di Studi*. Florence.

Hope, C. 1986. "Religious Narrative in Renaissance Art," *Journal of the Royal Society of the Arts* 134:804–18.

Hope, C. 1988. "La produzione pittorica di Tiziano per gli Asburgo," in *Venezia e la Spagna*, ed. L. Corrain. Milan.

Hope, C. 1990. "Titian, Philip II and Mary Tudor," in *England and the Continental Renaissance*, eds. E. Cheney and P. Mack. London.

Hope, C. 1994. "A New Document about Titian's *Pietà*," in *Sight and Insight: Essays on Art and Culture in Honour of E. H. Gombrich at 85*, ed. J. Onians. London.

Horapollo, 1551. *Hieroglyphica*. Paris.

Hughes, A. 1986. "'An Accademy for Doing.' I: The Accademia del Disegno, the Guilds and the Principiate in Sixteenth-Century Florence," *Oxford Art Journal* 9:3–10; II: "The Academies, Status, and Power in Early Modern Europe," *Oxford Art Journal* 9:50–62.

Hughes, T. 1997. *Tales from Ovid*. London.

Huizinga, J. 1959. "The Problem of the Renaissance," in *Men and Ideas*. New York.

Hulse, C. 1993. Review article. *Art Bulletin* 75:327–9.

Humfrey, P. 1996. "Marietta Tintoretto," *Dictionary of Art*, XXXI, ed. J. Turner. London.

Huse, N., and W. Wolters. 1990. *Venice: Architecture, Sculpture, and Painting, 1460–1590*. Chicago.

Hüttinger, E., ed. 1992. *Case d'artista dal Rinascimento a oggi*. Turin.

Ianziti, G. 1988. *Humanist Historiography under the Sforzas: Politics and Propaganda in Fifteenth-Century Milan*. Oxford.

Isermeyer, C. A. 1950. "Die Capella Vasari und der Hochaltar in der Pieve von Arezzo," in *Eine Gabe der Freunde für Carl Georg Heise zum 28.vi.1950*, ed. E. Meyer. Berlin.

Jacobs, F. 1984. "Vasari's version of the history of painting: Frescoes in the Casa Vasari, Florence," *Art Bulletin* 66:399–416.

Jacobs, F. 1994. "Woman's Capacity to Create: The Unusual Case of Sofonisba Anguissola," *Renaissance Quarterly* 47:74–101.

Janson, H. W. 1973. "The Equestrian Monument from Cangrande della Scala to Peter the Great," in *Sixteen Studies*, ed. H. W. Janson. New York.

Jarzombek, M. 1989. *On Leon Baptista Alberti: His Literary and Aesthetic Theories*. Cambridge, Mass.

Jarzombek, M. 1992. "The Victim and the Hangman: The Tragedy of the Humanist Eye," *Architecture California* 14:43–9.

Jex-Blake, K., and E. Sellers, eds. 1968. *The Elder Pliny's Chapters on the History of Art*. Chicago.

Jones, R., and N. Penny, 1983. *Raphael*. New Haven and London.

Junkerman, A. C. 1993. "The Lady and the Laurel: Gender and Meaning in Giorgione's *Laura*," *Oxford Art Journal* 16:49–58.

Juren, V. 1974a. "Fecit, Faciebat," *Revue de l'Art* 26:27–30.

Juren, V. 1974b. "La Signature épigraphique," *Revue de l'Art* 26:24–6.

Juren, V. 1974c. "Practique artisanale du Nord," *Revue de l'Art* 26:21–3.

Kahr, M. M. 1976. "Velásquez and *Las Meninas*," *Art Bulletin* 57:225–46.

Kantorowicz, E. 1965. "The Sovereignity of the Artist," in *Selected Studies*. Locust Valley, N.Y.

Kappeler, S. 1986. *The Pornography of Representation*. Minneapolis.

Katzenellenbogen, A. 1961. "The Representation of the Seven Liberal Arts," in *Twelfth-Century Europe and the Foundations of Modern Society*. eds. M. Clagett, G. Post, and R. Reynolds. Madison.

Kecks, R. G. 1995. *Ghirlandaio*. Florence.

Kelly-Gadol, J. 1969. *Leon Battista Alberti: Universal Man of the Renaissance*. Chicago.

Kelly-Gadol, J. 1987, "Did Women have a Renaissance?" in *Becoming Visible: Women in European History*, eds. R. Bridenthal and C. Koonz. Boston, Mass.

Kemp, M. 1976. "'Ogni dipintore dipinse sé': A neo-Platonic echo in Leonardo's art theory?" *Cultural Aspects of the Renaissance: Essays in Honor of P. O. Kristeller*, ed. C. Clough. Manchester.

Kemp, M. 1977a. "From 'Mimesis' to 'Fantasia': The Quattrocento Vocabulary of Creation, Inspiration, and Genius in the Visual Arts," *Viator* 8:347–98.

Kemp, M. 1977b. "Leonardo da Vinci and the Visual Pyramid," *Journal of the Warburg and Courtauld Institutes* 40:128–49.

Kemp, M. 1981. *Leonardo da Vinci: The Marvellous Works of Nature and Man*. Cambridge, Mass.

Kemp, M. 1989a. "The Super-artist as Genius: The Sixteenth-century View," in *Genius: The History of an Idea*, ed. P. Murray. Oxford.

Kemp, M., ed. 1989b. *Leonardo on Painting*. New Haven and London.

Kemp, M. 1992a. "Lust for Life: Some thoughts on the Reconstruction of Artists' Lives in fact and fiction," in *L'Art et les revolutions: XXVIIe Congrès International de l'Histoire de l'Art*. Strasburg.

Kemp, M. 1992b. "The Mean and Measure of all Things," in *Circa 1492: Art in the Age of Exploration*, ed. J. Levenson. Exh. cat. National Gallery of Art. Washington, D.C.

Kemp, M. 1992c. "Cecilia Gallerani," in *Circa 1492: Art in the Age of Exploration*, ed. J. Levenson. Exh. cat. National Gallery of Art. Washington, D.C.

Kemp, M., and J. Roberts. 1989. *Leonardo da Vinci*. Exh. cat. Hayward Gallery. London.

Kennedy, R. W. 1964. "Apelles Redivivius," in *Essays in Memory of Karl Lehmann*, ed. L. F. Sandler. New York.

Kent, F. W. 1977. *Household and Lineage in Renaissance Florence*. Princeton.

Kerrigan, W., and G. Braden. 1989. *The Idea of the Renaissance*. Baltimore.

Kidson, P. 1981. "The Figural Arts," in *The Legacy of Greece: A New Appraisal*, ed. M. I. Finley. Oxford.

King, C. 1988. "Late Sixteenth-century Careers' Advice: A New Allegory of Artists' Training: Albertina, Inv. No. 2763," *Wiener Jahrbuch für Kunstgeschichte* 41:77–96.

King, C. 1990. "Filarete's Portrait Signature on the Bronze Doors of St. Peter's, and the Dance of Bathykles and His Assistants," *Journal of the Warburg and Courtauld Institutes* 53:296–9.

King, C. 1995. "Looking a Sight: Sixteenth-century Portraits of Woman Artists," *Zeitschrift für Kunstgeschichte* 59:381–406.

King, M. L. 1991, *Women of the Renaissance*. Chicago.

Kinneir, J., ed. 1980. *The Artist by Himself: Self-portrait Drawings from Youth to Old Age*. London.

Kirwin, W. C. 1971. "Vasari's Tondo of Cosimo I with his architects, engineers, and sculptors in the Palazzo Vecchio," *Mitteilungen des Kunsthistorischen Institutes in Florenz* 15:105–22.

Klapisch-Zuber, C. 1990/91. "Images without Memory: Women's Identity and Family Consciousness in Renaissance Florence," in *Imaging the Self in Renaissance Italy*, Symposium at the the Isabella Stewart Gardner Museum, Boston, in *Fenway Court*.

Klibansky, R., E. Panofsky, and F. Saxl, 1964. *Saturn and Melancholy: Studies in the History of Natural Philosophy, Religion, and Art*. New York.

Koerner, J. L. 1986. "Albrecht Dürer and the Moment of Self-Portraiture," *Daphnis* 15:409–39.

Koerner, J. L. 1993. *The Moment of Self-Portraiture in German Renaissance Art*. Chicago.

Kraitrova, M. 1992. "La casa di Andrea Mantegna a Mantova e quello di Piero della Francesca," in *Case d'artista: dal Rinascimento a oggi*, ed. E. Hüttinger. Turin.

Krautheimer, R. 1970. *Lorenzo Ghiberti*. 2 vols. Princeton.

Kreytenberg, G. 1994. *Orcagna's Tabernacle*. New York.

Kris, E. 1952. *Psychoanalytic Explorations in Art*. New York.

Kristeller, P. 1902. *Andrea Mantegna*. Berlin.

Kristeller, P. O. 1937. *Supplementum Ficinianum*. Florence.

Kristeller, P. O. 1961. "The Philosophy of Man in the Italian Renaissance," in *Renaissance Thought: The Classic, Scholastic, and Humanist Strains*. New York.

Kristeller, P. O. 1964. *The Philosophy of Marsilio Ficino*. Gloucester, Mass.

Kristeller, P. O. 1965. "The Modern System of the Arts," in *Renaissance Thought II*. London.

Kristeller, P. O. 1979. "Renaissance Concepts of Man," in *Renaissance Thought and its Sources*. New York.

Kristeller, P. O. 1985. "Changing Views of the Intellectual History of the Renaissance since Jacob Burckhardt," in *Studies in Renaissance Thought and Letters II*. Rome.

Kruft, H. W. 1969. "Ein Album mit Porträtzeichnungen Ottavio Leonis," *Storia dell'Arte* 4:447–58.

Kuehn, T. 1991. *Law, Family, Women: Toward a Legal Anthropology of Renaissance Italy*, Chicago.

Kusche, M. 1989. "Sofonisba Anguissola en Espana retratista en la corte de Felipe II junto a Alonso Sanchez Coello y Jorge de la Rua," *Archivio Espanol de Arte* 248:391–420.

Kusche, M. 1994. "Sofonisba Anguissola al servizio dei re di Spagna," in Gregori 1994.

Kusche, M. 1995. "Sofonisba Anguissola: her life and works," in Ferino-Pagden and Kusche 1995.

Kuspit, D. 1972. "The Self-Portrait as a clue to the artist's being-in-the-world," in *Proceedings of the sixth international congress of aesthetics, Uppsala, 1968*, ed. R. Zeitler. Uppsala.

Lacan, J. 1977. "The Mirror State as Formative of the Function of the I as Revealed in Psychoanalytic Experience," *Écrits; A Selection*. London.

Ladis, A. 1982. *Taddeo Gaddi: Critical Reappraisal and Catalogue Raisonné*. Columbia, Mich.

Land, N. E. 1997a. "Narcissus Pictor," *Source* 16, 2:10–15.

Land, N. E. 1997b. "Parmigianino as Narcissus," *Source* 16, 4:26–30.

Landino, C. 1974. "Commento di Cristoforo Landino fiorentino sopra la Comedia di Dante Alighiero poeta fiorentino," in *Scritti critici e teorici*, ed. R. Cardini. Rome.

Langdon, G. 1989. "A Reattribution: Alessandro Allori's Lady with a Cameo," *Zeitschrift für Kunstgeschichte* 52:25–45.

Langedijk, K. 1964. "Silentium," in *Nederlands Kunsthistorisch Jaarboek* 15:3–18

Langedijk, K. 1981. *The Portraits of the Medici: Fifteenth–Eighteenth Centuries*. 3 vols. Florence.

Langedijk, K. 1992. *Die Selbstbildnisse der*

Hollandischen und Flamischen Künstler in der Galleria degli Autoritratti der Uffizien. Florence.

Lavin, I. 1977–8. "The Sculptor's Last Will and Testament," *Allen Memorial Art Museum Bulletin* 35:4–39.

Lavin, I. 1992. "David's Sling and Michelangelo's Bow," in *Der Künstler über sich in seinem Werk*. Internationales Symposium der Bibliotheca Hertziana Rom 1989, ed. M. Winner. Weinheim; reprinted in I. Lavin, *Past–Present: Essays on Historicism in Art from Donatello to Picasso*, Berkeley and Los Angeles, 1993.

Lecchini Giovannini, S. 1991. *Alessandro Allori*. Florence.

Lecoq, A.M. 1974a. "Cadre et Rebord," *Revue de l'Art* 26:15–20.

Lecoq, A.M. 1974b. "Apelle et Protogène," *Revue de l'Art* 26:46–7.

Lecoq, A.M. 1975. "'Finxit:' le peintre comme 'fictor' au XVIe siècle," *Bibliothèque d'Humanisme et Renaissance* 37:225–43.

Lejeune, P. 1989. *On Autobiography*, ed. P.J. Eakin, trans. K. Leary. Minneapolis.

Leonardo da Vinci 1924. *Trattato della pittura*, 2 vols., ed. A. Borzelli. Lanciano.

Leopold, N.S.C. 1980. "Artists' Homes in Sixteeth-Century Italy". Ph.D. diss., Johns Hopkins University. Baltimore.

Levenson, J.A., K. Oberhuber, and J.L. Sheehan. 1973. *Early Italian Engravings from the National Gallery of Art, Washington D.C.* Washington, D.C.

Levey, M. 1981. *The Painter Depicted: Painters as a subject in painting*. London.

Lewis, D. forthcoming. *National Gallery of Art Systematic Catalogue: Medals and Plaquettes*. Washington, D.C.

Liebenwein, W. 1990. "The Prince as Artist and Artisan," in *World Art: Themes of Unity in Diversity*. Acts of the XXVI International Congress of the History of Art, ed. I. Lavin. University Park, Pa.

Lightbown, R. 1978. *Sandro Botticelli*. Berkeley and Los Angeles.

Lightbown, R. 1986. *Mantegna*. Berkeley and Los Angeles.

Lightbown, R.W. 1994. "The Portraits of Piero della Francesca," in *Hommage à Michel Laclotte: études sur la peinture du moyen âge et de la Rénaissance*. Paris.

Lomazzo, G.P. 1587. *Breve Trattato della Vita dell'autore descritta da lui stesso in rime sciolte*, in *Rime di Giovanni Paolo Lomazzo, Milanese Pittore . . .* Milan.

Lomazzo, G.P. 1973. *Scritti sulle Arti*, ed. R.P. Ciardi. 2 vols. Florence.

Long, P.O. 1985. "The Contribution of Architectural Writers to a 'Scientific' Outlook in the Fifteenth and Sixteenth Centuries," *Journal of Medieval and Renaissance Studies* 15:265–98.

Lucie-Smith, E., and S. Kelly. 1987. *The Self-Portrait: A Modern View*. London.

Luchs, A. 1989. "Tullio Lombardo's Ca' d'Oro Relief: A Self-Portrait with the Artist's Wife," *Art Bulletin* 71:230–36.

Luchs, A. 1995. *Tullio Lombardo and Ideal Portrait Sculpture in Renaissance Venice, 1490–1530*. Cambridge.

Lukehart, P.M. 1996. "G.B. Paggi," in *Dictionary of Art*, XXIII, ed. J. Turner. London.

Lunardon, S. 1985. *Hospitale S. Mariae Cruciferorum: l'ospizio Crociferi a Venezia*. Venice.

Luzio, A. 1913. *La Galleria dei Gonzaga, venduta all'Inghilterra nel 1627–8*. Rome.

Lynch, J.B. 1964. "Giovanni Paolo Lomazzo's Self-Portrait in the Brera," *Gazette des Beaux-Arts* 64:189–97.

Lynch, J.B. 1966. "Lomazzo and the Accademia della Valle di Bregno," *Art Bulletin* 48:210–11.

MacLaren, N., revised A. Braham. 1988. *National Gallery. The Spanish School*. London.

Maclean, I. 1980. *The Renaissance Notion of Woman*. Cambridge.

Maclehouse, L.S., and G.B. Brown, eds. 1907. *Vasari on Technique*. New York.

Madrid 1988. *Zurbarán*, Museo del Prado. Madrid.

Maginnis, H.B.J. 1993. "Giotto's World through Vasari's Eyes," *Zeitschrift für Kunstgeschichte* 56:385–408.

Magnani, L. 1995. *Luca Cambiaso da Genova all'Escorial*. Genoa.

Mahon, D. 1947. *Studies in Seicento Art and Theory*. New York.

Mahon, D. 1957. "Afterthoughts on the Carracci Exhibition," *Gazette des Beaux-Arts* ser. 6, 9:193–207; 267–98.

Maier, B. 1952. *Umanità e stile di Benvenuto Cellini scrittore*. Milan.

Mâle, E. 1958. *The Gothic Image*. New York.

Mallory, N.A. 1990. *El Greco to Murillo: Spanish Painting in the Golden Age, 1556–1700*. New York.

Malvasia, C.C. 1841. *Felsina pittrice; vite de' pittori*, II, ed. G. Zanotti. Bologna.

Man, P. de. 1979. "Autobiography as Defacement," *Modern Languages Notes* 94:919–30.

Man, P. de. 1983. "Ludwig Binswanger and the Sublimation of the Self," in *Blindness and Insight: Essays in the Rhetoric of Contemporary Criticism*. Minneapolis.

Mancini, G., 1956. *Considerazioni sulla Pittura*, ed. L. Venturi. Rome.

Manning, B.S., and W. Suida. 1958. *Luca Cambiaso: la vita e le opere*. Milan.

Marani, E. 1961. *Mantova: le arti*. 2 vols. Mantua.

Marchini, G. 1978. *Filippo Lippi*. Milan.

Marcus, L.S. 1992. "Renaissance/Early Modern Studies," in *Redrawing the Boundaries: The transformation of English and American Literary Studies*, eds. S. Greenblatt and G. Gunn. New York.

Marin, L. 1995. *To Destroy Painting*. Chicago.

Marrow, J.H. 1983. "'In desen speigell': A New Form of 'Memento Mori' in Fifteenth-Century Netherlandish Art," in *Essays in Northern European Art Presented to Egbert Haverkamp-Begemann on his Sixtieth Birthday*, ed. A.M. Logan. Doornspijk.

Marsh, D. 1985. "Petrarch and Alberti," in *Renaissance Studies in Honor of Craig Hugh Smyth*, I, ed. A. Morrogh et al. Florence.

Martin, J. 1997. "Inventing Sincerity, Refashioning Prudence: The Discovery of the Individual in Renaissance Europe," *American Historical Review* 102:1309–42.

Martin, T. 1993. "Michelangelo's *Brutus* and the Classicizing Portrait Bust in Sixteenth-Century Italy," *Artibus et Historiae* 27:67–83.

Martindale, A. 1972. *The Rise of the Artist in the Middle Ages and Early Renaissance*. London.

Martindale, A. 1976. "Andrea Mantegna: Historicus et Antiquarius," Inaugural lecture delivered before the University of East Anglia. Norwich.

Martindale, A. 1979. *The Triumphs of Caesar by Andrea Mantegna in the Collection of H.M. The Queen at Hampton Court*. London.

Martineau, J., ed. 1992. *Andrea Mantegna*. Exh. cat. Royal Academy of Arts, London, and Metropolitan Museum of Art, New York. London.

Martines, L. 1979. *Power and Imagination*. New York.

Martines, L. 1991. "The Protean Face of Renaissance Humanism," *Modern Language Quarterly* 51:105–21.

Masciotta, M. 1955. *Autoritratti dal XIV al XX secolo*. Milan.

Mason Rinaldi, S. 1984. *Palma il Giovane: l'opera completa*. Milan.

Massi, N. 1990. "The self-portrait of Lotto in the Crucifixion of Monte San Giusto," *Source* 9:1–4.

Mauss, M. 1985. "A Category of the Human Mind: The Notion of Person; the Notion of Self," in *The Category of the Person: Anthropology, Philosophy, History*, eds. M. Carrithers, S. Collins, and S. Lukes. Cambridge.

McClure Ross, S. 1983. "The Redecoration of Santa Maria Novella's Cappella Maggiore," Ph.D. diss., University of California. Berkeley.

McIver, K.A. 1993. "Music and the Sixteenth-Century Painter: Lappoli, Brusasorci, and Garofalo," *RIdIM/RCMI Newsletter* 18/2.

McIver, K.A. 1997. "Maniera, Music, and Vasari," *Sixteenth-Century Journal* 28:45–55.

McIver, K.A. 1998. "Imaging and Self-Imaging of the Renaissance Woman in Italy: Lavinia Fontana," *Woman's Art Journal* 19, 1.

McMahon, A.P., ed. 1956. *Leonardo da Vinci,*

Treatise on Painting (Codex Urbinas Latinus 1270). 2 vols. Princeton.

Meijer, B. W. 1985. "Cremona e i Paesi Bassi," in *I Campi. Cultura artistic cremonese del cinquecento*. Milan.

Meller, P. 1963. "Physiognomical Theory in Renaissance Heroic Portraits," in *The Renaissance and Mannerism*, Twentieth International Congress of the History of Art. Princeton.

Meller, P. 1974. "Two drawings of the Quattrocento in the Uffizi: A study in stylistic change," *Master Drawings* 12:261–78.

Meller, P. 1980. "Il lessico ritrattistico di Tiziano," in *Tiziano e Venezia*. Vicenza.

Mellini, G. L. 1986. "Raffaello a sua immagine," *Labyrinthos* 9:76–109.

Mendelsohn, L. 1982. *Paragoni: Benedetto Varchi's "Due Lezzioni," and Cinquecento Art Theory*. Ann Arbor.

Mezzatesta, M. P. 1980. "Imperial Themes in the Sculpture of Leone Leoni." Ph.D. diss. New York University.

Mezzatesta, M. P. 1984. "Marcus Aurelius, Fray Antonio de Guevara, and the Ideal of the Perfect Prince in the Sixteenth Century," *Art Bulletin* 66:620–33.

Mezzatesta, M. P. 1985. "The Façade of Leone Leoni's House in Milan, the Casa degli Omenoni: The Artist and His Public," *Journal of the Society of Architectural Historians* 44:233–49.

Michelangelo. 1960. *Rime*, ed. E. Girardi. Bari.

Michelini Tocci, L. 1986. "Federico di Montefeltro e Ottaviano Ubaldini della Carda," in *Federico di Montefeltro: lo stato*, eds. G. Cerboni Baiardi, G. Chittolini, and P. Floriani. Rome.

Middeldorf, U. 1978. "On the Dilettante Sculptor," *Apollo* 107:310–22.

Middeldorf Kosegarten, A. 1980. "The Origins of Artistic Competitions in Italy," in *Lorenzo Ghiberti nel suo tempo*, I. Florence.

Miles, M. R. 1989. *Carnal Knowing: Female Nakedness and Religious Meaning in the Christian West*. Boston, Mass.

Millon, H. A., ed. 1994. *From Brunelleschi to Michelangelo: The Representation of Architecture*. Washington, D.C.

Moffitt, J. 1988. "Painters Born under Saturn: The Physiological Explanation," *Art History* 11:195–216.

Molho, A. 1991. "Burckhardtian Legacies," *Medievalia et Humanistica* 17:133–9.

Moxey, K. 1994. *The Practice of Theory: Poststructuralism, Cultural Politics, and Art History*. Ithaca.

Muir, E. 1995. "The Italian Renaissance in America," *American Historical Review* 100: 1095–1118.

Mulcahy, R. 1987. "Federico Zuccaro and Philip II: The Reliquary Altars for the Basilica of San Lorenzo de El Escorial," *Burlington Magazine* 129:502–9.

Müller, B. 1992. "Casa Zuccari a Firenze e Palazzo Zuccari a Roma: casa d'artista e casa dell'arte," in *Case d'Artista dal Rinascimento a oggi*, ed. E. Hüttinger. Turin.

Muraro, M., and D. Rosand, eds. 1976. *Tiziano e la silografia Veneziana del Cinquecento*. Vicenza.

Murphy, C. P. 1996. "Lavinia Fontana and 'Le Dame della Città': Understanding female artistic patronage in late sixteenth-century Bologna," *Renaissance Studies* 10:190–208.

Naples. 1985. *Cinque Secoli di Stampa Musicale in Europa*. Exh. cat. Museo di Palazzo Venezia.

Nelson, N. 1933. "Individualism as a Criterion of the Renaissance," *Journal of English and Germanic Philology* 32:316–34.

Nesselrath, A. 1993. "Raphael's Gift to Dürer," *Master Drawings* 31:376–89.

New Haven. 1994. *Vasari's Florence: Artists and Literati at the Medicean Court*. Exh. cat., Yale University Art Gallery.

Oberhuber, K. 1977. "The Colonna Altarpiece in the Metropolitan Museum and Problems of the Early Style of Raphael," *Metropolitan Museum Journal* 12:55–90.

Oberhuber, K. 1984. *Raffaello*. Milan.

Oberhuber, K. 1986. "Raphael and Pintoricchio," in *Raphael Before Rome*, ed. J. H. Beck. Center for Advanced Study in the Visual Arts, Symposium Series V, *Studies in the History of Art* 17:155–172.

Offner, R. 1934. "A Portrait of Perugino by Raphael," *Burlington Magazine* 65:245–57.

Olney, J. 1972. *Metaphors of Self: The Meaning of Autobiography*. Princeton.

Onians, J. 1988. *Bearers of Meaning*. Princeton.

Ostrow, S. E. 1966. "Agostino Carracci," Ph.d. diss., New York University.

Ostrow, S. F. 1990. "Marble Revetment in Late Sixteenth-Century Roman Chapels," in *IL 60*, ed. M. A. Lavin. Ithaca, N.Y.

Paleotti, G. 1961. "Discorso intorno alle immagini sacre e profane," in *Trattati d'arte del Cinquecento*, II, ed. P. Barocchi. Bari.

Panofsky, E. 1953. "Artist, Scientist, Genius: Notes on the 'Renaissance-Dammerung,'" in *The Renaissance*. New York.

Panofsky, E. 1955. *The Life and Art of Albrecht Dürer*. Princeton.

Panofsky, E. 1965. *Renaissance and Renascences in Western Art*. Stockholm.

Panofsky, E. 1969a. "Erasmus and the Visual Arts," *Journal of the Warburg and Courtauld Institutes* 32:200–227.

Panofsky, E. 1969b. *Problems in Titian, mostly iconographic*. New York.

Paoletti, J. 1992. "Michelangelo's Masks," *Art Bulletin* 74:423–40.

Pardo, M. 1984. "Paolo Pino's 'Dialogo di Pittura': A Translation with Commentary," Ph.D. diss., University of Pittsburgh.

Parker, P. 1996. "Rude Mechanicals," in *Subject and Object in Renaissance Culture*, eds. M. de Grazia, M. Quilligan, and P. Stallybrass. Cambridge.

Parlato E. 1988a. "Il gusto all'antica del Filarete scultore," in Rome 1988.

Parlato, E. 1988b. "L'iconografia imperiale," in Rome 1988.

Partridge, L. 1971. "The Sala d'Ercole at the Villa Farnese at Caprarola, Part I," *Art Bulletin* 53:467–86.

Partridge, L. 1978. "Divinity and Dynasty at Caprarola: Perfect History in the Room of Farnese Deeds," *Art Bulletin* 60:494–530.

Partridge, L., and R. Starn. 1980. *A Renaissance Likeness: Art and Culture in Raphael's "Julius II."* Berkeley and Los Angeles.

Pascal, R. 1960. *Design and Truth in Autobiography*. London.

Pasini, P. G. 1987. "Matteo de' Pasti: Problems of Style and Chronology," *Italian Medals*, ed. J. G. Pollard. Center for Advanced Study in the Visual Arts, Symposium Papers VIII, in *Studies of the History of Art* 21:143–59.

Passeri, G. B. 1772/1934. *Vite dei pittori, scultori, ed architetti che [h]anno lavorato in Roma, morti dal 1614, fino al 1673*, ed. J. Hess. Leipzig and Vienna.

Pastore, G., ed. 1986. *La Capella del Mantegna in Sant'Andrea a Mantova*. Mantua.

Pease, D. E. 1995. "Author" in F. Lentricchia and T. McLaughlin, eds., *Critical Terms for Literary Study*, 1995. Chicago.

Pepper, D. S. 1973. "Annibale Carracci Ritrattista," *Arte Illustrata* 6, 53:127–37.

Perry, M. 1977. "Candor Illaesvs: The Impresa of Clement VII and Other Medici Devices in the Vatican Stanze," *Burlington Magazine* 119:676–86.

Pevsner, N. 1940. *Academies of Art Past and Present*. Cambridge.

Pevsner, N. 1942. "The Term 'Architect' in the Middle Ages," *Speculum* 17:549–65.

Pigman, G. W., III. 1980. "Versions of Imitation in the Renaissance," *Renaissance Quarterly* 23:1–32.

Pilliod, E. 1989. "Studies in the Early Career of Alessandro Allori," Ph.D diss., University of Michigan. Ann Arbor.

Pilliod, E. 1992. "Bronzino's Household," *Burlington Magazine* 134:92–9.

Pilliod, E. 1998. ""Representation, Misrepresentation, and Non-Representation," in *Vasari's Florence: Artists and Literati at the Medicean Court*, ed. P. Jack. Cambridge.

Pinacoteca di Brera. 1989. *Pinacoteca di Brera, scuole lombarda, ligure e piemontesi, 1535–1796*. Milan.

Piola Caselli, L. 1982. "La storietta del Filarete dietro la Porta di S. Pietro," *L'Urbe* 45:232–9.

Plon, E. 1887. *Leone Leoni, sculpteur de Charles-Quint et Pompeo Leoni, sculpteur de Philippe II.* Paris.

Plutarch. 1914–26. *Lives,* trans. B. Perrin. 11 vols. London and New York.

Poirier, M. 1970. "The Role of the Concept of *Disegno* in Mid-sixteenth Century Florence," in *The Age of Vasari.* Notre-Dame.

Pollard, J. G. 1984. *Italian Renaissance Medals in the Museo Nazionale of Bargello.* 3 vols. Florence.

Pollitt, J. J. 1965. *The Art of Greece, 1400–31 B.C. Sources and Documents.* Englewood Cliffs, N.J.

Pollitt, J. J. 1974. *The Ancient View of Greek Art: Criticism, History, and Terminology.* New Haven.

Pope-Hennessy, J. 1966. *The Portrait in the Renaissance.* New York.

Pope-Hennessy, J. 1985. *Cellini.* New York.

Pope-Hennessy, J. 1986. *An Introduction to Italian Sculpture.* 3 vols. Oxford.

Posner, D. 1971. *Annibale Carracci: A Study in the Reform of Painting around 1590.* London.

Posner, D. 1986. in Washington, D.C., 1986.

Pouncey, P., and J. Gere. 1962. *Italian Drawings in the Department of Prints and Drawings in the British Museum.* London.

Prinz, W. 1962. "Die Darstellung Christi und die Bildnisse des Andrea Mantegna," *Berliner Museen* 12:50–54.

Prinz, W. 1963. "La seconda edizione del Vasari e la comparsa di 'vite' artistiche con ritratti," *Il Vasari* 24:1–14.

Prinz, W. 1966. "Vasaris Sammlungen von Künstlerbildnissen," *Mitteilungen des Kunsthistorischen Institutes in Florenz,* supplement to vol. 12.

Prinz. 1971. *Die Sammlung der Selbstbildnisse in den Uffizien,* 1. Berlin.

Prinz, W., et al., 1979. in Uffizi 1979.

Pullan, A. 1994. "Head to Head Encounters" (review article), *Oxford Art Journal* 17:103–112.

Quintavalle, A. G. 1969. "In una serie di ritratti, l'autobiografia del Parmigianino," *Paragone* 20, 235:53–63

Quivigier, F. 1995. "The Presence of Artists in Literary Academies," in *Italian Academies of the Sixteenth Century,* eds. D. S. Chambers and F. Quivigier. London.

Rapp, J. 1987. "Das Tizian-Porträt in Kopenhagen: ein Bildnis des Giovanni Bellini," *Zeitschrift für Kunstgeschichte* 50:359–74.

Rash Fabbri, N., and N. Rutenberg. 1981. "The Tabernacle of Orsanmichele in Context," *Art Bulletin* 43:385–405.

Rearick, W. R. 1990. "Exhibition Review: Palma il Giovane," *Burlington Magazine* 132:292–93.

Regosin, R. 1977. *The Matter of my Book: Montaigne's Essays as the Book of the Self.* Berkeley and Los Angeles.

Redig de Campos, D. 1954–5. "Notizie intorno all'autoritratto di Raffaello nella Scuola d'Athene," *Atti della Pontificia Accademia Romana di Archeologia* ser. 3, 28:253–7.

Reiss, J. B. 1995. *The Renaissance Antichrist: Luca Signorelli's Orvieto Frescoes,* Princeton.

Reynaud, R. 1981. *Jean Fouquet.* Paris.

Reynolds, T. 1974. "The 'Accademia del Disegno,' in Florence, Its Formation and Early Years." Ph.D. diss., Columbia University. New York.

Ricci, C. 1907. *La Pinacoteca di Brera.* Bergamo.

Ricci, S. 1902. "Di una medaglia autoritratto di Antonio Averlino detto il 'Filarete' nel Museo Municipale di Milano," *Rivista numismatica italiana* 15:227–38.

Richter, G. M. A. 1929. *The Sculpture and Sculptors of the Greeks.* New Haven.

Richter, G. M. A. 1971. *The Engraved Gems of the Greeks, Etruscans, and Romans. Part II. Engraved Gems of the Romans.* London.

Richter, I. A. 1969. *Paragone: A Comparison of the Arts by Leonardo da Vinci.* Oxford.

Richter, J. P. 1970. *The Literary Works of Leonardo da Vinci,* 3rd ed. London.

Ridolfi, C. 1924. *Le maraviglie dell'arte,* ed. D. F. von Hadeln. Berlin.

Ringbom, S. 1984. *Icon to Narrative: The Rise of the Dramatic Close-Up in Fifteenth-Century Devotional Painting,* 2nd ed. Doornspijk.

Ripa, C. 1603. *Iconologia.* Rome.

Ripa, C. 1764–7. *Iconologia.* Rome.

Ripa, C. 1986. *Iconologia* [Padua, 1618], ed. P. Bruscaroli. 2 vols. Turin.

Rivasecchi, V. 1987. "Lo Specchio sul Cavaletto," in *Lo Specchio e il Doppio: Dallo Stagno di Narciso allo schermo televisivo.* Milan.

Robertson, C. 1996. "The Carracci as Draughtsmen," in *Drawings by the Carracci from British Collections,* eds. C. Robertson and C. Whistler. Ashmolean Museum, Oxford.

Roebuck, C., ed. 1969. *The Muses at Work: Arts, Crafts, and Professions in Ancient Greece and Rome.* Cambridge, Mass.

Roman, C. F. 1984. "Academic Ideals of Art Education," in *Children of Mercury: The Education of Artists in the Sixteenth and Seventeenth Centuries.* Providence, R.I.

Rome. 1988. *Da Pisanello alla Nascita dei Musei Capitolini: L'Antico a Roma alla Vigilia del Rinascimento.* Exh. cat. Capitoline Museum, Rome.

Ronchini, A. 1865. "Leone Leoni d'Arezzo," *Atti e memorie delle R. R. Deputazioni di Storia Patria per le provincie Modenesi e Parmensi* 3:9–41.

Roncière, C. de la. 1988. "Tuscan Notables on the Eve of the Renaissance," in *A History of Private Life. II Revelations of the Medieval World,* ed. G. Duby. Cambridge.

Rosand, D. 1965. "Palma Giovane and Venetian Mannerism," Ph.D. diss., Columbia University. New York.

Rosand, D. 1970a. "Palma il Giovane as Draughtsman: The Early Career and Related Observations," *Master Drawings* 8:148–61.

Rosand, D. 1970b. "The Crisis of the Venetian Renaissance Tradition," *L'Arte* 11–12:5–54.

Rosand, D. 1978. *Titian.* New York.

Rosand, D. 1982a. "Titian and the Critical Tradition," in *Titian: his World and his Legacy.* New York.

Rosand, D. 1982b. *Painting in Cinquecento Venice.* New Haven and London.

Rosand, D. 1983. "The Portrait, the Courtier, and Death," in R. W. Hanning and D. Rosand, eds., *Castiglione: The Ideal and the Real in Renaissance Culture.* New Haven and London.

Rosand, D. 1986. *The Meaning of the Mark: Leonardo and Titian.* Franklin D. Murphy Lectures VIII. Spencer Museum of Art, University of Kansas. Lawrence.

Rosand, D. 1987. "Ekphrasis and the Renaissance of Painting: Observations on Alberti's Third Book," in *Florilegium Columbianum: Essays in Honor of Paul Oskar Kristeller,* eds. K. L. Selig and R. Somerville. New York.

Rosenthal, E. E. 1962. "The House of Andrea Mantegna in Mantua," *Gazette des Beaux-Arts* ser. 6, 60:327–48.

Rosenthal, E. E. 1973. "The Invention of the Columnar Device of Emperor Charles V at the Court of Burgundy in Flanders in 1516," *Journal of the Warburg and Courtauld Institutes* 36:198–230.

Rosenthal, P. 1984. *Words and Values: Some Leading Words and Where They Lead Us.* Oxford.

Roskill, M. 1968. *Dolce's "Aretino" and Venetian Art Theory of the Cinquecento.* New York.

Rossi, P. L. 1994. "The Writer and the Man: Real Crimes and Mitigating Circumstances," in *Crime, Society, and the Law in Renaissance Italy,* eds. T. Dean and K. J. P. Lowe. Cambridge.

Rossi, S. 1980. *Dalle Botteghe alle Accademie: realtà sociale e teorie artistiche a Firenze dal XIV al XVI secolo.* Milan.

Rossi, S. 1984. "La compagnia di San Luca nel Cinquecento e la sua evoluzione in Accademia," in *Ricerche per la Storia Religiosa di Roma,* V, ed. L. Fiorani. Rome.

Rossi, S. 1989. "Un doppio ritratto del Caravaggio," *Quaderni di Palazzo Venezia* 6: 149–55.

Rousseau, J.-J. 1959. *Oeuvres Complètes.* Paris.

Rowland, I. D. 1997. "The Intellectual Background of the School of Athens: Tracking

Divine Wisdom in the Rome of Julius II," in *Raphael's School of Athens*, ed. M. Hall. Cambridge.

Rowlands, J. 1980. "Terminus, the Device of Erasmus of Rotterdam: A Painting by Holbein," *Bulletin of the Cleveland Museum of Art* 67:50–53.

Rubin, P. L. 1990. "What Men Saw: Vasari's Life of Leonardo da Vinci and the Image of the Renaissance Artist," *Art History* 13:34–46.

Rubin, P. L. 1995. *Giorgio Vasari: Art and History*. New Haven and London.

Ruda, J. 1993. *Fra Filippo Lippi: Life and Work with a Complete Catalogue*. London.

Sacchi, R. 1994a. "Registro," in Gregori 1994.

Sacchi, R. 1994b. "Fonti a stampa e letterarie, 1550–1625," in Gregori 1994.

Sacchi, R., 1994c. "Sofonisba Anguissola," in Gregori 1994.

Sansovino, F. 1563. *Venetia città nobilissima e singolare descritta*. Venice.

Sartre, J.-P. 1966. "Faces, preceded by Official Portraits," in *Essays in Phenomenology*, ed. M. Natanson. The Hague.

Saxl, F. 1957. *Lectures*. 2 vols. London.

Scarpellini, P. 1984. *Perugino*. Milan.

Schaefer, J. O. 1983. "Saint Luke as Painter: From saint to artisan to artist," in *Artistes, Artisans et Production Artistiques au Moyen-Age*, ed. X. Barral y Altet. Rennes.

Schaeffer, J. O. 1984. "A Note on the Iconography of a Medal of Lavinia Fontana," *Journal of the Warburg and Courtald Institutes* 47:232–34.

Schapiro, M. 1973. *Words and Pictures: On the literary and the symbolic in the Illustration for Text*. Paris.

Scher, S. 1989. "Immortalitas in Nummis: The Origins of the Italian Renaissance Medal," *Trésors Monétaires*, supplement 2. Paris.

Scher, S. ed. 1994. *The Currency of Fame: Portrait Medals of the Renaissance*. New York.

Schiff, R. 1984. "Representation, Copying, and the Technique of Originality," *New Literary History* 15:332–63.

Schneider, L. 1984. "Raphael's Personality," *Source* 3:9–22.

Schneider, L. 1990. "Leon Battista Alberti: Some Biographical Implications of the Winged Eye," *Art Bulletin* 72:261–70.

Schneider, N. 1994. *Vermeer, 1632–1675: Veiled Emotions*. Cologne.

Schneider Adams, L. 1993. *Art and Psychoanalysis*. New York.

Schutte, A. J. 1991. "Irene di Spilimbergo: The Image of a Creative Woman in Late Renaissance Italy," *Renaissance Quarterly* 44:42–57.

Schutz-Rautenberg, G. 1978. *Künstlergrabmaler des 15. und 16. Jahrhunderts in Italien*. Cologne.

Schwartz, H. 1952. "The Mirror of Art," *Art Quarterly* 15:97–118.

Schwartz, H. 1959. "The Mirror of the Artist and the Mirror of the Devout," in *Studies in the History of Art dedicated to William Suida*. London.

Schwartz, H. 1967. "Schiele, Dürer and the Mirror," *Art Quarterly* 30:210–23.

Schwartz, M. 1997. "Raphael's Authorship in the Expulsion of Heliodorus," *Art Bulletin* 79:467–92.

Schweig, B. 1940. "The History of Mirrors," in *Glass* 17:50–51, 81–2, 108–12, 180–84.

Schweikhart, G. 1992. "Boccaccios *De claris mulieribus* und die Selbstdarstellungen von Malerinnen im 16. Jahrhundert," in *Der Künstler über sich in seinem Werk*, ed. M. Winner. Weinheim.

Schweikhart, G. 1993. "Das Selbstbildnis im 15. Jahrhundert," in *Italienische Frührenaissance und nordeuropaisches Spätmittelalter*, ed. J. Poeschke. Munich.

Seneca, L. A. 1962. *Lettere a Lucilio*, ed. M. Pittau. Brescia.

Settis, S. 1975. "Immagini della meditazione, dell'incertezza, e del pentimento nell'arte antica," *Prospettiva* 2:4–18.

Seymour, C. 1966. *Sculpture in Italy, 1400–1500*. Harmonsworth.

Seymour, C. 1967. *Michelangelo's David: A Search for Identity*. New York.

Sheard, W. S. 1992. "Giorgione Portrait Inventions *c*.1500: Transfixing the Viewer," in *Reconsidering the Renaissance*, ed. M. A. di Cesare. Binghamton.

Shearman, J. 1965a. *Andrea del Sarto*. Oxford.

Shearman, J. 1965b. "Titian's Portrait of Giulio Romano," *Burlington Magazine* 107:172–5.

Shearman, J. 1974. "Il Tiburio di Bramante," *Studi Bramanteschi, Atti del Congresso Internazionale Milano–Urbino–Roma, 1970*. Rome.

Shearman, J. 1983. *The Pictures in the Collection of Her Majesty the Queen: The Early Italian Pictures*. Cambridge.

Shearman, J. 1984. "Doppio ritratto di Raffaello," in *Raffaello Architetto*, eds. C. L. Frommel, S. Ray, and M. Tafuri. Milan.

Shearman, J. 1990. "The Historian and the Conservator," in *The Princeton Raphael Seminar*, eds. J. Shearman and M. B. Hall. Princeton.

Shearman, J. 1992. *Only Connect . . . Art and the Spectator in the Italian Renaissance*. Bollingen Series XXXV. Princeton.

Shelby, L. R. 1965. "Medieval Masons' Tools. II. Compass and Square," *Technology and Culture* 6:236–48.

Shoemaker, I. H., and E. Broun, 1981. *The Engravings of Marcantonio Raimondi*. Lawrence, Kan.

Signorini, R. 1974. "Federico III e Cristiano I nella Camera degli Sposi a Mantova," *Mitteilungen des Kunsthistorischen Institutes in Florenz* 18:227–50.

Signorini, R. 1976. "L'autoritratto del Mantegna nella Camera degli Sposi," *Mitteilungen des Kunsthistorischen Institutes in Florenz* 20:205–12.

Signorini, R. 1981. "Gonzaga Tombs and Catafalques," in Chambers and Martineau 1981.

Signorini, R. 1985. *Opvs Hoc Tenve*. Mantua.

Siguenza, J. de. 1963. *La fundacion del monasterio de El Escorial*. Madrid.

Silver, L. 1983. "Step-Sister of the Muses: Painting as Liberal Art and Sister Art," in *Articulate Images: The Sister Arts from Hogarth to Tennyson*, ed. R. Wendorf. Minneapolis.

Simons, P. 1985. "Portraiture and Patronage in Quattrocento Florence with special reference to the Tornaquinci and their Chapel in S. Maria Novella," Ph.D. diss., University of Melbourne.

Simons, P. 1987. "Patronage in the Tornaquinci Chapel, Santa Maria Novella, Florence," in *Patronage, Art, and Society in Renaissance Italy*, eds. F. W. Kent and P. Simons with J. C. Eade. Oxford.

Simons, P. 1993. "(Check)Mating the Grand Masters: The Gendered, Sexualized Politics of Chess in Renaissance Italy," *Oxford Art Journal* 16:59–74

Simons, P. 1995. "Portraiture, Portrayal, and Idealization: Ambiguous Individualism in Representations of Renaissance Women," in *Language and Images of Renaissance Italy*, ed. A. Brown. Oxford.

Simons, P. 1997. "Homosociality and erotics in Italian Renaissance Portraiture," in *Portraiture: Facing the Subject*, ed. J. Woodall. Manchester.

Simpson, D. 1995. *The Academic Postmodern and the Rule of Literature: A Report of Half-Knowledge*. Chicago.

Sleptzoff, L. M. 1978. *Men or Supermen?: The Italian Portrait in the Fifteenth Century*. Jerusalem.

Slim, H. C. 1972. *A Gift of Madrigals and Motets*. Chicago.

Smith, C. 1994, in Millon 1994.

Snyder, J. 1985. "Las Meninas and the Mirror of the Prince," *Critical Inquiry* 11:539–72.

Sohm, P. 1995. "Gendered Style in Italian Art Criticism from Michelangelo to Malvasia," *Renaissance Quarterly* 48:759–808.

Solberg, G. 1991. "Taddeo di Bartolo: his life and work," Ph.D. diss., New York University.

Sonnenburg, H. von. 1983. *Raphael in der Alten Pinakothek*. Munich.

Sonnenburg, H. von. 1990. "The Examination of Raphael's Paintings in Munich," in *The Princeton Raphael Symposium*, eds. J. Shearman and M. B. Hall. Princeton.

Soprani, R. 1768. *Vite de' pittori, scultori, ed architetti genovesi*. Genoa.

Soussloff, C.M. 1990. "Lives of poets and painters in the Renaissance," *Word and Image* 6:154–62.

Soussloff, C.M. 1997. *The Absolute Artist: The Historiography of a Concept*. Minneapolis.

Spencer, J.R., 1965. *Filarete's Treatise on Architecture*. 2 vols. New Haven.

Spencer, J.R. 1978. "Filarete's bronze doors at St. Peter's," in *Collaborations in the Italian Renaissance*, eds. J. Paoletti and W.S. Sheard. New Haven and London.

Spencer, J.R. 1979. "Filarete, the Medallist of the Roman Emperors," *Art Bulletin* 61:549–61.

Spicer, J. 1991. "The Renaissance Elbow," in *A Cultural History of Gesture from Antiquity to the Present Day*, eds. J. Bremmer and H. Roodenburg. Oxford.

Spini, G. 1966. "Politicità di Michelangelo," in *Atti del Convegno di Studi Michelangioleschi*. Rome.

Starn, R. 1989. "Seeing Culture in a Room for a Renaissance Prince," in *The New Cultural History*, ed. L. Hunt. Berkeley and Los Angeles.

Starn, R. 1994. "Who's afraid of the Renaissance," in *The Past and Future of Medieval Studies*, ed. J. Van Engen. Notre Dame.

Starn, R. 1995. "Places of the Image in Italian Renaissance Art: Clues, Symbols, and Signatures in Mantegna's Camera Picta," in *Place and Displacement in the Renaissance*, ed. A. Vos. Binghamton, N.Y.

Starn, R., and L. Partridge. 1992. *Arts of Power: Three Halls of State in Italy, 1300–1600*. Berkeley and Los Angeles.

Steinberg, L. 1975. "Pontormo's Alessandro de' Medici, or I Have Only Eyes for You," *Art in America* 63:62–65.

Steinberg, L. 1981. "Velazquez' 'Las Meninas,'" *October* 19:45–54.

Stephens, J. 1990. *The Italian Renaissance: The Origins of Intellectual and Artistic Change before the Reformation*. London.

Stewart, A. 1990. *Greek Sculpture: An Exploration*. New Haven and London.

Strehlke, C. 1985. "Pontormo, Alessandro de' Medici, and the Palazzo Pazzi," *Philadelphia Museum of Art Bulletin* 81, 348:3–15.

Suida, W. 1953. *Bramante pittore e il Bramantino*. Milan.

Suida, W. 1954. "Spigolature Giorgionesche," *Arte Veneta* 8:153–66.

Suida Manning, B., and W. Suida, 1958. *Luca Cambiaso*. Milan.

Summers, D. 1969. "The Sculptural Program of the Cappella di San Luca in the SS. Annunziata," *Mitteilungen des Kunsthistorischen Institutes in Florenz* 14:67–90.

Summers, D. 1978. "David's Scowl," in *Collaboration in Italian Renaissance Art*, eds. W.S. Sheard and J.T. Paoletti. New Haven and London.

Summers, D. 1981. *Michelangelo and the Language of Art*. Princeton.

Summers, D. 1987. *The Judgment of Sense*. Cambridge.

Summers, D. 1993. "Form and Gender," *New Literary History* 24:243–71.

Tanner, M. 1993. *The Last Descendants of Aeneas: The Hapsburgs and the Mythic Image of the Emperor*. New Haven and London.

Taylor, C. 1989. *Sources of the Self: The Making of Modern Identity*. Cambridge, Mass.

Taylor, M.C. 1984. "The Disappearing Self," *Notebooks in Cultural Analysis: An Annual Review*. Durham, N.C.

Thompson, D.V., Jr. 1932. *The Craftsman's Handbook "Il Libro dell'Arte." Cennino d'Andrea Cennini*. New Haven.

Thomson de Grummond, N. 1975. "VV and Related Inscriptions in Giorgione, Titian, and Dürer," *Art Bulletin* 57:346–56.

Tietze-Conrat, E. 1934. "Marietta, fille du Tintoret: peintre de portraits," *Gazette des Beaux-Arts* 12:258–62.

Tietze-Conrat, E. 1955. *Mantegna*. New York.

Titian. 1977. *Le Lettere*, ed. C. Gandini. Pieve di Cadore.

Trachtenberg, M. 1971. *The Campanile of Florence Cathedral: "Giotto's Tower"*. New York.

Tronca, M.S. 1995. "La Collezione di Leone Leoni e le sue implicazioni culturali," in *Leone Leoni tra Lombardia e Spagna. Atti del Convegno, 1993*, ed. M.L. Gatti Perer. Milan.

Trusted, M. 1990. *German Renaissance Medals*. London.

Tsudi, H. von. 1884. "Filaretes Mittarbeiter an den Bronzethuren von St. Peter," *Repertorium für Künstwissenschaft* 7:291–4.

Turner, N. 1993. "The Gaburri/Rogers Series of Drawn Self-portraits and Portraits of Artists," *Journal of the History of Collections* 5:179–216.

Uffizi. 1979. *Gli Uffizi: Catalogo Generale*. Florence.

Valcanover, F. 1969. *L'Opera completa di Tiziano*. Milan.

Valentiner, W.R. 1955. "Bandinelli, Rival of Michelangelo," *Art Quarterly* 18:241–64.

Van Os, H.W. 1977. "Vecchietta and the Persona of the Renaissance Artist," in *Studies in Late Medieval and Renaissance Painting in honor of Millard Meiss*. New York.

Van de Velde, C. 1975. *Frans Floris (1519/20–1570)*, Brussels.

Van Marle, R. 1932. *Iconographie de l'art profane au Moyen-âge et à la Renaissance*. 2 vols. The Hague.

Vasari, G. 1982. *Giorgio Vasari: Der Literarische Nachlass*, eds. K. Frey and H.-W. Frey. Hildesheim.

Vasari/Barocchi. 1962. *Giorgio Vasari: La Vita di Michelangelo nelle redazioni del 1550 e del 1568*, ed. P. Barocchi, 6 vols. Milan and Naples.

Vasari/De Vere. 1912–14. *Lives of the Most Eminent Painters, Sculptors and Architects by Giorgio Vasari; Newly Translated by Gaston Du C. De Vere*. 10 vols. London.

Vasari/Milanesi. 1906. *Le Vite de' più eccellenti Pittori, Scultori ed Architettori scritte da Giorgio Vasari pittore aretino con nuove annotationzi e commenti di Gaetano Milanesi*. 9 vols. Florence.

Venturi, A. 1908. *Storia dell'arte Italiana. VI. La Scultura del Quattrocento*, Milan.

Verdier, P. 1968. "L'iconographie des Arts Liberaux dans l'art du Moyen-âge jusqu'à la fin du quinzième siècle," in *Arts Liberaux et Philosphie au Moyen Age*. Actes du 4ème Congrès International de Philosophie Mediévale. Montreal and Paris.

Vermeule, C.C., III. 1965. "A Greek Theme and Its Survivals: The Ruler's Shield (Tondo Image) in Tomb and Temple," *Proceedings of the American Philosophical Society* 109:361–97.

Vienna. 1991. *Die Gemäldegalerie des Kunsthistorischen Museums in Wien: Verzeichnis der Gemälde*. Vienna.

Virgil. 1983. *The Eclogues. The Georgics*, trans. C. Day Lewis, intro. R.O.A.M. Lyne. Oxford.

Vishny, M. 1986. "A Year of Reflection: Paul Klee's 1919 self-Portraits," *Gazette des Beaux-Arts* 108:89–94.

Volk, M.C. 1978. "On Velásquez and the Liberal Arts," *Art Bulletin* 70:69–86.

Wackernagel, M. 1981. *The World of the Florentine Renaissance Artist: Projects and patrons, workshop and art market*, trans. A. Luchs. Princeton.

Waddington, R.B. 1989. "Medallic Portraits of Michelangelo. One: Leone Leoni's Medal," *The Medallist* 6, 2:2–3.

Waddington, R.B. 1993. "Graven Images: Sixteenth-century portrait medals of Jews," *The Medal* 23:13–21.

Wagner, H. 1969. *Raffael im Bildnis*. Bern.

Waldman, L. 1994. "'Miracol' Novo et Raro,'": Two unpublished contemporary satires on Bandinelli's 'Hercules and Cacus,'" *Mitteilungen des Kunsthistorischen Institutes in Florenz* 38:419–27.

Wallace, W.E. 1992a. "Michelangelo In and Out of Florence between 1500 and 1508," in *Leonardo, Michelangelo, and Raphael in Renaissance Florence from 1500 to 1508*. Washington, D.C.

Wallace, W.E. 1992b. "How did Michelangelo become a sculptor?" in *The Genius of the Sculptor in Michelangelo's Work*. Montreal.

Wallace, W.E. 1994. *Michelangelo at San Lorenzo: The Genius as Entrepreneur*. Cambridge.

Warnke, M. 1992. "Filaretes Selbstbildnisse: Das geschenkte Selbst," in *Der Künstler über sich in seinem Werk*, ed. M. Winner. Weinheim.

Warnke, M. 1993. *The Court Artist: On the ancestry of the modern artist*. Cambridge.

Washington, D.C., 1986. *The Age of Correggio and the Carracci: Emilian Painting of the Sixteenth and Seventeenth Centuries*. Exh. cat., National Gallery of Art.

Washington, D.C., 1995. *Johannes Vermeer*. Exh. cat., National Gallery of Art.

Washington, D.C., and Houston. 1988. *Painters by Painters*, exhibition of self-portraits from the Uffizi Gallery.

Waterhouse, E. 1936. "The Palazzo Zuccari," *Burlington Magazine* 69:133–4.

Watkins, R. 1957. "The Authorship of the Vita Anonima of Leon Battista Alberti," *Studies in the Renaissance* 4:101–12.

Watkins, R. 1960. "L. B. Alberti's Emblem, the Winged Eye, and His Name, Leo," *Mitteilungen des Kunsthistorischen Institutes in Florenz* 9:256–8.

Watson, P. 1990. "Autobiography in Three Dimensions," Abstracts of the Papers given at the Annual Meeting of the College Art Association of America.

Wazbinski, Z. 1977. "Artisti e Pubblico nella Firenze del Cinquecento. A proposto del topos Cane abbaiante," *Paragone* 28, 327:3–24.

Wazbinski, Z. 1985. "Lo Studio, La Scuola Fiorentina di Federco Zuccari," *Mitteilungen des Kunsthistorischen Institutes in Florenz* 29:275–341.

Wazbinski, Z. 1991. *L'Accademia Medicea del Disegno a Firenze nel Cinquecento: Idea e Istituzione*. Florence.

Webhorn, W. A. 1978. *Courtly Performances: Masking and Festivity in Castiglione's "Book of the Courtier"*. Detroit.

Weil-Garris, K. 1981. "Bandinelli and Michelangelo: A Problem of Artistic Identity," in *Art the Ape of Nature: Studies in Honor of H. W. Janson*, eds. M. Barasch and L. F. Sadler, New York.

Weil-Garris, K. 1983. "On Pedestals: Michelangelo's 'David,' Bandinelli's 'Hercules and Cacus,' and the Sculpture of the Piazza della Signoria," *Römisches Jahrbuch für Kunstgeschichte* 20:378–415.

Weil-Garris, K. 1990. "La morte di Raffaello e la Trasfigurazione," in *Raffaello e l'Europa*, eds. M. Fagiolo and M. L. Madonna. Rome.

Weil-Garris Brandt, K. 1990. "The Self-Created Bandinelli," in *World Art: Themes of Unity in Diversity*. Acts of the XXVIth International Congress of the History of Art, II, ed. I. Lavin. University Park, Pa.

Weintraub, K. J. 1975. "Autobiography and Historical Consciousness," *Critical Inquiry* 1:821–48.

Weintraub, K. J. 1978. *The Value of the Individual: Self and Circumstance in Autobiography*. Chicago.

Weiss, R. 1965. "The Medals of Julius II," *Journal of the Warburg and Courtauld Institutes* 28:163–82.

Weissman, R. "The Importance of being Ambiguous: Social Relations, Individualism, and Identity in Renaissance Florence," in *Urban Life in the Renaissance*, eds. S. Zimmerman and R. Weissman. Newark, N.J.

Welch, E. S. 1995. *Art and Authority in Renaissance Milan*. New Haven and London.

Westfall, C. W. 1969. "Painting and the Liberal Arts: Alberti's View," *Journal of the History of Ideas* 30:487–506.

Wetenhall, J. 1984. "Self-portrait on an Easel: Annibale Carracci and the Artist in Self-portraiture," *Art International* 27:48–55.

Wethey, H. E. 1969–71. *The Paintings of Titian*. 3 vols. Oxford.

Wilchusky, M. 1994, cat. entry in Scher 1994.

Wilde, J. 1978. *Michelangelo: Six Lectures*. Oxford.

Wind, E. 1937. "Aenigma Termini," *Journal of the Warburg and Courtauld Institutes* 1:66–9.

Wind, E. 1958. *Pagan Mysteries in the Renaissance*. New Haven.

Wind, E. 1969. *Giorgione's Tempesta with Comments on Giorgione's Poetic Allegories*. Oxford.

Winner, M. 1986. "L'autoritratto di Raffaello e la misura per il nostro occhio: appunti sulla costruzione prospettica della Scuola d'Athene (c.1510–11)," in *Tecnica e Stile: esempi di pittura murale del rinascimento italiano*. eds. E. Borsook and F. Superbi Gioffredi. Florence.

Winner, M. 1989. "Annibale Carracci's Self-Portraits and the Paragone Debate," in *World Art: Themes of Unity in Diversity*. Acts of the XXVIth International Congress of the History of Art, II, ed. I. Lavin. University Park, Pa.

Wittkower, R. 1950. "The Artist and the Liberal Arts," *Eidos* I, no. 1:11–17.

Wittkower, R. 1952. *The Drawings of the Carracci at Windsor Castle*. London.

Wittkower, R. 1961. "Individualism in Art and Artists: A Renaissance Problem," *Journal of the History of Ideas* 22:291–302.

Wittkower, R. 1962. *Architectural Principles in the Age of Humanism*. New York.

Wittkower, R. 1965. *Painting in Italy, 1600–1700*. Harmondsworth.

Wittkower, R. 1973. "Genius: Individualism in Art and Artists," in *Dictionary of the History of Ideas*, I, ed. P. P. Weiner. New York.

Wittkower, R., and M. Wittkower, 1963. *Born under Saturn. The Character and Conduct of Artists: A Documented History from Antiquity to the French Revolution*. New York.

Wittkower, R., and M. Wittkower, 1964. *The Divine Michelangelo: The Florentine Academy's Homage on his Death in 1564*. London.

Wolff-Metternich, F. G., and C. Thoenes. 1987. *Die frühen St. Peter-Entwürfe, 1505–1514*. Bibliotheca Hertziana (Max Planck-Institut) 25. Tübingen.

Wolters, C. 1953–6. "Ein selbstbildnis des Taddeo di Bartolo," *Mitteilungen des Kunsthistorischen Institutes in Florenz* 7:70–72.

Wood, J. M. 1985. "The Early Paintings of Perugino," Ph.D. diss., University of Virginia.

Woodall, J. 1989. "Honour and Profit: Antonis Mor and the Status of Portraiture," *Leids Konsthistorisch Jaarboek* 8:69–89.

Woods-Marsden, J. 1987. "'Ritratto al Naturale': Questions of Realism and Idealism in Early Renaissance Portraits," *Art Journal* 46: 206–19.

Woods-Marsden, J. 1988. *The Gonzaga of Mantua and Pisanello's Arthurian Frescoes*. Princeton.

Woods-Marsden, J. 1993. "Per una tipologia del ritratto di stato nel Rinascimento Italiano," in *Il Ritratto e la Memoria. Materiali 3*, eds. A. Gentili, P. Morel, C. Cieri Via. Rome.

Woods-Marsden, J. 1994. "Toward a History of Art Patronage in the Renaissance: The Case of Pietro Aretino," *Journal of Medieval and Renaissance Studies* 24:275–99.

Woods-Marsden, J. (forthcoming) 1998. "Pisanello and the Self: The Birth of Autonomous Self-Portraiture," in *Pisanello: le peintre aux sept vertues*, ed. D. Cordellier, Musée du Louvre. Paris.

Zampetti, P. 1968. *L'Opera completa di Giorgione*. Milan.

Zapperi, R. 1987. "I ritratti di Antonio Carracci," *Paragone* 38, 449:3–22.

Zapperi, R. 1989. *Annibale Carracci: ritratto di artista da giovane*. Turin.

Zapperi, R. 1990. "Il ritratto e la maschera: ricerche su Annibale Carracci ritrattista," *Bollettino d'Arte* 60:85–94.

Zapperi, R. 1991. "Federico Zuccari censurato dalla corporazione dei pittori," *Städel-Jahrbuch* n. s. 13:177–90.

Zemel, C. 1997. *Van Gogh's Presence*. Berkeley and Los Angeles.

Zimmerman, T. C. P. 1971. "Confession and Autobiography in the Early Renaissance," in *Renaissance Studies in honor of Hans Baron*, eds. A. Molho and J. A. Tedeschi. Florence.

Zimmerman, T. C. P. 1995. *Paolo Giovio: The Historian and the Crisis of Sixteenth-Century Italy*. Princeton.

Zöllner, F. 1992. "'Ogni Pittore Dipinge Sé: Leonardo da Vinci and 'Automimesis,'" in *Der Künstler über sich in seinem Werk*, ed. M. Winner. Weinheim.

Zucker, W. M. 1962. "Reflections on Reflections," *Journal of Aesthetics and Art Criticism* 20:239–50.

68 Giovanni Boldù, self-portrait medal, bronze, 1458, obverse, National Gallery of Art, Washington, D.C. Samuel H. Kress Collection.

69 "God as Architect," Bible Moralisée, Rheims, France, mid-thirteenth century. Illumination. Österreichische Nationalbibliothek, Vienna.

70 Attributed to Gentile Bellini, *Man with a Pair of Dividers or Compasses* (here identified as Giovanni Bellini), canvas, early sixteenth century, National Gallery, London.

71 Vettor Gambello, medal of Giovanni Bellini, bronze, early sixteenth century, obverse and reverse, British Museum, London.

72 Detail of pl. 74.

73 View of the Sala dell'Udienza in the Collegio del Cambio, Perugia, fresco, 1500.

74 Detail of pl. 73, with Perugino's self-portrait.

75 Pinturicchio, *Annunciation*, fresco, 1502, S. Maria Maggiore, Spello.

76 Detail of pl. 75, with self-portrait.

77 Attributed to Raphael, *Self-Portrait*, panel, c.1505–6, Royal Collection, Hampton Court.

78 Umbrian/circle of Raphael, *Half-length Portrait of a Young Man* (?copy of possible Raphael self-portrait), Alte Pinakothek, Munich.

79 Umbrian/circle of Raphael, *Half-length Portrait of a Young Man* (?copy of possible Raphael self-portrait), Budapest, Szépművészeti Muzéum.

80 Perugino, *Francesco delle Opere*, panel, 1494, Galleria degli Uffizi, Florence.

81 Attributed to Raphael or circle of Raphael, *Self-Portrait*, panel, c.1520, Galleria degli Uffizi, Florence.

82 Wenceslaus Hollar, copy of Giorgione, *Self-Portrait*, c.1505–10, engraving, 1650. Made before the portrait was cut down.

83 Detail of pl. 87, with self-portrait.

84 Raphael, *School of Athens*, fresco, 1510–11, Stanza della Segnatura, Vatican Palace, Rome.

85 Detail of pl. 84, showing two portraits, here identified as Raphael and Pinturicchio.

86 Sodoma, *St. Benedict's First Miracle: The Repair of the Cribble*, fresco, 1505–6, Monte Oliveto Maggiore.

87 Raphael, *Self-Portrait with a Friend*, c.1519, Musée du Louvre, Paris.

88 Raphael, *Pope Leo X with two Cardinals*, panel, 1517, Galleria degli Uffizi, Florence.

89 Leonardo da Vinci, *Cecilia Gallerani*, c.1490, National Museum, Cracow.

90 Attributed to Giovanni Battista Paggi, *Self-Portrait with an Architect Friend*, canvas, 1580s, Martin von Wagner Museum, Würzburg.

91 M. C. Escher, *Hand with Reflecting Sphere*, lithograph, 1935, Detroit Institute of Art. Gift of Dr. Herman J. Linn and Arlen W. Linn in memory of Orr Bevington White and in honor of his wife, Garrie Bruce White.

92 Parmigianino, *Self-Portrait in a Convex Mirror*, panel, 1524, Kunsthistorisches Museum, Vienna.

93 Attributed to Baccio Bandinelli, *Self-Portrait*, panel, early 1530s, Isabella Stewart Gardner Museum, Boston.

94 Titian, *Giulio Romano*, canvas, 1536–8, Private Collection.

95 Leone Leoni, medal of Bandinelli, bronze, 1550s, obverse and reverse, National Gallery of Art, Washington, D.C., Samuel H. Kress Collection.

96 Niccolò della Casa, *Portrait of Bandinelli*, engraving, c.1540–45, National Gallery of Art, Washington, D.C., Ailsa Mellon Bruce Fund.

97 Enea Vico, *Bandinelli's Academy*, engraving after drawing by Bandinelli, c.1550, Museum of Fine Arts, Boston. Horatio Greenough Curtis Fund.

98 Giorgio Vasari, *Cosimo I de' Medici surrounded by his Architects, Engineers, and Sculptors*, fresco, 1555–8, Sala di Cosimo I, Palazzo Vecchio, Florence.

99 Circle of Vasari, *Giorgio Vasari*, panel, 1571–4, Galleria degli Uffizi, Florence.

100 Detail of pl. 101.

101 Giorgio Vasari, *The Return of the Marchese of Marignano*, fresco, 1563–5, Salone dei Cinquecento, Palazzo Vecchio, Florence.

102 Giorgio Vasari, *Portraits of Members of the Artist's Workshop*, fresco, 1563–5, Salone dei Cinquecento, Palazzo Vecchio, Florence.

103 Titian, *Self-Portrait*, canvas, early 1550s, Gemäldegalerie, Staatliche Museen, Berlin.

104 Attributed to Agostino Ardenti, medal of Titian with portrait of his son Orazio, bronze, c.1563, whereabouts unknown.

105a Attributed to Pastorino da Siena, medal of Titian, bronze, 1540s, obverse, British Museum, London.

105b Unknown medalist, medal of Titian, bronze, obverse, Victoria and Albert Museum, London.

106 Titian, *Self-Portrait*, canvas, c.1565–70, Prado, Madrid.

107 Leone Leoni, facade of Casa Omenoni, Milan.

108 Leone Leoni, self-portrait medal, bronze, 1541, obverse and reverse, National Gallery of Art Washington, D.C., Samuel H. Kress Collection.

109 Leone Leoni, self-portrait medal, bronze, before 1549, obverse, whereabouts unknown.

110 Leone Leoni, self-portrait medal, bronze, 1541, reverse (larger than actual size), National Gallery of Art, Washington, D.C., Samuel H. Kress Collection.

111 Federico Zuccari, *Self-Portrait as Pendant to that of Taddeo*, canvas, late sixteenth–early seventeenth century, Lucca, Pinacoteca.

112 Federico Zuccari, *Portrait of Taddeo Zuccari as Pendant to Self-Portrait*, canvas, late sixteenth–early seventeeth century, Galleria degli Uffizi, Florence.

113 Fede Galizia, *Federico Zuccari*, canvas, 1604, Galleria degli Uffizi, Florence.

114 Detail of pl. 115, with self-portrait.

115 Federico Zuccari, cupola of Florence cathedral, detail of west compartment showing Holy People of God, fresco, 1579.

116a Style of Pastorino, medal of Federico Zuccari, bronze, c.1578–9, reverse, showing the cupola of Florence cathedral, British Museum, London.

116b Style of Pastorino, medal of Federico Zuccari, bronze, 1588, reverse, showing the high altarpiece in the apse of S. Lorenzo de El Escorial, Museo Nazionale del Bargello, Florence.

117 Taddeo Zuccari, *The Meeting of Francis I, Charles V, and Cardinal Alessandro Farnese*, fresco, early 1560s, Caprarola, Sala dei Fasti Farnesi.

118 Federico Zuccari, detail of self-portrait with his wife, fresco, early 1590s, lunette, Sala Terrena, Palazzo Zuccari, Rome.

119 Federico Zuccari, detail of self-portrait with Taddeo, lunette, fresco, early 1590s, Sala Terrena, Palazzo Zuccari, Rome.

120 Federico Zuccari *Apotheosis of the Artist*, fresco, early 1590s, vault, Sala Terrena, Palazzo Zuccari, Rome.

121 Federico Zuccari, *Virgin and Child with Saints and Members of the Zuccari family*, canvas, 1603, S. Angelo in Vado, formerly S. Caterina, now Palazzo Communale.

122 Detail of pl. 132.

123 F. A. Casoni, medal of Lavinia Fontana, bronze, 1611, reverse (larger than actual size), British Museum, London.

124 Detail of pl. 130.

125 Pierre Dumonstier le Jeune, *The Hand of Artemisia Gentileschi*, drawing, 1625, British Museum, London.

126 Sofonisba Anguissola, *The Chess Game*, 1555, Muzeum Narodowe, Poznan.

127 Detail of pl. 126, showing female hands engaged in playing the intellectual game of chess.

128 Detail of pl. 132.

129 Sofonisba Anguissola, *Self-Portrait with a Book*, 1554, Kunsthistorisches Museum, Vienna.

130 Sofonisba Anguissola, *Self-Portrait holding a Medallion inscribed with the Letters of her Father's Name*, vellum, early 1550s (actual size), Museum of Fine Arts, Boston. Emma F. Munroe Fund.

131 Katharina van Hemessen, *Self-Portrait at the Easel*, canvas, 1548, Öffentliche Kunstsammlung, Basel.

132 Sofonisba Anguissola, *Self-Portrait at the Easel, painting a Devotional Panel*, late 1550s, Muzeum Zamek, Lancut.

133 Anonymous medallist, medal of Diana Scultori (who married Francesco Volterrano in 1576), bronze, c.1576, obverse and reverse, British Museum, London. The reverse shows a hand holding an engraving burin.

134 Anonymous medallist, medal of Francesco Volterrano (husband of Diana Scultori), bronze, c.1576, obverse and reverse, British Museum, London. The reverse shows a hand holding a square and compass.

135 Giorgio Vasari, *Pittura*, fresco, 1542, Casa Vasari, Arezzo.

136 F. A. Casoni, medal of Lavinia Fontana, bronze, 1611, obverse and reverse, British Museum, London.

137 Sofonisba Anguissola, *Self-Portrait as a Portrait being created by Bernardino Campi*, canvas, c.1559, Pinacoteca Nazionale, Siena.

138 Sofonisba Anguissola, *Self-Portrait at the Keyboard, with Female Retainer*, canvas, late 1550s, Spencer Collection, Althorp, Northamptonshire.

139 Sofonisba Anguissola, *Self-Portrait*, canvas, before 1564, Musée Condé, Chantilly.

140 Engraved copy of Sofonisba Anguissola, *Self-Portrait at Three-quarter Length*, 1560s, formerly Leuchtenberg Collection.

141 Detail of pl. 144.

142 Lavinia Fontana, *Self-Portrait at the Keyboard*, 1577, Accademia di San Luca, Rome.

143 Attributed to Marietta Robusti, *Self-Portrait at the Keyboard*, canvas, c.1580, Galleria degli Uffizi, Florence.

144 Lavinia Fontana, *Self-Portrait in the Studiolo*, 1579, Galleria degli Uffizi, Florence.

145 Jacopo Pontormo, *Alessandro de' Medici*, 1534, Museum of Art, Philadelphia, The John G. Johnson Collection.

146 Frans Floris, *St. Luke painting the Virgin*, 1556, Koninklijk Museum voor Schone Kunsten, Antwerp.

147 Dosso Dossi, *Jupiter painting in the Presence of Mercury*, 1520s, Kunsthistorisches Museum, Vienna.

148 Giovanni Britto, *Titian sketching* (copy of Titian self-portrait), 1550, woodcut, Rijksmuseum, Amsterdam.

149 Alessandro Allori, *Self-Portrait*, c.1555, Galleria degli Uffizi, Florence.

150 Antonis Mor, *Self-Portrait at the Easel*, 1558, Galleria degli Uffizi, Florence.

151 AD OMNIA, *The Divine Creator holding Palette and Brushes in front of a Virgin Canvas*. Emblem 2 from Diego de Saavedra Fajardo, *Idea de un principe politico cristiano*, Madrid, 1640, I, 82.

152 Luca Cambiaso, *Portrait of the Artist painting a Portrait of his Father*, 1575–80, whereabouts unknown.

153 Dirck Cornelisz. van Oostsanen, *Portrait of the Artist's Father painting a Portrait of the Artist's Mother*, 1550s, Museum of Art, Toledo, Ohio. Gift of Edward Drummond Libbey.

154 Francisco Zurbarán, *The Crucifixion with a Painter*, canvas, c.1630–35, Prado, Madrid.

155 Jacopo Palma il Giovane, *Self-Portrait painting the Resurrection of Christ*, canvas, 1590s, Brera, Milan.

156 Palma Giovane, *Self-Portrait as a Crociferi Monk*, canvas, c.1606, Bardisian Collection, Venice.

157 Annibale Carracci, *Self-Portrait with other Male Figures*, canvas, c.1588–90, Brera, Milan.

158 Annibale Carracci, *Self-Portrait*, canvas, 1593, Pinacoteca Nazionale, Parma.

159 Attributed to Agostino Carracci, *Self-Portrait*, canvas, 1580s, Galleria degli Uffizi, Florence.

160 Annibale Carracci, preparatory sketches for *Self-Portrait on Easel in Workshop*, c.1604, Royal Collection, Windsor Castle.

161 Annibale Carracci, *Self-Portrait on Easel in Workshop*, c.1604, Hermitage Museum, St. Petersburg.

162 Marcantonio Raimondi, *Il Morbetto*, engraving, c.1515–16, Davison Art Center, Wesleyan University, Middletown, Conn.

163 Quentin Matsys, medal of Erasmus, bronze, 1519, reverse, Fitzwilliam Museum, Cambridge.

164 Leone Leoni, medal of Michelangelo, bronze, 1561, obverse, National Gallery of Art, Washington, D.C., Samuel H. Kress Collection.